Eric Kligerman

Sites of the Uncanny

Interdisciplinary German Cultural Studies

Edited by
Scott Denham · Irene Kacandes
Jonathan Petropoulos

Volume 3

Walter de Gruyter · Berlin · New York

Eric Kligerman

Sites of the Uncanny

Paul Celan, Specularity and the Visual Arts

Walter de Gruyter · Berlin · New York

⊗ Printed on acid-free paper which falls within the guidelines
of the ANSI to ensure permanence and durability.

Library of Congress Cataloging-in-Publication Data

Kligerman, Eric.
 Sites of the uncanny : Paul Celan, specularity and the visual arts / by
Eric Kligerman.
 p. cm. − (Interdisciplinary German cultural studies ; v. 3)
 Includes bibliographical references and index.
 ISBN 978-3-11-019135-6 (alk. paper)
 1. Celan, Paul − Influence. 2. Popular culture − Germany. 3. Ho-
locaust, Jewish (1939−1945), and the arts. 4. Collective memory − Ger-
many. 5. Celan, Paul − Criticism and interpretation. I. Title.
 PT2605.E4Z62595 2007
 831'.914−dc22
 200702435

ISBN 978-3-11-019135-6
ISSN 1861-8030

Bibliographic information published by the Deutsche Nationalbibliothek

The Deutsche Nationalbibliothek lists this publication in the Deutsche Nationalbibliografie;
detailed bibliographic data are available in the Internet at http://dnb.d-nb.de.

Printed in Germany
Cover design: Christopher Schneider, Berlin
Printing and binding: Hubert & Co. GmbH & Co. KG, Göttingen

Table of Contents

Acknowledgments

I would like to express my heartfelt gratitude to the editors of the Inter-disciplinary German Cultural Studies series at the Walter De Gruyter Press—Scott Denham, Irene Kacandes, and Jonathan Petropolous—who took an interest in the project, provided incisive criticism, and recommended it to Heiko Hartmann for publication. Irene Kacandes's patient readings of the manuscript, her enriching comments, intellectual engagement, and friendship have been far greater than she might imagine. She has assisted me considerably with the challenges of both conceptualizing and articulating the arguments of this book. I am also incredibly grateful for the attentive reading of my manuscript and detailed feedback I received from my colleague and friend Nora Alter. I have benefited greatly from her countless suggestions and critical insights. Her rigorous questions, theoretical acuity and careful listening helped me define and clarify my ideas. I am indebted to Julia Hell for her help with the earlier stages of this project and for challenging me to re-frame my thinking about Celan's poetry, specularity, and the Holocaust in new ways. Her own thoughtful scholarship and guidance during graduate school have proven invaluable to me.

A special thanks goes to David Bathrick and Anson Rabinbach and to all those who participated in the enriching DAAD summer seminar on visual culture and the Holocaust at Cornell University in 2003. Many people have offered their expertise in reading parts of this manuscript, and I have benefited especially from discussions with Karyn Ball, Darcy Buerkle, Franz Futterknecht, Leah Hochman, Dragan Kujundzic, Dan Magilow, and Sven-Erik Rose. I would also like to acknowledge the many friends and colleagues at the University of Florida who have been a limitless source of encouragement and support throughout this project, including Alex Alberro, Richard Burt, Nina Caputo, Mitch Hart, Todd Hasak-Lowy, Dan Kaufman, Gwynn Kessler, Barbara Mennel, Leah Rosenberg, and Judy Page. I am very appreciative of the administrative and financial support I have received from the program in German and Slavic Studies and the Center of Jewish Studies—Jeff Adler, Keith Bullivant, Will Hasty, Jack Kugelmass, and Ken Wald—that made possible my research travels to Germany and elsewhere. For her friendship and assistance, I also wish

to thank Annemarie Sykes, and Jonathan Barnes for helping me procure the rights to the images in this book.

I thank Mary Fahnestock-Thomas for the preparation of the manuscript, including her meticulous and thoughtful copyediting, indexing, professional expertise, and helpfulness. I would like to express my gratitude to my family, especially Karen, Mark and Sam Kligerman, along with Gilda Josephson for their continual enthusiasm and encouragement throughout the writing of the manuscript. In addition, I am grateful and indebted to Erin, who helped balance the intensity of my work with her kindness, humor, love, and unwavering support. And lastly, I would like to thank my brother Bruce Kligerman, z"l, who shared with me his passion for philosophy, poetry, and the Grateful Dead. He has been the source of inspiration throughout all the years of my intellectual endeavors, and it is to him and to my mother that this book is dedicated. May their memories be a blessing.

List of Illustrations

Introduction: Facing the Holocaust

Positioning the Spectator

At the opening of the Nuremberg Trials in 1945, the chief prosecutor, Robert Jackson, stunned the courtroom when he declared: "We will show you these concentration camps in motion pictures. Our proof will be disgusting and you will say I robbed you of your sleep" (Douglas, 449). Jackson's prophetic words capture the "absolute insomnia" that would be attached to these horrific images not only for those present during the trial but for a subsequent three generations of spectators.[1] Depicting what the allies discovered inside the camps at the time of liberation, the documentary film *Nazi Concentration Camps* provides a visual archive of the crimes committed against the camp inmates. Through the use of black-and-white footage accompanied by a narrator's impassive voice describing the various forms of torture and murder that took place inside the camps, audiences encounter graphic images of violence and cruelty. In addition to the iconic images of burnt corpses, the vacant gaze of emaciated inmates, and depictions of bulldozers pushing corpses into mass graves at Bergen Belsen, there are two iconic scenes of witnessing: one depicting General Eisenhower and General Patton examining the horrific remains of the camp, the other showing a defeated German population near Buchenwald who were forced to look at the remnants of Nazi atrocities.

In their accounts of the film's screening during the trial, members of the audience—journalists, lawyers, judges, and prisoner psychologists—broke off their descriptions of what was shown on the screen and concentrated instead on the reactions of a particular group of witnesses in the courtroom: the accused. Many present in the courtroom turned from the screen and directed their gaze toward the perpetrators. As they describe

1 I am taking the term "absolute insomnia" from Emmanuel Levinas's Talmudic reading "Damages Due to Fire." He uses it to describe the subject's responsibility to the Other in the midst of Auschwitz's shadow: "Everywhere war and murder lie concealed, assassination lurks in every corner, killings go on on the sly. There would be no radical difference between peace and Auschwitz. I do not think pessimism can go much beyond this. Evil suppresses human responsibility and leaves no corner intact where reason could collect itself. But perhaps this thesis is precisely a call to man's infinite responsibility to an untiring wakefulness, to an absolute insomnia" (cited in Cohen, 71).

the visceral reactions of the accused to the film's horrific scenes, the reader is asked to re-imagine the absent images, images that as of November 1945 had yet to reach their iconic status: "Funk covered his eyes ... Frank mutters 'Horrible!' ... Rosenberg fidgets, peeks at screen, bows head, looks to see how others are reacting ... Doenitz has head buried in his hands ... Keitel now hanging head."[2] This terse and fragmentary style offers a verbal counterpart to the mangled bodies projected in the courtroom. And still, some sixty years later, the written record of this courtroom scene places the reader within an ethical frame of responsibility with regard to the scenes of violence: we are asked to occupy the place of the perpetrators. Through the suspension of our own subject position, we are required to perform the imaginative act of visualizing from the perspective of the accused what they were reacting to and to fill in the missing images.[3]

Why would these high-ranking officials within the Nazi party react in such a manner to these documentaries? What exactly do their distressed responses stem from? In his analysis of the screening at Nuremberg, Lawrence Douglas offered these thoughts:

> Their agitation seems baffling: we are left wondering whether the defendants had never before *seen* or *imagined* the atrocities they had orchestrated, or whether the realism of the filmic representations, their construction from an outsider's perspective, produced an awareness among the defendants greater than that gained through their engagement as Nazi functionaries. (456, my italics)

In this telling juxtaposition of affect, imagination, perspective, and new representational modes of seeing, I would argue that it is not the limits of the imagination that the accused run up against here; rather, they exhibit through their specular agitation the very refusal to imagine the violent effacement of the Other depicted in the film. A cognitive dissonance opens up in the spectator who beholds the responses of the accused. We try to reconcile the acts of effacement that these men helped institute as law with their imaginative failure revealed through their looks of astonishment and horror. The somatic effects of shock become indicative of the recognition of an ethical catastrophe presented throughout the documentary.

Yet this emphasis on observing how the perpetrators in the courtroom turned away from the horrific images displayed in the film manifests itself within the documentary film itself: the camera focuses on the effects that the "forced witnessing" of the camps had on German citizens who were compelled by the Allied troops to visit the extermination sites

2 This description comes from the report of G. M. Gilbert, the prisoner psychologist at Nuremberg (Douglas, 455).

3 For further analysis of the command to German civilians to look at corpses after the discovery of the camps, see Zelizer's *Remembering to Forget* and Barnouw's *Germany 1945*.

(Douglas, 472). Once again, the effects the mass graves had on the spectators reflect the imaginative failure displayed by the Nazi functionaries. In one of the most stirring scenes shown to the courtroom, the camera gazes on Weimar's smiling citizens being taken by American troops to Buchenwald. They do not know where they are being led. The camera cuts to their looks of horror as they stand before the mass graves. The specular intricacies of the scene lie in the process of screening, whereby horror is projected onto the townspeople's reaction. Their faces mediate the horror. By introducing the townspeople to this new perspective—proximity to the mass graves—the bystanders are forced to see what they had both evaded and refused to imagine during the reign of the National Socialists.[4]

The witnesses' agitation in the courtroom and before the mass graves in the camps shows the previous refusal to imagine the very possibilities of the Other's destruction. In what Douglas calls an act of "coerced witnessing," the sight of the corpses is intended to shock and overwhelm the viewer: witnessing is replaced with visual trauma. Despite what he describes as a "visual knowledge of atrocity," Douglas continues by asserting that the film's overwhelming of the senses creates "an irrefutable imprint upon the mind, a trauma of sight. The ultimate coercion issues not from the conquering army that commands the act of witnessing, but from the tangible evidence of atrocity itself" (472–73). The command to Weimar's citizens to look is replaced with a breakdown of sight in which the act of belated witnessing ends with an immense sensory shock before the mass graves of the exterminated. The sights of horror shift to the visceral response conveyed by the viewer's averting his/her gaze.

Douglas's depiction of visual knowledge is compromised by his use of the phrase "trauma of sight." The bodily effects the images have on the spectator—lost sleep, overwhelmed senses, turning away, crying, covering the eyes—are not necessarily marks of visual cognition of the atrocities. Contrary to forming visual knowledge or proof, I would claim that cognition turns into an epistemic disruption reminiscent of Freud's depiction of trauma in *Beyond the Pleasure Principle*. The traces of the dead do not force memory upon the spectators; instead, these traces become symptomatic of the very failure of memory that is central to traumatic repression. The breakdown of perception caused in the beholder by overwhelming visual stimuli of the mass graves does not produce the memory of the corpse;

4 Zygmunt Bauman writes in his *Modernity and the Holocaust*, "People refused to believe the facts they stared at. Not that they were obtuse or ill-willed. It was just that nothing they had known before had prepared them to believe. For all they had known and believed, the mass murder for which they did not even have a name yet was, purely and simply, unimaginable. In 1988, it is unimaginable again. In 1988, however, we know what we did not know in 1941; that also *the unimaginable ought to be imagined*" (85).

instead, the "irrefutable imprint" evokes Freud's "Erinnerungsspur," or memory imprint. In this model, memory is burned inside the witness of a trauma and the visual knowledge migrates to symptoms of repression.

Douglas examines how the courtroom functions as an epistemological frame to gain "visual knowledge" of the Holocaust, whereby the phenomenology of seeing the filmic traces is ineluctably bound to questions of understanding the crimes of genocide. In what follows, my interest shifts from Douglas's emphasis on visual knowledge to the trauma of sight that is central to diverse modes of Holocaust representation. In turn, I emphasize the ethical dimensions of the reader/spectator's engagement with representations of the Holocaust by focusing on the phenomenological collapse that is constitutive of this very relation between the individual and the artwork. I have used Douglas's questions revolving around affect, imagination, perception, and new modes of representation to help me set up my analysis of the spectator's relation to prosthetic sites of Holocaust memory. By prosthetic sites, a term I am borrowing from Alison Landsberg, I am referring to the place where a memory arises—such as in a movie theatre or a museum—at the boundary between the individual and a historical narrative about the past. According to Landsberg, an experience unfolds at this site in which the spectator not only "sutures" her/himself into this history, but also takes on a more "deeply felt memory of a past event" through which s/he did not live (*Prosthetic Memory*, 2). In her analysis of prosthetic memory in the United States, Landsberg explores the interplay between the intensification of affect for the spectator and the effect this has on his/her cognitive relation to traumatic spaces of history, such as slavery and the Holocaust. [5]

This book, *Sites of the Uncanny: Paul Celan, Specularity and the Visual Arts*, investigates prosthetic sites of Holocaust memory in Germany in the spaces of literature, film, painting, and architecture, and the ethical ramifications of this desire to suture or identify with the Other's trauma. It includes three main components: first, I offer an extensive theoretical discussion of the uncanny in relation to the Holocaust and to what I am naming the "Holocaustal uncanny"; second, I analyze Paul Celan's depictions of poetry and art in his "Meridian Speech," a text in which the poet renders the uncanny into an ethical category and out of which my terminology emerged; and finally, I apply the concept of the Holocaustal uncanny to various artists who have translated Celan's poetics into visual modes of representation. The Holocaustal uncanny shifts from the act of reading to acts of seeing and entering texts that confront the spectator with catastrophic scenes of loss.

5 I will also be referencing Landsberg's article "America, the Holocaust, and the Mass Culture of Memory," which is based on the fourth chapter of her book.

In the texts I examine, the command to Weimar's citizens to look at the horrors of the camps is transformed into the artists' objective of luring the spectator into these prosthetic memory sites and inducing a visceral response of agitation in that spectator. But unlike the command to go to the camps, the prosthetic sites I explore are infused with an affective charge that relies less on what one sees and more on the very disruption of perception. These new frames of reference do not necessarily show the images of the extermination, but rather withhold them from the spectator's gaze. While the reader/spectator might desire an encounter with the Holocaust that could lead to visual understanding, the artist puts on display scenes of epistemic collapse that position the spectator before an ethical catastrophe that s/he is forced to re-imagine. The artist, whether poet, painter, filmmaker or architect, breaks the spectator's passive act of looking at horror by demanding a re-imagination of the acts of effacement using such techniques as erasing, blurring, or disfiguring the text.

Sites of the Uncanny explores four modes of representation—poetry, film, painting, and architecture—in their relation to the trauma of the Holocaust. My focal point is the works of Paul Celan and the ripple effect that his poetics has had on visual artists who probe the Holocaust, specifically Alain Resnais, Anselm Kiefer, and Daniel Libeskind. After investigating how Celan's uncanny poetics can be read as a response to Heidegger's "virtual silence" concerning the Holocaust,[6] I track the transformation of Celan's work in the cultural imaginary of postwar Germany, showing the extent to which his work is considered emblematic of the country's memory politics and how his poetry serves as a template for provocative forms of uncanny art in the aftermath of the Holocaust.

Why do we need to turn back to Celan's poetics in order to explore contemporary deliberations about how Germany commemorates the traumatic history of the genocide carried out against Europe's Jewish communities? The questions concerning representation that are deeply ingrained in current memory debates were themselves initiated by Celan sixty years ago with the release of his poem "Todesfuge," which shattered and reformed both the conventional techniques of lyric poetry and the semantic and syntactic functions of the German language. By approaching Celan's lyric with both spatial and visual questions in mind, *Sites of the Uncanny* examines the ways in which German memory work unfolds in relation to his poetry. Celan's own attraction to the visual arts and to questions regarding space have been reciprocated by other artists who were themselves influenced by and drawn to Celan's poetics. This book shows how Celan's poems pave the way toward other voids that pervade visual

6 The term "virtual silence" is used by Berel Lang in his book *Heidegger's Silence* (22).

representations of the Holocaust. I employ Celan's concept of "Toposfor-
schung"—the investigation of place—from his "Meridian Speech" to
probe the traumatic spaces of film, painting, and architecture (*Gesammelte
Werke* 3: 199). The intimate dialogue between Celan's lyric and the debates
surrounding the Holocaust at the end of the twentieth and beginning of
the twenty-first centuries remains the backdrop of this study.

Although the poet, the filmmaker, the painter, and the architect ex-
plored in this study come from four distinct subject positions in relation
to the Holocaust—a survivor, a bystander in an occupied country, a mem-
ber of the *Nachgeborene*, and a child of Holocaust survivors—their methods
of positioning the spectator resemble one another. Each artist problema-
tizes the cognitive position of the spectator with regard to the artwork and
prompts an ethical relation between reader/spectator and text. The desire
to become an epistemic subject and to know the Holocaust is destabilized
by each. They are not so much engaged in disproving Adorno's dictum
concerning the limits of representation and the Holocaust; rather, their
employment of such strategies as proximity (spatial), anxiety (affect), and
disrupted vision (perception)—all of which connect back to the subject's
epistemic processing of an experience—have an ethical dimension as well.
Emphasizing this ethical engagement with the traces left behind by the ex-
termination, each artist lures the reader/spectator into unmasterable
scenes of terror and asks of her/him to re-imagine what the artists them-
selves withhold from their respective texts.

Empathic Imagination: Identification and the Other

Several contemporary studies that explore the relation between affect,
imagination, and prosthetic sites of Holocaust memory in American cul-
ture tend to emphasize the spectator's desire to overcome distance in or-
der to have an authentic or immediate "Holocaust experience."[7] Such an
experience involves getting "closer" to the catastrophic events and its vic-
tims. In addition, this proximity is connected to the affective state of em-
pathy for the Other's suffering. Although the authors of these works
foreground the cognitive aspects of this drive of the nonwitness to know
what happened, there is a tendency to blur the theoretical categories of
epistemology, aesthetics, and ethics. Ultimately, the ethical import behind
these concepts of affect and proximity is sidestepped in favor of making
the Holocaust an object of knowledge.

7 I am referring to Gary Weissman's term from his *Fantasies of Witnessing* and will return later in
 the introduction to his study of the spectator's desire to approach the Holocaust.

In her work on "prosthetic memory," Landsberg examines how expe-
riential forms of Holocaust representation provide what she calls an "ex-
periential ... mode of knowledge" ("America," 74). Her term "prosthetic
memories" refers to "artificial" memories arising from experiential forms
of representation that produce a bodily sensation in the spectator. Such
sites are designed to stimulate a somatic knowledge of the Holocaust by
opening up experiential relations to events that are not one's own. A fab-
ricated memory arises in the spectator through an affective charge that the
representation is to induce upon the spectator's body. Landsberg focuses
on the Holocaust Museum and Memorial in Washington, D.C., where the
desire of the visitor is to "come as close as possible to taking on the
symptoms—the memories—of the Holocaust, through which he did not
live" (73). The prosthetic site of the museum consists of experiential
modes that try to produce cognitive knowledge by bringing one "closer"
to the Holocaust. Landsberg's discussion of "corporeal understanding"
(81) focuses on the exhibition of the boxcar that once transported Jews to
Treblinka. The museum visitor through the exhibition thus has a corpo-
real interaction with remnants from the extermination. The blending of
space between the spectator and the objects of the past offers the "illu-
sion of unmediated proximity" (78): the spectator is encouraged to fanta-
size about stepping inside this remnant of the trauma.

In this prosthetic site, which Landsberg also calls a "transferential
space" (72), the goal is for the museum visitor to take on an affective state
associated with the victims.[8] The visitor adopts not simply the memories
of the victims, but also their symptoms in these substitute spaces; there is
a blurring of identification where the spectator perceives him/herself as
the victim inside the claustrophobic space of the boxcar. But in her analy-
sis of this "as if" experience, which offers the visitor an illusion of unme-
diated proximity, Landsberg fails to explore the risks of such acts of em-
pathic identification. Such terms as "proximity to," "empathy with," and
"imaginary identification with" the victims function as epistemic tools that
allow the spectator to get physically closer to the Holocaust, but their
ethical import remains essentially unexamined. While she suggests that
America's encounter with prosthetic memory of the Holocaust might
bring us closer to "local traumas" such as slavery and the slaughter of Na-
tive Americans (86), Landsberg fails to question how one's subject posi-
tion and responsibility to the Other are problematized through such fixed

8 Although she may reject the possibility of any therapeutic or curative associations in her
 analysis of the museum, there is indeed something therapeutic developing in Landsberg's
 analysis as seen in her choice of terms such as "transferential space" and "utopian vision" of
 memory (72, 67).

identification with the victim. She ultimately evades questions regarding the spectator's potential identification with the perpetrator's perspective.

In his *Fantasies of Witnessing: Postwar Efforts to Experience the Holocaust,* Gary Weissman extends Landsberg's investigation of prosthetic memory to include an analysis of why Americans in particular desire to feel closer to the Holocaust. Using a series of spatial terms that revolve around the notion of proximity to the Holocaust's horror, Weissman examines how the nonwitness—his term for those who engage with the history and events of the Holocaust but are not relatives of the victims—tries to approach the Holocaust's "illusive reality" and face its horror (216). The spectator assumes that an intensification of affect contributes to an increase in understanding; the goal is "to witness the Holocaust *as if* one were actually there" (4). It is not the Holocaust that haunts the nonwitness; rather, people desire to feel its horror because they are haunted by its absence (24). This proximity is achieved through what Weissman calls "fantasies of witnessing" the horror. There is a *desire to know* what it was like to be there and to attain a vicarious Holocaust experience.[9] For Weissman the inclination to feel horror is an attempt by the spectator to move closer to the "Holocaust experience," as if it were a part of his/her own memory (92). Through an imaginary identification with the victim, an illusory connection between the spectator and the Holocaust is formed.

Weissman asks whether an artwork "that *encourages* viewers to imagine the 'unimaginable' necessarily occupies a higher moral ground than one that takes the next step of giving visual form to what has been imagined?" (205). His question, which is left open, concerns the notion of the *Bilderverbot,* that is, the prohibition against forming images in relation to the Holocaust. However, Weissman's primary concern is not with the representational limits the artist encounters when trying to represent historical trauma; instead, his interest returns to the spectator's desires to face the Holocaust, to see and feel its horror, and the resulting fantasies. Hence, such processes of imagining the Holocaust focus on the epistemological characteristics of the event.

Both Landsberg and Weissman limit their interpretive frame to models that seek to recreate or achieve as closely as possible a resemblance of the event. But what happens to Landsberg's and Weissman's concept of the spectator's fantasy of witnessing when the artwork goes in the opposite direction, that is, when the reader/spectator is confronted with *abstract* representations, works that subvert concepts of realism and narrative cohesion and destroy any notion of an authentic or "truthful" Holocaust experience? I am neither judging a particular moral hierarchy regarding

9 See also, for instance, James Young's concept of "vicarious experience" in his book *At Memory's Edge: After-images of the Holocaust in Contemporary Art and Architecture.*

"good" and "bad" forms of Holocaust representation nor using these works as cognitive frames to understand the Holocaust; rather, I am interested in how abstract modes of Holocaust representation lure the nonwitness into their spaces and disrupt the imagination in order to expose both the very impossibility of witnessing and reveal the absolute alterity of the Holocaust and its victims.

This interplay of empathy, the imagination, and Holocaust representation has been approached by Carolyn Dean in her insightful analysis of the waning of empathy *The Fragility of Empathy: After the Holocaust*. While Landsberg and Weissman explored affect's relation to understanding the Holocaust, whereby literary and filmic depictions of the Holocaust place the reader/spectator into an empathic relation with the victim, Dean examines "the collective failure of the empathic imagination" in the spectator's encounter with atrocity images (15). Dean claims that the nonwitness is caught between the numbing effects and the heightened state of agitation induced through an overexposure to the shock of Holocaust images. Describing how our obligation to human beings "is increasingly based on bodily suffering, on our imaginings of the terror and deprivation to which bodies elsewhere are subjected," Dean questions "post-Holocaust anxieties about the failure or corruption of empathy" (42). In particular, she probes how this waning of empathy manifests itself in the cultural narrative of numbness or indifference that pervades recent critical studies on trauma.[10]

I am particularly interested in Dean's analysis of empathic imagination in relation to Daniel Jonah Goldhagen's *Hitler's Willing Executioners*. Dean, examining how empathy both enables and constrains historical knowledge, investigates the critical reception of Goldhagen's book in relation to his technique of forging an identification between his readers and the victims of genocide. While historians may try to find the proper balance between affect and empiricism in order to uphold both the victims' dignity and the "moral integrity" of their texts (54), many historians have criticized Goldhagen for contaminating any "pure identification" between the reader and the victims. The focal point of these critiques, Dean contends, is Goldhagen's controversial use of empathic identification. The reader of *Hitler's Willing Executioners*, assuming both the genocidal gaze of the perpetrators *and* an empathic position of a witness to the atrocities, becomes simultaneously a complicit and a mourning bystander. Paraphrasing Jane

10 For instance, Dean is referring to Susan Moeller's *Compassion Fatigue*, Gitta Sereny's *Albert Speer: His Battle with Truth*, William Reddy's *The Navigation of Feelings: A Framework for the History of Emotions*, Samantha Power's *"A Problem from Hell": America in the Age of Genocide*, and Susan Sontag's *Regarding the Pain of Others*. Each study examines what Arthur and Joan Kleinman call an "exhaustion of empathy" that overcomes the individual who is exposed to the traumas of the nineteenth and twentieth centuries (9).

Caplan's critique of Goldhagen, Dean traces the argument that such an ambivalent identification hampered a "healthy empathic identification" and "truly meaningful identification" by "contaminating any pure identification with victims" (51).

While Dean claims that Goldhagen's critics, such as Caplan, Geoff Eley, Atina Grossman, and Hans Mommsen, interpret an ambivalent identification as a threat to the reader's relation with the victims of the Holocaust, I suggest that any narrative that operates on the illusion of a pure, empathic identification with the victims runs the risk of becoming redemptive. Such a narrative would make possible the dangers of closure to the process of imagining and mourning the Other's effacement. Furthermore, any narcissistic drive for a "pure identification" with the victim threatens to obliterate the victim a second time by claiming the experience as one's own. I argue that this very act of blurring the lines of identification or destabilizing the position of the reader/spectator is necessary not only to subvert both closure and redemptive Holocaust narratives, but also to make possible the conditions of an ethics based on proximity, where the reader/spectator is confronted with the limitations of such empathic identification.

"All poets are Yids": Translating the Holocaust

In order to conduct a closer investigation of the empathic imagination, I want to introduce two opposing examples regarding spectatorship and empathic identification, the first focusing on the potential threat of over-identification with the victim and the second presenting a complete lack of imaginary identification with the Other. While this analysis might seem like a departure from a study on how Celan and his lyric have been translated into visual culture, it is central to Germany's multiple encounters with the poet. Celan, uneasy with Germany's fervent turn to him, was fearful that he was being co-opted as a sign that the legacy of the expulsion and murder of Europe's Jews had been mastered. I will examine the poetic inscription "All poets are Yids" in Celan's poem "And with the Book from Tarussa" in relation to empathy and the imagination and then turn to Adolph Eichmann's encounter with evidence of the Holocaust during his trial in Jerusalem—an encounter which demonstrates his "lack of the imagination" (Arendt 287). Finally, my study of the limits to empathic imaginings is integral to the ethical implications behind how artists have chosen to face Celan for over the past five decades in their efforts to confront the Holocaust.

Celan begins "Und mit dem Buch Aus Tarussa" (1962) from the collection *Niemandsrose* with "All poets are Yids," an epigraph from the Russian poet Maria Tsvetaeva. In Tsvetaeva's formulation the poet aligns herself with the Other.[11] This is not a religious connection, but rather the poet, like the Jew with whom she identifies, finds herself in exile, banished and vilified. The poem not only begins but also ends in a space of exile; it starts with indecipherable Cyrillic marks at the top of the page and ends at a geographical point of exile—Kolchis, a place layered in history as well as myth. Celan leaves her words untranslated in its Cyrillic script. I will examine the significance of the epigraph in relation to identification and translation as conveyed later in the poem's following lines:

Kyrilisches, Freunde, auch das	Cyrillic, friends, that too
ritt ich über die Seine,	I rode over the Seine,
ritts übern Rhein.	rode it over the Rhine.
(*Gesammelte Werke*, 1:289)	(Felstiner, *Paul Celan*, 197)

Celan's use of "ritt ich über" (I rode across) suggests an act of translation as conveyed in the term *über-setzen*, which literally means to set across. These two components—empathic identification and translation—constitute the ethical impetus of the poem with regard to questions concerning alterity and the imagination. What is the connection between the epigraph's assertion that "All poets are Yids" and Celan's decision not to translate this inscription? How does the poem accentuate an ethical modality based on both its inscription and the concealment of this inscription's meaning through the lack of translation? While Tsvetaeva's words gesture to the notion of a totalizing identification with the Other, Celan's withholding of translation attests to the very preservation of alterity. By denying the reader access to the opening inscription, the poet makes part of the poem irrecuperable. Ultimately its trajectory, leading the reader through a multiplicity of texts, reveals the import of the epigraph.

With its numerous *von*'s the poem depicts the process of moving from and toward a particular location. It begins, "All poets are Yids," then moves from the constellations in the heavens ("Vom Sternbild des Hundes") to the terrestrial realm ("Von einem Baum"), across several bridges and rivers, to its endpoint "Kolchis," a town on the eastern shores of the

11 The epigraph is actually a transformation of a line from Tsvetaeva's "Poem of the End" (1924), in which she describes a walk through Prague's Jewish ghetto. Her choice of the derogatory term "Yid" instead of "Jew" helps capture the hatred behind the words of the anti-Semite. Her incisive words from 1924 stand as an ominous warning to what was soon to happen in her own homeland and to her family; in 1941 her husband, a Russian Jew, was murdered by occupying German forces, and shortly after his death she committed suicide, thereby sharing the fate of the Jewish victims with whom she identified.

Black Sea, in the Caucasus. But the poem's telos, *Kolchis*, ultimately gestures back to the opening inscription. Its development functions as an exegesis of the indecipherable markers at the top of the page (the Cyrillic letters): traces that contain within them questions concerning otherness, exile, mourning, and remembering the dead. By leaving this epigraph untranslated, hence foreign and strange, Celan obscures its meaning from the reader, allowing only a possible belated recuperation of meaning through the act of reading and interpreting the poem's content. "All poets are Yids" attests to the presence of an empathic imaginary by positing an act of identification with those vilified and cast out.[12]

Celan leads his reader through a landscape permeated with death-infused images ("Unland," "Unzeit," "Hyänenspur," and "vom Wald Unbetreten"), across rivers and eastward to Kolchis, a space significant simultaneously in myth, history, and poetry. Despite its mythic associations with the place where Jason and the Argonauts sailed in search of the Golden Fleece, this place in the east is not necessarily the site of redemption.[13] Kolchis is also located near Ovid's place of exile and banishment. But the trajectory that the poem follows from Pont Mirabeau (the bridge near Celan's home in Paris, where he lived in exile), across the Seine and the Rhine (an indication of the country that precipitated his flight) to Kolchis is steeped in personal history as well: it passes over the poet's destroyed home, the Bukovina, and toward the place where his family was murdered in the Transnistria labor camp by the Black Sea.

12 See also Celan's translation of Yevgeny Yevtushenko's poem "Babi Yar" (1961), which he translated shortly before writing "Und mit dem Buch aus Tarussa." Yevtushenko's poem commemorates the twentieth anniversary of the machine-gunning of 33,771 Jews on September 29–30, 1941, at a gorge in a forest near the town of Babi Yar in the Ukraine. The forest in Celan's "Mit dem Buch aus Tarussa" ("Vom Wald / Unbetreten") resonates with images he had translated weeks before in "Babi Yar." But what is perhaps most striking is that once again the non-Jewish poet identified himself as a Jew. In his poem Yevtushenko recalls the catastrophic history of the Jews, moving from exile and enslavement in Egypt, to Dreyfus' false imprisonment, to images of Anne Frank and finally to the mass graves at Babi Yar. The poem begins,

Over Babi Yar no monument stands.
A rough slope—one unhewn gravestone.
I'm in dread...
I believe I am now
 A Jew...
Dreyfus, him too, that's me.
 (Felstiner, *Paul Celan*, 187)

13 I am indebted here to Katja Garloff's exceptional analysis of this poem. She persuasively shows how any utopian reading of the poem's ending in relation to "Kolchis" is problematic (152–55).

Finally, the word "Kolchis" resonates with a poem Celan had trans-
lated not long before "Mit dem Buch aus Tarussa": Apollinaire's "Les
Colchiques". Although he encoded the title of this poem in the word
"Kolchis," Celan had also left an untranslated line of Apollinaire earlier in
the poem: "et quels / amours!" [And what / love!]. This citing of Apolli-
naire points ahead to the poem's closing word, "Kolchis," and its vocal
echo with *colchiques*, the French word for the meadow saffron, or crocus
flower, which in German is the *Herbstzeitlose* (literally meaning autumn-
less). Although a symbol for hope, this flower is also known to be very
poisonous. In addition to demonstrating the multiple layers of language
and its meaning, Celan shows with his arrival at Kolchis how translation is
not only the interplay between different languages, but how it also enli-
vens the texts themselves; translation is always intertextual. The poem
ventures by way of rivers to Kolchis: a proper name that connotes both
hope and a place of exile, and a flower that is both poisonous and a sign
of redemption.

If the goal of the translator is to retrieve from the text's original lan-
guage its meaning, Celan's poem reveals that translation also entails loss
or absence: something remains unbridgeable during translation.[14] While
the process of translation may refer to the crossing of linguistic spaces,
the withholding of translation in "Und Mit dem Buch aus Tarussa" im-
plies that such a conveyance of meaning has been obstructed or deferred.
With Benjamin in mind, Derrida writes of the prospect of truth in transla-
tion,

> Truth is apparently beyond every *Übertragung* and every possible *Übersetzung*. It is
> not the representational correspondence between the original and the translation,
> nor even the primary adequation between the original and some object or signifi-
> cation exterior to it. Truth would be rather the pure language in which the mean-
> ing and the letters no longer dissociate. (*Babel*, 195)

For Derrida, translation signifies a movement toward meaning, and this
movement requires a degree of incompletion. But while translation in-
vokes a future progression for Derrida and Benjamin, from a past text
into a new one, Celan's poem is both a temporal and a spatial movement
into the past, where works of memory and mourning unfold. Its final
word, "Kolchis," the mark of both exile and poison, points back to the
poem's epigraph and provokes recollection of those who were banished
and murdered along the poem's geographic trajectory.

14 Celan's translations of other poets reveal his affinity with Walter Benjamin's concept of
 translation, that the success of a translation is not contingent on the imitation of the original
 text but in its recreation of the theme of the primary text (see Benjamin, "Die Aufgabe des
 Übersetzers").

It is here, in this interplay of memory, mourning, and empathic identi-fication with those exiled, that I see a connection forming between ethics and translation. Like Derrida's depiction of the double-bind, which en-traps the translator between the unattainable original text and the task of converting its meaning into a second text, this dynamic exchange is con-sistent with an ethical modality as well. The tensions surrounding the pro-cess of translation inherent in Celan's poem, the necessity to translate and its very lack of completion, attest to the preservation of an underlying al-terity in the text. The Other, who is both foreign and irrecuperable, com-pels the reader to recall through its traces, beginning with Tsvetaeva's "All poets are Yids," what remains lost and dispersed throughout the poem. While Celan's poem acknowledges his desire for an empathic identifica-tion with and inclusion alongside the Jewish Other, he shows through the disruption of translation the very impossibility of sustaining such identifi-cation with the Other: the poem begins and ends in exile.

Tsvetaeva's words, written before the events of the Holocaust, take on entirely other implications in the aftermath of the death camps. Hatred and exile are now just steps on the path to mass extermination. Not only is this the experience that differentiates Jews from poets, it is also the moment when empathic identification with the Other breaks down. The impossibility of translating Tsvetaeva's words that Celan faced after the Holocaust stemmed from the impact history had on them: their meaning has been radically altered. However, as the poem unfolding beneath the epigraph testifies, it was necessary to tell the experience of exile and mur-der even if there was a risk that it would not be understood. Although the majority of Celan's readers might not be able to read the opening words of the poem, what he left untranslated is something different from silence. The following passage from Derrida's analysis of the singularity of the date in Celan's poetry encapsulates what is at stake in "Mit dem Buch aus Tarussa":

> The poem must expose its secret, risk losing it if it is to keep it. It must blur the border, crossing it and recrossing it, between readability and unreadability. The unreadable is readable as unreadable, unreadable insofar as readable; this is the madness of fire which consumes a date from within. Here is what renders it ash, here is what renders it ash from the first moment. ("Shibboleth," 43)

In this translation of space between the unreadable and the readable, the task of the reader is to bring into focus this mark of effacement, whether it is the remains of ash or the marks of an illegible language. Despite the original foreignness of Tsevtaeva's Cyrillic words, their import, though be-lated, resonates throughout the poem. The message concealed in the epi-graph becomes clear through the process of reading the poem.

Counter to Tsvetaeva's poetic mode of empathic imagination with the Other, Emil Fackenheim probes the very lack of imagination in the figure of Adolph Eichmann, the architect of the Final Solution, when he was confronted with evidence of the Holocaust during his trial in Jerusalem in 1961. In *To Mend the World: Foundations of Post-Holocaust Jewish Thought*, Fackenheim, a leading Holocaust theologian, investigates the limits of Jewish thought after Auschwitz and runs into the barrier of this one particular figure. The documentary footage used at the Nuremberg Trials was again shown in the Jerusalem courtroom during Eichmann's trial, and Fackenheim is haunted not by the images of the dead, but by the picture of Eichmann's face during the screening of the film; it is his face that returns on three occasions in Fackenheim's reflections on the limits of philosophical intelligibility in the face of the Holocaust. Fackenheim writes:

> The accused had preserved a solid composure throughout his trial. One day the courtroom was darkened and pictures of Eichmann's victims were flashed on a screen. Secretly, a camera was trained on him in the dark. Believing himself unobserved, Eichmann saw what he saw—and smirked. (237)

Wishing to grasp the "shudder" of the Holocaust "whole-of-horror" (239), Fackenheim's aim is to get inside the meaning of Eichmann's smirk before the filmic images of the camps, but when confronted with Eichmann's smugness, Fackenheim claims that philosophical thought is paralyzed.

Whether Eichmann's expression was a smile, a smirk, or nervous tick, his affective response to the film is the focal point of Fackenheim's discussion of cognitive paralysis with regard to the Holocaust. Eichmann's facial expression functions as the vanishing point to Fackenheim's understanding the Holocaust and he remarks that, "To get inside [Himmler and Eichmann] is to get inside the ideas behind the smirk ... this is not necessarily to accept these ideas it is in any case to obtain a kind of empathy" (239).[15] The inside of the Holocaust, metonymically conveyed through Eichmann's face, manifests itself as a mark of affect. But unlike Landsberg and Weissman, Fackenheim does not ask his reader to empathize with the victims; instead, he takes the perpetrator's perspective in order to go inside the Holocaust's "whole-of-horror." Fackenheim's formulation of getting inside the perpetrators' mind—this spatial authenticity of an inside—is tantamount to the intensification of affect registered through the spectator's facial expression. Fackenheim's own specular horror is induced not by the display of bodies, but by the reaction of the perpetrator to

15 In addition to Eichmann's smirk, Fackenheim also returns three times to Himmler's apparent satisfaction before scenes of the extermination. Fackenheim is fixated on the image of Himmler putting on gloves to burn Jewish bodies at Auschwitz and his exclamation, "Thank God. At last I too have burned a Jew with my own hands" (see Fackenheim, 186, 237, 243).

these bodies: a reaction that the philosopher cannot decipher. Trying to read upon the perpetrator's face his recognition of an ethical failure, Fackenheim sees instead an expression of satisfaction.

According to Fackenheim, the task of the philosopher is not to comprehend this horror, but rather to resist the paralysis of thought that could be induced by looking at Eichmann's face. It is here that his analysis shifts momentarily to an ethics: "The Holocaust whole-of-horror is (for it has been); but it ought not to be (and not to have been)" (239). For Fackenheim, resistance requires not only the attempt to think these two parts together—the ethico-temporal dimensions of "it is" and "ought not have been"—but also to move from thought to action. But Fackenheim cannot sustain an ethics with regard to the Other's face. What seems to be a motion toward an ethics, the "ought to," is dismissed in a footnote. As he remarks in a side comment, "The role of Kantianism has diminished in the present work" (300). The "ought to" of Kant, conveyed through the possibility of an act or response, is withheld or becomes irrelevant in the aftermath of the Holocaust.[16]

This interplay between perception, affect, and the imagination is constitutive of Emmanuel Levinas's ethics of the gaze and his concepts of the non-site, the shudder, and the face (Levinas's trope for the Other). Levinas's concept of the face-to-face relationship helps frame the ethical implications behind facing the Holocaust in this study. According to Levinas, "A face is a trace of itself, given over to my responsibility, but to which I am wanting and faulty. It is as though I am responsible for his mortality, and guilty for surviving" (*Otherwise than Being*, 91). For Levinas the face functions as a traumatic instance that is accompanied by a shudder and prompts the subject to turn towards herself to initiate the process of an impossible substitution for the Other. It is this very shudder that is missing from Eichmann's encounter with the trace of the Holocaust Other.[17]

16 Ultimately, Fackenheim constructs a narrative of Jewish resistance in which Israel symbolizes the overcoming of the rupture left in the wake of the Holocaust. Through his redemptive narrative, a *Tikkun* or mending is not an ethical possibility but is actualized in the State of Israel. Fackenheim transforms both the "ought to" and the notion of resistance behind his ostensible ethics into an ontological category configured in the grounding of Israel (248). Thus, the move from epistemology to ethics ultimately evolves into ontology. Fackenheim commits the very act of reification of the Holocaust that he himself critiqued. Reaching the paralysis of thought before Eichmann's face, Fackenheim, instead of probing an ethics of the "ought to" in the aftermath of the Holocaust, locates resistance by granting the existence of Israel ontological status.

17 Arendt examines another perspective of Eichmann's face-to-face encounter with the Holocaust. Arendt probes the lack of imagination emanating from Eichmann's own subject position in his exchange with his German-Jewish interrogator in a Jerusalem prison. Arendt claimed that Eichmann, "Never realized what he was doing. It was precisely this *lack of the imagination* which enabled him to sit for months on end *facing* a German Jew who was conducting the police interrogation, pouring out his heart to the man and explaining *again and*

My interest in Levinas lies specifically in how his ethics, rotating around space, anxiety, and disrupted vision, can be applied to prosthetic sites of Holocaust memory. Levinas positions his ethical subject before the persecuted Other, an Other whom he describes as homeless, naked, and hungry. In addition to positioning the subject as both potential victim *and* persecutor, Levinas denies the ethical subject any sustained empathic exchange of identification with the Other. His ethics necessitates the very disruption or suspension of the imagination. Analogous to the command that Weimar's citizens go to Buchenwald's mass graves, Levinas's first ethical imperative directs the human subject toward the face of the Other: a confrontation that he calls a trauma. Levinas writes, "I am as it were ordered from the outside, traumatically commanded, without interiorizing by representation and concepts the authority that commands me" (87). In this face-to-face encounter with the Other, the subject's phenomenological relation to the world dissolves into "a shuddering different from cognition," which interrupts her "serenity of consciousness" (87). The subject is traumatized by the command to approach the Other, and this sense of traumatization must repeat itself so that the ethical relation does not become commonplace. In his post-Holocaust ethics, Levinas's central concept of substitution is linked to the components of the imagination, identification, and proximity. However, during this act of substitution the attempt by the subject to sustain an empathic identification with alterity breaks down as s/he recognizes the very impossibility of such an act of imagination. I compare the break in the subject's "serenity of consciousness" when faced with the Other to the people's response to the command to approach those effaced in the Holocaust, that is, to the site of an ethical catastrophe. Finally, it is the figure of Celan that exemplifies this Holocaust Other toward whom Germany turns throughout this study.

Poetry as *Flaschenpost*

In 1958 the city of Bremen awarded Celan its prize for literature, and Celan went there to make an acceptance speech. In the course of it he described poetry as a "Flaschenpost"—a message in a bottle that is always on the way to someone (*Gesammelte Werke* 3:186). Following the poet's

again how it was that he reached only the rank of lieutenant colonel in the S.S. ... He was not stupid. It was sheer thoughtlessness—something by no means identical with stupidity—that predisposed him to become one of the greater criminals of that period" (287–88, my italics). In his face-to-face encounter, a trace of what remained left over from the extermination does not provoke any recognition of an ethical catastrophe; instead, there is a continuation of an imaginative failure that is inherently linked to an ethical collapse.

own call to face the Other and be receptive to his/her voice, researchers have investigated Celan's dialogue with the literary and philosophical tradition that influenced him, in particular the works of Hölderlin, Kafka, Heidegger, Benjamin, and Freud.[18] In addition, critics have studied how Celan "spoke" to other poets through his translations, for instance, to Shakespeare, Mandelstam, and Mallarmé.[19] *Sites of the Uncanny* shifts directions by examining the reception and translation of Celan's poetry by his successors in film, painting, and architecture. The convergence between Celan and visual culture is evident both in the distinction he makes between art and poetry in his Georg Büchner Prize speech in 1960—also known as "The Meridian Speech"—and in his ekphrastic poems. Beginning in 1947 with his introduction to a book of sketches by the surrealist artist Edgar Jené, Celan returned to the method of poetic ekphrasis, translating several paintings by Géricault, Rembrandt, and Van Gogh, as well as images from Chagall, into poems. He also collaborated with his wife, Gisèle Lestrange-Celan, a graphic artist, by transforming her lithographs into poems, and she in turn designed etchings based on his poetry.[20]

Moreover, I explore the political implications of Germany's appropriation of Celan and his poems during several moments of the postwar period in relation to the memory of the Holocaust. One need only examine the centrality of a poem like "Todesfuge" in Germany's cultural imagination to gauge the significance of the poet within Germany's collective memory, or perhaps even more notably, the very breakdowns of this memory in relation to the Holocaust. For John Felstiner, Celan's most engaged translator into English, his "Todesfuge" is the "Guernica of postwar European literature," a poem that testifies to what happened and serves as a testament to the German/Jewish rift (Felstiner, *Paul Celan*, 26).

Celan's name is most frequently associated with "Todesfuge," in particular with the repetition of the following lines: "Black milk of daybreak we drink it at evening," "Your golden hair Margareta / Your ashen hair Sulamith," and, perhaps most disturbing of all, the signature line from the poem, "Death is a master from Germany." The fetishistic repetition of these verses—considering the several hundred poems in Celan's oeuvre, including two volumes of translations of other poets—is significant, for the emphasis is frequently on the poem's formal structure, including its fugal components. In addition to describing "Todesfuge" as a "national obsession" in Germany ("Translating," 249), Felstiner discusses how the poem has often been misused in German classrooms by instructors focusing on its musicality and largely overlooking its traumatic content be-

18 See for instance Nägele, Fóti, Baer, and Lyon's *Paul Celan and Martin Heidegger*.
19 See Olschner's *Der feste Buchstab*, Ivanovic, Gelhaus, and Szondi's *Celan Studies*.
20 See Buck's *Bildersprache*, Colin's *Paul Celan:*, 83–96, and Könneker's *"Sichtbares, Hörbares."*

cause "[t]he poem's fluent meter was probably easier to teach than its abysmal irony" (*Paul Celan*, 232). Celan was known for his sardonic humor, and it is reflected in Germany's relation to his poem. He inscribes Goethe's beloved heroine Margarete (Gretchen) alongside the history of the death camps, and for three generations Germans have been repeating the poem along with the depiction of Germany's murderous legacy. Yet despite the disturbing images throughout the poem—black milk, ashen hair, and death emerging from the land of "Dichter und Denker"—rarely was the poem's historical content mentioned.

Sidra DeKoven Ezrahi describes how the obsessive recitation of "Todesfuge" has become a fixture at commemorative events: "At some subliminal level the Germans have come to know the poem the way a people knows its anthems and its liturgies, learning the words at such an early age and on ceremonial occasions that it has become an incantational procedure rather than an intended text" (268). With this analysis in mind, it is worth remembering the role assigned to this poem during the commemoration of the fiftieth anniversary of the *Kristallnacht* in the German Bundestag in 1988. "Todesfuge" was recited by the actress Ida Ehre, but what was remembered from that day was the ill-fated speech of the president of the Bundestag, Philipp Jenninger. Jenninger spoke of the events leading up to the 1938 pogrom and tried to convey the positive perceptions and mindset average Germans had at the time toward the National Socialist leadership. However, his matter-of-fact tone was construed by those present as sympathetic to the policies of the National Socialists, and the speech ultimately led to his resignation. So although "Todesfuge" was part of the official ritual of remembrance, the misperception that Jenninger failed to recall this history overshadowed the poem's recitation. The politician Hans Peter Voigt described the relation between the reading of the poem and Jenninger's speech directly after it as a "shattering break," and an Italian paper reported, "The historical wound between Germany and the Jewish people is again opened."[21]

As Ezrahi's use of the word "incantational" suggests, Celan's poem functions as a magical spell to ward off something dangerous: the haunting return of a traumatic past. But as the event in the Bundestag demonstrated, the poem is devoid of such magical powers. In his "Recollecting, Repetition, and Working Through," Freud describes the traumatized patient in the following manner, "We may say that the patient remembers nothing of what is forgotten and repressed, but that he expresses it in action. He reproduces it not in his memory but in his behavior; he repeats it without of course knowing that he is repeating it" (160). If Germany's re-

21 See "Mit Knobelbechern durch die Geschichte," *Der Spiegel*, 14 November 1988: 22–27.

lation to Celan's "Todesfuge" is just such an act—repeating without understanding the content of what is being spoken—as Ezrahi may claim, Kiefer and Libeskind disfigure and estrange Celan's poetics in order to break out of the repetitive mode that had befallen it and which threatened to turn Celan into a fetishized object.

Like particular photographs from the Holocaust—the images of a child with raised hands from the Warsaw Ghetto, the train tracks leading to the gate of Auschwitz-Birkenau, the piles of shoes and shorn hair—Celan's "Todesfuge" long ago achieved iconic status, but reciting the poem does not necessarily suggest or guarantee engagement with the Holocaust. In fact Celan himself greeted with an air of suspicion the bestowing of awards on him and invitations to read his poetry. Wary that Germany was exploiting his Jewish identity, Celan saw the Bremen and Büchner prizes as empty gestures of reconciliation; Germany's real objective, according to the poet, was to circumvent reflective and genuine engagement with its past.[22] In a letter to his friend Alfred Margul-Sperber, he expressed anxiety about becoming a sign for the re-integration of the Jewish Other back into Germany. He thought the granting of prizes was taking the place of a sustained work of memory. Most ironic is perhaps that Celan was not from Germany at all, but from the German-speaking enclave of the Bukovina in Romania. He wrote in a letter to Sperber,

> After I have been "annihilated" ["aufgehoben"] as a person, as a subject, I am allowed to continue living, perverted into an object, as a theme: mostly as a Steppenwolf without any place of origin, with traits that appear Jewish from a distance. What comes from me is redistributed—most recently my Jewishness. (57)[23]

Celan's use of the term "aufgehoben" (in quotation marks) recalls the end of Hegel's *Phenomenology of Spirit*, where the verb *aufheben* has four possible meanings: 1) to lift up, 2) to seize, 3) to preserve, and 4) to cancel or annul something. Hegel employs all four senses of the word in his closing section to describe how something can be held onto and preserved but at the same time annulled. He is describing the process of transformation in which Spirit integrates its previous stages of development into a synthetic unity and moves toward self-consciousness. According to Hegel, one

22 Shortly after receiving the Büchner Prize, Celan wrote in a letter from March 9, 1961, to Alfred Margul-Sperber that he was given the award by Germany's literary society "[s]o that, having gotten this alibi, they could all the better run me down" ("Briefe," 58; cited in Felstiner, *Paul Celan*, 189).

23 "Nachdem ich als Person, also als Subjekt 'aufgehoben' wurde, darf ich, zum Objekt pervertiert, als Thema weiterleben: als 'herkunftsloser' Steppenwolf zumeist, mit weithin erkennbaren Jüdischen Zügen. Was von mir kommt, gelangt zur Redistribution—jüngst auch mein Judentum."

stage of consciousness is elevated into the next stage, but only through the negation of the former. While *Aufhebung* involves the presence of memory (*Erinnerung*) and the preservation of what is past, something is cancelled out as well. The presentation (*Vorstellung*) or image (*Bild*) of Spirit is transformed (*aufgehoben*) into an absolute knowing (*absolutes Wissen*), and this process of *Aufhebung* is behind Hegel's concept of the development of world history.[24]

In Celan's use of "aufgehoben" the very opposite occurs: he was suspicious that Germany's turn to him was an attempt to overcome the events of the past (*Aufhebung*) that had brought about the erasure of his home. He seemed to fear that his homelessness ("'Herkunftsloser' Steppenwolf") was connected to the literary or mythic theme of the wandering Jew and not to the recent historical catastrophe that had befallen Europe's Jewish communities.[25] He saw himself being "perverted" into an object, fetishized solely on account of his *Judentum*. His use of "aufgehoben" reaffirms this sense that his identity was being erased. But Germany's turn to Celan and his "*Judentum*" did not signify a reflection on or a memory of the extermination of Europe's Jewish communities; rather, for Celan the history attached to the death camps was itself being evaded or cancelled,[26] and no Hegelian metaphysics could reconcile this historical rupture. Furthermore, although Germany might have intended to overcome its catastrophic past by bestowing awards on the Jewish poet, Celan's description overturns the end of Hegel's *Phenomenology*: seized by his German audience, Celan saw himself functioning for Germany as a mere presentation that they have failed to elevate to the level of self-consciousness. Germany's turn to Celan guaranteed neither an overcoming of Auschwitz nor a self-conscious relation to this catastrophic history. Instead, *Aufhebung* seemed to lead to the erasure of the subject: the granting of prizes takes the place of a sustained work of memory.

24 See the closing section of Hegel's *Phenomenology of Spirit* (491–93), where he discusses this interplay of image, presentation, spirit, memory, consciousness, and *Aufhebung*. I return in my conclusion to Hegel's concept of *Geist* (Spirit) in relation to German historical memory after the Holocaust.

25 As Celan showed in his "Meridian Speech" a year earlier, his homelessness directly emerged from this history. He described how he searched with his "nervous finger" on a "childhood map" for "the place of my own origin [*Herkunft*]," but "No such place was to be found" (*Gesammelte Werke* 3:202). He was "Herkunftlos" because his homeland, the Bukovina, had been devastated during the war.

26 The thoughts behind Celan's letter to Sperber are a reflection of Fackenheim's own probing of overcoming the Holocaust in relation to Hegel's philosophy. Fackenheim writes on several occasions in *To Mend the World*, "*Where the Holocaust is there is no overcoming; and where there is an overcoming the Holocaust is not* ... The Holocaust cannot be overcome by the post-Holocaust world*" (135).

Celan's growing anxiety about a resurgent anti-Semitism was also fueled by newspaper reports in the late 1950s concerning the presence of Nazi perpetrators in the West German government and the increase of anti-Semitic violence in Germany, including the desecration of Jewish cemeteries and the Cologne synagogue. In a letter to his friend Hermann Lenz concerning the extent to which anti-Semitism was still present in Germany, he remarked, "Die Kerle sind wieder da" [The guys are here again] (Lenz, 111).[27] When a critic from the *Berliner Tagespiegel* described "Todesfuge" as "contrapuntal exercises on notepaper," Celan replied that his poem remembered "Auschwitz, Treblinka ... the gassing"—all of which the critic had left out of his article. He also remarked that it was "high time" to discover poets who were writing "German poems" that were not "gedächtnislos" (lacking in memory). Throughout his poetry and prose Celan confronts his German audience with this very "lack of memory" (*Gisèle Celan-Lestrange* 2:116).[28]

In one especially telling letter from 1962 to his wife, Celan remarked that "Die Gruppe 47 vollendet meine Verdrängung" [Group 47 has ousted me completely], referring to the circumstance in which his name was excluded from Fritz Raddatz's introduction to the second part of the *Almanachs der Gruppe 47*, the German postwar literary group of which Celan had been a member since 1952 (*Gisèle Celan-Lestrange* 1:141). In addition, Raddatz wrote in the introduction that the words "Hitler, Atom bombs, SS, Nazi and Siberia" would not be a part of the volume, nor would the "hall full of hair and teeth in Auschwitz" be turned into prose or poems (*Gisèle Celan-Lestrange* 2:140). Celan's use of the word *Verdrängung*, the state of being driven out, also denotes the psychoanalytic concept of repression. Through his own metonymic function as a trace of survival from out of the catastrophe and a reminder of Germany's extermination policies during the Second World War, Celan associated the excision of

27 Celan was responding to an event at a poetry reading of his in Bonn, where someone had left behind on a table a grotesque caricature of him with the description "Hosianna dem Sohne Davids."

28 See also Celan's reactions to the charges of plagiarism directed against him in 1960 by Claire Goll, the widow of the French poet Yvan Goll. Although the accusations were proven to be false, Celan saw the campaign directed against him by journalists and critics in Germany as symptomatic of an anti-Semitism coming from leftwing intellectuals. In his letter of December 14, 1963, to his editor Gottfried Bermann Fischer, Celan discussed what he saw as a rising anti-Semitism in Germany that he linked to a "'liberal' anti-Semitism" coming from the "left." In addition to his sense of being cancelled out ("aufgehoben"), Celan was also wary of an attempt by the intellectual left to annul "Jewishness" (*das Jüdische*) through "absorption," "tutelage," and a "hidden Aryanization process." He detected in Germany the continuation of the process to eradicate difference through the assimilation of the Other. This letter is published in Hamacher and Menninghaus, 22. See also Felstiner's *Paul Celan*, 154–55, 172–74, and 222–23; and Katja Garloff's "Paul Celan's Revisiting of Eastern Europe" in her *Words from Abroad*.

his name from the introduction with the failure of Gruppe 47—of Germany's intellectual community—to engage with the Holocaust.[29] Celan's erasure (*Aufhebung*) by the Germans represented the onset of historical repression (*Verdrängung*) in postwar Germany's relation to the Holocaust.

A New Category: the Holocaustal Uncanny

The desire to understand the Holocaust by means of an empathic imagination is not the objective of the artists I examine; rather, each positions the reader/spectator in an ambivalent relationship to its catastrophic history. I believe that this positioning of the reader/spectator conforms more to the spatial import of a system of ethics than to an epistemic relation to the Holocaust. Like the Allies' command to German citizens to look at the graves and the faces of the dead, these artists entrap their audience in prosthetic memory sites that engage with the Holocaust. In addition, these artists approach the horror from another trajectory: a break with authenticity and verisimilitude, a turn to abstraction, and the shattering of any illusion of identification or of becoming a witness. Although the process of identifying with the Other may start as an honest desire of the spectator to attain empathic identification with the victim, such a vicarious experience risks degenerating into an illusion of being the Other. Applying Levinas's ethics to aesthetic projects that engage with the Holocaust, I am interested in how Levinas's irresolute position of spectator identification vacillates between complicity in and an incessant mourning for the persecution of the Other. Like Levinas's ethical model, the artworks I study here block such a fantasy of empathic identification or substitution, where the act of facing the horror of the Holocaust would potentially lead to a cathartic encounter with its remnants. Celan, Resnais, Kiefer, and Libeskind do not provide the spectator with the means to escape or work through the historical disposition of mourning; instead, the ethical implications behind their texts approximate a melancholia or, to use a term from Eric Santner, each artist positions the spectator within an "elegiac loop," where mourning unfolds again and again (*Stranded Objects*, 25).

My analysis of ethical space and affect in representations of the Holocaust is not constructed from Kant's categories of the beautiful or the sublime, but rather from the figure of the uncanny. Freud's investigation of the uncanny, although a psychological category linked to the concept of repression, commences with his probing of the term's aesthetic implications in literature. The uncanny, with its feelings of "unpleasantness and

29 For an extensive study of the presence of anti-Semitism in Gruppe 47, see Briegleb.

repulsion," indicates a "remote region" that is distinct from the categories of the beautiful and the sublime ("The Uncanny," 19). The uncanny spaces we encounter in Resnais, Kiefer, and Libeskind do not point exclusively to Freud's model of *das Unheimliche* with its emphasis on anxiety, lost vision, spatial disorientation, the compulsion to repeat, or the blurring of boundaries between reality and imagination, self and Other, and inside and outside. Rather, I propose a modification of the concept of the uncanny that evolves from Celan's poetics and Levinas's ethics and provides a map for navigating through other uncanny forms of Holocaust representation.

While anyone who approaches Celan's poetry, Resnais's film, Kiefer's works, or Libeskind's voids may see her- or himself as secondary witness to the Holocaust through acts of empathic identification, each artist tries to subvert this position of the witness by assaulting the subject's senses with a missing line of poetry, a desolate landscape, a blurred canvas, or the empty wall of a museum. The normal subject position is jarred and the conditions evoking the uncanny arise. I suggest that mimesis in Holocaust aesthetics is not simply the imitation of a traumatic scene, but rather the re-production of an anxiety consistent with the uncanny. Levinas's use of the term "substitution" at the center of his ethics does not refer to the subject identifying with the Other; he explicitly rejects substitution's relation to empathy. Instead, he insists that a different affectivity arises and calls it the "trope of a sense" (*Otherwise than Being*, 125). Although not so named by him, this affect bears a resemblance to the uncanny. The trope of the sense that triggers recognition of an ethical catastrophe in the artworks I examine marks both the very collapse of such an empathic imagination and the advent of what I name the *Holocaustal uncanny*.

The Holocaustal uncanny refers to the perceptual disruptions that accompany the spectator's relation to the artwork, resulting in an affective tonality of anxiety. As previously mentioned, the uncanny shatters such distinctions as self/Other and interior/exterior. This moment of the Holocaustal uncanny is not an act of union or substitution between the spectator and the place of the Other; rather, during the Holocaustal uncanny the spectator inhabits a space similar to what Mladen Dolar describes as the "paradoxical realm between the living and the dead" (6). The subject departs toward the Other and is caught in an unsettling space of non-identification, a space where fantasies of witnessing or empathic imagination break down. Instead of forming an empathic union with the Other, there is dissolution of any imaginary union between the spectator and the scene of trauma.

I propose this concept of the Holocaustal uncanny as a replacement for the recurrent use of empathy in Holocaust studies in relation to the

spectators' wish to "feel closer" to the trauma. This substitution deters any illusion of a totalizing, empathic re-imagining of the Holocaust and the construction of redemptive narratives. My shift to the interplay between affect and proximity via the concept of the Holocaustal uncanny allows me to probe the positioning of the spectator in relation to Holocaust representations. The cognitive lapses that we face in poems, paintings, films, and architecture that foreground erasures, specular disruptions, spatial voids, and visceral discomfort signify the moment when epistemic structures break down and a shift to an ethical context unfolds. This between-space, or "paradoxical realm," is consistent with the topos of Levinas's ethics, where the subject's affective state of vertigo or restlessness signals a "one degree of responsibility more, the responsibility for the responsibility for the other" (*Otherwise than Being*, 117); it is an ethics that resists any therapeutic closure to historical trauma. This "one degree more" conveys not only the lack of any stable subject position or any end to one's responsibility to the Other; in terms of the Holocaustal uncanny and the spectator's relation to the effaced Other, described by Levinas as an absolute insomnia, the process of working-through this traumatic past is repeatedly interrupted by a yet-to-be-assimilated trace of the Other.

A significant part of my analysis of the uncanny also arises from the philosophy of Martin Heidegger, who wrote extensively on the question of homelessness and anxiety. One of the most influential thinkers of the twentieth century, Heidegger's philosophy not only had a profound impact on Levinas and Celan, Kiefer and Libeskind have also engaged with the philosopher in their respective projects. Heidegger's thoughts on the uncanny, mourning, translation, and poetry are central to my concept of the Holocaustal uncanny. As much as Levinas's philosophy is a reaction to Heidegger on ontology, so too is Celan's poetry a reproach against Heidegger's incapacity to think the aftermath of the Holocaust. From *On Escape* (1935) to *Otherwise than Being* (1981) Levinas clearly demonstrated his desire to move away from Heidegger's preoccupation with Being in order to ground his ethics in relation to human beings.[30] Shortly after the end of the Second World War and his liberation from a POW camp, Levinas wrote in his *Existence and Existents*,

> If at the beginning our reflections are in large inspired by the philosophy of Martin Heidegger, where we find the concept of ontology and of the relationship which man sustains with Being, they are also governed by a profound need to

30 Describing the influence Heidegger's philosophy had on his own work with regard to the question of death, Levinas writes, "It distinguishes itself from Heidegger's thought, and it does so in spite of the debt that every contemporary thinker owes to Heidegger—a debt that one often regrets" (see *Dieu, la mort et le temps*, 16; cited in Derrida, *The Work of Mourning*, 209).

> leave the climate of that philosophy, and by the conviction that we cannot leave
> it for a philosophy that would be pre-Heideggerian. (19)

This "profound need" to depart from Heidegger became even more pressing for Levinas in the aftermath of Holocaust.

In his "Meridian Speech," where Celan's dialogue with Heidegger's work is most pronounced, I perceive something uncanny about the encounter between the two. Along the circuitous path of the speech, Celan turns the strangely familiar language of Heidegger scattered throughout the speech into points of orientation. But while one might anticipate an encounter with the mystery of Being, Celan instead turns Heidegger against himself and makes the philosopher's ontological terms say something about homelessness in relation to historical catastrophe: the philosopher's own terminology is able to articulate what Heidegger himself had refused to say. Through his exegesis of Heidegger, Celan shows not simply that a response to the Holocaust was possible, but that it was a necessity in the aftermath of the catastrophe. Bringing to light for the reader the very ethical failures embedded in Heidegger's philosophical thought, Celan also leads his reader down the familiar paths of Heidegger's uncanny only to take him/her into the abyss of the Holocaustal uncanny. The "mystery of an encounter" that Celan sets up in his "Meridian Speech" is not with Being, but with the effaced Other of the Holocaust.

Heidegger said that translation occurs not just between two languages, but that interpretation is itself a form of translation: "Every translation is interpretation. And all interpreting is a translating" (*Hölderlin's Hymn 'Der Ister,'* 65). This model of translation is key to my study. Celan's interpretation of Heidegger's uncanny in his "Meridian Speech" is itself a translation of the ontological implications of *das Unheimliche* into an ethical category. In turn, *Sites of the Uncanny* proceeds to other avenues of translation with regard to Celan's poetics. After probing Celan's translation of Resnais's Holocaust documentary not simply from French into German but also of the filmic image into poetic trace, I examine how Celan's poetics of the uncanny has been translated as well as reinterpreted by Kiefer and Libeskind. What shifts occur when the interconnections between translation, the uncanny, and the Holocaust developed in Celan's poetics are transferred into new aesthetic forms?

By reading Celan's poetry, viewing a film by Resnais or a painting by Kiefer, or going into Libeskind's architectural works, the reader/spectator expects to enter post-traumatic spaces that engage with the Holocaust and anticipates an encounter with the terror of National Socialism. Yet through our engagement with the works of these artists we are not entering the museums of concentration camps that supply our collective mem-

ory with the material images and traces of the extermination. Although the
spectator may expect or even want to see these palpable ruins in repre-
sentations of the Holocaust, the poet, filmmaker, the painter, and the ar-
chitect disrupt such acts of voyeurism. Counter to critics' claims that the
reader or spectator of these texts undergoes a catharsis or purgation, I ar-
gue that she experiences a series of perceptual woundings that cannot be
integrated into any redemptive narrative about the Holocaust.

Chapter 1, "Specular Disruptions: The Sublime, the Uncanny and
Empathic Identification," proceeds from Saul Friedlander's inquiry con-
cerning the need for a new interpretive category to discuss the Holocaust.
While some scholars use Kant to probe the Holocaust's interpretive lim-
its, I argue that they fail to reckon with Kant's concept by neglecting the
ethical implications behind the sublime and its call for witness. Taking this
previous scholarship into account, I further argue through Freud, Celan,
and Levinas for my concept of the Holocaustal uncanny. While for Freud
it was the uncanny that approached the reader/spectator, this direction is
reversed in the Holocaustal uncanny: the artist now lures the spectator
into the space of the dead; the frame of the artwork splits open and our
gaze is consumed by something abysmal. At this juncture, I transform
Levinas's first ethical imperative, which directs the human subject toward
the face of the Other—an encounter that Levinas both calls a trauma and
develops from Celan's poetics—into a command to approach substitute
sites of Holocaust memory. The aesthetic strategies in the artists I exam-
ine are anti-therapeutic: each constructs traumatic scenes that the specta-
tor can neither overcome nor master.

The chapters that follow document four periods of crisis in post-war
German memory in relation to the Holocaust: 1958, 1979, 1989, and
2005. Chapter 2, "Catastrophe and the Uncanny in Heidegger's Fetishized
Narrative," and chapter 3, "Broken Meridians: From Heidegger's *Pathway*
to Celan's *Judengasse*," investigate how Celan's model of the uncanny from
his Bremen and Büchner Prize speeches is not solely based on Freud's
"The Uncanny," but rather is a dialogue with Heidegger's philosophy.
While both Heidegger and Celan build their understanding of the uncanny
around such themes as memory, homelessness, and failed perception,
Celan does not merely appropriate Heidegger's ideas, but rather interro-
gates them with regard to what they say (or fail to say) about poetic lan-
guage, the uncanny, and catastrophe in the aftermath of the Holocaust.
Chapter 2 explores how Heidegger's post-war philosophy and the shifting
function of *das Unheimliche* in his writings contribute to Santner's concept
of a "fetishistic narrative." As he constructs his account of the uncanny,
Heidegger not only circumvents the Holocaust and its victims, he also ren-
ders Germany and the Germans as the uncanny figures of this narrative.

In chapter 3, the second part of my juxtaposition of Heidegger and Celan, I explore how Celan traverses Heidegger's path of the uncanny in order to depart eventually from this trajectory. At a time when the Holocaust was indeed being evaded within the context of German cultural memory and politics, the Romanian Jew, whose mother tongue was German, visited Germany from his place of exile in Paris to receive his awards and instructed his audience on how their language both remembers and thinks. Celan, functioning as a voice from beyond the grave, rose out of his destroyed home in the Bukovina and, although never mentioning his name, engaged in an implicit dialogue with Heidegger and the uncanny. Rejecting Heidegger's ontological model, which was unable to accommodate the Other, Celan transformed the uncanny into an ethical category by positioning the reader toward the historical date of the Other's effacement.

Chapter 4, "Celan's Cinematic: Anxiety of the Gaze in *Nuit et Brouillard* and 'Engführung,'" examines Celan's translation of Jean Cayrol's screenplay of Alain Resnais's film *Nuit et Brouillard* (*Night and Fog*, 1955/56) from French into German and brings it into conversation with Celan's poem "Engführung" ("The Straightening," 1958). Although the film assaults the spectator's gaze with graphic images, *Night and Fog* fails to express verbally the uniquely Jewish bodies it displays. While the Jewish victim is configured visually throughout the film by yellow stars and iconic photographs, the word "Jewish" is spoken only once. I explore how Celan's translation of the film into "Engführung" responds to this erasure of the Jewish victim in the film and in German memory in 1958. There are two acts of translation unfolding here; my focus mediates between the changes in translation from French into German, and the translation of affect from the visual medium of film into the discursive space of poetry. More specifically, this chapter examines how Celan's translation of the film into poetry transforms the cinematic landscape of extermination into a text that the spectator both sees and reads.

The multiple incarnations of Celan's returns to Germany during the country's postwar era—his physical presence at award ceremonies in Bremen (1958) and Darmstadt (1960); his poetry readings and visits to Tübingen (1961), Frankfurt (1965), and Freiburg (1967); and his meeting with Heidegger in Todtnauberg (1967 and 1970)—all have an uncanny sense to them: the poet provides form to a repressed past that keeps returning to Germany in the Holocaust's aftermath. Yet even after his suicide in 1970, Celan continued to revisit Germany. Chapter 5, "Re-figuring Celan in the Paintings of Anselm Kiefer," begins with an analysis of the period shortly after Celan's death, during which Marlies Janz claims that he receded from German consciousness. I contend, however, that it was not Celan that vanished during this period, but rather critical readings in-

vestigating the link between his lyric and the Holocaust.[31] After two dec-
ades of misappropriations of "Todesfuge," Kiefer took the poem through
an estrangement in order to break out of that repetitive mode to confront
the German spectator anew with Celan's lyric. While critics described
Kiefer as a "taboo breaker" for painting themes of the Third Reich, I
maintain that the real taboo he broke was silence about the Holocaust. As
Germany debated how to memorialize the Holocaust, Kiefer's artworks
became monumental, literally, in size. Although critics claim that his new
sculptures explore themes of Jewish mysticism and the Kabbalah, they
avoid discussing his continual use of Celan in these works. I argue that
Kiefer's most recent installations demonstrate his ongoing attempt to
prompt his audience to confront the Holocaust and Celan's poetry in the
period after re-unification.

My final chapter, "Ghostly Demarcations: Translating Paul Celan's
Poetics in Daniel Libeskind's Architectural Space," explores how Libes-
kind inscribes Celan's poetics into his Jewish Museum in Berlin and the
Felix Nussbaum Haus in Osnabrück. Both museums make it possible for
the visitor to enter into an architectural text that is characteristically like
Celan's poetry. In addition to the Jewish Museum's design, which is based
on Celan's concept of a *Sprachgitter* (speech-grille) with its crossing lines
and includes the Celan Courtyard conceived by Celan's wife, the graphic
artist Gisèle Celan-Lestrange, Libeskind also inscribes Celan's poem
"Engführung" on the wall of the Felix Nussbaum Haus at the museum's
most constricted point. Although critics argue that both museums are a
curator's nightmare in undermining and interfering with our reception of
the exhibits, Libeskind means for the exhibits and the architecture to be in
constant dialogue with one another. Contrary to the therapeutic model
that James Young sees unfolding in Libeskind's architecture, I think Libes-
kind breaks any consensual practice of working through trauma by con-
stantly subverting the spectator's vision and orientation in both museums.

Sites of the Uncanny concludes with an analysis of the memory debates
that were provoked by Martin Walser's Frankfurt Book Prize speech in
1998, where he described Auschwitz as a "moral club" and compared Pe-
ter Eisenman's design for the Holocaust Memorial in Berlin to a "night-
mare the size of a football field" (20). Like Celan, Resnais, Kiefer, and
Libeskind, Eisenman's memorial destroys our position as conventional
spectators as it lures us into its scene of erasure. To use a title from one of
his poems, Celan functions as a "shibboleth," that is, a password for
crossing thresholds, passing borders, and translating uneasy spaces. His

31 See Janz, "Haltlosigkeiten." The 1980s was also the period when numerous memoirs and
 biographies of Celan were being written by his friends; see Chalfen, Silbermann, and Bau-
 mann.

poetics provides a map that allows the spectator to pass not only into Resnais's filmic depiction of the camps and across the frames of Kiefer's paintings and the voids in Libeskind's museums, it guides my discussion of the ethics of memory in debates surrounding visual representations of the Holocaust.

Before moving to the graves that are screened in *Night and Fog*, configured poetically in Celan's "Engführung," painted by Kiefer in his tomblike *Sulamith*, and constructed in Libeskind's cenotaphic voids, I begin my analysis of the Holocaustal uncanny by returning to the mass graves depicted in Heinrich Himmler's Posen speech. I revisit the theoretical models of the sublime and the uncanny not only in relation to Himmler's words but also with regard to the historians' return to Posen. What makes the speech uncanny in the strictest sense of the term has less to do with what unfolds in Himmler's words and more to do with the repetitive return by critics to his document along with their attempts to occupy the position and perspective of the perpetrators. Finally, what also seems to return compulsively in the discussions of Posen are the theoretical optics of Kant and Freud.

Chapter 1

Specular Disruptions—The Sublime, the Uncanny, and Empathic Identification

In order to best introduce the theoretical issues central to the Holocaustal uncanny, I will spend a large segment of this chapter analyzing Heinrich Himmler's speech at Posen from October 4, 1943—or rather, how three historians act out their problematic relations to Himmler's Posen speech.[1] Himmler's speech is one of the only official public references that acknowledge the acts of genocide that were being perpetrated against Europe's Jewish communities. In their writings, historians Saul Friedlander, Dominick LaCapra, and Peter Haidu use this speech to construct their subject position vis-à-vis the Holocaust. While wary of the possibility of displacing history with theory, which according to LaCapra has a tendency to "trope away" the historical significance or impact of the trauma (*Representing the Holocaust*, 97), each historian applies similar theoretical models to Himmler's speech. Thus Friedlander, LaCapra, and Haidu begin their respective studies by reading the words next to Kant's category of the sublime, which includes its elements of failed imagination, the breakdown of senses, the lack of intellectual comprehension, disrupted representation, and an affective shudder following this theoretical scheme. Each historian then moves his respective theoretical lens to Freud's structures of trauma theory and his figure of the uncanny, which revolves around the affect of horror, the return of the repressed, the compulsion to repeat, and specular disruption.

Freud himself was aware of the relation between the uncanny and Kant's category of the sublime, and he draws the connection between them at the beginning of "The Uncanny," foregrounding the relation between his text and the "remote region" of aesthetics.[2] But there is one key distinction between the two terms. While the sense of the sublime is a dis-

1 Excerpts from Himmler's Posen speech are taken from Dawidowicz, 130–40.
2 Harold Bloom considers Freud's essay to be the only major contribution the twentieth century made to the aesthetics of the sublime and writes, "The sublime, as I read Freud, is one of his major *repressed* concerns, and this literary repression on his part is a clue to what I take to be a gap in his theory of repression" ("Freud and the Sublime," 101).

comfort brought about by the collapse of the imagination, there is also a
moment of pleasure as the subject is elevated by recognizing that the sub-
lime feeling originates within the self. In contrast, Freud observes about
the uncanny, "As good as nothing is to be found upon this subject in
elaborate treatises on aesthetics, which in general prefer to concern them-
selves with what is beautiful, attractive, and sublime, that is with feelings
of a positive nature ... rather than with the opposite feelings of unpleas-
antness and repulsion" (19). The latter sensations are symptomatic of the
uncanny. According to Freud, the most uncanny feeling revolves around
the site of a grave and the fear of being buried alive, which, he maintains,
symbolizes the repressed desire to return to the womb. Thus, Himmler's
evocation of a grave is particularly resonant. And it is not just any grave
that Himmler describes, but the mass graves of the extermination sites
that he wished to preserve as a secret with his fellow SS officers at Posen.
It is conspicuous that LaCapra, Friedlander, and Haidu avoid any mention
of the grave's uncanniness and focus exclusively on Himmler's elation in
full view of these bodies.[3] The historians' return to Posen does not entail
going toward the grave and seeking out its occupants; instead each critic
occupies the perpetrators' position, so in searching for a vantage point
from which to subject the Holocaust to philosophical analysis, each histo-
rian is limited by the uncanny effect of the speech.

In "The 'Final Solution': On the Unease of Historical Interpretation,"
Friedlander remarks that in order to analyze the Holocaust, "We would
need a new category equivalent to Kant's category of the sublime, but
specifically meant to capture inexpressible horror" (*Memory*, 115). He de-
scribes the Posen speech as containing elements of horror and *Unheim-
lichkeit* and acknowledges that the process of interpretation creates an "un-
ease" for the historian who attempts to interpret the Holocaust and runs
up against the "paralysis of comprehension" (108), an interpretive limit
stemming from "the noncongruence between intellectual probing and the
blocking of intuitive comprehension" (111). While the debate concerning
the representation of the Holocaust in literature and visual media often
posit Kant's aesthetic category of the sublime as an unproblematic given, I
contend that it is misappropriated when applied to the scene of an histori-
cal trauma. The category of the sublime is a misnomer for those who dis-
cuss the Holocaust in relation to Kant, because it is not traumatic enough.
Resisting LaCapra's depiction of the Holocaust as an inverted, "negative,"
or "transgressive" sublime, I insist that we must not try to rehabilitate fas-

3 In his analysis of the uncanny nature of Himmler's speech, LaCapra mentions the relation
 between the womb and the return of the repressed, where the female genitalia symbolize
 what was once familiar (*Heimlich*) but has become *Unheimlich*. However, LaCapra does not
 mention Freud's connection between the tomb and the womb (*History and Memory*, 38).

cism within the economy of Kant's aesthetic category. The expanding
number of Jewish victims about which Himmler boasts, along with his de-
scription of the murdering of the Jews as an "unwritten, never to be writ-
ten page of glory" (133), displays neither the Kantian movement towards
the infinite nor the failure of the imagination. Instead, this act of "unwrit-
ing" signifies the attempts by the Nazis to conceal or erase traces of a
crime.

The following analysis of the historians' inquiries into Himmler's
speech helps me set up some theoretical issues that are central to the
Holocaustal uncanny: empathic identification, affect, representational lim-
its, the uncanny, and questions of positionality. The term itself is illus-
trated again and again in the movement of the historians who approach
the brink of Posen's graves. Through the reading of an historical docu-
ment that describes the site of mass killings, each historian draws near the
scene of destruction in order to test the limits of historical understanding.
What results is the transformation of an epistemological probing into the
initial steps of an ethics of the gaze in relation to the Nazi genocide. Yet
in each of the previous explications of the speech where an uncanny sen-
sation arises, the historian's gaze is directed not toward the expanse of
corpses but toward Himmler's face. The Holocaustal uncanny, on the
other hand, positions the spectator before the scene of effacement.

In contrast to Friedlander's, Haidu's, and LaCapra's investigation of
the problems faced by the historian who encounters the rhetoric of si-
lence in Himmler's document, I shift to the textual voids that artists place
before the spectator. The moment of the Holocaustal uncanny occurs
when this fantasy of identification breaks down in relation to the effaced
Other and the reader/spectator is confronted with textual erasures. The
disruption of representation in Holocaust aesthetics does not protect us
from the shock of the trauma. While the spectator may desire to see the
scene of terror and identify with the victim, those artists that utilize the
technique of the Holocaustal uncanny subvert any empathic identification
through visceral shocks. Such shocks are induced by techniques reminis-
cent of Kant's concept of negative representation, but the artist withholds
the trauma from the spectator's gaze. Instead, the negative representation
functions as the place where the frame of the work opens up and the
spectator is led into the shock itself: spectatorial disruption, the loss of
sight and orientation, is the moment of anxiety. At the place where the
spectator expects to see something, she is taken to the scene of an erasure.

Elements of Kant's Sublime:
Subreption, Negative Presentation, and Shudder

What then are the ostensible intersections of Himmler's speech and Kant's sublime? Perhaps the most explicit one can be examined through the philosopher's depiction of the mathematical sublime. Himmler's speech centers on mass killings, which because of their sheer violence ultimately transform into the dynamic sublime. While the mathematical sublime refers to an increase in size or number, the dynamic sublime denotes the feeling aroused before violent or overpowering scenes of nature. As Kant remarks, "We call sublime what is absolutely large ... large beyond all comparison" (*Critique of Judgment*, 103).[4] He goes on to assert that the sublime cannot be located in things of nature—the phenomenal world—but must be sought solely in our ideas. "Nothing that can be an object of the senses is to be called sublime ... Our imagination strives to progress towards infinity, while our reason demands absolute totality as a real idea, and so the imagination ... is inadequate to that idea" (106).

The feeling of the sublime points to a faculty within the subject that surpasses any standard of sense. Kantian sublimity necessitates capitulation to a trauma of the imagination, and this submission indicates the moment when Kant believed the law of reason elevates the subject whose imagination has reached its bounds. This law, an idea of reason, is not an object of experience that can be represented through ordinary means. The moral agent, depicted by Kant as a spectator who stands before nature, tries to apprehend the law as an appearance; however, the imagination is incapable of this. In the end, the act of representing the law is thwarted and leads to displeasure in the subject: a dissonance arises between the faculties of imagination and understanding.

One of the most central elements of the sublime is the act of substitution, which Kant labels "subreption" (114). During subreption the subject tries to replace the non-object of the moral law located within herself with something graspable or representable in the external world. One can draw a parallel between the subject's search for adequate representations of the moral law to the process of cathexis in Freud's depiction of mourning and melancholia, where the subject searches for a substitute object to re-direct libidinal energy after the loss of the original object. For Kant this act of substitution ultimately fails, because the subject cannot represent the size and power of the external world adequately. In turn, the subject is threatened with self-annihilation as she recognizes her own weakness before the

4 When applicable, the page numbers for the original German, *Kritik der Urteilskraft*, will follow those for the English translation.

magnitude of the phenomenal world. But subreption must also fail in the end because, for Kant, there can be no substitute for the moral law. Analogous to how blocked cathexis signifies for Freud a state of melancholia, Kant's moral agent seems also to undergo a temporary melancholia as there is no adequate presentation for the infinite or the moral law. Kant describes how the subjugation of the individual's imagination before violent scenes of nature is tantamount to a "melancholic meditation" ("zum schwermütigen Nachdenken"; 129/173). Nonetheless, as the expanse of nature threatens to annihilate the subject, at the very moment of disappearance the subject attempts to circumvent annihilation by turning inward through reason to the moral law in order to be elevated once again.[5]

The emblematic scene of Kantian sublimity portrays the subject standing on a cliff overlooking a raging storm at sea. With her feet firmly planted on solid ground, the subject remains removed from the natural danger of this abyss. The danger is kept at a distance and the only thing threatened is the subject's imagination. The object, the violence of the storm, becomes an abyss for the imagination and pushes the subject's powers of interpretation to their limits. As Kant states, "If a thing is excessive for the imagination ... then the thing is an abyss ["Abgrund"] in which the imagination is afraid to lose itself" (115). But while Kant's cliff provides safe distance to observe nature's terror, we are also anchored from within by our moral vocation. The sublimity actually originates from within the subject and is projected outward through the process of subreption. At the moment when the violence pushes the individual to this limit, she turns inward to the faculty of reason and the moral law to escape the supposed threat from outside. Reason and the law elevate the subject against the imagination's limits: the fear of annihilation turns to pleasure as we behold the sublimity coming from within ourselves through our "supersensible vocation," that is, from the moral law (115).

According to Kant, the most sublime commandment is the Jewish law that legislates against graven images (135). He introduces here his term "negative presentation" ("Negative Darstellung") and posits that, similar to the infinite or the absolute, our presentation of the moral law can only be negative. However, even though this presentation of the infinite or the moral law can "never be more than merely negative, it still expands the

5 The connection of sublime feeling to Kant's ethics is already anticipated by the end of his *Critique of Practical Reason*, where such a play between the subject's annihilation and elevation unfolds in relation to the starry heavens above and the moral law within. We will see the subversion of Kant's expression of awe and wonder before the infinite sky and the moral law in chapter 5 in Anselm Kiefer's turn to Celan's lyric. In his painting-photograph "The Starry Skies" (1980), completed at the time when he also began to engage with Celan's poetry and the Holocaust, Kiefer turns to Kant's questions regarding ethics and representation in the aftermath of the Holocaust.

soul" (135). Nothing comes before the eyes, and what is expanding is not something external that the senses fail to grasp, but rather the imagination, which tries to form an image of the moral law "in us." Kant does not claim either that there is an absence of representation or that nothing is being presented. He still calls this process a "mode of representation" ("eine Darstellungsart") that is ineluctably bound to the sensation of the sublime. As French theorist Jean-François Lyotard so aptly captures this process, the imagination falters in its attempt to present the infinite, and what remains is only a trace, "The sign of a 'presence' that will never be a presentation" (*Lessons*, 152). Once the imagination is confronted with its inability to comprehend the trace left behind by its missed encounter with the absolute, the sensation of a shudder linked to the sublime accompanies the breakdown of this reflexive act and stands in its stead.

The closeness between Kant's sublime heights and the catastrophic depths of post-Holocaust aesthetics is maintained by questions concerning negative representation, lost experience, disrupted perception, and the feeling of anxiety. But while the sublime's integral characteristics revolve around fear conjoined with the effects of pleasure and elevation, during our encounter with a traumatic event, pleasure and elevation are withheld. In this space of a trauma we do not walk away "glad" in liberation from danger as we do in Kant's depiction of the sublime. Despite some structural and thematic parallels between the category of the sublime and the theoretical model of trauma, there are some glaring disconnects as well. During a traumatic event the very space of safety is lost. With the breakdown in perception the individual loses the ability to represent the experience and one might hear an echo to Kant in Freud's depiction of a perceptual disturbance during a traumatic occurrence. Freud writes, "Most of the unpleasure we experience is perceptual unpleasure. It is the external perception of something distressing" (*Beyond the Pleasure Principle*, 9). But in contradistinction to the sublime, standing before the traumatic event of the Holocaust one is left only with horror. It is an altogether other space where this distance is lost and we are no longer perceiving an object but an abyss. In this space we do not walk away "glad" in liberation from danger like Kant's description of the sublime in which the subject stands before nature's abyss. Nor can we fall back on such concepts as reason and the moral law, for they too have been burned away. The very ground of Kant's depiction of humanity—reason, freedom, the moral law, and the infinite—have been degraded in the Holocaust. Though we may find safety in knowing that it is not 1942 Germany, our position as spectators is put into jeopardy when encountering the vast array of Holocaust representations under consideration here.

"To see a hundred corpses lie side by side, or five hundred or a thousand …"

Himmler gave his infamous Posen speech to the SS on October 4, 1943, in the city of Posen, in what is today Poland. In his more than three-hour-long speech the head of the SS discussed such themes as the war with the Soviet Union, the air wars against German cities, America's entry into the war, the future of the German nation, and the honor and duty of the SS. But the speech is best known for its section entitled the "Judenevakuierung"—Himmler's euphemism for the deportation and extermination of Europe's Jewish communities—in which he gives an account of seeing the mass graves. Even before he begins his description of the Judeocide, the speech evinces signs of Kant's mathematical sublime. Focusing on Russian, Slavic, and Polish prisoners, Himmler stresses the accumulation of their bodies and laments the fact that the dead were not used for slave labor: "It is regrettable that the prisoners died by the tens and hundreds of thousands of exhaustion, of hunger" (130). He continues, "Shooting ten Poles today is a mere nothing when compared with the fact that we might later have to shoot tens of thousands in their place" (132). This growing number of bodies will ultimately lead up to Himmler's remarks on the extermination of Europe's Jewish populations:

I also want to make reference before you here, in complete frankness, to a really grave matter. Among ourselves, this once, it shall be uttered quite frankly; but in public we will never speak of it. Just as we did not hesitate on June 30, 1934, to do our duty as ordered, to stand up against the wall comrades who had transgressed, and shoot them, so we have never talked about this and never will. It was the tact which I am glad to say is a matter of course to us that made us never discuss it among ourselves, never talk about it. Each of us shuddered, and yet each one knew that he would do it again if it were ordered and if it were necessary.

I am referring to the evacuation of the Jews, the annihilation of the Jewish people. This is one of those things that are easily said. "The Jewish people is going to be annihilated," says every party member. "Sure, it's in our program, elimination of the Jews, annihilation—we'll take care of it." And then they all come trudging, 80 million worthy Germans, and each one has his one decent Jew. Of all those who talk this way, not one has seen it happen, not one has been through it. Most of you must know what it means to see a hundred corpses lie side by side, or five hundred, or a thousand. To have stuck this out and—excepting cases of human weakness—to have kept our integrity, that is what has made us hard. In our history, this is an unwritten and never-to-be-written page of glory …. (quoted in Dawidowicz, 132–33)

Yet in Himmler's depiction of mass killings there is no inadequacy—"Unangemessenheit," to use a Kantian term—of either the imagination or of the senses, because the SS are able to maintain both their integrity and their hardness before the graves. There is a harmony between the senses and what the spectator beholds. Furthermore, the number of dead can itself be measured (*Messen*) and the men Himmler addresses do not turn away in horror or displeasure from this scene; rather, they remain "hard." Kant's act of subreption necessitates a perceptual break with the object, but this does not occur in Himmler's depiction of beholding the mass graves: the eye never strays from the bodies. Contrary to any claim that the scene Himmler describes is "unrepresentable," there is indeed something seen—the corpses—and the very amassing of the dead bodies becomes for Himmler equal to what he calls the "sacred law" instilled in the SS (137). Throughout Himmler's speech, Hitler himself becomes the new categorical imperative.[6] Stressing both the sacredness of Hitler's orders and the devotion to duty, Himmler underscores repeatedly at Posen how the SS will remain loyal to Hitler and carry out his orders in both "spirit and letter" (136).

While again such terms may echo with a Kantian ethics, they ultimately veer away from his presentation of the moral law. Kant uses morality to talk about the faculty of reason, elevating the rational being above the realm of the senses. Reason demonstrates to the subject his superiority over nature and allows him to behold the unrepresentable in its absence. Himmler, on the contrary, remains in the realm of sense and experience, equating the amassing of bodies with "sacred law." Although Kant's law can be neither extracted from the realm of experience nor shown through representation, Himmler provides such a presentation.[7] There is never a rupture of sense for Himmler as he remains fixed in the realm of perception. Kant's law arises when sheer number and magnitude threaten to overwhelm the subject's sensibility and imagination; she is forced to turn inward to the law of reason before being annihilated by the limits to the imagination. But in his skewed renderings of law, duty, and principle—what Himmler refers to as "our idealism" (130)—orders are sacred and thus the act of extermination is sanctified: the SS complete their act while retaining their "decency and hardness." No fragmentation of the self occurs, nor is there any collapse of Himmler's method of representation.

6 Friedlander refers to such a description of sacredness as the mark of the "Führer-bond" (*Memory*, 110–11).

7 Throughout his *Groundwork to the Metaphysics of Morals* and *The Critique of Practical Reason*, Kant argues that the moral law cannot be located within the sensible world. The subject's act of reflection is unable to attain the absolute of morality. Such a presentation is withheld from the senses.

The most striking disconnect between the category of the sublime and the Posen speech is the very lack of any visual rupture occurring in Himmler's speech. At the moment of a perceptual breakdown during the sublime, terror and horror arise in the subject. However, the amassing of dead bodies never becomes an abyss for Himmler nor a source of horror, for he is able to maintain visual perception before the graves. While there is a momentary annihilation of the subject in Kant, in Himmler's description of a visual trauma, there is no loss of self. As he exclaims, "We had the moral right, we had the duty toward our people, to kill this people which wanted to kill us. Our inward being, our soul, our character has not suffered injury from it" (133). Developing this moment of the subject's temporary annihilation before formidable scenes of nature, Kant examines the terror that accompanies the subject's pursuit of encountering and reproducing inner sublimity in the external space. Himmler's description of unspeakability and the refusal to write this history ("This is an unwritten and never-to-be-written page of glory") are limits that were self-imposed, even as the amassing of bodies continued to be seen. For Himmler, only the complete extermination of the European Jewish communities functions as the limit for himself and his Führer.

In my view, and contrary to what LaCapra and Haidu will claim, Himmler's call to remain silent ("Among ourselves, this once, it shall be uttered quite frankly; but in public we will never speak of it") and his refusal to write this glorious page of history are not signs of Kantian limits to representation, nor do they point to Kant's notion of negative presentation engendered through the limits of sensibility. The law has indeed been represented through the depiction of the mass graves. What some might read as negative representation, such as the missing page of history or the call to silence, has nothing to do with a failure of the imagination, nor is it a sign of respect for the moral law. The description of this absent page simply marks the attempts to erase the traces of a crime and the speech is itself punctuated by Himmler's extolling the acts of kidnapping, forced labor, and mass shootings.[8] But what is perhaps even more remarkable about Himmler's call for silence and his insistence that this

8 Shoshana Felman eloquently captures this process of erasure in her study of Lanzmann's *Shoah*: "The scheme of the erasure of the witnesses must therefore be completed by the literal erasure—by the very burning—of the bodies. The witness must, quite literally, *burn out*, and burn out of sight" (226). As Richard Glazer, a survivor from Treblinka, describes witnessing the first burning of the bodies in his testimony in *Shoah*, "He sang in Yiddish, while behind him blazed the pyres on which they had begun then, in November 1942, to burn the bodies in Treblinka.... We knew that night that the dead would no longer be buried, they'd be burned" (quoted in Felman, 226). The absence of the corpse, reduced to ash, is indicative of the Nazi attempt to "leave no trace" of the crimes of historical murder.

chapter of history must never be written down is the very existence of his original typed speech and its recording.[9]

There is a tendency to misread Himmler's elation at Posen as a sign of sublimity, but what we discern is not an inverted nor a secular nor a transgressive sublime; instead, Himmler's speech has all the characteristics of what Kant labels "Wahnwitz," or fanaticism.[10] As Kant states,

> For once the senses no longer see anything before them, while yet the unmistakable and indelible idea of morality remains, one would sooner need to temper the momentum of an unbounded imagination so as to keep it from rising to the level of enthusiasm, than to seek to support these ideas with images and childish devices for fear that they would otherwise be powerless ... This pure, elevating, and merely negative exhibition of morality involves no danger of *fanaticism*, which is the delusion ["Wahn"] of *wanting to SEE something beyond all bounds of sensibility* (raving of reason). The exhibition avoids fanaticism precisely because it is merely negative ... Fanaticism is comparable to mania ["Wahnwitz"]. (135–36/183, my emphasis)

There is nothing sublime or traumatic in the Posen speech from the position of the perpetrators, who remain hard and decent, and never turn away in terror from the amassing of bodies. Such a disruption of vision from scenes of increased magnitude or of nature's violent power are necessary parts of the sublime. In fanaticism the imagination becomes "ruleless" and is referred to as a "disease" that deranges understanding (136). Through this "raving of reason" the subject believes he/she has found the determining basis for the law. But for Kant, sublime feeling only arises when the imagination fails to grasp the idea of reason, as the impossibility of the law's representation collides with the desire to exhibit this very absence through negative representation. The subject is ultimately elevated in her recognition that what expands is not nature, but the subject's imagination as it tries to keep up with the expanding faculty of reason.

Even the imagination and intellectual comprehension of the men Himmler addresses in Posen never run up against any such limits. Himmler describes how they "Know what it means to see a hundred corpses lie side by side, or five hundred or a thousand. To have stuck this out—excepting cases of human weakness—to have kept our integrity, that is what has made us hard." Kant's sublime arises out of a near annihi-

9 Himmler's voice from that day, along with the coughs and laughter of those in the audience, can be heard on multiple Internet sites. See for instance <www.nizkor.org>. In addition to listening to this recording, one can read parts of Himmler's transcript in German as well as in English translation.

10 I am referring to Friedlander and LaCapra's use of the term *Rausch* in their readings of Himmler's speech. I return later in the chapter to their respective analyses of this elation in the speech.

lation of the self, where the subject is brought to the brink of vanishing. But such a temporary self-annihilation does not occur in Himmler or the SS, for their "remaining firm" underscores the fact that the subject neither turns away nor is threatened by a cognitive abyss. In opposition to Kant's depiction, for Himmler it is the external image of the bodies that is increasing. There is never a disruption of the representational powers and senses, as Himmler and the SS do not turn away from the expanding pile of the dead. Any similarity with Kantian sublimity dissolves into Kant's description of mania and fanaticism.

While Himmler does invoke the concept of law, it is a law that has become hypostatized, has the form of Hitler's law. Although Himmler may praise the virtues of the inner law of the SS, he has reified the law by ascribing it to the orders of the Führer. This is the turn to fanaticism that Himmler himself adheres to at the end of his speech: "We are doing our duty more fanatically than ever, more devoutly than ever, more bravely, obediently, and honorably than ever" (140). The feeling of terror at the loss of one's self before the infinite turns into sublime feeling as the individual is elevated by the infinite power of reason found within him/herself. Yet such a turn does not transpire in the Posen speech. Himmler, invoking the sacred law, refuses to look away from the ever-increasing mound of bodies and believes that the mass graves are concomitant with the absolute law dictated by the Führer.

Despite the supposed echoes of Kantian themes that re-appear throughout the Posen speech—mathematical and dynamic sublime, references to a sacred law, to self-annihilation, and to a break with representation—the moment of the sublime is contingent upon a failure of the senses. Kant writes, "Nothing that can be an object of the senses is to be called sublime" (106). Instead, the subject is faced with an epistemological aporia that threatens the subject's imagination. Foregrounding the figure of silence and the limits of representation (*Bilderverbot*) depicted in the supposed breakdown of Himmler's language and his elation before the mass graves, each critic passes over the significance of the failure of perception for Kant. But perhaps even more relevant to both the sublime and the uncanny, each critic bypasses within Himmler's speech another key component of Kant's and Freud's categories. Kant describes how this perceptual rupture at the core of sublime feeling is accompanied by a shudder in those who are confronted with a limit event of the mathematical or dynamic sublime. During the sublime, the mind feels agitated ("bewegt") and "This agitation (above all its inception) can be compared with a vibration ["Erschütterung"]" (115/155). That which is excessive or violent becomes an abyss to the spectator's imagination. Lyotard again renders succinctly the state of this sublime affect: "The consequence for

thought is a kind of spasm … It exposes the 'state' of critical thought when it reaches its extreme limit—*a spasmodic state*" (*Lessons*, 56; my emphasis). Describing how his vision remains intact when he surveys the mass graves, Himmler is never overcome with such a spasm or shudder before this scene of violence.

When Himmler does in fact describe a shudder within his speech, it arises not before the mass graves of Jewish victims but from the killing of Ernst Röhm and other members of the SA during the Night of the Long Knives. Himmler remarks, "Each of us shuddered and each of us knew we would do it again if asked." But by specifically providing the event's date (30 June 1934), Himmler demonstrates that there is nothing traumatic or sublime about the day when the Nazis purged members from within their own ranks. According to both Kant and Freud, the moment of the sublime and of trauma entail temporal ruptures. Kant describes how the sublime sensation is produced by a "momentary inhibition" ("das Gefühl einer augenblicklichen Hemmung") in the subject's imagination (98/134). Through his choice of words, Kant forms a link between this breakdown of a moment in time to what the eye fails to see. Likewise in Freud, the moment of trauma comes about through a sensory rupture that fails to register the shock experience within the space of memory and results in what Cathy Caruth calls an "unclaimed experience." Contrary to being unclaimed, Himmler celebrates the criminal acts that, far from being unimaginable, were being perpetrated and witnessed by those who sat before him in Posen.

Friedlander and the Historian's Unease

The focus of Friedlander's chapter "The 'Final Solution': On the Unease of Historical Interpretation" centers on the historian's epistemological drive to comprehend the horrors of the "Final Solution." Employing Himmler's Posen speech as his template, Friedlander tells us that his aim is to "*come closer* to the nature of this difficulty" that the historian encounters when trying to interpret or derive meaning from the Holocaust (*Memory*, 103; my emphasis). Despite this attempt to place the "paralysis of comprehension" (108) before the Nazi genocide into a "clearer perspective"(107), Friedlander testifies to the way in which the historian is constantly stymied before the opaqueness of the Final Solution. His discussion of positionality and the Holocaust consists of two steps. Probing the historian's unease before the Holocaust, he shows how "coming closer" and searching for a "clearer perspective" in order to face traumatic history

involves an act of identification not with the victims, but with the perpetrators of the genocide. Friedlander turns to occupy the "psychology of the perpetrators" (104), who had at their disposal the most knowledge regarding the process and were in possession of the ideological motives behind the extermination. But the key position Friedlander investigates in the second part of his analysis is that of the historian who has an even greater scope of information needed to facilitate an intellectual probing of the extermination.

Despite his description of how the historian shares "common perceptions of human existence" with the perpetrators whom he analyzes, Friedlander eventually shows the gulf that opens up between the historian and perpetrator. The repetitive use of "we" in the following passage underscores the distinction he makes between himself and the Nazi other: "We try to overcome the feeling of strangeness and horror and try to find the point of psychological identity. We try to identify our own thinking with that of Himmler's world by an understanding stemming from the postulate of these psychological common denominators … to grasp the mindset we are probing" (108). Friedlander, delineating an inside to the Holocaust in relation to the perpetrators' vantage point, forms an imaginary identification with the perpetrators' position and mode of thought. After attempting to establish a position of identification based on shared communal perceptions, the historian's ability to identify with the Other constantly breaks down during the explication of Himmler's words. Unable to sustain this perspective and position before the graves, the historian's comprehension of the scene of horror collapses into an unease. Acknowledging the impossibility of interpreting this history from inside—that is, from the point of view of the perpetrators—he switches his investigation to how the historian analyzes the phenomenon of her/his interpretive anxiety from the "outside."

Friedlander asserts, "The historian can analyze the phenomenon from the 'outside,' but, in this case, his unease cannot but stem from the noncongruence between intellectual probing and the blocking of intuitive comprehension" (110). The Final Solution behaves like "a residue that defies the historian" (104) and blocks her/his understanding of the events. Whether he employs the term residue, trace, or remnant, such depictions suggest the traumatic effects that the events of extermination have on the historian; the residue left in the aftermath of the Holocaust poses an intellectual incertitude for him. Regardless of its echoes with the sublime, Himmler's Posen speech produces an interpretive limit that takes Friedlander from Kant to the effects ascribed to Freud's uncanny. More specifically, according to Friedlander, the perspective of the historian undergoes something similar to the uncanny in relation to Himmler's descrip-

tion of elation before the scenes of mass murder. Friedlander turns from
the event's alleged sublime effect on the perpetrators to the uncanny ef-
fect on the historian, who reads Himmler's elation over the increasing num-
ber of Jewish dead and is paralyzed by this rupture of comprehension.

What exactly is the source of this noncongruence and what does the
historian fail to grasp that eventually provokes this sense of "Unheimlich-
keit" (105)? The uncanny effect, as Friedlander shows, arises on several
planes with regard to his analysis of Himmler's words. Concentrating on
the Nazi repetition of seeing the amassing of the bodies and the histo-
rian's unease triggered by the incomprehension in observing the perpetra-
tors' celebratory reactions before the mass graves, Friedlander asserts,
"We try to overcome the feeling of strangeness and horror and try to find
the point of psychological identity" (108). Yet for Himmler and the SS, this
disconnect between the taboo against mass murder and the law that calls
for the extermination fails to induce any moral damage within its agents.

This uncanniness arises in the historian who is confronted with the
"dissonance" (105) between the perpetrators, who are fanatically commit-
ted to breaking the commandment against genocide, and the effect this
transgression produces in them. Describing how the speaker is overcome
with elation (*Rausch*) before the mass graves, Friedlander is struck by
Himmler's claim that those who participated in these crimes did not suffer
any moral damage. But what Friedlander finds even more disorienting is
Himmler's assertion that this "glorious page of history" should never be
written. There is an intensification of Friedlander's intellectual blockage in
his effort to comprehend Himmler's praise for the extermination and his
simultaneous call for secrecy. Attempting to interpret this disconnect be-
tween the lack of moral damage and the refusal to tell others of this glori-
ous deed, Friedlander argues that the actions of the SS are incomprehen-
sible to those outside this elite group. Himmler had stated in a speech at
Posen several months earlier,

> The hard decision had to be made that this people should be caused to disappear
> from the earth ... Perhaps at a much later time, we can consider whether we
> should say something more about this to the German people. I myself believe
> that it is better for us—us together—to have borne this for our people, that we
> have taken the responsibility for it on ourselves (the responsibility for an act, not
> just for an idea), and that we should now take this secret with us into a grave.
> (cited in Lang, *Act and Idea*, 26)

Foregrounding an inside/outside binary between the German perpetrators
and citizens, Friedlander argues that the secret could not be imparted to
those outside this group. Through such a description the historian re-

enforces the problem of positionality in relation to inside/outside perspectives to the site of trauma.

Friedlander's discussion of the uncanniness of the Posen speech explicitly turns on Freud's use of the term: that the feeling of the uncanny arises through the impossibility of distinguishing between the animate and inanimate, between something living and something dead. The example he offers is that of an automaton that comes to life in E. T. A. Hoffmann's "Der Sandmann." But Friedlander underlines a reversal of this figure in Himmler's speech. Instead of an automaton coming to life, the human now becomes an automaton, and Friedlander writes, "Our sense of *Unheimlichkeit* is indeed triggered by this deep uncertainty as to the 'true nature' of the perpetrators" (110). The ambiguity revolves around very human perpetrators who become mechanical in their drive to exterminate the Jewish communities of Europe. This seemingly emotionless drive to eradicate the Other breaks our identity with the perpetrators as human agents; we observe instead the work of machines.

But even this particular aspect of the uncanny—the tension between the mechanical and the human—cannot be sustained by Friedlander. Affect indeed arises in those who stood before the mass graves, and instead of suffering moral damage Himmler displays his elation through the act of seeing the amassing of bodies. Friedlander incorporates another component of Freud's uncanny in order to probe the historian's unease before the Holocaust: the compulsion to repeat as seen in the act of killing that adds to the ever-increasing mound of bodies. But this repetitive act becomes uncanny for those who analyze Himmler's words. For Friedlander, the uncanny effect arises from the inability to reconcile the rift between the perpetrators' elation before the site of mass extermination and our recognition of the law that protects the Other from being annihilated. According to Friedlander, this "Elation created by the staggering dimension of the killing, by the endless rows of victims" becomes for the historian a source of intellectual blockage (111); it is not only the place where the imagination is thwarted but it signifies as well the moment when Friedlander raises the need for a new category similar to that of Kant's sublime to probe the Holocaust.

Although his employment of such terms as incomprehension, blockage of the imagination, and intellectual uncertainty might suggest at first Kant's sublime, Friedlander circles around a category that is evocative of an intersection of the sublime and the uncanny. Yet he cannot find the term he is looking for. Moreover, his search for this new category leads him to the ethical dilemmas that confront the historian who employs the empathic imagination to engage with the Holocaust. Placing himself before the mass graves, Friedlander takes the position of the perpetrator and

shows the impossibility of both maintaining an identification with the Other and of occupying an inside perspective. He concludes his chapter with the warning that, as a result of its apparent historical exceptionality, "The Final Solution could well be inaccessible to all attempts at a significant representation and interpretation" (113).

Haidu and the "strangely familiar" of Himmler's Posen Speech

In his essay "The Dialectics of Unspeakability: Language, Silence, and the Narratives of Desubjectification," Peter Haidu begins by acknowledging his interaction with Friedlander's essay on the historian's unease before the Holocaust. Continuing with the themes of representational limits, the sublime, the uncanny, and empathic identification, Haidu executes an incisive rhetorical reading of silence in the Posen speech by examining Himmler's use of repetition, paranomasia, and apophasis, the rhetorical device of alluding to something while simultaneously denying it. These linguistic instabilities suggest to Haidu the interpretive challenge faced by the historian who attempts to investigate the events configured in the speech. Haidu discusses the difficulties the historian faces in trying to narrate the history of "the Event" (his term for the Holocaust), when the very structures of narrative have been radically altered by this history. Not only is the task of the historian to select and organize the materials needed to narrate the history, but she must also recognize how the ability to tell this story is affected by the "point of view" from which one chooses to narrate it: whether it is from the victims' or perpetrators' perspective (279).

In addition to examining the rhetorical strategy of apophasis, where Himmler declares the glory of the amassing bodies but orders strict silence, Haidu's analysis of the discourse of extermination shifts to a narrative that focuses on a Nazi ethics within the speech. In particular, he examines the ethical import within the speech as seen in Himmler's use of such terms as duty (*Pflicht*), right (*Recht*), and order (*Befehl*); the extermination becomes the response to a sacred command ("Heiliges Befehl") or moral imperative that Himmler directs to the SS. It is at this point that the epistemological drive of the historian who tries to construct a narrative trajectory to the document of extermination runs into an ethical complexity. Building from Levinas's concept of responsibility, which he associates with the face-to-face encounter with the Other, Haidu wonders how the Nazis could sustain this genocidal pursuit without any regard for the Other. He also formulates a link between this face-to-face encounter and empathy, and he insists that the human propensity is to identify with oth-

ers, which is "called 'pity' by Rousseau" (289). Haidu encounters in Himmler's words a disconnect between the belief that ethics is predicated upon the protection of the Other and the Nazi command that calls for the Other's destruction. He continues by showing how the perpetrators were able to break any sense of identification with the Other through a process of desubjectification: the Nazis constructed the Other as subhuman while simultaneously strengthening and elevating their own sense of identity and community among themselves. In turn, Haidu's face-to-face encounter with the Holocaust ultimately produces an effect like that of the uncanny in the historian; his shudder is produced not simply by this ethical collapse, but also from a sense of familiarity arising in his recognition of a continuity between this ethical system and his own.[11]

Empathy becomes once again a crucial category for Haidu, and he switches from the perpetrator's absent relation to the victim to the historian's own face-to-face relation with Himmler's perspective. Trying to identify with this Nazi gaze that rejects pity for the Other, the critic again focuses on the horror of the historian's gaze, where his shudder is provoked by his inability to sustain the Nazi perspective. Haidu writes,

> Neither individual empathy with the monsters of extermination, in some act of historical *Verstehen*, nor ritualistic condemnation provides the understanding that performs the necessary transgression of sacral apophasis. The force of outrage must be appropriated by the forging of tools of comprehension of the relation of the discourse of extermination to the enacted narrative history of extermination. (288)

He is describing here the collision between Himmler's language of extermination and the historian's own use of narrative that is required to break Himmler's "sacral apophasis." The placing of traumatic events into an historical narrative functions as a subversion to Himmler's call to silence. According to Haidu, the writing of history renders impermissible the victims' erasure (294), and it is the historian who becomes the ethical agent who counteracts the Nazi aim to conceal the traces of extermination.

11 Any question of the uncanny Other at Posen—the Jewish Other who is excised from the German body—revolves around the Jewish Other as foreign element in relation to the nation that is trying to maintain its identity of homogeneity. The figure of the uncanny that develops at Posen is closer to Kristeva's adaptation of Freud's concept in relation to xenophobia; the foreigner becomes a "symptom" of the difficulties of living with the Other (103). In the following passage from Kristeva we read something similar to LaCapra's own critique of nationalism's drive to remove what is foreign. She questions the uncanny's relation to the political: "Are we nevertheless so sure that the 'political' feelings of xenophobia do not include, often unconsciously, that agony of frightened joyfulness that has been called *unheimlich* …?" (191). Kristeva links a political affect associated with xenophobia to the sensation of the uncanny.

But it is this very face-to-face encounter not with the Other as victim but with the voice of the perpetrator where the process of empathic identification induces an uncanny effect in the historian. Haidu stresses the problems that stem from the impulse to accentuate the uniqueness of the "Event" and to describe its "disconnectedness from history" (291): the Jewish catastrophe becomes separated from history and such a schism, Haidu worries, could lead to a radical incomprehension that inadvertently contributes to the same rhetoric of silence or unspeakability that Himmler desired. Haidu shows instead how the Event is not entirely foreign but, as Himmler's language demonstrates, is strangely familiar or *unheimlich*. What is horrifying about Himmler's words is not their strangeness, but our sense of familiarity with them—his emphasis on rationality, morality, and subjectivity are core components of what he inherited from the Enlightenment. We hear in his words an echo of our own discourse and cultural values. Haidu admits to an uncanny effect induced by Himmler's words, where the historian recognizes in the speech modes that are "uncomfortably familiar," and this familiarity is what "freezes him [the historian] in terror" (292). Once again, it is not the scene described by Himmler that is uncanny, but rather it is our cognitive relation to the text that produces this sense of uncanniness. Himmler's words are *unheimlich* because his text is made up of themes and concepts from religion, poetry, idealism, and bureaucracy that are recognizable to the reader. What is horrifying about Himmler's speech is that his language is within the bounds of what we can imagine and that we are products of the same genealogy from which the Event emerged.

Haidu writes, "We freeze in horror at simultaneously recognizing in Himmler's discourse the foundations and the destruction of our own subjectivity" (294). We freeze in horror because the erasure came not from a missing referent or the fatality of language, but from the traditions of our own culture. In addition, in this ethical lapse we recognize that we are still part of this genealogy of thought, which ties us to the space of both the perpetrators and the victims. Our horror stems from recognizing in Himmler's speech that the Event is not a singular occurrence but can return, and it is in this acknowledgment of potential repetition that the sense of the uncanny arises. Like Friedlander's, Haidu's analysis focuses on questions concerning empathy and the uncanny, and then his epistemological probing shifts to a discussion of ethics. For Haidu, ethics is constituted by Levinas's figure of the face-to-face encounter with the Other, and Haidu places this face in relation to the camp victim. Although he correctly asserts that the Nazi non-compliance with Levinas's command for face-to-face responsibility is the counterpoint to and absolute inversion of his ethics, Haidu eventually misconstrues Levinas's face-to-

face as constituting an empathic relation with the Other. But empathy or any illusion of empathic identification is what Levinas wishes to avoid in his system of ethics. In addition, while Haidu first establishes how the face-to-face encounter is between oneself and the Other as victim, his own turn to empathic identification places him in relation to Himmler's voice. His utilization of Levinasian components of the face-to-face relation is indeed helpful, but his point of view remains fixed on the Nazi perspective.

Dominick LaCapra:
Empathic Unsettlement and Compulsive Repetition

Like Friedlander and Haidu, in his *Representing the Holocaust* (1994), *History and Memory after Auschwitz* (1998), and *Writing History, Writing Trauma* (2001), Dominick LaCapra revisits the site of Himmler's Posen speech through the shifting theoretical models of the sublime and the uncanny. He stresses the historian's need to "work though" historical trauma, and he maintains that "What is necessary is a discourse of trauma that itself undergoes—and indicates that one undergoes—a process of at least muted trauma insofar as one has tried to understand events and empathize with victims" (*Representing the Holocaust*, 220–21). Such a discourse enables the historian to comprehend the experience of the victims and makes them empathic to the other's suffering. Yet LaCapra also warns that such an approach could backfire, entrapping the historian in a process of acting out or repeating the disorienting effects of trauma. Each of LaCapra's studies analyzes the historian's empathic approach to the Holocaust and the hazards of probing the site of historical catastrophe. While in his first book he explores the impulse of some critics to examine the Holocaust—particularly Himmler's Posen speech—through the problematic category of the sublime, in his second book he frames the speech in relation to Freud's model of the uncanny. In his most recent study of the Holocaust, he extends his reading of Himmler's speech and the transgressive sublime to how anti-Semitism relates to "other forms of racism and victimization" (*Writing History*, 129), concluding that anti-Semitism is but another symptom of modernity's struggles to overcome difference.

Discussing the fixation on what he calls the "(an)aesthetic of the sublime," LaCapra asserts that such a fixation on this aesthetic category may unintentionally run the risk of fetishizing or compulsively repeating just one possibility of thought (*Representing the Holocaust*, 4). In his first reference to the Posen speech, he describes how language may "break down in the attempt to come to terms with limit cases. But another insistent motif

in this book is that one should not become fixated on this possibility (indeed eventuality) or restrict 'theory' to what itself may threaten to become its compulsive or melancholic 'acting-out'" (14). In his analysis of the speech he reflects on how the "Nazi sublime" becomes both potentially traumatic and a source of melancholia for those who analyze the disturbing words. But ultimately this compulsive acting out is exactly what we see unfold in LaCapra's incessant returning to the Posen speech.

This obsessive returning by the critic to Himmler's speech, in particular to the Nazi elation over the genocide, is symptomatic of the haunting effect that the speech has on historians, philosophers, and theorists. I feel compelled to draw attention to the compulsive repetition symptomatic of the uncanny, not in reference to the Nazi act of murdering the Jewish Other, but rather in reference to the historian who repeatedly tries to approach the inside perspective of the perpetrators. Although Himmler tells a story of repetition and death, it is not the repetition we find in Freud's figure of Tancred, who unintentionally kills his lover twice (*Beyond the Pleasure Principle*, 24). There is nothing unconscious, repressed, or painful for Himmler in his depiction of murder; his repetition evinces only pleasure. But for the historian who looks on, the effect is one of horror, and the historian compulsively returns ever and again to the site of extermination.

LaCapra's first mention of Himmler's Posen speech surfaces in the introduction as a parenthetical aside in relation to the Nazi sublime, and on the same page he warns the historian against the threat of fixation and acting-out in relation to the study of limit cases such as the Holocaust (14). Referring to the speech again in chapter 2, on the "Historians' Debate" (62–63), he employs an extensive footnote that includes a large segment of Himmler's description of the amassing of Jewish bodies in relation to both transgressive sublimity and the perpetrator's elation before the mass graves. LaCapra mentions the speech again parenthetically in the next chapter as an example of the Nazi sublime, and a few pages later he provides an incisive rhetorical reading of the speech (106–10). For a second time in his study, he cites the main section of the speech on the extermination of the Jews and again focuses on Himmler's elation before the graves.

LaCapra, like Friedlander, examines both Himmler's resistance to being negatively affected by the sight of the mass graves and his excitement:

> For Himmler, to have stuck out the impossible spectacle and to have kept one's integrity or decency is what makes one hard. There may be an incommensurable distance between sticking out the unspeakable, unrepresentable "scene" of mass death and keeping one's integrity, for the former would seem to refer to a negatively sublime moment that beggars the imagination and the latter to ordinary morality or normativity. (*Representing the Holocaust*, 109)

There is indeed something reminiscent of the Kantian sublime in this "spectaclelike" amassing of bodies that appears to be rising towards the infinite. According to LaCapra, Himmler's Posen speech represents the transvaluation of the traumatic into what he calls a "negative sublime" for the "fanatically committed Nazi" (14). The crimes are deemed a "secular sacred" (4) that transforms the traumatic scene beheld by the perpetrators into sublime elation. Himmler's silence bears the hallmarks of what seems to be an adequate response to the sublime, and in *History and Memory After Auschwitz* LaCapra describes how the increased number of bodies marks a "radically transgressive limit-experience for the Nazi perpetrator" (28–29).

Yet what LaCapra may call Himmler's "silent inscription" of history is actually self-willed and does not arise from the shock of seeing the bodies. Counter to any claim that this scene is "unrepresentable," Himmler's silence bespeaks not sublimity but criminality. Despite the analogy LaCapra makes between Himmler's words and the reverence one feels before Kant's categorical imperative (*Representing the Holocaust*, 109), this law of genocide can be both visualized and measured by the increasing number of Jewish dead. In contrast, Kant's act of subreption comes to an end as the subject collapses before the moral law—there is no adequate sensory experience to convey the moral law. The notion of a transgressive sublime becomes a deficient category in discussing perpetrator elation, for there is no catastrophic moment in which the imagination reaches its limit before the expanding pile of bodies in Himmler's speech. The law of extermination is not outside the bounds of the imagination, and one reads in the transcript from the Wannsee Conference from January 20, 1942, Eichmann's estimate of 11 million Jews in Europe.

Four years later in his *History and Memory after Auschwitz* (1998), LaCapra expands his critique of the negative sublime in relation to Himmler's speech and, with the help of Friedlander, turns to Freud's uncanny and the return of the repressed. For LaCapra, the uncanny is tied to the recognition of a dissonance between pre-modern and modern society, and he claims that what returns is barbarism from the past (3). He deems uncanny how a process that might seem to be a part of "pre-civilized" societies—purifying a society of impure objects through modes of sacrificialism—emerges within modern conditions that include "bureaucratization, formal rationality, and industrialized murder" (39). This appearance of elements from the pre-modern era signifies for LaCapra the return of the repressed, of "what *seemed* totally out of place and *unheimlich*" (39).

In order to arrive at the uncanny, LaCapra develops a link between Freud's sublimation and Kant's sublime: sublimation, like the sublime, involves a movement beyond the senses, and according to LaCapra, sublimation functions as a domestication of the sublime. In turn, the uncanny

elements of the National Socialists are concealed by what he regards as a Nazi sublimation that "counteracts the return of the repressed" through the act of displacement (38). The pre-modern acts of violent sacrifice are defamiliarized through the National Socialist language of purification. Hence, the violence of sacrifice has become simultaneously repressed and sublimated into a work of civilization: the Nazi goal of cleansing society transforms the pre-modern acts of sacrificing the Other into a cultural achievement. The extreme violence of the Nazis is rendered into its opposite—a secular sacred or negative sublime—and LaCapra claims this is where the once familiar but repressed now becomes *unheimlich* (38).

The dilemma for the historian, LaCapra maintains, stems from trying to understand this "disorienting linkage" of sacrificialism to the modern conditions (39), and here the focus of LaCapra's analysis shifts from the perpetrator's actions to the effect these actions have on the historian who recognizes the return of the repressed in the words of the National Socialists.[12] At the moment of his disorientation, which is induced by the movement of his own interpretation, LaCapra shifts his discussion to the historian's transferential relation to the object of study and to questions regarding the historian's subject position with regard to the trauma. His own perspective is in a state of flux as he tries to re-adjust his sense of identification from the perpetrators to the victims. Yet the historian is faced with another problem. LaCapra warns against the potential tendency to repeat in oneself the very object of study, to over-identify with the trauma and thus become affectively implicated in what is studied; the historian runs the risk of undergoing a muted trauma himself (40).

Envisioning the task of the historian as overcoming "the entire complex of relations defined by the grid: perpetrator-collaborator-victim-by-stander-resister" (42), LaCapra pulls into this grid of distinct subject positions the role of the historian as secondary witness. At the juncture where history and memory seem to encounter one another, he is wary of a potential repetition compulsion that would threaten the very construction of historical memory. In trying to understand the Final Solution, there is a risk that the historian could be affected by the trauma of the limit experi-

12 LaCapra's description of the collision between the modern and pre-modern in addition to Haidu's discussion of the key Enlightenment concepts that return in Himmler's speech can also be found in Mladen Dolar's own study of Freud's uncanny. For Dolar, the uncanny is in opposition to the rise of the Enlightenment and its modern subject, who is characterized by his/her rationality. Dolar contends, "There is a specific dimension of the uncanny that emerges with modernity ... In premodern societies the dimension of the uncanny was largely covered (and veiled) by the area of the sacred and untouchable. It was assigned to a religiously and socially sanctioned place ... With the triumph of the Enlightenment, this privileged and excluded place (the exclusion that founded society) was no more. That is to say the uncanny became unplaceable; it became uncanny in the strict sense" (7).

ence and begin to appropriate the Other's trauma. LaCapra posits the historian's need to work though the past, mourn the dead, and untangle the web of "trauma, the uncanny, the sublime" (40). For him the historian's role is to generate the lost anxiety of trauma in tolerable doses in order to circumvent repetition and filter the shock of history's traumas for the generations after the trauma. Emphasizing a working through as opposed to an acting out of traumatic events, LaCapra tries to derive an ethics from his use of psychoanalytic structures of mourning and trauma. In his historiography of the Holocaust, he searches for a therapeutic space in which the historian can engage with these haunting objects of history. He envisions the historian functioning as a *Reizschutz* that needs to resist repeating or traumatically re-enacting the past by modulating the anxiety left in the wake of historical trauma.[13]

But despite this movement of the Posen speech from seemingly more repressed textual spaces such as parentheses and footnotes, into the main body of each of his studies of the Holocaust, LaCapra's relation to the speech appears to be consistent with a repetition compulsion. As he continues to discuss the historian's search for a proper subject-position to the object of study, he moves closer to the silencing of affect, a silencing that is symptomatic of a compulsion to repeat. It is striking that in his third and most recent study of the Holocaust, *Writing History, Writing Trauma* (2001), where he revisits on several occasions Himmler and the SS remaining decent ("anständig") before the amassing pile of bodies, LaCapra seems to undermine his own emphasis on the importance of affect in historiography.

LaCapra acknowledges the necessity of translating trauma into affect and tries to present a writing of history that rearticulates affect by counteracting the "disabling dissociation" or disorienting effects of trauma (*Writing History*, 42). Despite aiming to inscribe an affective dimension into his narrative that simultaneously maintains a space of critical distance, his return to Himmler's speech demonstrates his failure to break out of trauma's repetitive loop. As if unable to sustain a gaze toward the victims, LaCapra redirects his attention to Himmler's speech at moments when he

13 Andrew Hebard provides an incisive reading of the problems with LaCapra's and Santner's use of psychoanalysis in their engagement with the Holocaust. He argues that both of them create narratives out of their use of psychoanalytic models that result in the very narrative closure they wish to avoid. Foregrounding the ethical implications of anxiety and the uncanny, Hebard focuses on the figure of the uncanny in Resnais's *Night and Fog*. But despite his use of such terms as proximity, positionality, and specular distance, the spatial and specular structures of the uncanny are underdeveloped in his analysis of its ethical implications. Instead, he foregrounds the subjects' relation to temporality (the interplay between past and present) within the film. I return to the function of specular anxiety in relation to the body in *Night and Fog* in chapter 4.

probes affect associated with the victims of Nazi brutality. The uncanny
sensation originates not from the mass graves, but from beholding
Himmler's reaction to genocide.[14] He repeatedly seeks out the intellectual
incertitude and unease that arise from the historian's confrontation with
Himmler's reaction before the site of extermination. Ironically, Himmler's
Rausch before the bodies functions as LaCapra's own *Reizschutz* against the
visceral effects of looking at the mass graves.

In *Writing Trauma, Writing History*, LaCapra discusses the need for hy-
brid modes of representing the Holocaust, which do not attempt to ap-
propriate the other's traumatic experience, but make use of "stylistic ef-
fects ... which cannot be reduced to formulas or rules of method" (41).
He describes one such effect as "empathic unsettlement," which should
"affect the model of representation in different, nonlegislated ways, but
still in a fashion that inhibits or prevents extreme objectification and har-
monizing narratives" (103). In particular, he turns to the narratives of
Holocaust survivors, who provide testimony by way of distortion, dis-
guise, and breaking the "all compelling frame" of Auschwitz (88–89). Al-
though his model of empathic unsettlement appears to fashion itself after
such narrative strategies, LaCapra's continued study of the Holocaust os-
tensibly counteracts affectivity with his compulsive return to the image of
Himmler's elation.

In his thoughtful analysis of the Yale Fortunoff video collection, La-
Capra disrupts his study of survivor testimony by shifting to Himmler's
description of the mound of corpses in order to once again discuss the
problems of representing the limit experience as a transgressive sublime.[15]
In his investigation of "unrepresentable excess" of the limit event, La-
Capra juxtaposes a survivor who was able to imagine the unimaginable
within Auschwitz (the destruction of a chimney by the Jewish resistance in
the camp) alongside a perpetrator for whom the Judeocide was a law that
needed to be fulfilled. By juxtaposing these two examples, he dismisses his
own warning against blurring unique subject positions (victims, perpetra-
tors, bystanders, and historians) and perspectives in relation to traumatic
history. Strikingly like his previous studies of the speech, he here contin-

14 For instance, in his chapter on Goldhagen's *Hitler's Willing Executioners*, LaCapra invokes
Himmler's words as if to restrain the excessive affect he detects in Goldhagen's study of
ordinary soldiers' extreme brutality toward their Jewish victims. Moving away from Gold-
hagen's visceral accounts of bone splinters, blood and brain left in the aftermath of mass
shootings, LaCapra shifts to the fanaticism of the leadership captured by Himmler's elation
(*Writing History*, 114–40).

15 LaCapra returns a third time to Himmler's speech and the question of the negative sublime
in chapter 5, which is based on an interview with LaCapra at Yad Vashem. He remarks that
although one must not be "fixated" on the negative sublime of Nazi ideology, the concept
should be introduced into one's probing of the Holocaust because it is "probably the most
difficult thing to understand" (*Writing History*, 168).

ues to displace the victims in his reading of Posen, averts his eyes before
the mass graves, and looks instead toward Himmler's reaction. Although
he warns against the complications of over-identification, his concept of
empathy still searches for degrees of identification not with those who
were traumatized by the event, but with the perpetrators who initiated the
trauma. LaCapra's well-intentioned model of working through trauma dis-
solves into a discourse that compulsively repeats the historian's anxiety
over the intellectual incertitude stemming from his confrontation with
Himmler's elation before the mass graves. "The most difficult thing to
understand" (168), Himmler's elation, functions as an epistemological
limit that produces an uncanny effect, and it is this effect to which the his-
torian compulsively returns that indicates the inability to integrate affect
into memory.

In his probing of Friedlander's historiography, LaCapra describes how
the role of the historian's account "repeats (with a difference?) the anxi-
ety-producing rupture and excess active in the object of study but resists
or recoils at elation or the Rausch" (*History and Memory after Auschwitz*, 34).
How can this formulation be applied to LaCapra himself? While there is
indeed difference (along with much repetition) in his probing of
Himmler's Posen speech with regard to the sublime and the uncanny,
there also seems to be an acting-out unfolding throughout his analysis.
The traumatic scene depicted in Himmler's words infects the historian's
mode of understanding. Although he tries to find the proper balance in
terms of affect, distance, and perspective to the content of Himmler's
speech, he ultimately slips into a compulsive, and ostensibly melancholic,
acting-out that he himself has warned against.

Crossing from the Sublime into Trauma:
The Holocaustal Uncanny

How does our intellectual probing of Posen's moral abyss, the absolute
horror left in the wake of Himmler's missing shudder, transform into a
post-Holocaust ethics in relation to the remnants left behind by the ex-
termination? There is nothing sublime or uncanny about the content of
Himmler's speech; what is uncanny is *our* relation to it. The place where
the compulsion to repeat reveals itself has less to do with Himmler's
words than with the theorists themselves, who return to and repeat their
references to the sublime in a space that is itself missing key components
of Kant's sublime. Instead, Himmler's text illustrates how the mode of
Kantian ethics dissolves into his depiction of fanaticism as evident in
Himmler's elation. Moreover, it is his fanaticism that provokes a sensation

of the uncanny in the outside observer. Like the aesthetics of the sublime, which was ultimately linked by Kant to his ethics, my reading of the uncanny, which for Freud was based on aesthetics, opens up for me insights into an ethics based on the interplay between the specular and positionality. Furthermore, the distortion of the subject's perspective and position before scenes in which the sensation of the sublime are evoked in the imagination functions for me as the juncture between the sublime and the uncanny, where a blurring unfolds at the line of demarcation between a series of binary relations.

While Haidu and LaCapra may show how the uncanny attributes of Himmler's speech reside in temporal components related to the return of the repressed, they tend to bypass the spatial and visual elements associated with the uncanny. Not only is the figure of the uncanny "unplaceable," as Mladen Dolar claims in his explication of where it can be situated historically (22), the effect of the uncanny, in addition to the interplay between past and present, is itself tied to the very blurring of boundaries between interior/exterior, self/other, and subject/object. The uncanny is spatial at its core and, in terms of the Holocaust, it is linked both to questions of positionality between the spectator and the event and to the problems arising in subject identification before scenes of trauma. The uncanny "is not simply a topic, much less a 'concept,' but rather a very particular kind of scene: one which would call into question the separation of subject and object generally held to be indispensable to scientific and scholarly inquiry, experimentation and cognition" (Masschelein, 395). We behold such a disappearance of separation between scholarly inquiry and text in the historians' reception of Himmler's speech. The position of subject and scene (text) gives rise to an intellectual uncertainty within the historian, who is unsettled because of a blurring of positions.

In his penetrating analysis of the uncanny, Samuel Weber demonstrates how it is "inseparable from questions of perspective, of positioning, and hence from a relation of spectator to scene and of scenario to spectator. What is at stake in the uncanny is nothing more nor less than the disposition to 'put ourselves in the place of the other'" (31). As he declares, the uncanny is neither simply subjective feeling nor objective event, but arises from the blurring of these distinct boundaries and perspectives (16). Such a blurring is central to the confounding relation detected in the historians' affective disposition to Himmler's text. Although Himmler functions for them as a prosthetic lens to look at the mass graves, their attempts to understand the event through the Nazi perspective disintegrates into intellectual uncertainty. For the historian who probes Himmler's speech, specular terror stems from what they do not see: the perpetrator's shudder before the bodies. In addition to a blurring of distinct spaces that

contributes to intellectual uncertainty, ocular anxiety, which emerges from the breakdown of sight, is also central to the effect of the uncanny. What is missing from Posen is not a representation of this scene, but an anticipated affective horror upon the faces of those who saw the site of mass killings first-hand.

Kant describes how during the sensation of the sublime there is a cancellation of time, and this temporal rupture is also a constitutive element of trauma. Moving away from those discussions of the sublime and of trauma that focus on the lost moment of these two distinct missed experiences, I wish to concentrate on the spatial and specular components that are central to both trauma theory and the uncanny and return to one of the principal works on trauma studies, Cathy Caruth's *Unclaimed Experience: Trauma, Narrative, and History*. Emphasizing the temporal aspects of trauma, which she gleans from her reading of Freud's *Beyond the Pleasure Principle*, Caruth is indeed aware of the spatial components that arise in Freud's analysis of trauma and she discusses the relevance of borders and boundaries with regard to trauma's interaction with psychic structures within the consciousness.

Caruth, however, eventually downplays the importance of space and topography in her reading of traumatic scenes in order to focus on what she calls the "temporal definition" of trauma—that is, the traumatic experience is constituted by its "temporal unlocatability" and "the temporal dilemma of repetition" (133). In her analysis of Resnais's *Hiroshima mon amour*, where she describes how "the missing of the 'when' within the shock of sight is also experienced as a confusion of the body" (39), Caruth correctly delineates the interplay among some of the core elements of trauma: temporality, ocular disruption, and affective response of the body. In her reading of Freud's *Beyond the Pleasure Principle*, Caruth describes trauma as a "break in the mind's experience of time" in which the threat from outside is recognized *"one moment too late"* (61–2). Because "[t]he *missing* of this experience" is not "experienced *in time*," the traumatized subject tries to recuperate this lost experience belatedly. In turn, it is this missed experience that triggers the repetition compulsion, as the traumatized subject tries to re-inscribe the violent event into the space of memory by repeating this confrontation with the lost moment.

Yet Caruth sidesteps what preceded this temporal interruption. The subject's perceptual barrier (*Reizschutz*) needed to process and filter the shock of the experience was broken, and this breach resulted in the unmediated passage of the experience into the unconscious. Caruth's evasion of this spatial disruption is most evident in her reading of Freud's own flight from Vienna after the Nazi *Anschluss*, which he re-tells in his *Moses and Monotheism*. Foregrounding the structure of temporal deferral, she

concentrates on "the belatedness of the Jews' historical experience" (17). Similarly, in her interpretation of Freud's reaction to the Nazi invasion of his homeland, she argues that Freud's trauma stems from the departure, or deferred flight, from his home in Vienna. Even though Freud himself wrote, "Then in March 1938 came the *unexpected* German invasion. It forced me to leave my home ..." (19–20, my emphasis), Caruth mitigates the traumatic impact that the rupture of Austria's borders by the German military had on Freud. Despite her eloquent depiction of trauma as the moment when "the outside has gone inside without any mediation" (59), it is this very *"unexpected"* rupture for Freud of real historical boundaries that Caruth circumvents in favor of her concentration on the structural traumas inherent in his narrative of departure.[16]

In his model of trauma from *Beyond the Pleasure Principle*, Freud describes how the rupture of the barrier against stimuli (*Reizschutz*) results in an excess of affect that cannot be contained by consciousness. The boundary between inside and outside is shattered as Freud's system of perception-consciousness breaks down; the traumatic event that induces the shock slips past the eyes and lodges in the unconscious as a lost experience. In addition, the breaching of the protective barrier against too much stimuli is accompanied by the failure of the subject's readiness to feel anxiety (*Angstbereitschaft*): there is no time to prepare for the shock. With the disruption of perception-consciousness, unbound anxiety permeates the unconscious. In turn, the omission of anxiety from consciousness marks the very absence of the experience as a remembered event (20–24).

Instead of being incorporated into memory, the traumatic event is transformed into what Freud calls an *"Erinnerungsspur,"* or memory trace, a mark that indicates what is missing from memory. This trace, lodged behind the eyes in the space of the unconscious, manifests itself in recurring dreams and the compulsion to repeat—symptoms that Freud reads as attempts by the traumatized subject to recuperate belatedly the lost affect of anxiety. Once the specular distance that was lost during the rupture of the

16 On her notion of temporal unlocatability, see Caruth, 133–34. For an excellent reading of her evasion of historical trauma and her foregrounding of structural traumas, see Ruth Leys, *Trauma: A Genealogy*, 266–97. As we will also read in Levinas's system of ethics, the very breakdown of temporality that is so central to trauma also governs the moment of our encounter with the Other's face. Levinas employs such phrases as "a disturbance of rememberable time" (*Otherwise than Being*, 89) and "dead time" (102) and remarks that our turning away from the face "does not enter into the common time of clocks," but is marked by the break-up of time (89). Similar to the breakdown of representation and consciousness during a traumatic occurrence, our encounter with the Other's face escapes representation. However, in addition to this temporal rupture, Levinas's encounter with the face is centered on the spatial concept of proximity: the relationship with the Other that is devoid of images and is beyond the visible.

Reizschutz returns, the traumatic event, which is an unprocessed memory trace, is made visible. But as Freud tells us, what we are trying to re-capture is neither lost time nor a lost image; instead, we are in search of the lost affect of anxiety that is absent because of the rupture of the subject's *Reizschutz*.

Why would those aesthetic works that engage with the Holocaust in this current study employ an act that is reminiscent of Kant's technique of negative representation? Trauma, like the sublime, entails a visual rupture: something is left unseen. What remains invisible, a negative representation, marks the failure of perception that accompanied the initial rupture of the protective shield. As Freud remarked in *Inhibitions, Symptoms and Anxiety*, "Thus, the first determinant of anxiety, which the ego itself introduces, is loss of perception of the object (which is equated with loss of the object itself)" (106). The works that evoke the Holocaustal uncanny configure a traumatic space that jeopardizes the perception of the spectator. We encounter in these projects acts of structural erasures that depict scenes of historical ones. Like the limits of the senses that define the sublime, Freud's description of a traumatic moment is also accompanied by the disruption of sense. The traumatic shock from outside breaks through the protective shield that not only filters the shock but also allows us to experience anxiety. But the aesthetic strategies of those figures who implement the Holocaustal uncanny consequently follow an anti-therapeutic model; each constructs traumatic scenes that the spectator can neither overcome nor master. Instead, the spectator is forced to gaze at these scenes as she reflects on the significance of the texts' aporetic structures. By withholding a representation, the reader/spectator is provoked into remembering images, that is, re-imagining the destruction on her own.

Freud's concept of the uncanny, in other words, serves as a metaphoric inscription of trauma. Like his depiction of trauma, the traits of the uncanny are broken boundaries, the failure of memory, repetition compulsion, and a "morbid anxiety" that he links to a violence enacted on the eyes ("The Uncanny," 47). The move from trauma to the uncanny is bound by the dissolution of sight. Freud's narrative of the uncanny, built around Hoffmann's "Der Sandmann," centers on the loss of vision. Hoffmann's tale overflows with images of blindness. While the mother informs her child that the Sandman's arrival signifies that he is sleepy, as if one had thrown sand into his eyes ("als hätte man euch Sand hineingestreuet"), the old lady who cares for the child tells him that the Sandman collects the eyes of children who do not go to bed and feeds them to his own children (332). Whereas this ocular anxiety is for Freud a symbol of castration anxiety, the assault on the spectator's vision in the Holocaustal uncanny signifies the artist's attempts first to reproduce the struc-

ture of trauma in order to provoke fear in the spectator by leading her/his gaze into a void left behind by the Holocaust. The breakdown of vision, which itself becomes the representation of an epistemic fracture in the artwork, is the mark of the scene of trauma. Second, through this disruption of sight, the spectator is solicited to provide her own images and to access her cultural mnemic archive connected to Holocaust memory. Ultimately, this void, whether in poetry or visual culture, disrupts any illusion of a vicarious experience of facing the Holocaust.

Now that I have arrived at this understanding of the spatial implications of trauma, I can discuss the uncanniness of Holocaust art. For the sake of clarity, I would like to repeat here some key distinctions between Freud's concept of the uncanny and the Holocaustal uncanny. First, Freud's uncanny is organized around the spatial configurations of blurred boundaries and dissolving frames. Dolar describes the uncanny as arising when the line of demarcation between such constructions as subject/object, essence/appearance, or interior/exterior are blurred and "the most intimate interiority coincides with the exterior and becomes threatening, provoking horror and anxiety" (6). When something shatters a well-known division, the uncanny rises to the surface. The modes of estrangement and terror associated with the uncanny are produced when this line fades.

How then is the Holocaust uncanny? Whereas for Freud it is the uncanny figure of the phantom who crosses the line between the living and the dead to approach the individual, and we read this in Hoffmann's tale as the mother tells her child, "Der Sandmann *kommt*" (332, my emphasis), this direction is reversed in the Holocaustal uncanny; here, the artists lure the spectator into the space of the dead. In Freud's *Uncanny* literal ghosts are not uncanny, but rather the sensation of the uncanny arises when the border between fiction and reality is crossed and the specter moves from one realm into the other.[17] Friedlander argues that while those artworks confronting the Holocaust are probing for unexpected vantage points to examine the event, the trauma's opaqueness cannot be dispelled (*Memory*, 134). The artist builds the trauma into language, film, painting, or architecture, and in addition to the construction of these new vantage points, the spectator too is taken into the structural voids. In representing the Holo-

17 Freud writes, "The souls in Dante's *Inferno*, or the ghostly apparitions in *Hamlet*, *Macbeth*, or *Julius Caesar*, may be gloomy and terrible enough, but they are no more really uncanny than is Homer's jovial world of ghosts. We order our judgment to the imaginary reality imposed on us by the writer, and regard souls, spirits and specters as though their existence had the same validity in their world as our own has in the external world. And then in this case too we are spared all trace of the uncanny. As soon as the writer pretends to move in the world of common reality he takes advantage, as it were, of our supposedly surmounted superstitiousness; he deceives us into thinking that he is giving us the sober truth, and then after all oversteps the bounds of possibility" ("The Uncanny," 57).

caustal uncanny, the line or frame of the artwork splits open and our gaze is consumed by something abysmal. Breaking the division between interior and exterior, the artists of the Holocaustal uncanny reframe the conventions of the media by doing violence to the frame. The world of fiction does not cross over this line into our world, nor does the specter step across the frame; at the disruption of representation in Holocaust aesthetics, it is the spectator who is led across the rupture in the artwork's frame, into the site of the dead.

Any discussion of the uncanny must confront the question of repression. Since the uncanny is a form of anxiety, and anxiety itself is produced through an act of repression, Freud's uncanny involves as well the return of the repressed. In addition, Freud makes a connection between repression and language. What remains repressed in the unconscious is exactly a non-verbalized representation of something lost, whether it be an object or the affect of a traumatic event. In his essay "Repression," Freud remarks, "Repression denies ["versagt"] mental representations to consciousness" (148), and he adds in a letter to Fliess that repression is "the denial of translation" ("die Versagung der Übersetzung") (*Origins of Psychoanalysis*, 175). As Weber discusses in *The Legend of Freud*, "Versagung" can be translated as an interdiction: the unconscious constructs an interdiction against the representation of an unpleasant memory or affect, leaving it devoid of translation.[18] There is no word that corresponds with the loss, which remains untranslated in the space of the unconscious.

However, by introducing the notion of a Holocaustal uncanny I am not arguing that the past has been forgotten; nor do I contend that the mechanism of repression is at work in the projects I explore. As opposed to Freud's notion of a return of the repressed, it is not repressive modes of the unconscious that deny the translation of an anxiety-provoking event. Rather, it is the artist who denies the spectator's eye an expected sight upon a canvas, the walls of the void, or a word in a poem. Through the act of negative representation, an act that imposes negative perception on the spectator, the artist/writer assaults the spectator's desires to see something. At the site of a trauma, the catastrophe is left blank not in order to shield us from something horrible, but to force us to remember the historical void left behind by the Nazi genocide. The voyeuristic gaze of the spectator is broken and s/he must re-visualize the lost moment of trauma. The voids of poetry, film, painting, and architecture thus compel

18 See also Weber's chapter "Metapsychology Set Apart," esp. 85–98, where he provides an excellent reading of the uncanny in relation to the evolution of Freud's concept of anxiety.

the spectator to reflect on what is missing and to fill in the lack of representation with a memory. The denial of representation functions neither as screen nor *Reizschutz*, but rather it is itself the gap through which the spectator unknowingly crosses into the space of shock and anxiety. In turn, the spectator is required to make the translation of the space into thought.

Julia Kristeva is correct to read in Freud's analysis of the uncanny his own struggles as an outsider or uncanny Other within a society marked by anti-Semitism. She writes, "Freud's personal life, a Jew wandering from Galicia to Vienna and London, with stopovers in Paris, Rome, and New York (to mention only a few of the key stages of his encounters with political and cultural foreignness), conditions his concern to face the other's discontent as ill-ease in the continuous presence of the 'other scene' within us" (181). At the core of Freud's understanding of the uncanny is the question regarding perspective and positionality in relation to the Other and the affect that arises in the subject when facing this "other scene." As Freud states at the beginning of "The Uncanny," he will translate (*hineinversetzen*) himself into the uncanny feeling (20), or more correctly rendered, he will put himself in another's place and try to empathize with the Other. Freud's concept of the uncanny is ethical at its core as each person must try to put him/herself into the Other's place. However, the uncanny is not about identifying with the Other, of either a feeling of *Einfühlung* or *Mitleid* with the stranger; instead, what is revealed by the concept of the uncanny is the very impossibility of sustaining such an empathic identification with the Other. It is at this point that I can return to Celan via Levinas.

The Uncanny Ethics of Levinas and Celan

Toward the conclusion of *Otherwise than Being,* a study that lays out a theory of the face-to-face ethical relationship, Levinas asserts: "What took place humanly has never been able to remain closed up in its site … There is no need to refer to an event in which the non-site, becoming site, would have exceptionally entered into the spaces of history" (184). He re-enforces the distinction between an event that takes place in history and the face-to-face encounter of the ethical moment, which he describes as occurring at a non-site and outside of time. Yet in his essay "Nameless" he illustrates such an event, where the non-site indeed remained u-topic and exceptionally entered history. Levinas writes of the Holocaust:

Over a quarter of a century ago, our lives were interrupted, and doubtless history itself ... when one has that tumor in the memory, nothing has been able to fill, or even cover over, the gaping pit. We still turn back to it from our daily occupations almost as frequently. The vertigo that grips us at the edge is always the same. Should we insist on bringing into this vertigo a portion of humanity whose memory is not sick from it own memories? (*Proper Names*, 120)

This site of ruptured history is an afflicted memory identified by a compulsive backward glance toward the grave by the survivor, a look that is accompanied by the provocation of spatial anxiety: vertigo. Questioning whether those born after the Holocaust should be ordered to approach the grave and be exposed to its vertigo, Levinas asks, "Will they be able to understand that feeling of chaos and emptiness?" (120). Epistemic questions shift to a concern with affect.

A structural parallel arises between the vertigo induced through this approach to the extermination site and Levinas's description of the ethical moment when a "shudder" is produced in the subject who is confronted with the Other's alterity. The subject is held in relation to this face by what Levinas calls "proximity," also a "null-site," which is defined by a sense of restlessness in which the subject comes "closer and closer" to the face without ever arriving. A correspondence unfolds between the non-site of ethics and the Holocaust. Levinas describes the face-to-face encounter with the Other not as a knowing, but as "a shuddering different from cognition" induced by perceptual violence and contributing to a breakdown of "serenity of consciousness" (*Otherwise than Being*, 87). The ethical imperative that orders the subject to approach the Other is not part of the faculties of cognition, representation, or imagination; rather, the encounter with the Other's face is indicative of a shock that "makes an impact, traumatically, in a past that cannot be reassembled by memory, historiography" (88). Despite the non-representational status of the face, which is itself linked to the imagination's failure, there is still an imperative to imagine the Other's face and approach what cannot be seen. The shudder arises from a double bind: the imperative to imagine the unimaginable (incorporating the Other into consciousness) "jostles the presence of mind" (88).

The encounter with the Other's face takes on the description of a trauma as observed in Levinas's employment of such terms as shudder, jostle, blow, and strike. A perceptual rupture occurs, whereby the shudder replaces perception of the face—the ethical moment for Levinas. During the onset of an approach to alterity, "I am ordered from the outside, traumatically commanded, without forming a concept or representation of the authority that commands me" (87). At this ethical moment, Levinas remarks that there is an absence of the transcendental imagination: the subject is affected by alterity without forming an image of this Otherness.

What is left behind in the subject is a trace that is "unconvertible into a memory" (105). Toward an ethical relation with the Other, the affect of anxiety functions as the placeholder to the disruption of the imagination, representation, memory, and perception. In the following passage, Levinas depicts how the moment of the ethical, which does not announce itself, arises: "The consciousness is affected, then, before forming an image of what is coming to it, affected in spite of itself. In these traits we recognize a persecution ... It is as though persecution by another were at the bottom of solidarity with another. How can such a passion take place and have its time in consciousness?" (102). One cannot help but hear the echoes between Levinas's ethical moment and Freud's concept of the disruption of the *Angstbereitschaft* during trauma. During the surfeit of anxiety, constitutive of Levinas's ethics and Freud's concept of repression, representations for either the ethical or traumatic moment are lacking. But in contradistinction to Freud, where the traumatic moment is emptied of affect due to the failure of the *Reizschutz*, affect arises in Levinas's ethics at the site where memory is lacking and a trace is present.

It is necessary for this study on post-Holocaust modes of representation to analyze how Levinas connects his ethical framework—one that consists of the interruption of the subject's phenomenal relation to the Other's face, the disruption of vision, and the rejection of images—to the subversion of the spectator's position to the modern artwork. In turn, Levinas detects a correspondence between contemporary poetry and visual culture, a resemblance that leads him to Celan's poetics. While Levinas claims that "ethics is an optics," the post-Holocaust ethical gaze for him is analogous to the mode of seeing that constitutes the spectator's gaze before the works of Cubism (*Difficile Liberté*, 33). In *Existence and Existents* (1947), one of his earliest investigations of the concept of alterity and the beginning of his subsequent studies on alterity, Levinas explores a notion of subjectivity that is not predicated upon a phenomenological recourse to the senses. His analysis of alterity begins with a gaze associated with how one looks at a cubistic painting. Rejecting the synthesis of phenomenon, Cubism's gaze denotes the impossibility of totalizing the Other. It is the art form most reflective of this manner of looking that maintains both proximity and alterity. The gaze associated with Cubism is not reducible to the categories of cognition. Rather than try to mimic the object, the cubist artwork tried to develop a new mode of representation in which the spectator becomes responsible for assimilating and reconstructing what was not shown in the work.

Before turning to the function of modern artworks, Levinas remarks that in classical forms of art, art extracts the object from the perspective of the world and provides an image of an object in place of that very ob-

ject: "A situation depicted or an event recounted must first of all repro-
duce the real situation or event" (*Existence*, 52). But he maintains that
modern art's function is to present reality "after the world has come to an
end" (52). His discussion of Cubism is a reflection of how the world ap-
pears in the aftermath of two world wars. Written in 1947, two years after
he was released from a German POW camp and the world became aware
of the horrors of the death camps, Levinas's analysis of art after this world
has come to an end focuses specifically on Cubism as a "protest against
realism" which comes "from this feeling of the end of the world and of
the destruction of representation which it makes possible" (56). He goes
on to portray modern painting as a "struggle with sight," because seeing
requires the ability to integrate and place into relation the elements of per-
ception so that the object comes into appearance. But in the world of
contemporary painting, "fissures appear" (56). Modern art is about neither
beauty nor the visible; instead, Levinas describes it as a "deformation," a
"breakup of continuity."

Then Levinas draws a connection between modern painting and po-
etry:

> Sight seeks to draw out of the light beings integrated into a whole. To look is to
> be able to describe curves, to sketch wholes in which elements can be integrated,
> horizons in which the particular comes to appear by abdicating particularity. In
> contemporary painting things no longer count as elements in a universal order ...
> [For instance, in Cubism] things break away and are cast toward us like chunks
> that have weight in themselves, blocks, cubes, planes, triangles, without transi-
> tions between them ... There is a rationality of these forms when taken in them-
> selves, a painting makes them exist in themselves, brings about an absolute exis-
> tence in the very fact that there is something which is not in its turn an object or
> a name, which is unnameable and can only appear in poetry. (*Existence*, 55–57)

The artworks of Cubism cannot be described as mimetic, for they do not
intend to correspond with objects in the world. The work is no longer
visible the way the world is, and the spectator has difficulties integrating
what is shown in Cubism into an object or image. So what qualities does
Levinas think Cubism shares with poetry, or more specifically, how is
Cubism becoming discursive? Like modern poetry, Cubism is not con-
cerned with images, but with materiality. The Cubists utilized residue of
the natural world to signify reality. They did not strive for an accurate re-
construction of the natural world, but presented it through fragments.
Levinas dismisses the visualization of the image and focuses instead on
the very materiality of the artwork itself. As in Cubism, the materiality of
language has less to do with the words than with the spaces, letters, sylla-
bles, and sounds of the text. The chunks of forms—blocks, cubes, planes,

triangles—in Cubism come towards us in poetry as the materiality of language: the sounds of shattered or fractured words.[19]

It should come as no surprise that Levinas turns to Paul Celan and his "pre-syntactic" language as the template for his ethics of alterity.[20] Levinas's questions concerning ethical proximity, the rejection of the image, the interplay between visual art and poetry, and the disruptive optics of Cubism are integral components of Celan's poetics. Celan's poetry, like Levinas's ethics, does not foreground the image ("Bild"), representation ("Vorstellung"), or mimesis, but rather proximity and perception and Levinas describes his poetry as "a language of proximity" (*Proper Names*, 41). In the central chapter of *Otherwise than Being*, "Substitution," Levinas begins with the epigraph from Celan's poem "Praise of Distance" ("Lob der Ferne"): "I am you, when I am I" ("Ich bin du, wenn ich ich bin"; 99). The chapter subtly becomes an exegesis of Celan's poem, which repeats four times the line, "In the springs of your eyes" ("Im Quelle deiner Augen"; *Gesammelte Werke* 1:133).

Despite the poem's title, "In Praise of Distance," the repetition of "In the springs of your eyes" reinforces both the notion of proximity and the act of looking at the Other's face. Levinas refers to this encounter with alterity as an identity "gnawing away at itself—*in a remorse*" (*Otherwise than Being*, 114). In turn, this remorse arises when the subject acknowledges that her responsibility for the Other cannot be fulfilled. In this vertiginous relation to the Other, consisting of a restlessness or "absolute insomnia" (*Nine Talmudic Readings*, 193), there is always one degree of responsibility more that opens up between the subject and alterity: I am never you. The moment when phenomenology of the face breaks down along with memory signifies the point where ethical comportment to the Other arises. Thus, Levinas's ethics consists of a double bind; the command to imagine oneself in the Other's place is linked to the fact of the imagination's failure and recognition of the very inability to fulfill this command. Consequently, our ethical obligation in Holocaust aesthetics consists in the artists' command to the spectator to imagine him/herself in place of the Other, who has been reduced to ash. In the act of imagining, or substitut-

19 Levinas's description of modern art bears a striking resemblance to Celan's depiction of poetry in his "Meridian Speech": "It is true, the poem, the poem today, shows—and this has only indirectly to do with the difficulties of vocabulary, the faster flow of syntax or a more awakened sense of ellipsis, none of which we should underrate—the poem clearly shows a strong tendency towards silence" (*Collected Prose*, 48).

20 While Gerald Bruns examines this relation between art and poetry in Levinas and situates Levinas's interest in poetry next to the works of Mallarmé, he fails to address the role of Celan in Levinas's writings. This absence is even more striking because Bruns does highlight the interplay between poetry and proximity, a relation pivotal in Levinas's essay on Celan.

ing oneself in the Other's place, the imagination falters as the subject realizes the impossibility of such an act.

In his essay on Celan's poetics, "Paul Celan: From Being to the Other," Levinas raises this very question regarding the function of the imagination. He inserts into a footnote the parallels he detects between Kant and Freud in relation to perception, schematization, and the imagination—the very elements Kant requires in order to form an understanding of an experience (*Proper Names*, 175). For Kant, understanding operates through the interplay among the senses, images, and temporality, whereby the imagination plays the vital role of mediating the relation between the senses and images (*Bilder*). An experience is structured from concepts, which are themselves formed out of images. The function of the imagination is to bring the manifold parts of an experience together. In his compact footnote to this section, Levinas moves through Kant, Hegel, Husserl, and Heidegger to De Waelhen's book on psychosis (*La Psychose*) and Freud's thoughts on the "phenomenological sensible" in relation to sexual difference (175). Sketching out a series of polemics that traverse Kant's distinction between the phenomenal and noumenal realms, and Hegel's dialectic between subject and object, to Freud's depiction of male/female sexual difference, Levinas detects parallels between the pivotal role of the faculties of perception in both the trajectories of continental philosophy and psychoanalysis. In his analysis of the poetic model presented by Celan in his "Meridian Speech," the corresponding structural gap manifests itself in the relation between the experience that the poem attempts to construct and the recipient of the poem.

In a section that analyzes the attempt to think transcendence in Celan's poetry, Levinas again turns to Kant and his notion of schematization, which Levinas describes as a "descent into sensibility" (175). Schematization refers to the process in Kant where the imagination synthesizes the manifold parts of an experience through the forming of concepts. Through this union between the imagination and understanding, a phenomenon becomes knowable. A concept can only be applied with the assistance of its schema, which, Kant tells us, is a "representation of a universal procedure of imagination in providing an image for a concept" (*Critique of Pure Reason*, 182). For Kant the imagination is bound to image-production and delineates the form of an experience. But in his probing of the ethical composition of Celan's lyric, Levinas is interested in what happens to this schematization in relation to the movement from "the place to the non-place" of poetry (42). Again, Levinas alludes to Celan's "Meridian Speech," where the poet maps out his search for the u-topos, or missing place, of poetry. It is along this path toward the absence of place, Levinas asserts, that the reader is to think transcendence in Celan's

poem. However, transcendence does not refer to a movement upward for Celan, but rather movement toward an abyss (*Gesammelte Werke*, 3:195). In Levinas's reading of Celan's poetics, transcendence entails the disruption of the senses, of schematization, and thus of the construction of images.

Levinas declares that the function of the poem is "*not in order to see ideas*, but in order to prohibit evasion; the first meaning of that insomnia that is conscience—rectitude of responsibility before any appearance of forms, images, or things" (*Proper Names*, 43; my emphasis). By underscoring Celan's own mistrust of the image that he formulates throughout the "Meridian Speech," Levinas gestures toward another central polemic established by Celan in the same place: the relation between *Kunst* (art) and *Dichtung* (poetry). In contradistinction to art's association with a definite place, the visible, mimesis, and the construction of images, poetry is marked by the loss of place, the disruption of the senses, and the dissolution of both mimesis and the image. In the following lines Levinas discloses the root of his attraction to Celan's poetics. He detects in Celan's poetry the rudiments of an ethics based on a responsibility for the Other, one that ultimately revolves around a disposition of the uncanny: "But the poem thus leaves the real its alterity, which pure imagination tears away from it; the poem [quoting Celan] 'lets otherness's ownmost also speak: the time of the other'" (44). While poetry preserves alterity, the pure imagination, which is a reference to art, cancels out this Otherness. The moment of poetry is characterized by the very disruption of the imagination and of sense; poetry is a "language of proximity" (41) that is both pre-syntactical and pre-logical.

Levinas's interest in the function of place in Celan's poetry takes him to the terrain of the uncanny. His own *Toposforschung* of Celan's poetics uncovers an ethics based on the non-site or u-topos of the poem where the imagination breaks down.[21] In a passage evocative of the uncanny, Levinas writes,

21 In a footnote to *Otherwise than Being* that reflects on the ethical subject's relation to the trace of the Other, Levinas again compares Kant and Freud. He writes, "It is not here a question of descending towards the unconscious ... The unconscious remains a play of consciousness, and psychoanalysis means to ensure its outcome, against the troubles that come to it from repressed desires, in the name of the very rules of this game ... The play of consciousness is a game par excellence, 'transcendental imagination,' but as such source of phantasms" (194). By juxtaposing Freud's structures of the unconscious to Kant's concept of the imagination, Levinas wishes to show how his notion of the trace cannot be assimilated by the faculty of the imagination. The trace of the Other is neither an aesthetic nor a psychoanalytic marking, but for Levinas this trace indicates the subject's ethical responsibility for the Other. While psychoanalysis is concerned with alleviating the symptoms of anxiety and transforming the trace into an image, Levinas's ethics is determined by a continual state of haunting.

This unusual outside is not another landscape. Beyond the mere strangeness of art and the openness of beings on Being, the poem takes yet another step: strangeness is the stranger, the neighbor. Nothing is more strange or foreign than the other man, and it is in the light of utopia that man shows himself. Outside of all enrootedness and all dwelling: statelessness as authenticity! (*Proper Names*, 44)[22]

During this movement toward the Other, whom Levinas also calls an "apparition" (*Otherwise than Being*, 87), he writes that the I "discovers a place in which the person, in grasping himself as a stranger to himself, emerges" (*Proper Names*, 43). He locates in Celan's poetry the configuration of such an uncanny movement, where the poem ventures toward an "unusual outside [that] is not another landscape" but a radically other place of the foreign (44). The political and historical undertones in Levinas's description of the Other's location, which he refers to as "statelessness as authenticity," is compounded by "the time of the other." This time is also specifically historical in nature, for it is the time of "Israel's Passion under Hitler" (45). In "The Meridian" Celan provides the date at the root of his poem: the 20th of January—that is, the day of the Wannsee Conference (*Gesammelte Werke* 3:196).

Levinas presents here a description not just of the poet's journey, but also of his own movement in the shadow of National Socialism. The trajectory of both philosopher and poet, of two Jewish thinkers living in the aftermath of catastrophic loss, does not trace the departure from and return to the self; instead, during this encounter with the Other that transpires within the non-place, "It is as if in going toward the Other I met myself and implanted myself in a land, henceforth native, and I were stripped of all the weight of my identity" (44). Describing this movement as "essentially Jewish" (44), Levinas recognizes in Celan his own historical arc consisting of imprisonment, the extermination of his family, exile, and the search for a possible encounter with the Other amidst the destruction of home. Despite the philosopher's description of his own implicit and personal identification with the poet, the possible encounter that unfolds in Celan's poetics—and in Levinas's ethics—does not consist of an empathic identification with the Other; rather, the poet underscores its very impossibility. In this "essentially Jewish" movement toward alterity, what Celan refers to as "*Verjuden*" in his draft of the "Meridian Speech," Levinas hears a "modality of the *otherwise than being*" (*Proper Names*, 46).[23]

22 In his analysis of place and non-place in Celan's poetics, Levinas is also setting up his opposition to Heidegger's notion of place in poetry. Parenthetically referring to Celan's poem "Engführung," he notes the rupture between Celan and Heidegger, and calls it "a break with the naivety of the Herald, the Messenger of the Shepherd of Being" (*Proper Names*, 45).

23 For Celan, *Verjuden* (to become Jewish) specifically refers to how one faces the Jewish Other who was effaced during the Holocaust. In chapter 3, on Celan and Heidegger, I elaborate on

Corresponding to Levinas's assertion that "Substitution is not the psychological event of compassion or intropathy in general, but makes possible the paradoxical psychological possibilities of putting oneself in the place of the other" (*Otherwise than Being*, 146), Celan's strategies of substitution focus on the fissuring of any illusion of unity. While empathic identification implies an imagined solidarity with the victim, described by Levinas as homeless, hungry, and persecuted, Celan's poetics, like Levinas's ethics, requires the very fracturing of this union or empathic moment. Levinas's depiction of substitution is not synonymous with empathy, but something else is transpiring. He contends, "My substitution for another is *the trope of a sense* that does not belong to the empirical order of psychology, an *Einfühlung* or a compassion which signify by virtue of this sense" (*Otherwise than Being*, 125; my emphasis).[24] Substitution is not a literal act but a trope of a sense, and Levinas, distancing himself from both a psychological understanding of empathy and from its origin as an act of aesthetic contemplation, draws it into the space of ethics. In recognizing the fiction of *Einfühlung*, Levinas posits instead a sensation accompanying substitution that corresponds to the subject's recognition of the impossibility of integrating difference within oneself.

Once again Levinas will invoke the absence of the transcendental imagination as the subject is affected by alterity and rendered "speechless" by this encounter with the face of the Other. For Kant the break of the imagination signifies the moment when the subject's sensations of awe, wonderment, and respect before the moral law are triggered. But in Levinas, the imagination's disruption, which is constituted by the lack of words and images, indicates the moment when an affective tonality that is more consistent with the uncanny than with the sublime replaces the faculties of sense and the imagination. The subject becomes aware of the impossibility of occupying the Other's place. The very tropes Levinas employs to describe the encounter with the Other's face revolve around a discourse of trauma; he talks of traumatization of the self, wounds, hem-

Celan's concept of *Verjuden*, a term he uses in his drafts of the "Meridian Speech," in relation to his rejection of Heidegger's ontological uncanny and Celan's own foregrounding of an uncanny poetics that doubles as an ethics (130). These drafts are found in the Tübinger edition of the speech and will be abbreviated as "Meridian Tbg."

24 Robert Vischer coined the German term "*Einfühlung*" in 1872 to refer to an intimate connection between the viewer and the perceived object in the realm of art. Aesthetic pleasure arises at the moment when the subject and object are fused with one another. The English equivalent for the word would be "empathy." But in his use of the term *Einfühlung*, Levinas distances himself from its role in the nineteenth-century psychological understanding of art, categorically rejecting this sense of union and pleasure in modern art. See for instance his discussion of aesthetics (*aisthesis*) and its relation to sense in *Existence and Existents*. In the subject's encounter with the modern artwork, "Sensation is not the way that leads to the object but the obstacle that keeps one from it" (53).

orrhages, a pain that tears me from myself, obsession, exile, shudder, temporal disturbance, and anxiety.[25]

Levinas's ethics is not simply an outgrowth of a German philosophical tradition, but it is rooted in the aftermath of traumatic history. His opening inscription to *Otherwise than Being* situates his ethics of the Other in history. The removal of the Other has indeed an historical precedent and can be traced back to this epigraph that remembers the victims of National Socialism. Levinas dedicates his book to "The memory of those who were closest among the six million assassinated by the National Socialists" and to the millions of other victims of the "same hatred of the other man, the same anti-Semitism." Recalling those murdered in the Holocaust, Levinas forms a connection between the act of remembering the Jewish dead and the turn to other potential victims of persecution. Later in the book he gestures back to this opening inscription: "The most lucid humanity of our time ... has in its clarity no other shadow, no other disquietude or insomnia than what comes from the destitution of the others. Its insomnia is but the absolute impossibility to slip away and distract oneself" (93). The destitution of the Other marked by history—exile, homelessness, hunger, exposure to the elements—resonates with the very hatred of the Other that opens up his analysis.

But at the bottom of the dedication page, Levinas writes a second inscription, in Hebrew, and thus in a language unreadable to most of its readers. In this untranslated script, reminiscent of Celan's epigraph in "And With the Book from Tarussa," Levinas remembers those family members who were murdered by the Nazis. It is here, at the turn to the foreign, that language functions as a trace—vague signs left behind in the extermination's aftermath. Our movement from the top of the page, across the gap, and to the Hebrew letters is a reading, seeing, and going across nothing. As our eyes encounter the remnants of the Other configured in Hebrew, we recall their effacement, which was just memorialized at the top of the page. The reader's eyes pass over the word traces, and

25 In "The Obsession of the Other: Ethics as Traumatization," Michel Haar discusses this very connection between trauma and ethics in Levinas and reduces Levinas's ethics to an obsessional anxiety marked by what he calls paranoia. One of Haar's main criticisms focuses on Levinas's use of the term "persecution" and he writes, "It is unbelievable that an immemorial or a priori form of persecution precedes all historical and moreover, contemporary images and aspects of persecution" (101). If persecution is historically based, Haar wonders how it can then be the cornerstone of Levinas's ethics, since ethics itself is non-epistemological. Haar questions how one could have a concept of persecution that is non-phenomenological or ahistorical, and thus outside the realm of experience. While Haar's argument may revolve around the premise that persecution is necessarily linked to an historical scene and is influenced by contemporary images and events, he fails to consider anywhere in his essay how trauma radically transfigures the categories of epistemology and experience.

she is responsible for translating these remnants into a memory of those effaced in the passage above. It is this memory of the millions killed that haunts Levinas's analysis of one's ethical comportment to the Other: a relation that affects us traumatically "in a past more profound than all I can reassemble by memory" (*Otherwise than Being*, 88). For Levinas, the ethical subject recalls this singular historical event by showing solidarity with other victims of oppression who find themselves exiled, homeless, and persecuted in the present.

Upon the spectral topography of this dedication page, the reader encounters legible text, aporetic silence and traces of the unreadable. By withholding a corresponding translation in the second text, Levinas forms neither a compulsive repetition nor a mere doubling of passages. Instead, he confronts his readers with an incomplete translation that preserves the very alterity that the National Socialists and other forms of racial hatred try to annihilate. To reiterate what Freud says about the experience of the uncanny, one must start by translating oneself (*hineinversetzen*) into that state of feeling, so that the *possibility* of experiencing it can be awakened in the subject (20). Through this juxtaposition of three distinct textual spaces, Levinas places us in the role of the translator who is left with foreign remnants at the bottom of the page. Whether it is called a "state of feeling" or a "trope of a sense," the experience associated with this impossible translation of a text revolving around mourning is uncanny at its core.

The act of translation or substitution between inscriptions is itself incomplete, and we recall that for Levinas substitution is not an actual undertaking but the "trope of a sense," which consists of a paradox: the responsibility of substitution is conjoined to the very recognition of the impossibility of performing such a task (*Otherwise than Being*, 125–26). The movement of our reading of the inscriptions at the beginning of *Otherwise than Being* captures this "trope of a sense" that constitutes our responsibility for the Other. Specular disruption, disorientation, and a shudder before the trace of the foreign are some of the components implicit in our opening act of reading. The disruption of identification, whether between inscriptions or one's encounter with the Other, gives rise to an affective tonality similar to an impossible mourning or melancholia. In my application of Levinas's ethics, which he develops from questions regarding specular ruptures, poetry, affect, traumatic history, spatial anxiety, and a shudder before the foreign, the "trope of a sense" that arises during one's encounter with the effaced Other in prosthetic sites of Holocaust memory is constitutive of the Holocaustal uncanny.

According to Levinas, "From its infancy philosophy has been struck with a horror of the other that remains other—with an insurmountable al-

lergy" ("The Trace of the Other," 346). While horror of the Other may reach back to Western philosophy's origins and its constant struggle with overcoming difference and integrating the Other within oneself, this relation between philosophy and horror takes on an entirely new meaning in relation to those exterminated during the Holocaust. To use the language of Celan's "Meridian Speech," it is the "terrifying silence" of the Other's date (20 January) configured poetically in Celan's *Atemwende* (Breathturn) where the reader encounters the absolute Other of the poem (*Gesammelte Werke* 3:195). The mode of the Holocaustal uncanny evokes an affective tonality that shatters the spectator's identification or solidarity with the Other. The Holocaustal uncanny opens up the possibility of an ethics, of a responsibility to the effaced Other, bound to an incomplete mourning that resists both redemptive narratives and any sense of closure by means of an empathic identification. The poems, films, paintings, and architectural sites that I examine next are not places of a possible unification with the Other, but are instantiations of this unbridgeable gap, where the reader/spectator recognizes the impossibility of assimilating either the effaced Other or its traumatic date within her- or himself.

Chapter 2

Catastrophe and the Uncanny
in Heidegger's Fetishized Narrative

A Missed Encounter: Heidegger and Celan

In order to fully comprehend the Holocaustal uncanny in Celan's "Meridian Speech" (1960), it is necessary to consider the relevance of Heidegger's writings on the uncanny along with their full philosophical and theoretical implications; his "Ister" lectures (1942) lay out the dynamics of the relation between poetry, the uncanny, and history, the fundamental components of Celan's speech. Heidegger's reading of Hölderlin's poem "Der Ister," which he juxtaposes to Sophocles' *Antigone* in his "Ister" lectures, provides a map for exploring Celan and the uncanny, and also sheds light on Celan's own poetic journey into the foreign in the years after the war. Although Heidegger explicitly rejects the political import of Sophocles' tragedy and dismisses any attempts to bring National Socialism into a discussion of *Antigone* (*Hölderlin's "The Ister,"* 86), on his circuitous journey from the Bukovina to Germany via Paris, Celan used the forum of his award speech to politically engage with his audience on the questions regarding German memory in the aftermath of the Holocaust. In contradistinction to Heidegger's analysis of *Antigone*, in which he highlights the topics of the uncanny and poetry in relation to the history of the mystery of Being, Celan's poetics of the uncanny is structured like an ethics and charts an encounter with the Other steeped not in the history of Being, but in the history of human beings rendered homeless by the policies of the Third Reich.

At the conclusion of his analysis of *Antigone* in the "Ister" lectures, Heidegger describes Antigone as "the purest poem itself" (*Hölderlin's "The Ister,"* 119), saying that she herself "*is* the poem of becoming homely (*heimisch*) in being unhomely. Antigone *is* the poem of being unhomely in the proper (*eigentlichen*) and extreme (*höchsten*) sense" (121). In his rejection of Hegel's claim that Sophocles' *Antigone* is one of the "most sublime presentations of piety" and "an opposition of the highest order in ethics" (*Elements*, 206), Heidegger's ontological investigation of Antigone fore-

grounds instead poetry's uncanniness with regard to how it discloses the mystery of Being and its own uncanny path. According to Heidegger, while it was the German poets who were establishing new historical ground to face the mystery of Being, only through the thinker's dialogue with Germany's poets could the disclosure of this history be actualized. Despite all these signposts pointing toward Celan as one such poet, Heidegger does not in fact engage with him. The question so often asked is why Heidegger refuses to respond to the poems of Celan, a foreign poet who both wrote in German and set forth the uncanny path of poetry. Did Heidegger recognize that the ethical structures and the political import he deftly avoided in Sophocles' *Antigone* were themselves inescapable in Celan's lyric? Although Celan's path of poetry leads the reader toward a confrontation with catastrophe (a key term in Heidegger's "Ister" lectures), the catastrophe consists of calendars and dates that challenge the reader to recollect and reflect on the historical meaning behind the loss of home and the missing graves.[1]

Felstiner traces Celan's earliest engagement with Heidegger's philosophy back to 1951:

> His personal library shows him delving into Heidegger's work from at least 1951. In March 1952 and again a year later, he studied *Sein und Zeit*. Then in the summer of 1953, he took up essays from Heidegger's *Holzwege*, marking passages on Hölderlin and Rilke. He underscored the philosopher's remarks on Hölderlin's elegy "Bread and Wine," especially the poem's question, "what use are poets in a destitute time?" [*Wozu Dichter in dürftiger Zeit?*]. (*Paul Celan*, 72)

Celan's engagement with Heidegger's philosophy, as well as his personal encounters with the philosopher at his home in Freiburg, would continue until the year of the poet's death, 1970. In turn, Heidegger was an avid reader and admirer of Celan's poetry, and for a *Festschrift* on Heidegger's seventieth birthday (1959), he asked his publisher to see if Celan would contribute a poem. The poet declined. However, the two eventually met at Celan's poetry reading at the University of Freiburg in 1967—he read his poems in the same auditorium where Heidegger had given his Rectoral Address in 1933. Shortly before Celan's arrival in Freiburg, Heidegger had told a friend regarding Celan's lyric, "I know everything of his" (Felstiner, *Paul Celan*, 245).

After Celan's reading, Heidegger presented the poet with a copy of his book *What Is Called Thinking?* and invited him to his cabin in Todtnauberg in the Black Forest. The two walked through the woods and, in addition to discussing contemporary French philosophy, Celan impressed Heideg-

1 For an analysis of the grave-like structures in Celan's lyric, see Uta Werner's *Textgräber: Paul Celans geologische Lyrik*.

ger with his knowledge of the fauna and flora of the region. Their walk
into the woods along a country path served as the setting where the exiled
Jewish poet and the former member of the National Socialist Party might
possibly have entered into a dialogue about all that had happened. The
meeting also provided Heidegger with a chance to break his silence and
fulfill what Celan had inscribed in his guest book: "With a hope for a
coming word in the heart." But it never happened. The very landscape
that day reflected the outcome of the conversation: the *Feldweg* along
which the thinker and the poet walked became so sodden that they were
forced to return to the cabin.[2]

A week later the poet commemorated his visit to Heidegger's moun-
tain retreat in the poem "Todtnauberg" and described "the half- / trod-
den log- / paths on high moorland" (*Selected Poems*, 315). Both the walk
and the conversation were incomplete. Celan converts Todtnauberg's
landscape into the terrain that Heidegger himself refused to approach: the
catastrophic *topos* of the extermination camps. And Celan transforms Hei-
degger's familiar home into the uncanny post-memorial space of the death
camps.[3] The very formal center of the poem is a variation of the lines
Celan had earlier written in Heidegger's guest book, " A hope, today, /
for a thinker's / (un- / delayed coming) /word / in the heart" (315). The
word that Celan seeks is not an explanation from Heidegger for why he
saw "inner truth and greatness" in National Socialism. The implications of
Heidegger's silence on Auschwitz entailed more than just the absence of
an apology: his failure to respond to Celan signified his refusal to become
a historical witness to either the poetic experience of Celan's dating of the
poem, or to the traumatic history inscribed within the poem's material.[4]

Otto Pöggeler describes how very disappointed Celan was with both
his meeting with Heidegger and with a letter from Heidegger thanking
him for a copy of the poem. In the letter Heidegger acknowledged that
since their meeting, there had been "much silence" between them ("Seit-
dem haben wir Vieles miteinander zugeschwiegen").[5] Heidegger contin-
ued that despite this silence, one day something would emerge from the
unspoken in their conversation ("Ich denke, dass einiges noch eines Tages

2 The two men had another encounter in March 1970 during another poetry reading of
 Celan's in Freiburg. Celan rebuked Heidegger for what seemed to be inattentiveness during
 the reading, and after the poet left, Heidegger remarked that Celan was "Heillos." Celan
 killed himself a month later (see Gerhart Baumann, *Erinnerungen an Paul Celan*, 80).

3 See for instance Pierre Joris's reading of paranomasia in "Todtnauberg," where Celan en-
 codes the legacy of fascism in the landscape around Heidegger's retreat in the Black Forest.

4 As Lacoue-Labarthe says at the end of *Poetry as Experience*, Heidegger's irreparable offense
 was not in his failure to ask forgiveness; rather, he should have broken his silence and said,
 "It is absolutely *unforgivable*" (122).

5 A copy of this letter is printed in the *Neue Zürcher Zeitung*; see Krass.

im Gespräch aus dem Ungesprochenen gelöst wird"). Significantly perhaps, Heidegger's letter was belated, coming six months after the arrival of Celan's gift.

Heidegger had written in a lecture on Hölderlin's poetry, "Therefore the poet turns to others, so that their remembrance may help towards an understanding of the poetic word, with the result that in the process of understanding each may have a homecoming in the manner appropriate for him" ("Remembrance," 269). In his turn to Heidegger, Celan was in search of an *Andenken*—both a remembering and a thinking—in relation to the catastrophic loss of home brought about by the policies of National Socialism. The path to this homecoming opening up in Celan's lyric would take its reader to the most uncanny of places, but it was a path Heidegger was unable or unwilling to follow. In his "The Thinker as Poet" written shortly after the war and during his retreat into the forests of Todtnauberg, Heidegger wrote, "As soon as we have the things before our eyes, and in our hearts an ear for the word, thinking prospers" (5). Although Celan would hear Heidegger's words—pain, memory, word, heart, turn, thinking, and the uncanny—and ask for one in return, even after his face-to-face encounter with the poet, Heidegger's word was not late, but missing.

I am not the first to comment on the missed encounter. Lyotard captures perfectly Heidegger's failure to respond to Celan when he writes at the end of *Heidegger and "the jews"*:

> Thus, one cannot say that Heidegger's thought "leaves open" the question of his silence on the Holocaust. It seals it hermetically. This silence *is* this nonquestion, this closure and foreclosure. ... It is no "ultimate paradox" that the memory (and not "the memorial") of this foreclosure (Heidegger's silence) is "guarded in the poem of a Jewish poet," Celan, after his encounter with Heidegger. "Celan" is neither the beginning nor the end of Heidegger; it is his lack: what is missing in him, what he misses, and whose lack he is missing. (94)

Just as he puts "the jews" in quotation marks, Lyotard puts "Celan" in quotation marks at the very end of his analysis. As David Carroll remarks in his introduction to Lyotard's *Heidegger and "the jews"*, "the jews" are situated in "the (non)place of an Otherness that thought cannot think but cannot not think either" (xii). Unable to assimilate "the jews," thought tries instead to deny, repress, or annihilate what it fails to contain within itself. "The jews" signifies for Lyotard both the imperative and the absolute impossibility of representing this radical alterity. And "Celan" no longer functions as a proper name; rather, it both embodies Heidegger's refusal to think and signifies the catastrophic history he refuses to think about. Heidegger not only forgets "the jews," his writings in the aftermath

of the extermination demonstrate a concealing, or *Verschwiegenheit* (Heidegger's term for silence from *Being and Time*), of this historical catastrophe.

Employing Lyotard's terminology, I see "Celan" as the name for the *lack* that comprises Heidegger's flight from thinking. This lack is symptomatic of *das Unheimliche*, the affective state which Heidegger refused to think in relation to technological genocide. Moreover, I maintain that Heidegger's ontological analysis of the uncanny, which devolves into the structural components of Freud's return of the repressed, is ultimately revisited by Celan's poetics of the uncanny. It is the very ethical import behind the uncanny, eluded by Heidegger, that Celan's poetics retrieve. Celan thinks through the path of the uncanny that Heidegger refuses to follow, a Holocaustal uncanny that leads one to a date of radical alterity, January 20th: the date of the Other's effacement.

In the speech delivered when he was awarded the Georg Büchner Prize, Celan describes how a poem is written from its own date towards another date, and thus towards an encounter with an Other, the recipient of the poem. All of his poems, Celan tells us, embark from a 20th of January: "Perhaps we can say that every poem is marked by its own '20th of January' ... [Poems] try to be mindful [*Eingedenk sein*] of this kind of date" (*Collected Prose*, 47/*Gesammelte Werke* 3:196). In addition to corresponding with the day Büchner's Lenz gets lost in the mountains, January 20, 1942 is the historical date of the Wannsee Conference, when the plans for the Final Solution were developed.[6] Derrida asserts in his essay on Celan that a date is a witness; it addresses the Other. As we have seen, sometimes Celan's poems are addressed to definite places and thus bear particular individuals in mind, such as the one he addressed to Heidegger in 1967 in Todtnauberg. Although Heidegger and Celan may follow similar *Feldwegen* —paths that consist of questions regarding memory, thinking, technology, anxiety, language, poetry, and the uncanny—one thinker arrives at a clearing in the death camps, while the other remains in his native land and the forests around Todtnauberg.[7]

6 The significance of this date, January 20, was not revealed until after the war during the Nuremberg Trials in 1945/46. The organization of the Final Solution occurred at the Villa in Wannsee, and the protocol prepared there by Eichmann and Heydrich was extensively used as evidence against the accused at Nuremberg. The relevance of the date seemed to have again disappeared until Celan's insistence to his audience during the Büchner Prize speech in 1960 to be mindful of such dates. The importance of the date of the Wannsee Conference would return again the following year (1961) during the Eichmann trial in Jerusalem.

7 For one of the most recent and comprehensive analyses of the Heidegger/Celan encounter, see James Lyon's *Paul Celan and Martin Heidegger*, which appeared too late for me to use it sufficiently in this book.

Heidegger and Narrative Fetishism

In the summer of 1942, Martin Heidegger gave a series of lectures on Friedrich Hölderlin's hymn 'Der Ister" (1803) at the University of Freiburg. The Ister, the Greek name for the Danube River, has its origin in the mountains of the Black Forest and flows southeast to its source near the Black Sea by Romania. Hölderlin, however, poetically reverses the flow of the river, placing the origins of its course in the east:

Der [Ister] scheinet aber fast
Rückwarts zu gehen und
Ich mein, er müsse kommen
Von Osten.

He [The Ister] appears, however, almost
to go backwards and
I presume he must come
from the East.
(Heidegger, *Hölderlin's "The Ister,"* 5)

Thus the Greek spirit flows toward Germany. In the second half of his Ister lectures, Heidegger shifts from Hölderlin's river poem to an analysis of Sophocles' *Antigone*. In particular, he focuses on the Greek word *deinon*, which Heidegger, through his understanding of Hölderlin, translates into *das Unheimliche*, or the uncanny:

The journeying into the unhomely must go "almost" to the threshold (*Grenze*) of being annihilated in the fire, in order for the locality of the homely to bestow that which gladdens and saves. (167)

Alternating between the themes of wandering and leaving home, Heidegger analyzes how it was the role of the Germans to take over where Greek thought left off, to turn toward the Greek fires and think through the enigma of Being. A year later, in the essay "Remembrance of the Poet" (1943), he shifts from the topic of departure to homecoming in his reading of Hölderlin's poem "Heimkehr" ("Homecoming"), an elegy that narrates the return of a youth across the Alps and Lake Constance to his homeland in Swabia. In the poem Hölderlin declares, "To be sure! It is the native land, the soil of the homeland" ("Remembrance," 239). By venturing into the foreign and into distant lands, Heidegger tells us, the poet/wanderer is prepared for a homecoming where he is welcomed back into what is familiar to him: "There they welcome me. O voice of the town, of the mother!"

Despite Heidegger's insistence that Hölderlin's poetry does not re-
quire a date—"For the 'now' of his poetry there is no date conforming to
the calendar. Moreover, there is no need here of any date" (8)—the dates
of these two lectures are not of mythopoetic origins of Being, but of
events in German history that Heidegger seems to encode within his lec-
ture. By 1942 the German military had advanced deep into the east of the
Soviet Union, a journey that started in June 1941 with Hitler's Operation
Barbarossa. The Ister's actual eastern movement parallels the movement
of German troops in 1942 that were occupying parts of the Soviet Union.
By 1943, when Heidegger's lecture "Remembrance of the Poet" was pre-
sented, Germany's retreat from the east was well underway as the news of
the defeat at Stalingrad was being reported back home. In the conclusion
to his reading of "Heimkehr," Heidegger implores the others waiting at
home in the Fatherland to welcome back the returning children who sacri-
ficed their life for the homeland.[8] Toward the end of the essay Heidegger
remarks that there is always one among the greeting heralds who "alone
and in advance, may first conceal the greeting in the word" (269). The
philosopher conceals within his lectures allusions to events of the Second
World War, and his reading of "Heimkehr" functions as a welcoming of
the vanquished soldiers to Germany.

Yet the narrative that Heidegger constructs around the figures of *das
Unheimliche* and *Heimkehr* does not end in 1943 with the retreating German
army. In an essay from 1955 titled "Gelassenheit" ("Releasement"), Hei-
degger alludes to contemporary German history's relation to *das Unheim-
liche*. Although a commemorative address (*Gedenkfeier*) in honor of the
composer Conradin Kreutzer, in actuality the text becomes a sidestepping
of German history in the aftermath of the Second World War. The un-
canny for Heidegger in 1955 manifests itself in two ways: first, he deems
uncanny those Germans who were forced to leave their homes in the
eastern territories at the end of the war; second, the condition of the
world under the sway of the atomic bomb, which he calls the symbol
("Kennzeichen") of the modern age, is also a mark of the uncanny (*Dis-
course on Thinking*, 49).

In this commemorative address revolving around Heidegger's
thoughts on the loss of reflective thinking (*Nachdenken*)—a word all the
more significant as we locate this "thinking *after*" after the twelve years of
National Socialism—Heidegger refuses to think through the aftermath of
Germany's crimes as symbolized by Auschwitz. In trying to analyze criti-
cally the threats and dangers of technology, Heidegger bypasses any men-
tion of the catastrophic machine of the Third Reich. Eliding the traumas

8 In using the word "Opfern"—"to sacrifice"—Heidegger also conveys the notion of "Opfer"
 —"victim" ("Remembrance," 267).

initiated by Germany, he casts Germany as the victim of the war. If there was a cloaked or hidden narrative of the Second World War in the lectures from 1942 and 1943, the narrative that unfolds in Heidegger's writings after the war can be framed by Eric Santner's concept of "narrative fetishism." Heidegger may have claimed in his *Spiegel* interview that he encoded his resistance to National Socialism in his lectures on Nietzsche and Hölderlin's poetry from 1934 to 1945, but this is undermined by looking at his postwar writings, in particular when he again reflects on *das Unheimliche* (see "Only a God Can Save Us Now"). In 1955 he had the opportunity in "Gelassenheit," a memorial address, to make explicit what he said he had previously masked. He returns again to the concept of *das Unheimliche* but circumvents any mention in his lecture of those rendered homeless by Germany's militarism and Germany's own technological exploits.

I propose that in Heidegger's narrative of the un-homed, there is a fetishistic re-inscription of Germany as the victim of the war. According to Santner, narrative fetishism refers to "[t]he construction and deployment of a narrative consciously or unconsciously designed to expunge the traces of the trauma or loss that called the narrative into being in the first place" ("History Beyond," 144), and Santner contrasts narrative fetishism to Freud's work of mourning. While during *Trauerarbeit* the subject assimilates the loss or traumatic shock into memory through the process of "translating, troping, and figuring loss," narrative fetishism is a symptom of the inability or refusal to mourn by positioning the origins of loss somewhere else. Santner concludes, "Narrative fetishism releases one from the burden of having to reconstitute one's self-identity under 'posttraumatic' conditions; in narrative fetishism, the 'post' is indefinitely postponed."

In his analysis of the works of the historian Andreas Hillgruber and filmmaker Edgar Reitz, Santner explores the lack of any traumatizing impact the Holocaust had on identity construction in Germany as seen in their respective works. According to Santner, both Hillgruber and Reitz refigure trauma by transforming the Germans into victims, and in their own fetishistic narratives they circumvent the crimes of the National Socialists. I believe that Heidegger's conceptualization of *das Unheimliche* functions as a fetishized narrative that avoids the trauma engendered by the politics of National Socialism. Departing from Santner's reading of the word "*Heimat*" in Reitz's film *Heimat*, a word that had figured prominently in the marginalizing and destruction of European Jewry but an association that was evaded by Reitz, I am interested in Heidegger's word in his narrative about the loss of home: *Un-heimliche*. He first applies the term to structural traumas of ontology in *Being and Time*, then returns to its poetic connotations in his lectures on Sophocles' *Antigone* and Hölderlin, and then again in the postwar period in relation to history and technology.

While the lost traumatic shock that Santner refers to may denote the missing anxiety that is central not only to Freud's theories of trauma, the uncanny, and repression, anxiety is also a fundamental element throughout Heidegger's philosophy; it is the affective state of being that the subject continuously tries to evade. But in his essays on "Der Ister," "Heimkehr," and "Gelassenheit," and especially in his discussion of the figure Antigone, the subject goes toward and reflects on the anxiety-inducing space of the uncanny. The uncanny, however, is not threatening, but becomes for Heidegger a place where historical shocks are replaced with a mythopoetic celebration of Being. Whether intentionally or not, the traumatic traces that Heidegger expunges from his narrative revolve around the crimes of the Third Reich, in particular the Holocaust, and in his postwar reflections on the uncanny, he bypasses the anxiety associated with the traumatic shocks of the Third Reich. When the uncanny is again situated in relation to loss, Heidegger locates both the site and the origin of loss not in 1933, 1939, or 1942, but rather in 1945 with Germany's defeat.

In following the trajectory of Heidegger's concept of the uncanny in the postwar years, one sees how he fails to respond to the series of catastrophes that led to the traumas inflicted upon the German homeland. There is a refusal to mourn or remember. His fetishized narrative, revolving around the poles of *das Unheimliche* and *Heimkehr*, positions Germany and the Germans as the uncanny ones. While mourning may be a pivotal concept in his essays on Hölderlin's and Stefan George's poetry, historical mourning is ultimately supplanted by a celebration of Being.[9] The loss of home recedes into a mythopoesis whereby the ground for Being is given foundation and the traumas brought about by the Third Reich are circumvented.

Santner's narrative fetishism is structured like Freud's theory of repression, where distressing traces of memory or perception are avoided. Repression, the protective coat that prevents something from coming to

9 See Heidegger's essay on Stefan George, "Das Wort", in *Unterwegs zur Sprache*. In his writings on pain and poetry, Heidegger insists that there be a response to pain over the loss of the word. He even gives a name to the answer to pain: melancholia ("Schwermut"): "The spirit that answers to pain, the spirit attuned by pain and to pain, is melancholy" (*On the Way to Language*, 153–54) [Der dem Schmerz entsprechende "muot", ist die Schwermut (235)]. The response by *Schwermut* is a listening (*hören*) to and a remembrance (*im Andenken*) of this loss. By renouncing the word, the poet is able to retain it in memory, and only through listening to the poem can we hear the thinking of poetic being (*Denkwürdige des Dichtertums*) and ponder the essence of poetry (154/235). Yet in Heidegger's use of the term *Andenken*, memory remains interiorized; it is this very inwardness that Celan's poetry reacts against and tries to break free of. Celan will exclaim in his "Meridian Speech" that the poem breaks its silence in its triumphant call from out of the abyss, "But the poem speaks. It is mindful of its dates [*Es bleibt seiner Daten eingedenk*], but it speaks" (*Selected Prose* 48).

light so as to spare the subject any discomfort of memory, is described by Freud as a flight from memory, a turning away (*Abwendung*) from an unpleasant experience. Although in narrative fetishism one may try to erase the traces of trauma, Freud asserts that trauma always leaves behind traces of memory (*Erinnerungsspuren*); not all the traces can be expunged. These traces manifest themselves as symptoms of repression—most notably the uncanny affect of the repetition compulsion—and the residue demarks the point where something is concealed or hidden.

Neil Hertz argues in his analysis of Freud's uncanny that figurative language is the means by which what is imperceptible or hidden is given color, for example, the way a patient repeats particular words or phrases. Responding to Freud's claim that "[w]hatever reminds us of the inner repetition-compulsion is perceived as uncanny," Hertz describes how there is an encoding of a hidden event behind the compulsion to repeat and continues, "Repetition becomes 'visible' when it is colored by something being repeated, which itself functions like vivid or heightened language, lending a kind of rhetorical consistency to what is otherwise quite literally unspeakable" (*End of the Line*, 102). Heidegger's repeated use of the figure *das Unheimliche* functions as the audible trace that indicates something concealed and, in effect, also discloses the uncanny moment in his fetishized narrative. What is left hidden or silent, the unspeakable gap to which his use of the word gestures, is the catastrophe of the Holocaust. In the context of his postwar writings Heidegger's *Verschwiegen*, which means not only to remain silent but also to conceal, does not refer to the call of Being as it did in *Being and Time*, but points to the silence about Auschwitz.

Heidegger's reading of the uncanny undergoes a series of reinscriptions as it is associated with Being, Sophocles' *Antigone*, Hölderlin's poetry, the loss of Germany's eastern territories, and German refugees, and finally the word refers to the world under the sway of the atomic bomb. The word's trajectory, moving from ontological to poetic and historical significance, eventually turns back into the ontological to reveal Heidegger's very sidestepping of history. Reading existential trauma through a Freudian optics of the uncanny, I will demonstrate how Heidegger's texts become symptomatic of a post-traumatic philosophy, one that revolves around catastrophe, lost experience, and repetition.[10] Ultimately, this excursus through Heidegger's uncanny prepares me for my entrance into Celan's uncanny poetics, which in turn is a response to Heidegger's failure to think through the catastrophic ruins left in the aftermath of the Holocaust.

10 For an analysis of the relation between trauma and Heidegger, see "Heidegger's Nazi Turn" in Dominick LaCapra's *Representing the Holocaust: History, Theory, Trauma* (137–68).

Fear and Anxiety in Heidegger's *Being and Time*

In paragraph 40 of *Being and Time*—a section where Heidegger develops the distinction between anxiety (*Angst*) and fear (*Furcht*) in their relation to representation and place—the interplay between Heidegger's concepts of anxiety, being thrown into the world (*Geworfenheit*), and the spatial-temporal configuration of existential trauma overlap with Freud's own psychoanalytic model of trauma. As was established in chapter 1, Freud conceptualizes trauma as a spatial disfiguration that results in a temporal disruption and hence a loss of experience. What transpires in the following passage from *Being and Time* is strikingly similar to the depiction of the disruption of *Angstbereitschaft* in Freud's analysis of trauma in *Beyond the Pleasure Principle*.

> Accordingly, when something threatening brings itself close (*nähert*), anxiety (*Angst*) does not "see" any definite "here" or "yonder" from which it comes. That in the face of which one has anxiety is characterized by the fact that what threatens is nowhere (*Nirgends*). Anxiety "does not know" what that in the face of which it is anxious is. "Nowhere" does not signify nothing: that is where any region lies, and there to lies any disclosedness of the world for essentially spatial Being-in (*räumliches In-Sein*). Therefore, that which threatens cannot bring itself close from a definite direction within what is close by; it is already there (*schon da*), and yet nowhere; it is so close that it is oppressive (*beengt*) and stifles one's breath (*Atem verschlägt*), and yet it is nowhere. (186)

The echoes of Freud are prominent, as Heidegger appears to be sketching existential trauma. The danger that threatens *Dasein* goes by unseen; the lack of comprehension of the threat remains missing and is itself bound to an excess of anxiety that overwhelms the subject. Since the direction of the threat cannot be pinpointed to a "here or there," to a particular place, the above passage is characterized by a heightened state of anxiety. What actually is the threat that approaches *Dasein*? Prior to this paragraph, Heidegger shows how the dread (*Angst*) that surrounds *Dasein* stems from *Dasein*'s awareness that it is immersed in a temporal relation to the world; it is a Being-towards-death, and Heidegger will remark later in *Being and Time* that *Dasein* seeks to flee in the face of its own death (251–52). But it is not merely the trauma of temporal finitude that constitutes this dread; *Dasein* finds itself *already* in the world, what Heidegger calls a thrownness (*Geworfenheit*) into the midst of beings. Anxiety emerges when the individual acknowledges that Being-in-the-world is a *thrown* Being-towards-death, "Thrownness is neither a fact that is finished nor a fact that is settled"(179). The throw, devoid of any specific temporal-spatial coordinates, cannot be located. I read this lost moment of the throw, the lack of per-

ception and the inability to comprehend the throw through the faculty of understanding, as symptoms of an existential trauma: the throw becomes a lost moment withheld from *Dasein*'s understanding and experience. But as Heidegger argues, this throw is a necessary trauma for *Dasein* and functions as the constitutive moment of *Dasein*'s identity.

Conjoined to this temporal uncertainty of the throw in section 40 of *Being and Time*, anxiety is conceptualized in spatial terms in the following words: here, there, nowhere, spatial Being-in, near, direction, and oppressive (*beengt*).[11] Both a definitive time and place are missing, and Heidegger connects his concerns about time to an anxiety about place. Although the lost time of the throw is configured through spatial metaphors, the place whence anxiety comes is devoid of direction and is called "nowhere." Heidegger goes on to link the temporal condition of uncertainty of the throw to yet another ontological counterpart of *Dasein*; *Dasein*'s more primordial (*ursprüngliche*) state, like its thrownness, is bound to the affect of *das Unheimliche* or the *Unzuhause*. *Dasein* originally finds itself not at home in the world. The temporal trauma of the throw is conjoined to its spatial complement in the state of being uncanny (188).

Because of anxiety's unlocatability (*Nirgends*), *Dasein* ultimately tries to fasten onto that which is threatening by transforming objectless *Angst* into something that can be perceived or grasped. Once Heidegger develops his distinction between *Angst* and *Furcht*, a theory of representation in relation to existential trauma begins to unfold: temporal dread (*Angst*) associated with thrownness and Being-towards-death is configured in terms of a spatial fear (*Furcht*). In addition to allowing *Dasein* to grasp an object, fear also "comes from some definite region" (*Being and Time*, 185). When anxiety, which for Heidegger is both indefinite and formless, is transferred onto the world and given form, a fear of something develops.[12] As Heidegger remarks, "Fear is something we encounter in the world" (179). Fear, a condition linked to a phenomenological experience, provides a specular distance that makes possible the perception of that which threatens (indefinite anxiety) as it approaches. We are affected by the threatening nature of a particular thing in the world.[13]

11 The integral relation between *Angst* and space can be seen in the very etymology of the word. *Angst* derives from the Latin word *angustiae*, which means narrowness or constriction. *Angst* (anxiety), *Enge* (narrow), and *beengt* (oppressive) are etymologically related.

12 In the German expression *Ich habe Angst vor etwas* (I am afraid of something), the *vor* suggests the spatial element constitutive of anxiety; that which produces anxiety is located in front of us.

13 Two years before *Being and Time* in his *The History of the Concept of Time*, Heidegger engaged with this question of fear and anxiety, asserting that *Furcht* derives from *Angst*: "All fear finds its ground in dread" (284). Throughout section 30, where this distinction between fear and anxiety unfolds, Heidegger reiterates the connection of fear, perception, and representation by using such terms as "allow to be seen" (*sehenlassen*), "grasp" (*erfassen*) and "present" (*vorstel-*

But for Heidegger, the real threat to *Dasein*'s identity stems from both *Dasein*'s flight from the uncertainty of its throw and movement into the world of representations. In the following passage, Heidegger describes the turn to visual perception at the moment of fear, where this visualizing of anxiety—*das Unheimliche*—is conceptualized as a fleeing:

> By this time, we can see (*sichtbar*) phenomenally what falling, as fleeing, flees in the face of. It does not flee in the face of entities within the world; these are precisely what it flees towards. ... [W]e flee into the "at-home" of publicness, we flee in the face of the not at home, that is, we flee in the face of the uncanniness ... in Dasein as thrown Being-in-the-world. (*Being and Time*, 189)

At the moment of anxiety there is no definite datum or reference to one's surroundings, and this uncertainty creates the uncanny feeling in which one feels no longer at home in one's familiar surroundings. While during the condition of anxiety, Being-in-the-world becomes a "not at home," fear on the other hand indicates the moment when *Dasein* turns away from the uncanny. This turn signifies for Heidegger a fleeing that transforms anxiety into fear and thus makes the uncanny into something perceivable. The flight into the space of representation reveals *Dasein*'s attempt to grasp or comprehend its existential trauma. But after attempting to represent anxiety through the turn or fall into the world, Heidegger claims that authentic existence necessitates a return to the moment of trauma, to the throw and *das Unheimliche*: these are the constitutive elements of *Dasein*.

Heidegger writes, "The uncanny pursues Dasein constantly" (*Being and Time*, 189). *Dasein* finds itself caught up in a process of traumatic repetition that oscillates between fear and anxiety. The turn (*Abkehr*) from a formless, placeless dread (*unzuhause*), which is linked to a temporal rupture, shifts to a pre-occupation with things in the world (*zuhause*). While *Angst* is associated with a non-definitive place (*überhaupt Gegend*), Heidegger locates *Furcht* in a definite place (*bestimmten Gegend*); the moment of lost time is translated into a spatial representation. Yet this spatial world of things and forms ultimately "shrivels up," sending *Dasein* back to its singu-

len). *Dasein* attempts to make present (*das Gegenwärtigen*) the lost moment of the throw into Being (*Geworfenheit*). Thus, *Dasein* temporalizes the throw by making it present (*History*, 392–93). It is interesting to note that Heidegger uses the image of a grenade about to explode in order to describe a moment of fear: the subject prepares for the shock of the explosion. Heidegger's example comes very close to Freud's distinction between *Angst*, *Furcht*, and *Schreck* (fright) in *Beyond the Pleasure Principle*. Freud too will use the example of exploding bombs, an example that is symptomatic of trauma's repercussions arising in the aftermath of the Great War.

larity.[14] Heidegger's call for the disruption of representation makes possible a return of *das Unheimliche* and its concomitant of objectless dread. At this moment of the uncanny, memory is lacking, and as Heidegger writes, "Dasein is thrown into this uncanniness. Anxiety brings one back to one's own thrownness and this bringing back is neither a remembering nor a forgetting ... Anxiety brings one back to one's thrownness as something possible which can be repeated" (*Being and Time*, 343–44). What appears to be transpiring is a repetition of anxiety without its transformation into memory. As Heidegger develops later in his "Ister" lectures, it is Antigone who ultimately resists this flight from the uncanny and willfully goes toward the space of homelessness: her grave. My extended focus on Heidegger's figure of the turn (*Abkehr*) points ahead to one of the key concepts in Celan's "Meridian Speech." He too stresses the necessity of turning toward the uncanny, but unlike in Heidegger, the subject who turns toward the void left behind by a historical catastrophe—not an ontological rupture—is positioned between recollecting and forgetting the date in which human beings were rendered homeless.

Heidegger's depiction of the return to the moment of the throw unfolds like Freud's theory of belatedness (*Nachträglichkeit*) in his studies on trauma. Likewise, in *Being and Time* the anxiety-filled moment keeps repeating itself and returns *Dasein* to its origins in *das Unheimliche*: "Dasein is taken all the way back to its naked uncanniness" (344). Yet Heidegger's existential approach to trauma inverts Freud's psychoanalytic model. For Freud the failure to turn away from a traumatic moment, resulting in the rupture of one's *Angstbereitschaft* and the absence of memory, necessitates a belated re-presentation of the lost moment in order to circumvent the symptoms of the compulsion to repeat, which is configured in Freud's notion of *das Unheimliche*. But for Heidegger, all attempts to make the lost moment visual have the reverse effect of not reconstituting the subject, but of dissolving it. Unlike in Freud, the very process of representing *das Unheimliche* in Heidegger threatens the authentic identity of one's original state of not-being-at-home. However, unable to be sustained, these representations collapse and *Dasein* returns back to the original state of anxiety and the uncanny. In contradistinction to Freud, the experience of the un-

14 Heidegger uses the word *sinken* for shrivel up (*Being and Time*, 187) and we hear an echo of this in Celan's "*schrumpfen*" in the "Meridian Speech" (*Gesammelte Werke* 3:196). "Perhaps it is here where the Medusa's head shrivels up ..." [*Vielleicht schrumpft gerade hier das Medusenhaupt* ...] (*Selected Prose*, 47). Both forms of contraction occur at moments when the process of representation dissolves.

canny does not pose a threat to identity for Heidegger, but is the subject's fundamental state of existence. While the act of representation for Freud signifies the commemorative powers of the subject who attempts to turn unprocessed trauma into memory, the moment when anxiety transforms into fear through what Heidegger calls "presentation" (*Gegenwärtigen*) marks the point of forgetting the original uncanny moment of Being. Despite Heidegger's use of the term *Augenblick* (literally meaning a glance of the eye) for the moment of anxiety, this "moment of vision" is both unperceived and without location. The *Augenblick* is counter-mimetic, and all attempts to transform a temporal lack into something spatial are transient. Spatial representations of fear fall back into temporal anxiety. When the process of representation is abandoned, we enter not the space of memory, but into a repetition of the traumatic moment.

Having just traversed some of the key features of how the uncanny unfolds in *Being and Time*, I want to underscore here one of the pivotal distinctions between the turning-away (*Abkehr*) in Heidegger and the turn that transpires in Celan's figure of the *Atemwende*, or Breathturn in the "Meridian Speech." Celan too will show how poetry follows the path of art into a forgetting and self-estrangement. But at the moment (*Augenblick*) of the Breathturn, when language in the poem momentarily pauses, art and representation dissolve. At this uncanny moment of a terrifying silence (*furchtbares Verstummen*), Celan provides his reader with a date (*Gesammelte Werke*, 3:196). While Heidegger depicts *Dasein*'s Being-in-the-world as governed by a process of repetition that vacillates between fleeing and moving toward the uncanny, Celan transforms this repetition into the possible recollection of an uncanny date. For him, poetry acknowledges both the singularity of the date and its very repetition. The uncanniness of the date is rendered spatial through Celan's disruptions of poetic language that manifest themselves through a stutter, broken or foreign words, or a missing line that suspends our reading of the poem.

Antigone: The Uncanny, History, and Loss of the Ethical

Like what unfolds in *Being and Time*, the question concerning representation in Heidegger's "Ister" lectures again manifests itself in the relationship between temporal and spatial structures. In order to break free from representational modes of thinking as depicted in *Being and Time*, where time is rendered spatially, Heidegger turns to Hölderlin's poetry, where his concept of time provides an alternative to a temporality based on clocks or calendars. He writes in his exegesis of Hölderlin's poem, "Wie wenn am Feiertage …," "Such a time can never be dated, and is never measur-

able in numbers of years or the division of centuries" (*Erläuterung*, 76).[15] Why does Heidegger wish to withdraw from the traditional way of conceptualizing time and search for a new way of comprehending the spatio-temporal link? The answer is found in his reflections on technology:

> Via our calculations and machinery, we have such convincing power over its [nature's] "spaces" and "times" that the space of our planet is *shrinking* and the annual seasons and years of human life are being *condensed* into *diminutive* numerical values for the purposes of our calculative planning far in advance. (*Hölderlin's "The Ister,"* 39; my italics)

According to Heidegger, time and space, the central elements of metaphysics, are being used to dominate and enslave the world. This enslavement is predicated upon technology's use of representational thinking, through which these very spatio-temporal categories control nature. Wishing to overcome the drive of metaphysics to dominate the world, Heidegger sees in Hölderlin's poetry an alternative to such an antagonistic relation between oneself and the world. He goes on to claim that since it is devoid of "symbolic images" (*Sinnbilder*) and outside representational thinking, Hölderlin's poetry could serve as a point of departure from how metaphysics has in the past conceptualized time and space (18). Rejecting the Cartesian concepts of space and time, Heidegger argues through Hölderlin's lyric for a reconfiguration of these very categories, where time signifies a process of homecoming (*Zuhause*), and space (*Raum*) shifts to a dwelling in a particular place (*Ort*). [16]

Hölderlin's "Der Ister" starts with a figure of time but quickly shifts to an image of place, as the poem replaces the "now"—"Jetzt komme, Feuer!" (l. 1)—with a "here"—"Hier aber wollen wir bauen" (l. 15). Heidegger tells us that this "now" is not historiographic and has nothing to do with calendar time or events (*Historie*), but with the historical itself (*Geschichte*): the "now" of the poem marks the original dwelling of Being. Heidegger maps out in Hölderlin's poetry the distinction between *Historie* and *Geschichte*. *Historie* is a narrated history consisting of events, a reconstruction of the past through the telling of these events, a domain for human inquiry like any other object of study and devoid of ontological significance. On the other hand, historicality (*Geschichtlichkeit*) refers to a particular historical process that is open-ended and allows for the revelation of

15 See also Heidegger's *Basic Problems of Phenomenology*, where he continues with this distancing from actual dates: "The date does not need to be calendrical in the narrow sense" (262–63).

16 For an incisive reading of the function of place in Heidegger's analysis of Hölderlin's poetry, see Stuart Elden's "Heidegger's Hölderlin." While Elden focuses on the status of the rivers in Hölderlin's poems (Neckar, Rhein, and Ister) in relation to the founding of a homeland, he leaves out of his discussion the function of *das Unheimliche* and the loss of home.

Being; it is not concerned with past events but rather with the continuity of becoming. In opposition to clock time, the experience of time (*Geschichte*) in Hölderlin cannot be dated. This shift in conceptualizing history indicates a narrative fetishism that eventually unfolds in Heidegger's philosophical project. By turning away from calendar time, he can circumvent history and remain fixed on metaphysical questions regarding temporality. The dismissal of the date allows Heidegger to avoid the historical events transpiring at the time he delivered his lectures.

But one can indeed date Heidegger's lectures and situate historically what he refuses to say. In the image of the world's contraction brought about by the powers of technology, one cannot help but hear in such words as shrinking (*zusammenschrumpfen*), condensing (*zusammenrinnen*), and diminutive (*kleine Zahlenwerte*) Germany's war for *Lebensraum*. Nor can the reader overlook the irony of these words since the German war machine expanded eastward in its invasion of the Soviet Union. In 1942 Germany was not shrinking, but rather growing by taking over the rest of Europe. Heidegger substitutes real historical events as seen in his shift to the ontological significance of space along with his dismissal of calendrical time.

Heidegger's fetishized narrative surfaces in his simultaneous referencing of and distancing from contemporary historical events that are interspersed throughout his lectures. Although he includes in his "Ister" lectures a scathing attack on Anglo-Saxonism and Americanism and the threat they pose to the homeland, this historical moment ultimately recedes into a mythopoetic relation between the Greeks and Germans: "We know today that the Anglo-Saxon world of Americanism has resolved to annihilate Europe, that is, the homeland [*Heimat*]" (68). While he begins with a particular moment in history to demarcate the uncanny (the war in Europe), Heidegger transforms the threat or danger of losing one's home in the midst of a war into a state of existential homelessness as seen in the figure of Antigone. History (*Historie*) recedes from his analysis of the uncanny as German history and European history are replaced by the history of Being (*Geschichte*). What begins to take shape in this fetishistic narrative is that Sophocles' *Antigone* conceals the real catastrophe unfolding in Europe in 1942 and left unthought in Heidegger's philosophy: National Socialism's conquest of Europe.

Although Heidegger begins his lecture within the catastrophic historical events engulfing Europe, they ultimately disappear from the lectures and are replaced by an ontological catastrophe:

> The most powerful catastrophes we can think of in nature and in the cosmos are nothing in terms of their uncanniness compared to that uncanniness that the human essence in itself is, insofar as human beings, placed among being as such … forget being … The uncanniness of the unhomely here consists in the fact

that human beings themselves in their essence are a *Katastrophe*—a reversal (*Umkehrung*) that turns them away (*abkehrt*) from their own essence. Among beings, the human being is the sole catastrophe, yet here it is at once necessary to remark that we fail to recognize this essential determination of human beings if we devalue the catastrophe as the "disastrous" and evaluate this in turn according to the standards of a pessimistic view of the world. (77)

The turning away and state of forgetting in the above passage point back to the depiction of *Dasein*'s *Abkehr* in *Being and Time*. Confronted with anxiety engendered through the recognition of one's uncanny Being-in-the-world, *Dasein* flees from its uncanny essence into the world of phenomenal relations. Now in his "Ister" lectures this flight, which is a turning-away or forgetting of one's original uncanny nature, is deemed a catastrophe. However, this catastrophe takes on a positive connotation for Heidegger, who sees it as a necessary step in the venture toward the uncanny and Being's mystery.

In the second part of his "Ister" lectures, Heidegger reinscribes the ontological associations of *das Unheimliche* from *Being and Time* into his reading of Sophocles' *Antigone*. He uses the above description of catastrophe to demonstrate exactly what Antigone will eventually rebel against; her act of resistance is not against the state or Creon's unjust law, but she resists the catastrophe of forgetting the uncanny. Heidegger is able to evade the negative implications of catastrophe both in the tragedy and in Europe in 1942, turning the point of catastrophe into a celebration of Antigone's uncanniness. Circumventing the ethical import generally associated with Sophocles' play, Heidegger transforms the threat of losing one's home in the midst of a war into Antigone's state of existential homelessness. Instead of fleeing this experience with the uncanny, she seeks an estrangement from the familiar and heads towards the mystery of Being in her movement towards exile and the tomb.

In one of the most influential studies in German philosophical thought of Sophocles' *Antigone*, Hegel argues that the primary focus of the play rests on the conflict between two laws: Creon's law (the law of the state), which forbids the burial of Antigone's brother Polyneices on punishment of death, is countered by the law of the gods, which requires burial of the dead by the sister (*Phenomenology of Spirit*, 267–89). Antigone disobeys Creon's law in order to comply with the law of burial. To whom does the dead body of Polyneices belong, to the state or the family? Emphasizing the ethical crisis around which the play revolves, Hegel describes how Antigone becomes stateless in her abiding by one law and her rejection of the other. Heidegger, however, implicitly dismisses Hegel's ethical interpretation of the play, and we discern this refutation of Hegel's position within Heidegger's use of quotation marks: he argues that the

play is not about the conflict between "state" and "religion" (*Hölderlin's "The Ister,"* 118). By rejecting the interpretation that suggests Antigone's compliance with the law of burying her brother stems from the gods' unwritten laws, Heidegger distances himself from questions of ethics, mourning for the dead, and the individual's resistance against the state. Instead, his interpretation of the play centers on Antigone's willful journey to her own grave, which Heidegger sees as exemplifying Being-toward-death: the authentic experience tied to Being's uncanniness.

Heidegger's analysis of what is at stake in becoming uncanny begins with a discussion of translation: a process that is uncanny at its core. Focusing almost exclusively on the first choral ode of the tragedy, named the "ode to man," Heidegger maintains that the play becomes a celebration of the "most uncanny" of human beings: Antigone. According to him, the act of translation involves an encounter between what is one's own and the foreign, and his description of translation concurrently provides insights into Antigone's own trajectory within the tragedy. Centering his exegesis on the lines from the chorus, "Manifold is the uncanny, yet nothing / more uncanny looms or stirs beyond the human being" (60), Heidegger reflects on the translation of the Greek word *deinon*. While *deinon* contains multiple meanings such as fearful, powerful, and the inhabitual, for Heidegger, "our word", that is the German word for *deinon*, is *das Unheimliche*, or the uncanny. *Das Unheimliche* is not only the focal point of Heidegger's discussion of translation, the meaning of the word also illustrates the very process of what transpires during translation. The mystery of becoming homely involves the place of translation, where the spirit of one language crosses into another, and he writes, "A historical people *is* only from the dialogue between its language and foreign languages" (65). In Heidegger's reading and translation of Sophocles' *Antigone*, a dialogue unfolds between Germany and ancient Greece. This confrontation (*Auseinandersetzung*) through the act of translating one's own language into the foreign is itself a "detour" (*Umleitung*) in the process of becoming homely (*Heimischwerden*; 65). Homecoming is predicated upon venturing into the foreign, into what is uncanny. With the assistance of Hölderlin's lyric, Heidegger approaches the uncanny in his turn toward the Greek world.

In his analysis of Sophocles, Heidegger remarks, "Every translation is an interpretation. And all interpreting is a translating" (65). Hence, Heidegger too is performing an act of translation through his exegesis of Sophocles' choral ode. In this encounter between one's own and the foreign, Heidegger's interpretation and translation of the choral ode explore the possibilities of becoming historical (*geschichtlich*), where the relation between the way history unfolded for the ancient Greeks makes possible an understanding of how history is experienced today (1942) for the Ger-

mans. If Greek history begins with a departure, the history of the West, specifically Germany, begins with a return or homecoming. But as Heidegger reiterates, this is not a history based on events and calendars, but rather the history of Being.

According to Heidegger, Sophocles' drama focuses on the Greek concept of Being, where Being signifies "the foundation of being-at-home (*Heimischsein*)" (*Hölderlin's "The Ister*," 118). The collision in the tragedy is the opposition not between state and religion, but between two types of the uncanny. In his strictly ontological study of difference, Heidegger presents two divergent ways of not being-at-home. As in his depiction from *Being and Time*, he first describes *Dasein*'s flight into the world of phenomenal experience. This type of being-at-home in earthly interests and an interpretable world, which Heidegger attributes to the realm of the state (*polis*) in *Antigone*, signifies for him a not-being-at-home (*unheimischsein*). He opposes this mode of uncanniness to the more authentic ontological concern with homelessness and estrangement: a being-at-home (*Heimischsein*) as belonging to Being. Signifying the later form of the uncanny, Antigone represents a homecoming that is bound to being unhomely. In her sought-for expulsion from the state, and thus from the human realm, she abandons earthly concerns for ontological ones and turns toward the uncanniness of Being in her movement into the tomb.

In his earlier reading of *Antigone* in *An Introduction to Metaphysics* (1935), Heidegger foregrounds what it is he will do to the text: "The exegete must use violence" (162). We see such a violent exegesis in his reading and translation of Sophocles, where he cuts from his analysis the relevance of Antigone's relation to her dead brother, her resistance to the tyrant's law, the act of burial, and thus the significance of her act of mourning. In addition to his treatment of history in his "Ister" lectures, Heidegger's fetishized narrative continues to unfold in his reading of Sophocles' play, where he dismisses both the ethical import and the role of mourning in the play. This elision of mourning is all the more striking, for it is a focal point that Heidegger consistently returns to in his writings on poetry. Just before his "Ister" lectures and without any explanation of his claim, Heidegger declared in an essay on Hölderlin's "Andenken," "The most joyful in Mourning? The figure and fate of 'Antigone' says enough" (*Hölderlin's "Andenken*," 72). His oppositional formulation "joyful in mourning" indicates what will unfold in his in-depth analysis of Sophocles' tragedy. Turning the theme of mourning into one of celebration, Heidegger contends that Antigone avoids catastrophe because, instead of turning away from the uncanny, she embraces it and thereby becomes homely (*heimisch*).

For Heidegger, the act of memory in the play does not involve remembrance of the dead, but rather manifests itself in Antigone's recollec-

tion of home (*Hölderlin's "The Ister,"* 115). Circumventing the ethical di-
mensions of mourning and burying the dead, Heidegger's omissions signal
as well his ultimate refusal to extend mourning to a historical plain. His
leaving unthought in 1942 Antigone's approach to the body of her unbur-
ied brother provides a telling marker to his own failure to approach all of
those deprived of graves or rendered homeless in the aftermath of the
Holocaust. The fetishized narrative developing through Heidegger's vio-
lent exegesis of the play, a violence that both transforms the historical ca-
tastrophe befalling Europe into Antigone's existential catastrophe and ex-
cises the theme of mourning, leads us back to the absence of the ethical in
Heidegger's analysis. Avoiding any trace of the ethical significance behind
Antigone's act of burying her brother, Heidegger appropriates the play in
order to carry out his own ontological interpretation:

> What Antigone is determined by is that which, first of all, gives to the honoring
> of the dead and to the prerogative of blood its ground and necessity ... The be-
> longing to death and to blood which characterize the human being alone is itself
> determined, first of all, by the human being's relation to death itself. (147)

In addition to the echoes one hears in this passage of an Aryan myth of
"Blut und Boden," the act of burial remains solely an existential, not an
ethical, act. Passing over Antigone's rejection of the tyrant's law forbid-
ding the city to bury and mourn properly the death of her brother, Hei-
degger claims, "We must think beyond the cult of the dead and blood re-
lations and return to the word of Antigone as it is said ... she names being
itself" (118). The dead are neither remembered nor mourned in his read-
ing of the play, and this lapse prefigures his treatment of the historical and
ethical catastrophe in the space of postwar German memory.

By the conclusion of his analysis of Antigone's uncanny essence, Hei-
degger reflects on the polemic between Greek *techne* and modern technol-
ogy (*Technik*). For the ancient Greeks, *techne* designated the making of
something, such as a work of art. In Heidegger's understanding of the
word *techne*, which he juxtaposes to *poiesis*, *techne* makes possible the revela-
tion of Being through poetry. But the destructive force of modern tech-
nology, expressed through its potential danger of reifying the world, signi-
fies for Heidegger the place where the history of Being is not only threat-
ened, but where it could possibly be revealed. Heidegger writes, "Modern
human beings nowhere have an originary 'lived experience' of art works
anymore—but only of the machine and its destructive essence. It is this
that is the 'lived experience' of modern human beings: their sole lived ex-
perience" (114). The essence of *deinon* as experienced in a Greek way
through art (*techne*) is lost and the modern can only confront the abyss of
Being, and thus the possibility of a homecoming, through the devastating

forces of technology. In the dialogue between the Germans and the ancient Greeks, Heidegger believed it was the role of the Germans, in particular its poets, to turn toward the Greek fires and think through the enigma of Being. Heidegger contends, "The journeying into the unhomely must go 'almost' to the threshold (*Grenze*) of being annihilated in the fire, in order for the locality of the homely to bestow that which gladdens and saves" (167). One shudders before the horror of these lines when read through the optics of postwar European thought. The fires that Heidegger approaches remain fixed in their mythopoetic origins, not the war ruins brought about by the powers of technology. In the years after the war, instead of pausing before the abyss left in the wake of National Socialism's fires, in particular the *Kennzeichen*, or sign, of Auschwitz, Heidegger leaps over the abyss, leaving unthought the culminating moment of technology's erasure not of Being, but of human beings.

Memorial Address

On October 30, 1955, Heidegger was invited to give a commemorative speech in his hometown of Messkirch for the 175th birthday of the composer Conradin Kreutzer (*Gelassenheit*).[17] The address was titled "Gelassenheit," which literally means releasement or a letting go. Heidegger's first expression to his audience is "a word of thanks," and we recall the link he makes in *What is Called Thinking?* between thinking (*Denken*), thanking (*Danken*), and remembrance (*Andenken*). Reflecting on the threat to meditative thought, Heidegger considers how "calculative thinking" (*das rechnende Denken*) is replacing "meditative thinking" (*das besinnliche Nachdenken*). Again, he moves from thanking to a discourse on thinking, whereby the *Gedenkrede* becomes first and foremost a reflection on the relation between commemoration, thinking, and history. He stresses several times "the here and now" of the occasion and invokes the historicality of the time about which he is reflecting: "It is enough if we dwell on what lies close and meditate on what is closest; upon that which concerns us, each one of us, here and now; here on this patch of home ground; now, in the present hour of history (*Weltstunde*)" (*Discourse on Thinking*, 47). Addressing his German audience, Heidegger's emphasis is on a definitive historical moment and place; the "*nach*" of *Nachdenken*, the here and now of the speech, points to Germany in the aftermath of the Second World War. He admonishes his audience to be attentive to his address and not just entertained by what they hear: "Thus even a memorial address gives no assur-

17 A translation of *Gelassenheit* is found in Heidegger's *Discourse on Thinking*, 43–57.

ance that we will think at a memorial celebration"; and he continues, "Man today is in flight from thinking" (*auf der Flucht vor dem Denken*) (44–45).

In a speech that considers the importance of "thoughtful reflection" we cannot help but hear the irony in Heidegger's use of the word "Nach-denken" throughout his text. In both this *Gedenkrede* and the thirty years of philosophical writings after the liberation of the death camps, he fails to think the "Nach" of Auschwitz. Heidegger once again keeps silent by forgetting to remember the victims of the extermination. Focusing exclusively on what happened to Germany and the Germans *after* the war, Heidegger indefinitely postpones the "post" of the traumas inflicted by the National Socialists. In effect, the speech manifests a constitutive moment where Heidegger's narrative fetishism unfolds in relation to the uncanny. He asserts that the flight from thinking is indicative of *das Unheimliche*: "Thoughtlessness is an uncanny visitor who comes and goes everywhere in today's world" (45).

After celebrating his homeland (*schwäbischer Boden*) as the ground from where great "Dichter und Denker" have come, Heidegger continues by extolling the greatness of "East Prussia, Silesia, and Bohemia," territories that were lost in the war's aftermath. At this moment he begins to move into the space of uncanniness in a historical sense of the term, as these place names evoke the loss of home and of being *unheimlich*:

> Many Germans have lost their homeland, have had to leave their villages and towns, have been driven from the native soil (*vom heimatlichen Boden Vertriebene*) … They are strangers now to their former homeland (*Sie sind der alten Heimat entfremdet*). And those who have stayed on in their homeland? Often they are still more homeless than those who have been driven from their homeland (*die Heimatvertriebene*). (48)

He confines his brief albeit revealing historical analysis of the homeless and those forced out of their homes to the Germans. Throughout his address Heidegger will repeat the phrase "we grow more thoughtful and ask …," and although he names this single historical event of Germans being removed from their homes in the aftermath of the war, he fails to acknowledge or reflect upon the events which preceded the expulsion of Germans from the eastern territories (48). Heidegger may name and praise the cultural contributions of Silesia, but he evades the fact that Auschwitz, "the Silesian slaughterhouse," is also located here (Vidal-Naquet, 175).

In addition to those people who have become estranged (*entfremdet*) through forced eviction in the aftermath of the war, Heidegger portrays how technological advancements in modes of communication also endanger those who stayed in their homes. In a description reminiscent of the approach of anxiety in *Being and Time*, the instruments of communication

"assail" us from no specific direction. Heidegger repeats the word "closer" to convey this looming threat for which we cannot prepare ourselves: "Much closer to man today than his fields ... closer than the sky over the earth ... closer than the change from night to day ... closer than the tradition of his native (*heimatlichen*) world" (*Discourse on Thinking*, 48). In the following lines Heidegger conveys how technology spatially confines us: "In all areas of his existence, man will be encircled even more tightly (*enger*) by the forces of technology," and ultimately he names atomic power as the greatest technological threat to the world, for it has the capacity to annihilate (*vernichten*) everything (51).

Like in his "Ister" lectures, Heidegger again employs an historical moment as a springboard to move into his discussion of the history of Being. Asking his audience what has happened to those driven from their homes (*Heimatvertriebene*) and to those who stayed at home (*Heimat Gebliebene*), he answers that their autochthony (*Bodenständigkeit*) has become threatened by technology. He continues to probe the ontological implications of technology presented in his "Ister" lectures:

> We do not know the significance of the uncanny increasing dominance of atomic technology. It is not that the world is becoming entirely technical which is really uncanny. Far more uncanny is our being unprepared (*nicht vorbereitet*) for this transformation, our inability to confront meditatively what is really dawning in this age. (52)

Heidegger now links the concept of anxiety to technology, where the uncanny springs from our lack of preparation to confront meditatively technology's threat to the world. Unable to think through the implications of technology's expansion, we read and hear but do not understand this threat because of the speed in which we are receiving the information. Eventually, Heidegger's historical reflection moves from Germany and the aftermath of the war to what he calls the symbol of the modern age: the symbol (*Kennzeichen*) of the atom bomb (49). For him, we fail to think about the meaning of this symbol: "We forget to ask: what is the ground that enabled modern technology to discover and set free new energies in nature?" (50). The question becomes the point in the speech in which *Nachdenken*, thinking after and about the rupture of the extermination camps in relation to the uncanny, could transpire.

A militaristic tone punctuates "Gelassenheit," in which the world becomes an object (*Gegenstand*) that calculative thinking attacks (*Angriffe ansetzt*), and the German homeland is overcome by a sense of homelessness in the aftermath of the war. But Heidegger ultimately distances himself from the effects of war. The threat of atomic energy no longer stems from its military use (*ohne kriegerische Handlungen*), but rather from the risk that its

energies will break free and exterminate everything (*alles vernichten*) (51). Once again, like his opening remarks in the "Ister" lectures from 1942 when America and England threatened Germany's home, Heidegger focuses on scientists from these two countries: the driving forces behind technology. America and England, not Nazi Germany, are the perpetrators who have unleashed this power and who represent the enslavement of the world through technology.

In one section of "Gelassenheit" the attentive listener hears by way of association Heidegger's infamous comments regarding the death camps from his 1949 lectures in Bremen. The ground (*Boden*) itself has been rendered uncanny through technology's link to the farming industry, and Heidegger claims that,

> Farming and agriculture, for example, now have turned into a motorized food industry ... There is then in all technical processes a meaning, not invented or made by us, which lays claim to what man does and leaves undone. We do not know the significance of the uncanny increasing dominance of atomic technology. *The meaning pervading technology hides itself.* (54–55)

Farming and atomic bombs are for Heidegger symptomatic of technology's uncanniness. In 1949 he had made the comparison between agriculture, atomic weapons, and the gas chambers: "Agriculture is now a mechanized food industry, in essence the same thing as the production of corpses in the gas chambers and extermination camps, the same thing as blockades and the reduction of countries to famine, the same thing as the manufacture of the hydrogen bomb" (see Sheehan). Six years later in "Gelassenheit," Heidegger edits from this analogy the role of the death camps, and it seems that what he "lets go of" in an essay about reflective thought, technology, and *Vernichtung* is not just recognition of Germany's involvement in the extermination, but that the extermination even transpired. Heidegger's textual transformation becomes consistent with an act of effacement. The removal from "Gelassenheit" of his remarks about the gas chambers in his Bremen lectures witnesses to Heidegger's own act of concealment or willful silence (*Verschwiegenheit*) regarding the Holocaust. [18]

Toward the end of "Gelassenheit" the threat of technology from which the meditative subject flees eventually dissolves. As he had indi-

18 Heidegger's re-writing and editing of his texts arises again in the question of whether or not he inserted a parenthetical comment in his *Introduction to Metaphysics*, where he praised "the inner truth and greatness" of National Socialism. He had claimed that in the original text to his 1935 lecture he had included in parentheses after this controversial statement that he was referring to "the encounter between planetary technology and modern man" (199). While this statement about technology can be read in his 1953 published version of *An Introduction to Metaphysics*, there is no proof that it appeared in the text he presented in 1935; the original page of the manuscript is missing (see "Only a God Can Save Us," 104).

cated ten years earlier in his "Ister" lectures, technology's uncanniness becomes the new ground (*Bodenständigkeit*) through which Being could be revealed by way of meditative thinking. *Das Unheimliche* shifts from something threatening to something salvific. The loss of home conveyed in *das Un-heimliche* is replaced with the sought-for home in the mystery (*Geheimnis*) of Being, a mystery that is disclosed through meditatively thinking about the meaning hidden in technology (*Discourse on Thinking*, 55–56). In Heidegger's metahistorical and fetishized narrative, the revelation of Being finds its origins in the lost experience of Being for the Greeks and culminates in its disclosure through a reflection in Germany on technology's dangers. Transforming Germany into a victim as seen in the loss of the eastern territories, Heidegger replaces the dominating symbol of Germany's technology—the industrialized killing of millions—with the sign of the atomic bomb.

According to Santner, a fetishized narrative contributes to "an inability or refusal to mourn" ("History Beyond the Pleasure Principle," 144), and we can see this in the failed work of mourning in Heidegger's philosophy of Being; the looping configuration of Being's loss compulsively repeats its structural traumas (forgetting, the return of *das Unheimliche* and *Angst*) within the fetishized narrative of the German *Heimat*. While a dating or historicization of trauma is imperative, Heidegger focuses on the wrong trauma. Instead, he inserts into his narrative the German homeland and its people as the only victims of the war. Heidegger's ethical collapse stems from his failure to expand his position as a historical witness and respond to the series of catastrophes that led to the traumas inflicted upon the German homeland.

Unlike the turn from *das Unheimliche* to *zuhause* in *Being and Time*, where *Dasein* "forgets" Being (339), Heidegger finds in technology the place where the mystery (*Geheimnis*) of Being could potentially reveal itself. Yet *Dasein* (or the meditative thinker) is not ready (*nicht vorbereitet*) to confront the uncanny that emerges in the world's swerve toward technology (*Discourse on Thinking*, 52). Heidegger's description from "Gelassenheit" of the failure to prepare for the uncanny hearkens back to the belatedness found in *Being and Time*, where he refers to the moment of vision (*Augenblick*) when one would be prepared for anxiety as the "preparation for anxiety" (*Bereitschaft zur Angst*; 296). With echoes of Freud's *Angstbereitschaft*, Heidegger describes a disposition of postponement. The delayed moment is a mark of belatedness, where the "now" of *Angst* is withheld, and "The moment (*Augenblick*) of Being is a phenomenon which cannot be clarified in terms of the 'now' (*das Jetzt*)" (338). As *Dasein* tries to encounter itself in its uncanniness, the acquisition of this moment is not definite but only

possible, "The present (*Gegenwart*) of anxiety holds the moment of vision (*Augenblick*) at the ready (*auf dem Sprung*)" (344).

One detects in the movement from *Being and Time* to "Gelassenheit" a continuity that passes through his "Ister" lectures, where Heidegger describes how the uncanny human being "experiences everything yet remains without experience, insofar as it is unable to transform that which it has made its way through into an experience that would let it attain any insight (*Einsicht*) into its own essence" (*Hölderlin's "Der Ister,"* 75). Something remains unseen. The original moment when Being was disclosed signifies the lost experience not yet configured as a memory. Similar to Freud's depiction of trauma, the emphasis is again on the quintessential characteristics of failed vision, violated spatial boundaries and a lost experience: something makes its way through (*Durchgemachte*) but cannot be rendered into an in-sight (*Ein-Sicht*). The lost experience of being thrown into the world becomes the existential traumatic moment for *Dasein*.

The forgetting of Being, which designates the failure of *Dasein* to confront its own uncanniness, manifests itself not simply in *Being and Time*, but this existential trauma ultimately becomes displaced by Heidegger onto the space of traumatic history as seen in both his war-time and post-war writings on the uncanny. But Heidegger does not hear his own call to remember and meditatively think "the present hour of history." Habermas writes, "If his talk of an 'essential happening' had any meaning at all, the singular event of the attempted annihilation of the Jews would have drawn the philosopher's attention" ("Work and Weltanschauung," 449). In Heidegger's notorious remarks from his Bremen lectures, Auschwitz loses its singularity and is merely conjoined with other forms of technology: agriculture, the mechanized food industry, and the atomic bomb. By failing to date (*Zeitangabe*) the here and now of the historical catastrophe (*Being and Time*, 408), he turns away from the role of historical witness. This omission is all the more unpardonable considering both his complicity during the early years of National Socialism and what Berel Lang aptly names Heidegger's "virtual silence," which refers to his inadequate responses after the war.[19] Although it is the danger of *Vernichtung* that prompts Heidegger's *Nachdenken*, and the receptive listener cannot fail to hear *Vernichtungslager* (extermination camp) in Heidegger's choice of words, the event of Auschwitz never becomes an object of anxiety.

Returning from his prohibition to teach in Germany in the years after the war, Heidegger investigates the link between thinking (*Denken*), remembrance (*Andenken*), and memory (*Gedächtnis*) in his 1951/52 lectures

19 For an excellent examination of this interplay between Heidegger's silence and the moments when he was provided with the chance to speak about the events of the Holocaust, see Lang's *Heidegger's Silence*, 22.

from *What Is Called Thinking?*, which begins with a discussion of Hölderlin's poem "Mnemosyne" and the fear of losing one's language in foreign lands. In his lectures from the summer of 1952, Heidegger's focus shifts momentarily from mythic spaces to contemporary German history as he encourages those present in his lecture to visit a photo exhibition on German prisoners of war and to listen to their "soundless voice." He writes immediately after his recommendation,

> Thought is remembrance [*Andenken*]. But remembrance is something other than an ephemeral realization of the past. Remembrance is concerned with what affects us. We are not yet in the proper space to reflect [*nachzudenken*] upon freedom, or even speak of it, so long as we also shut our eyes to this annihilation [*Vernichtung*] of freedom. (*Was heisst Denken?* 159)[20]

The *Vernichtung* that Heidegger alludes to here, similar to his use of the term in "Gelassenheit," revolves around the victimization of the Germans in the war's aftermath; the "*Vernichtung* of freedom" gestures toward the German POWs imprisoned and deprived of freedom in Soviet prisons, not the one perpetrated by Germany under the reign of National Socialism. Heidegger hears in Hölderlin's "Mnemosyne"—a poem that starts with the near loss of speech and concludes with the death of memory and the loss of mourning—the "soundless voice" of Germany's exiled soldiers. He appeals to the conscience of his audience to remember those homeless compatriots who find themselves exiled in the Soviet Union. Despite his own warnings about the "fleeting actualization of the past," Heidegger's reflections on Germany's recent history function to efface any recollection of Germany's genocidal actions during the Third Reich.

The philosopher who stressed the importance of meditative thinking leaves unthought the event of Auschwitz. Scholars who claim that Heidegger responded to Auschwitz often turn to his reflections on silence from *Being and Time*, where the call of Being does not report events, but instead remains silent. Heidegger writes, "Keeping silent has been characterized as an essential possibility of discourse. Anyone who keeps silent when he wants to give us to understand something, must 'have something to say'" (296). Providing an ontological solution for an historical crisis, critics claim that silence was the philosopher's appropriate form of response. The ontological crisis (loss of Being) is conflated with an historical catastrophe. One such apologist is William Vaughan. Detecting a correspondence between the use of silence in Heidegger and Celan, Vaughan attempts to vindicate Heidegger's silence and claims that there is a needful

20 It is interesting to note that this passage was not included in the English edition of *What Is Called Thinking?*

silence that belongs to Heidegger's conception of language in relation to the Holocaust and witnessing:

> Only a listening can emerge for the later Heidegger, a reticent, deafening listening which is not the absence of speech but the condition of its possibility, a needful silence that belongs to language. Perhaps, in turn, we cannot grasp the holocaustal as well. Perhaps such a witnessing does not occur in the fullness of the poet's expression, nor is even about the power of language so much as our relation to it. It is about the breaking off of such, the abdication, a secret allegory of *Gelassenheit.* (95)

Vaughan's depiction of Heidegger's silence, the question of witnessing, and *Gelassenheit,* bear the hallmarks of an ontological approach to the Holocaust. By sidestepping the ethical import behind Heidegger's failure to respond to Celan, Vaughan seems to maintain the ontological primacy of the death camps, whereby a response is placed in abeyance. Ultimately, Vaughan reflects on how Heidegger's silence mirrors the silence of Celan's poetry. He conflates Heidegger's concept of silence (*Verschwiegen*) with that of Celan's silence (*Verstummen*). Yet there is an essential difference between these two modes of silence. Heidegger's *Verschwiegen* connotes a decision or will not to speak, not the impossibility of speech (*Verstummen*). *Verschwiegen* also suggests the idea of suppressing, keeping secret, or hiding something. It is a silence that shows the possibility of speech. The imposition of silence comes from within the subject, not from external constraints. When Heidegger did speak about the Holocaust, such as his remarks about the mechanized food industry, atom bombs, and the gas chambers, his language merely concealed the unique catastrophe and horror of the Judeocide.[21]

Vaughan, I believe, is correct in associating the breaking off of this relation to the poet's language with the fragility of witnessing. Where the response falters, we must try to discern something in our listening to a "needful silence." The emphasis shifts from Heidegger's task of respond-

21 See also Heidegger's postwar correspondence with his former student Herbert Marcuse in 1947/48. Marcuse, a German-Jewish émigré, had visited Heidegger's cabin in Todtnauberg in search of a word from him, which he did not receive. In a series of letters Marcuse confronted Heidegger on his silence regarding Nazism and its persecution and extermination of European Jews. Heidegger responded by shifting the discussion from the Jewish victims to East Germans and writes, "To the serious legitimate charges that you express 'about a regime that murdered millions of Jews, that made terror into an everyday phenomenon, and that turned everything that pertains to the ideas of spirit, freedom, and truth into its bloody opposite,' I can merely add that if instead of 'Jews' you had written 'East Germans' [i.e., Germans of the eastern territories], then the same holds true for one of the allies, with the difference that everything that had occurred since 1945 has become public knowledge, while the bloody terror of the Nazis in point of fact had been kept secret from the German people" (Wolin, 163).

ing to Celan's ruptured lyric to our own attempts to listen for a postponed word in Heidegger's silence. Although he reads in Heidegger's silence a recognition of the impossibility of witnessing, Vaughan bypasses the moments when Heidegger broke his silence, was not reticent but had, as previously shown, addressed the disclosure of the camps. What makes Heidegger's refusal to bear witness to the catastrophe unfolding in Celan's lyric even more disturbing is that he had in fact stressed the necessary link between witnessing, history, and *Dasein* in relation to poetic language in "Hölderlin and the Essence of Poetry."

Heidegger writes, "Who is human? He who must bear witness to what he is (*zeugen muss*) ... Man is *he* who he *is*, precisely in the testimony (*Bezeugung*) of his own existence ... Being a witness (*das Zeugesein*) as a belonging together with entities as a whole occurs as history" (*Existence and Being*, 274; trans. modified). By placing the death camps alongside the atom bomb and mechanized farming, Heidegger breaks his silence. What we hear then in his response is not a "secret allegory of *Gelassenheit*," where releasement opens up the possibility of Being's revelation; instead, the attentive listener detects between the lines of "Gelassenheit" a self-censoring, or the trope of aposiopesis, the breaking off of speech that points not to an impossibility of witnessing but to Heidegger's willful concealment of history.

Having analyzed some of the key components behind Heidegger's understanding of the uncanny, I am now in a position to explore in the next chapter how Celan traverses the pathway of Heidegger's thoughts on poetry and the uncanny. In the second part of my examination of the poet and philosopher, I reveal how Celan probes Heidegger's philosophy and thinks through the very imperative Heidegger had formed but had refused to fulfill. Celan enters the foreign in order to arrive at "Eine Art Heimkehr" (*Gesammelte Werke*, 3:201); it is a type of homecoming that must first go through the quintessential German thinker of the twentieth century whose philosophy of home and the uncanny did not pause to think through the catastrophe of the Holocaust. But, to use Heidegger's own formulation, Celan's "violent exegesis" of Heidegger's uncanny (*Introduction to Metaphysics*, 162) does not force his ontological system into an ethics. While Celan might double and repeat Heidegger's terminology on the uncanny in both his Bremen and his Büchner Prize speeches, he is ultimately dissecting Heidegger's philosophy and interspersing its traces throughout the speech. Guiding his reader down the familiar paths of Heidegger's uncanny, Celan not only brings to the surface the very ethical failures embedded in Heidegger's philosophical thought, he also leads his audience into an entirely other place: the abyss of the Holocaustal uncanny.

Chapter 3

Broken Meridians—From Heidegger's *Pathway* to Celan's *Judengasse*

Almost a decade before his meeting with Heidegger and his writing of the poem "Todtnauberg" that commemorated his failed encounter with the philosopher, Celan, in his Bremen Prize and Georg Büchner Prize speeches (1958 and 1960, respectively), critiqued Heidegger's and Germany's evasion of the Holocaust. The recipient of the Georg Büchner Prize is habitually asked to make a speech that delineates his/her understanding of literature. In his speech, which is also called "The Meridian Speech," Celan establishes the connection between the uncanny and the Holocaust. A meridian is a topographic term that designates two poles (the north and south poles) connected by a line traversing the equator. For Celan, the term refers to the multiple poles that comprise his poetry and lead to a possible encounter with the Other, namely art and poetry, forgetting and memory, self and Other, and home and the uncanny. In the opposition between art and poetry, art stands for mimesis, forgetting, and the uncanny. Poetry, however, follows art's uncanny path in order to break free of representation, albeit for only a brief moment, in its search for the Other and recollection of a date. At this juncture between art and poetry another type of uncanny arises, and Celan links this mode of the uncanny to the Holocaust.

In his interpretation of *Antigone*, Heidegger also speaks of poles when he writes, "Perhaps the *polis* is that realm and locale around which everything question-worthy and uncanny turns in an exceptional sense. The *polis* is the *polos*, that is, the pole, the swirl (*Wirbel*) in which and around which everything turns" (*Hölderlin's 'The Ister,'* 81). Heidegger's discussion of the *polis* ("state") takes him away from the political and to the ontological pole (*polos*) of a rotation around which the uncanny reveals itself. At the site of this pole, the human being (*Mensch*) turns away from the realm of other beings and toward the uncanny in what Heidegger calls a counterturn (*Gegenwendigkeit*; 86–87). Distancing himself from a catastrophic history unfolding before him in 1942, Heidegger explicitly asserts in his discussion of the *polis* that he is neither concerned with the political nor

interested in any connection between the polis and the politics of National Socialism (86). Instead, the *polis* signifies the site of Being's uncanniness. In his analysis of *Antigone* there is a suspension of thinking about both ethics and the political as Heidegger presents questions regarding onto-logical difference. The *polis* marks the site of history, and, as previously discussed, by history Heidegger means the disclosure of Being's mystery.

Although the poles of Celan's "Meridian Speech" also rotate around the concept of the uncanny and constitute a counterturn that disrupts po-etry and that Celan names his *Atemwende* (Breathturn), he recognizes, unlike Heidegger, that these poles are political at their core.[1] The intersect-ing lines of his meridian lead the Eastern European Jew who lived in exile in Paris to a possible encounter with the Other. Standing before his Ger-man audience as the trace of the foreign, Celan uses the forum of this ceremony to address his audience about thinking and remembering the uncanny's relation to the roots of historical homelessness. Celan is himself the remnant from out of this uncanny site; he is the Jewish Other who confronts his German audience with irrecuperable loss and the task of memory.

Bremen's Ghost

The uncanny movement that unfolds in Darmstadt, where Celan was awarded the Büchner Prize, is prefigured by the speech he delivered in 1958 on the occasion of receiving the Bremen Prize for Literature. No-where is the visitation by a specter, which is emblematic of an uncanny re-turn, more evident in Celan's oeuvre than in his Bremen speech. In his compact, two-page speech, the poet discusses the trajectory—topograph-ic, literary, and historical—that both he and his poems had to follow in order to reach the city of Bremen. In his exceptional reading of Celan's poetry, Derrida asserts, "[t]he poem must lose its secret" in order for the process of remembrance to transpire. Contrary to claims that the meaning behind Celan's poems is hermetically sealed within their crypts, the poem's inscription must become readable so that "the danger of the abso-lute crypt" does not dissolve into something repressive ("Shibboleth," 43). Derrida is very close in his analysis to Abraham's "Notes on the Phan-tom":

> The phantom is meant to objectify, even if under the guise of individual or col-lective hallucinations, the gap that the concealment of some part of a loved one's

1 For an analysis of the political import behind Celan's lyric and his "Meridian Speech," see Marlies Janz's *Vom Engagement absoluter Poesie.* Janz approaches the political significance be-hind Celan's texts from an Adornian perspective.

life produced in us. The phantom is, therefore, also a metapsychological fact.
Consequently, what haunts are not the dead, but the gaps left within us by the
secrets of others. (Abraham and Torok, 171)

The phantom marks the recollection of an absence; the revenant's figure
is the perfect image of erasure, whereby the ghost enacts its own vanish-
ings and returnings. In Bremen Celan becomes the phantom who imparts
to the Other, his German audience, a secret. Standing before this audi-
ence, he functions as a metonymic sign of the absent community. In ac-
cordance with de Man's description of *prosopopeia*, Celan is the "voice from
beyond the grave" that needs to convey its secret (see de Man, "Autobiog-
raphy as De-Facement," 75–76).

While he was making his way to Bremen to accept its prestigious liter-
ary prize, Celan was all too aware that Germany was evading its past. His
concerns that the specters of National Socialism were still present in
Germany are echoed by Adorno in his influential essay "What Does Com-
ing to Terms with the Past Mean?" (1959). Reflecting on the persistence
of National Socialism in the postwar years in Germany, Adorno discusses
the tendency by those in the Federal Republic to free themselves from the
past and claimed that the "effacement of memory is more the achieve-
ment of an all-too-wakeful consciousness than it is the result of its weak-
ness in the face of the superiority of unconscious processes" (117). He
underscores the figure of those who remained silent by noting caustically,
"In the hangman's house one shouldn't speak of the noose; otherwise,
you wind up with ressentiment" (115). While politicians as well as the
public might have been conscious of what had transpired during the pre-
vious decade, Germany's non-confrontation with the past was assisted by
the avoidance of open discussion of the Nazi crimes.

The role of the Holocaust in postwar German political memory was
minimal during this period. Throughout the 1950s silence seemed to be a
pre-condition for German democratization. Although financial restitution
was key to the process of *Wiedergutmachung*, an active seeking of justice for
Nazi crimes was lacking. Not only was an amnesty program for those who
were accused of Nazi crimes strongly supported in Germany, the Adenau-
er administration also included former Nazis within the government. A
series of scandals in West Germany occurred as members of the judiciary
and diplomatic sectors of the government became tainted by accounts
about their Nazi past.[2] Furthermore, an era of silence reined over the
commemorative events throughout the decade, and there was a tendency

2 One of the most high-profile cases was Adenauer's appointment of Hans Globke as his
 chief of staff. Globke had been a high-ranking member of the Nazi government who helped
 with the establishment of the Nuremberg race laws.

to conflate all who died during the war: the victims of fascism included those who died during Allied bombings, German soldiers killed at the front, German civilians forced to leave their homes, and individuals murdered in the death camps. This merging of all the victims of the war was especially prevalent in East Germany, where politicians equated Dresden with Auschwitz during official commemorations. Finally, anti-Semitic tendencies still seemed present in German society. On the evening of December 25, 1959, the newly consecrated Cologne synagogue was desecrated with swastikas, and in the months afterwards a rash of swastikas sprung up throughout Germany.[3]

Keeping track of these events through the news media, Celan wrote to the German-Jewish poet Nelly Sachs who lived in exile in Sweden, "Cruelty comes daily into my house daily, believe me" (Celan/Sachs, 14). On top of the above-mentioned events, Celan was troubled on a personal level by what he perceived as anti-Semitic attacks against him and his poetry. In particular, he was incensed by a review of his collection *Sprachgitter* (Speech-Grille) by the literary critic Günther Blöcker, who, ignoring the historical components of his poems, described Celan's "Todesfuge" and "Engführung" as "contrapuntal exercises written on music paper" (*Gisèle Celan-Lestrange* 2:116). Again sharing his anxiety and anger with Sachs, Celan writes, "Ah you have no idea of the situation in Germany these days" (Celan/Sachs, 17). This cloud of suspicion through which Celan viewed Germany's relation to him and his poems permeated his trip to Bremen.[4]

By inviting Celan to accept his prize, the city in effect conjures up a shade from a dead community and bids him speak. We remember from Freud's essay that the uncanny refers to something that should have remained covered or repressed but rises to the surface. In Bremen, Celan describes how the German language comes to the light of day from a crypt-like space (*wieder zutage treten*), accompanied by its ghostly poet, who stays with his language as it passes through the darkness of history (*Gesammelte Werke*, 3:186). Leading his audience to the land of the dead, Celan shows how the German language was itself wounded by this traumatic history.

Was the granting of the literary prize to Celan an attempt by the Germans to free themselves from the weight of the past, as if to ease Germany's own conscience and to expiate its crimes? Moreover, does this recognition of a Jewish poet in the aftermath of the Holocaust necessarily constitute a remembrance of the past and its victims? Celan, I believe, does not think so, for his concise speech revolves around the subject of

3 For a detailed account of political memory in postwar Germany, see Jeffrey Herf's *Divided Memory*.
4 See also Felstiner's *Paul Celan*, 147–49.

memory, in particular how the German language recalls its catastrophic past. Celan's speech in Bremen, the same city where Heidegger gave his lectures on technology comparing the gas chambers to the atomic bomb and the mechanized food industry in 1949, serves to subvert any therapeutic space of mourning for his audience. He refers to the German language as "our language" (*Collected Prose*, 33), and his use of the possessive pronoun is revealing; although his mother tongue was indeed German, the Romanian-born poet, who fled his home in the Bukovina through Hungary at the end of the war, stopping-over in Vienna and finally residing in exile in Paris, was a polyglot. Since he lived in Paris and was an avid translator of French poetry, one might have expected him to write primarily in French. His decision to write in German can also be read as a political gesture, and one recalls his assertion, "Only in one's mother tongue can one express one's own truth. In a foreign language the poet lies" (Chalfen, 148). In employing the language of his mother, Celan chooses to enter a conversation with those responsible for the death of his parents and the destruction of his home.

While the speech begins as an analysis of the etymological links between "thinking and thanking" (*Denken und Danken*) and their connections to "to bear in mind" (*eingedenk sein*), "devotion" (*Andacht*), and "remembrance" (*Andenken*), it soon shifts direction to the landscape of the poet's origins, which Celan connects to the setting of Buber's Chassidic tales. Celan's discussion of the etymology of "thinking and thanking" draws Heidegger's *What Is Called Thinking?* immediately into the speech along with his claim that the history of words "gives us a direction."[5] The opening of the Bremen speech has an anxious and desperate tone as the poet, moving back and forth between the past and present, searches for his origins. The speech's unsettling movement seems more like a re-enactment of a search than its retelling.

Die Landschaft, aus der ich—auf welchen Umwegen! aber gibt es das denn: Umwege?—, die Landschaft, aus der ich zu Ihnen komme, dürfte den meisten von Ihnen unbekannt sein. Es ist die Landschaft, in der ein nicht unbeträchtlicher Teil jener chassidischen Geschichten zu Hause war, die Martin Buber uns allen auf deutsch wiedererzählt hat. Es war, wenn ich diese topographische Skizze noch um einiges ergänzen darf, das mir, von sehr weit her, jetzt vor Augen tritt,—es war eine Gegend, in der Menschen und Bücher lebten. Dort, in dieser

5 Heidegger, *What Is Called Thinking?*, 137. See also Christopher Fynsk's "The Realities at Stake in the Poem." Fynsk addresses the extent to which Celan pursues Heidegger's philosophical concepts (*Technik*, *Ereignis*, *Gegend*, and *Mitsein*, to name a few) in his two speeches. My reading of Celan's "Meridian Speech" has benefitted greatly from Lacoue-Labarthe's essay "Catastrophe," especially where he analyzes the uncanny in relation to Celan's speech. However, whereas Lacoue-Labarthe does not see an ethics unfolding in Celan's speech, later in this chapter I explore how the catastrophe of the uncanny in Celan is at its core ethical.

nun Geschichtlosigkeit anheimgefallenen ehemaligen Provinz der Habsburger-
monarchie, kam zum erstenmal der Name Rudolf Alexander Schröders auf mich
zu. (*Gesammelte Werke*, 3:185)

The region from which I come to you—with what detours! But then, is there
such a thing as a detour?—will be unfamiliar to most of you. It is the home of
many of the Hassidic stories which Martin Buber has retold in German. It was—
if I may flesh out this topographic sketch with a few details which are coming
back to me from a great distance—it was a landscape where both people and
books lived. There in the former province of the Habsburg monarchy, now
dropped from history, I first encountered the name Rudolf Alexander
Schröder.... (*Collected Prose*, 33)

Celan constructs a boundary between history and fiction, between his de-
stroyed home fallen from history and Buber's tales, and crosses back again
into the historical with his reflections on "what happened" (*was geschah*;
Gesammelte Werke, 3:186). He traverses these boundaries and it is as if he
not only climbs out of the realm of books but out of these historical ruins
as well. The poet violates the space between fiction and reality along with
the border between historical erasure (the Bukovina, 1942) and historical
presence (Bremen, 1958). He constructs a topographical frame in which
the destroyed East of Europe is located, and it is from this site that his
travels to Bremen originate. Belonging to a home fallen from history (*an-
heimgefallen*), Celan goes across this frame and embodies the return of the
repressed: something effaced re-appears, and what was buried in the un-
conscious begins to rise to the surface. The poet, standing before this au-
dience, functions as an uncanny trace that points back to the annihilation,
to the landscape where Buber's tales—and the poet himself—were once
at home (*zuhause*); it is an area that is now *unheimlich*.

The poem, which Celan refers to as an "instance of language" (*Er-
scheinungsform der Sprache*), emerges like a ghost from an historical abyss to
Bremen:

Erreichbar, nah und unverloren blieb inmitten der Verluste dies eine: Die
Sprache. Sie, die Sprache, blieb unverloren, ja, trotz allem. Aber sie musste nun
hindurchgehen durch ihre eigenen Antwortlosigkeiten, hindurchgehen durch
furchtbares Verstummen, hindurchgehen durch die tausend Finsternisse todbrin-
gender Rede. Sie ging hindurch und gab keine Worte her für das, was geschah;
aber sie ging durch dieses Geschehen. Ging hindurch und durfte wieder zutage
treten, "angereichert" von all dem. (*Gesammelte Werke*, 3:185–86)

Only one thing remained reachable, close and secure amid all losses: language.
Yes, language. In spite of everything, it remained secure against loss. But it had to
go through terrifying silence, through the thousand darknesses of murderous

speech. It went through. It gave me no words for what was happening, but went through it. Went through and could resurface, "enriched" by it all. (*Collected Prose*, 34)

The movement of language in Bremen, unlike Heidegger's transhistorical depiction of poetic language, is indeed contingent on history, and Celan repeats "durch" eight times. There is no rising above, but only a going through time. In addition, juxtaposing "reachable" (*erreichbare*) and "thousand" (*Tausend*), he encodes the echo of a "Thousand Year Reich" in the passage. In this "terrifying silence" (*furchtbares Verstummen*) of the "thousand darknesses of death-bringing speech" (*tausend Finsternisse todbringender Rede*), language cannot give name or word to "what happened" (*was geschah*). Even though language may not have been lost, Celan is still unable to provide a proper name to the event. Instead, he comes up with his own term for the Holocaust: "this Happening" (*dieses Geschehen*). In this space devoid of light where something happened, language goes through a wounding. The death-bringing speech that had once marked his own exclusion is re-appropriated by the poet, and now materializes into the language in which he writes his poems.

Heideggerian echoes in relation to memory and thinking abound throughout Celan's speech. But while we may hear in his use of the word "devotion" (*Andacht*) an allusion to the place of a gift in the heart formulated by Heidegger, where the heart is the location of memory—"The heart, thus giving thought and thus being memory, gives itself in thought to that to which it is held. It thinks of itself as beholden (*hörig*) ... because its devotion is held in listening. Original thanking is the thanks owed for being" (*What Is Called Thinking?*, 141)—the direction of Celan's poem swerves away from any ontological precept and toward a potential encounter with the Other:

> Das Gedicht kann ... eine Flaschenpost sein, aufgegeben in dem—gewiss nicht immer hoffnungsstarken—Glauben, sie könnte irgendwo und irgendwann an Land gespült werden, an Herzland vielleicht. (*Gesammelte Werke*, 3:186)

> A poem ... may be a letter in a bottle thrown out to sea with the—surely not always strong—hope that it may somehow wash up somewhere, perhaps on a shoreline of the heart. (*Collected Prose*, 34–35)

The poem heads toward, "something open, inhabitable, an approachable you, perhaps an approachable reality" (*Auf etwas Offenstehendes, Besetzbares, auf ein ansprechbares Du vielleicht, auf eine ansprechbare Wirklichkeit*), and one may recall that for Heidegger the Open was simultaneously the place where Being originated and the site of *das Unheimliche* (*Collected Prose*,

35/*Gesammelte Werke*, 3:186).[6] In contradistinction to Heidegger, Celan's "Offen," which is also an uncanny space, is divested of any ontological import; instead, it is configured in the "wounded reality" (*wirklichkeitswund*) of history. Beginning in the un-homed space of the east and the effaced ground of the Bukovina, Celan situates the uncanny within language, which now carries history's traumas with it.

The crossing of Heidegger and history climaxes at the end of Celan's speech:

> Es sind die Bemühungen dessen, der überflogen von Sternen, die Menschenwerk sind, der, zeltlos auch in diesem bisher ungeahnten Sinne und damit auf das unheimlichste im Freien mit seinem Dasein zur Sprache geht, wirklichkeitswund und Wirklichkeit suchend. (186)

> Efforts of those who, with man-made stars flying overhead, unsheltered even by the traditional tent of the sky, exposed in an unsuspected, terrifying way, carry their existence into language, racked by reality and in search of it. (35)

With the "man-made stars flying overhead," a possible reference to the satellites that would soon occupy the skies the year after the speech, Celan's uncanny, like Heidegger's, is linked to the sway of technology along with the conditions of estrangement and exile. "Tentless" (*Zeltlos*) also re-enforces this state of Jewish exile: the tent being the place of the Israelites' estrangement in the desert during the flight from Egypt. It is a particularly Jewish type of homelessness, not in relation to Exodus or the Diaspora, but to the destruction of the poet's home in the Bukovina.

In Celan's complex interweaving of Heideggerian thought, an encounter with Being is replaced by a possible encounter with the Other. While the thinking and remembrance of lost homes serve as the place from which the speech embarks, this point of departure also provides direction (*um mich zu orientieren*) for a future encounter between the poet and an "addressable you" (*ansprechbares Du*), as the poem ventures toward the Other's "heartland" (*Herzland*). Heidegger claims, "Originally, 'memory' means as much as devotion (*An-dacht*): a constant concentrated abiding with something—not just with something that has passed, but in the same way what is present and with what may come" (*What Is Called Thinking?* 140). By underscoring this *Herzland* Celan returns to Heidegger's formulation regarding thinking, thanking, devotion, memory, and the heart. But in his dialogue with his audience, and implicitly with Heidegger's philosophy, the poet wishes for this "ansprechbares Du" to hear and to remember not the call of Being, but the wound of reality and the homeless Other annihilated by the death-bringing speech of the Third Reich.

6 For an analysis of Heidegger and the Open, see Fóti, 30–35.

Celan seems to be enacting in Bremen the very movement depicted by Heidegger in his reading of *Antigone* from the "Ister" lectures:

> A guest is that foreigner who for a time becomes homely in a homely place foreign to them, and thus themselves bring what is homely for them into the homely of the foreign and are received by the homely of the foreign ... The guest makes the thinking of the homely into a steadfast remembrance of the journeying to the foreign ... The appropriation of one's own is only the encounter and guest-like dialogue with the foreign. (140–42)

However, Celan, the foreign guest in Bremen, is the trace of the unhomed one who tries to provoke in the host's native soil a recollection of a journey in which the guest traveled through history's catastrophic flames to Germany. He warns not against the forgetting of Being, which Heidegger said was concealed through technology's sway over the world, but against the historical repression of "that which happened." In order for the audience in Bremen to possess what is their own (*eigene*) and is most authentic (*eigentliche*) to them in their encounter with the foreign (the exiled Romanian Jew living in Paris), they must first hear and reflect on what the poet says they have in common with him: the relation of the German language to Celan's loss of home and to the historical import of Jewish homelessness.[7] Heidegger described how the poet "must be struck and blinded in the face of the 'fire.' This is why he is initially unable to find the words so that it seems as though he has lost his tongue (*Sprache*)" (*Hölderlin's 'The Ister,'* 151). Celan indeed finds the words (thinking, thanking, devotion, remembrance, and heart), Heidegger's words, after they have passed through a terrifying silence. His paths of thought, or *"Gedankengänge,"* are simultaneously paths of memory. In his ominous conclusion, which comprises modern technology, the most uncanny (*unheimlichste*) and a wounded reality (*wirklichkeitswund*), the space of this encounter between the Jewish poet and his German audience is itself infused with the Holocaustal uncanny. The poet turns the thinker's words upon themselves to confront his audience, and by proxy Heidegger, not with the metaphysical fires of the Greeks or of Being, but with the historical fires of the extermination.

7 Habermas aptly conveys this necessity not only to listen but also to look, when he reflects on Heidegger's "Letter on Humanism." As Heidegger was investigating "the history of Being" shortly after the war, Habermas describes how "[t]he images of the horror that the arriving Allies encountered in Auschwitz and elsewhere had made their way into the smallest German village. If his talk of an 'essential happening' had any meaning at all, the singular event of the attempted annihilation of the Jews would have drawn the philosopher's attention..." ("Work and Weltanschauung," 449).

Freud's Uncanny: Doubles, Repetitions, Ghosts, Blindings, and the Medusa's Head

Before examining the two types of the uncanny in "The Meridian," a po-lemic evocative of Heidegger's two modes of the uncanny, I will present some of the Freudian elements of the uncanny that are present in Celan's speech. This highlighting of Freud helps to augment the terrifying and un-settling nature of the uncanny that Heidegger himself eventually marginal-izes from his own investigation of the concept. "The Meridian" opens with a description of Pygmalion's statue coming to life, dancing mario-nettes, and the automatons from Büchner's *Leonce und Lena*. In turn, these figures are joined to images of dismemberments, repetitions, doublings, and ghostly returns. There are many uncanny characters throughout Celan's speech; in *Dantons Tod* there are two Camilles ("Not him, but the other one") and those who are about to die on the scaffold in Büchner's drama wish to come back and "die again" (*Gesammelte Werke*, 3:189). Celan also depicts the uncanny figure of Lenz, who has multiple layers as seen in the historical Lenz (Jakob Michael Reinhold Lenz) and Büchner's *Lenz*.[8] And from *Dantons Tod*, Celan maintains this theme of ghostly returns in the figure of Lucile by describing how "[s]he comes to you year after year, not by accident quoted so frequently" (*Sie kommt ja, die so oft und kaum von ungefähr so oft zitierte, mit jedem neuen Jahr zu Ihnen—das ist Lucile*; *Collected Prose*, 39/*Gesammelte Werke*, 3:189). Each year the citing of Lucile's words returns her to Darmstadt. In addition to meaning "to quote," the verb "zi-tieren" also suggests the act of conjuring a ghost. The quotation becomes a specter, a disembodied voice through which the absent Other returns.

Yet eventually art and poetry become for Celan the most uncanny components in his speech. He begins by tracing the different appearances that art (*Kunst*) takes throughout Büchner's plays. In the third paragraph of the speech, Celan writes "Art comes up again" (*Die Kunst kommt wieder*), and he employs the word "again" (*wieder*) four times in this paragraph in relation to art's return throughout Büchner's dramas. In addition to art's recurrent nature, Celan uses the word "erscheint" (appears) in relation to art: "Die Kunst erscheint" and "Die Kunst tritt in Erscheinung." The

8 Doubling is central to Freud's uncanny. Derrida examines the doubling of the date in his es-say "Shibboleth," where it is the traumatic date "January 20" that undergoes a doubling. Freud states, "This invention of doubling as a preservation against extinction has its coun-terpart in the language of dreams, which is fond of representing castration by a doubling or multiplication of the genital symbol" ("The Uncanny," 40). It is not the fear of mutilation that grips "The Meridian"; rather, the poet's anxiety over becoming mute or losing the power to speak is transferred to the reader/spectator, who is confronted with the task of reading/seeing absence.

word *Erscheinung* conveys the sense of something specter-like. Art behaves like an apparition, and this link between repetition and specter eventually develops into Celan's claim that art is at home (*zuhause*) in the uncanny (*Gesammelte Werke*, 3:192).

Foregrounding Schelling's definition that the uncanny is the name for everything that "ought to have remained hidden and secret, and yet comes to light," Freud's use of the uncanny begins with the visual connotation of perceiving something that was concealed ("The Uncanny," 28). But after this definition Freud demonstrates in his reading of "Der Sandmann" how the uncanny proceeds from a visual wound; the feeling ascribed to something uncanny is directly attached to the idea of being robbed of one's eyes (32–36). Celan too will emphasize the uncanny's relation to the subversion of sight and the play between darkness and light. This disruption of what is seen or read in the poem becomes for Celan the moment of a possible recollection of a date. Moving in his speech from darkness (*Dunkelheit*; *Gesammelte Werke*, 3:195) into the "light of the not-place" (*Licht der U-topie*; 199), Celan's search for the place and time of poetry ultimately leads him through the topography of the uncanny to the erasure of his home.

"The Meridian" begins with multiple plains of vision, where art becomes something ghostlike that springs before the eyes—"Die Kunst ... springt in die Augen"—and figures like Lucile, Lenz, and Danton constantly return throughout the speech (188). But what Celan is actually setting up is the ultimate vanishing of sight, where the disruption of vision assists the poet in his critique of mimesis. Lucile, who tells how she likes to watch Camille speak and "sees speaking," describes herself as "art blind" (*Kunstblinde*) (189). Furthermore, toward the conclusion of his speech, Celan informs his audience that his concept of the Breathturn becomes visible (*sichtbar*) in the figure of Lucile, whose suicidal words function as the "place of poetry" (*Um des Ortes der Dichtung*) that he is in search of (*Collected Prose*, 45 / *Gesammelte Werke*, 3:194). But the Breathturn signifies the disruption of language. Lacoue-Labarthe asserts that in Celan's poetry, "The poetic art consists of perceiving, not representing" ("Catastrophe," 151). However, I would go one step further and argue that Celan's poetry struggles with the dislocation of perception. While one who approaches a poem of Celan's may see her- or himself as a secondary witness to the Holocaust, Celan tries to undermine this position of the witness by assaulting the reader's senses with a missing line of poetry or a fragmented or foreign word.

One particular image linked to Freud's uncanny that appears in "The Meridian" and is connected to questions regarding vision and mimesis is the figure of the Medusa's head. The image of the severed head recalls the

uncanny's relation to dismemberment in Freud, "Dismembered limbs, a severed head, a hand cut off at the wrist, feet which dance by themselves—all these have something particularly uncanny about them, especially when they prove able to move of themselves" ("The Uncanny," 49–50). "The Meridian" overflows with dismembered body parts—hands, feet, eyes, ears, and a head—and each contributes to the uncanny atmosphere of the speech. Although Freud connects dismemberment to castration anxiety, Celan's Medusa's head serves as a metonymy for the anxiety over the artist's struggle with representation.[9] Citing Büchner's Lenz, Celan writes:

> Wie ich gestern neben am Tal hinaufging, sah ich auf einem Steine zwei Mädchen sitzen: die eine band ihr Haar auf, die andre half ihr; und das goldne Haar hing herab, und ein ernstes bleiches Gesicht, und doch so jung, und die schwarze Tracht, und die andre so sorgsam bemüht. Die schönsten innigsten Bilder der altdeutschen Schule geben kaum eine Ahnung davon. Man möchte manchmal ein Medusenhaupt sein, um so eine Gruppe in Stein verwandeln zu können, und den Leuten zurufen. (*Gesammelte Werke*, 191–92)

> As I was walking in the valley yesterday, I saw two girls sitting on a rock. One was putting up her hair, and the other helped. The golden hair hanging down, and a pale, serious face, so very young, and the black dress, and the other girl so careful and attentive. Even the finest, most intimate paintings of the old German masters can hardly give you an idea of the scene. Sometimes one would like to be a Medusa's head to turn such a group to stone and gather the people around it. (*Collected Prose* 42)

Celan uses the Medusa figure early on in his speech as a point from which he will later break. In the above passage the focus is on how the artist transforms the natural and the beautiful into an object of art. There is an attempt to imitate a beautiful scene. However, in classical literature the sight of the Medusa's gaze would turn the onlooker to stone, freezing the individual in terror.

Celan, while interested in the function of representation in poetry, ultimately re-directs his focus from the role of the poet to the affect created in the recipient of the poem. There is a poetics of anxiety in which the artist's fears of failing to represent shift to the reader's horror in her inability to read or see. A crisis of witnessing arises. The image of the Medusa's head from Büchner's *Lenz* that turns to stone a beautiful moment in nature ultimately dissolves in Celan's critique of mimesis. All attempts to reify a beautiful moment transform into poetry's confrontation with a terrifying event. Celan moves from Pygmalion's stone coming to life at the

9 Freud himself wrote an essay on the "Medusa's Head" (1922) which connects back to his theory of the uncanny with its emphasis on castration anxiety.

opening of "The Meridian" to the artist's desire to turn to stone a beautiful scene in nature and to the reader who is petrified by the countermimetic moment of the poem: the "one brief moment" (*Augenblick*) of the Breathturn. At the moment of poetry, the glance of the Medusa's head dissipates and a terrifying silence emanates from the text (196).

Following the Path of Art: Poetry and the Uncanny

In his discussion of the poles between art and poetry, Celan's dialogue with Heidegger's notion of the uncanny becomes most evident. Poetry and art have their own distinct uncanny sides. In his first reference to the uncanny, Celan describes how we must step into a realm that is uncanny and where art seems to be at home:

> Das ist ein Hinaustreten aus dem Menschlichen, ein Sichhinausbegeben in einen dem Menschlichen *zugewandten* und unheimlichen Bereich ... denselben, in dem die Affengestalt, die Automaten und damit ... ach, auch die Kunst zuhause zu sein scheinen. (192; my italics)

> This means going beyond what is human, stepping into a realm which is *turned toward* the human, but uncanny—the realm where the monkey, the automatons, and with them ... oh, art, too, seem to be at home. (42–43)

We can hear in Celan's word "*zugewandten*" (turn toward) a connection with his extensive drafts of the speech, where he had previously used the Heideggerian term "*Umkehr*" in relation to turning toward the uncanny ("Meridian Tbg," 30).[10] As he maps out the place of poetry, which ultimately takes us to a torn map from his childhood, we move across the boundary from the human into the uncanny and into art. For the individual who crosses into the realm of the uncanny and has art before her/his eyes, a self-estrangement and forgetting transpires:

> Wer Kunst vor Augen und im Sinn hat, der ist—ich bin hier bei der Lenz-Erzählung—, der ist selbstvergessen. Kunst schafft Ich-Ferne. Kunst fordert hier in einer bestimmten Richtung eine bestimmte Distanz, einen bestimmten Weg. (*Gesammelte Werke*, 3:193).

> The man whose eyes and mind are occupied with art—I am still with *Lenz*—forgets about himself. Art makes for distance from the I. Art requires that we travel a certain space in a certain direction, on a certain road. (*Collected Prose*, 44)

10 I am referring to the Tübingen edition of the speech, which contains over 300 pages of reworkings and notes that he compiled during the composition of his "Meridian Speech." I will use the abbreviation "Meridian Tbg" to refer to this edition of the speech.

In Celan's repeated use of the term "definite" (*Bestimmten*) in relation to spatial concepts, the undertones of Heidegger's polemic between fear and anxiety in *Being and Time* are discernible. Art is consistent with Heidegger's configuration of fear, which comes from a "definite direction" (*bestimmten Richtung*; 186) and includes a mimetic quality that is linked to a forgetting. I do not wish to suggest that there is any intrinsic connection between art and the affect of fear; rather, I am stressing the pivotal role of mimesis and forgetting in relation to Celan's category of art and Heidegger's notion of fear (*Furcht*), both of which open up inauthentic spaces of the uncanny. In this phenomenological relation to the world of representations, Celan's concept of art—like Heidegger's depiction of fear—is associated with the forgetting of the temporal dimensions of the uncanny. Celan continues:

> Büchners Stimme fordert mich zu dieser Vermutung auf, alte und älteste Unheimlichkeiten, dass ich heute mit solcher Hartnäckigkeit dabei verweile, liegt wohl in der Luft—in der Luft, die wir zu atmen haben. (192)

> This uncanny, Büchner's voice leads me to suppose, takes us far, very far back. And it must be in the air—the air we have to breathe—that I so stubbornly insist on it today. (43)

The figure of the uncanny begins to transform; it is no longer located solely in art, but becomes something situated in history as well. The uncanny in the air (*Luft*) "today," Darmstadt 1960, recalls the "Grab in den Lüften" from "Todesfuge," Czernowitz 1945; it summons up everything that was reduced to ash. Furthermore, Celan begins to set up his figure of poetry as a Breathturn. Poetry takes the uncanny moment into itself, remembers it, and is silent before becoming voice. In contrast to art's uncanniness and its relation to place as seen in such terms as "direction," "distance," and "way," the uncanniness of poetry is linked to time. While mimesis is bound to the tendency toward forgetting, poetry frees itself from art (*Kunst-frei*), and thus from forgetting, in order to make possible the recollection of a date. Poetry follows the path of art (*Dichtung, die doch den Weg der Kunst zu gehen hat?*)—a path linked to representation (the Medusa's head) and thus to a self-forgetting—in order to break free from this very path and to remember a date (193).

Celan's Breathturn designates the disruption of art, where poetry for an instant sets itself free from mimesis. The figure of the Medusa's head no longer signifies an act of freezing or representing a beautiful moment as in Büchner's *Lenz*, but returns to its classical associations of terror and fear. The image of a "terrifying silence" used by Celan to describe the Holocaust in his Bremen speech from 1958 is used again to describe the moment of the Breathturn. Reflecting on Büchner's Lenz desiring to walk

on his head, Celan remarks, "His 'Long live the king' is no longer a Word. It is a terrifying silence. It takes his—and our—breath and words away" (*Sein 'es lebe der König' ist kein Wort mehr, er ist ein furchtbares Verstummen, es verschlägt ihm—und auch uns—den Atmen und das Wort*; *Collected Prose*, 47/ *Gesammelte Werke*, 3:195). Celan's words just prior to the Breathturn passage gesture to Heidegger's description of how the approach of the uncanny "stifles one's breath" (*Atem verschlägt*) from *Being and Time* (186). Although this constriction of breath is infused with an ontological significance for Heidegger, the disruption of word and breath in Celan now refers to the historical silence and terror reconfigured structurally in the poetic caesuras that are meant to shock the recipient of the poem.

Despite the opening link between art and the uncanny, in which poetry was first opposed to art's uncanniness, poetry eventually takes this uncanniness into itself. While in art the subject forgets him/herself, the Breathturn disrupts this forgetting. The break with art signifies the advent of the potential memory of a date:

> Dichtung: das kann eine Atemwende bedeuten. Wer weiss, vielleicht legt die Dichtung den Weg—auch den Weg der Kunst—um einer solchen Atemwende willen zurück? Vielleicht gelingt es ihr, da das Fremde, also der Abgrund *und* das Medusenhaupt, der Abgrund *und* die Automaten, ja in einer Richtung zu liegen scheint,—vielleicht gelingt es ihr hier, zwischen Fremd und Fremd zu unterscheiden, vielleicht schrumpft gerade hier das Medusenhaupt, vielleicht versagen gerade hier die Automaten—für diesen einmaligen kurzen Augenblick? Vielleicht wird hier, mit dem Ich—mit dem *hier* und *solcherart* freigesetzten befremdeten Ich,—vielleicht wird hier noch ein Anderes frei? (*Gesammelte Werke*, 3:195–96)

> Poetry is perhaps this: an *Atemwende*, a turning of our breath. Who knows, perhaps poetry goes its way—the way of art—for the sake of just such a turn? And since the strange, the abyss *and* Medusa's head, the abyss *and* the automaton, all seem to lie in the same direction—it is perhaps this turn, this *Atemwende*, which can sort out the strange from the strange? It is perhaps here, in this one brief moment, that Medusa's head shrivels and the automatons run down? Perhaps, along with the I, estranged and freed *here, in this manner*, some other thing is set free? (*Collected Prose*, 47)

In this space where representation comes to its end, Celan's investigation shifts from art to poetry. At the moment of the Breathturn, when poetry sets itself free from mimesis, a second type of uncanny arises: the figure of the Medusa dissolves and is replaced by the *Augenblick* (literally, glance of an eye) of a terrifying silence. Celan neither tries to imitate a beautiful moment (Lenz's contemplation of how one would like to be a Medusa's head) nor performs a Medusa-like act of turning to stone the moment of absolute horror; rather, his poetics of the Breathturn examines the risk that the reader may turn to stone, frozen before the horror of an historical

erasure. At the turn of breath, mimesis has less to do with the imitation of a traumatic scene than with the reproduction of affect upon the reader/spectator.

The Medusa's head, Celan and Büchner's image for mimesis, meets its dissolution in the Breathturn, and Celan writes, "Vielleicht schrumpft gerade hier das Medusenhaupt." With the attenuation of this head Celan marks the place where his discussion begins to focus on poetry's relation to actual historical dates and events. In addition, Celan's shift from questions concerning the creation of beauty to the arousing of terror in the spectator returns us to the original function of the Medusa. In one of the most important uses of the Medusa, Dante connects her to a crisis of spectatorship in his *Inferno*. In book 9, just before Dante enters the gates of hell, the Medusa comes before the poet and his guide Vergil in order to thwart their journey. While Vergil covers the poet's eyes to protect him from the danger of what stands before him, Dante avoids giving any description of the Gorgon. The reader too is denied a description of this horror. With his vision obscured, Dante addresses the reader in what is one of the central passages of the *Inferno*: "Men of sound intellect and probity, / weigh with good understanding what lies hidden/ behind the veil of my strange allegory" (ll. 60–62). The poet commands the reader to interpret what remains concealed in the poem. Likewise, in Celan's verse the poet leaves blank the catastrophe. But his withholding of an image is not simply an act of protecting us from what is too horrible to see. This counter-mimetic moment is also an act of provocation. In our encounter with the poet's "pause of breath" (*Atempause*; 196)—a pause that arises in Celan's use of semantic fissures throughout his lyric—the voyeuristic act of looking/reading is interrupted. At the poem's turn of breath we ourselves must translate the scene of effacement into a remembered event. The poetic caesura does not shield us from the possible threat of being turned to stone before the horror of the Holocaust, but rather the rupture is in fact the very space of poetic anxiety.

The break in the poem is the place where the Medusa's head dissolves and an *Augenblick* looks back and shocks the reader with its "terrifying silence." At the place of poetry's Breathturn, another kind of Medusian gaze looks back at us, shocking and repelling us. We become transfixed by what we read, or rather, by what we do not read. It is the terrifying spectacle of nothing. The poet does not try to imitate terror: the space is itself terrifying. We are left gazing at the abyss left behind by the historical and poetic rupture. Poetry "takes our breath and words away." What do we see, or read, at a moment when words are lacking? At this *Augenblick*, when nothing is read or seen, Celan provides a date, "Perhaps we can say that every poem is marked by its own '20th of January?'" (*Vielleicht darf*

man sagen, dass jedem Gedicht sein '20. Jänner' eingeschrieben bleibt?) (*Collected Prose*, 47/*Gesammelte Werke*, 3:196). Poems, Celan tells us, try to be mindful of such dates. By ultimately naming an actual date (January 20), he uses the Medusa to designate the moment of an aesthetic crisis in relation to history, not to nature. The poetic disruption of the Breathturn synthesizes a temporal with a spatial trauma. Celan inscribes the date of an historical wound into the linguistic ruptures of the poem; in turn, these linguistic traumas point to the geographic tear found in Celan's map at the close of his speech.

Despite Celan's use of the term *"Umkehr"* throughout his drafts of the speech, a term that resonates with Heidegger's concept of the uncanny, it appears only once toward the end of the final version of "The Meridian," when Celan approaches the site of his home. After following the path of the poem where all "tropes and metaphors in the poem want to be led *ad absurdum*" (51), he tells his audience, "It is time to turn back" (*Es ist Zeit, umzukehren*), and he writes, "I have come to the end—I have come back to the beginning" (51/200). Poetry for Celan must first go towards this uncanny space of art, of mimesis and self-estrangement before a "type of homecoming" is possible. In his draft of this section of the speech, Celan formulates, "Anfang: Es gibt, auch im Gedicht, geheime Wege/ Czortkow-Czern.<owitz> Darmstadt" ("Meridian Tbg," 184). Through his interrogation of Heidegger's mode of the uncanny, Celan transforms Heidegger's mystery (*Geheimnis*) of Being into the "secret (*geheime*) paths" that lead from the poet's lost home in Czernowitz into the foreign of Darmstadt, Germany. By the conclusion of "The Meridian" he alternates between the *topos* of the poem's abyss, which swallows the images, tropes, and metaphors, to the *u-topos* of his missing home.

Celan has sketched only a "type of homecoming," for as he tells his audience near the end of his speech, he cannot find his home on his childhood map. In effect, the poet guides us to the effaced map of the Bukovina:

Ich suche das alles mit wohl sehr ungenauem, weil unruhigem Finger auf der Karte—auf einer Kinder-Landkarte, wie ich gleich gestehen muss. Keiner dieser Orte ist zu finden, es gibt sie nicht, aber ich weiss, wo es sie, zumal jetzt, geben müsste, und ... ich finde etwas! (202)

I am looking for all this with my imprecise, because nervous, finger on a map—a child's map, I must admit. None of these places can be found. They do not exist. But I know where they ought to exist, especially now, and ... I find something else. (54)

In coming across the rip in the map, Celan discovers the marks of an ellipsis, and he uses this figure of an erasure to make present what was destroyed. A few lines later in his speech Celan uses the ellipsis again, "I find … a meridian" (55). The three points of the ellipsis signify both presence and absence. The ellipsis makes spatial the moment of traumatic time and signifies the mark of a spatial-temporal wound: the Breathturn of the text. For Celan, what he calls "the investigation of place" (*Toposforschung*) transpires "im Lichte der U-topie," that is, in the light of a not-place (199). He reads the rip in the map where the Bukovina once stood and translates this trauma into the structural and graphic tears of the poem. The poet's "anxious" search with his finger upon the map is eventually transferred to the reader's eyes, which are wounded by the reading of poetic fissures upon the page. In one's search for the "u-topie" that Celan inscribes in his poetry, a "discomfort" ensues for the reader. While Celan repeatedly emphasizes his search for the place of trauma (his lost home) and claims that he uses language to orient himself in relation to where he was and to where he is going, the poetic terrain serves to disorient the reader who accompanies Celan into the poem.

The act of seeing that dominated the beginning of "The Meridian" now shifts by the conclusion of the speech to images of hearing. Celan turns the expression for quotation marks, "Gänsefüsschen" (goose feet), into "Hasenöhrchen" (rabbit ears) and "one must listen beyond words not without fear" (*nicht ganz furchtlos*; *Collected Prose*, 54/*Gesammelte Werke*, 3:202). The vanishing of the word at the Breathturn signifies the moment when the poet tries to induce fear and memory in the reader, who must listen to or try to read the silent interstices of the poem. The advent of the Holocaustal uncanny in the speech is generated through the *u-topos* to which Celan has guided his audience: one realizes that he/she has been taken into an erasure—the poet's home/not-home of the Bukovina. Celan, re-inscribing the loss of perception central to a trauma into the space of poetry, translates the failed vision of a traumatic event into something not heard; he makes silence visible. Instead of taking one to a place to hear or read something, the poet guides his audience and reader into a void.

Through his polarization of two types of uncanniness and the movement toward the abyss (*Abgrund*), Celan directly engages with the twofold structure of Heidegger's uncanny. He too formulates an authentic mode of the uncanny, and it is found in the realm of poetry. In his depiction of poetry's uncanniness, Celan repeatedly uses derivations of the word "Eigene" (own), and one cannot help but hear Heidegger's own reflections on how the uncanny not-at-homeness is the authentic (*Eigentlich*) state of Being. Similarly, the poem, mindful of its dates, speaks on its "very own behalf" (*in seiner eigenen, allereigensten Sache*) (3:196), it possesses its own (*Ei-*

genste) time (3:199), and Celan orders us to take art into our "innermost narrowness" (*allereigenste Enge*) in order to set ourselves free (3:200). This turn inward into the *Enge* or narrows—into a space of *Angst*—again resounds with Heidegger's description of how the approach of anxiety is oppressive (*beengt*; *Being and Time*, 186). But unlike Heidegger, for whom the uncanny was outside the realm of clocks and calendars and was constituted by a sense of indefinite postponement, Celan provides a temporal designation to the uncanny. To become free of art implies not only a break with both mimesis and forgetting, this rupture also denotes the possible recollection of a date in which millions were rendered homeless.

While Heidegger's turn (*Abkehr*) in paragraph 40 of *Being and Time* may mark a forgetting, as *Dasein* turns away or flees from that which is uncanny, Celan's Breathturn counters this flight and initiates the potential encounter with the uncanny. Like Heidegger's depiction of Antigone approaching the abyss of her tomb, Celan's poem, along with its poet and reader, also goes towards the abyss, or *Ab-grund*, which literally means the removal of ground. Following the path of the uncanny not in an ontological but rather in a historical sense in his search for the place and time of poetry, Celan lures the reader into an encounter with a date: "Perhaps the newness of poems written today is that they try most plainly to be mindful of this kind of date?" (*Vielleicht ist das Neue an den Gedichten, die heute geschrieben werden, gerade dies: dass hier am deutlichsten versucht wird, solcher Daten eingedenk zu bleiben?*; *Collected Prose*, 47/*Gesammelte Werke*, 3:196). It is the very act of dating that Heidegger himself was unable or unwilling to fulfill. Although the reader might think she is getting the spatial import behind the place of poetry as seen in Celan's emphasis on direction (*Richtung*) and shortcuts (*Umwege*), the Breathturn, comprising "one brief moment," (*für diesen einmaligen kurzen Augenblick*), is temporal at its core. We return "again and again" not only to a place of erasure, but also to the mark that signifies the effaced Other: the 20th of January.

Translations: The Ethics of an Encounter

But does the audience in Darmstadt "hear" the poet? Have they understood his speech? Celan displays his own anxieties that the audience might not be receiving his message. Despite using the metaphor of a meridian as the connective that describes one's link to the Other, the path Celan chooses is anything but straight. Interspersed with multiple voices (he cites Büchner, Malebranche, Heimann, Shestov, Benjamin, Mallarmé, and Franzos) and languages (German is punctuated with moments of French), along with the invisible voice of Heidegger, Celan leads the audience

through a series of detours (*Umwege*).[11] He is well aware of the difficulties behind his poetic language, and in one of the most elliptical passages in "The Meridian" he describes how the poem becomes a conversation, very often a "desperate conversation" (*Collected Prose*, 50). While he may address his audience throughout the speech as "ladies and gentlemen," such politeness turns into a sense of urgency as the frequency of this expression increases towards the end of the speech. By employing this phrase, Celan is letting those who sit before him know that he is addressing them, and his repeated use of the expression reveals the poet's anxiety that their concentration might be waning. Celan commands his audience early in the speech to pay attention to his words about the Medusa's head—"Ladies and Gentlemen, please pay attention"—and later he demonstrates his own attentiveness by citing Benjamin, who was himself quoting Malebranche: "Attention is the natural prayer of the soul" (50). Furthermore, Celan's doubts about the possibility of an encounter is reinforced in his incessant use of such terms as "but," "perhaps," and "who knows." An air of uncertainty takes over the speech. Although his audience may see him, Celan worries that they might not hear him properly.

In effect, Celan puts his audience into the role of Büchner's Lucile from *Dantons Tod*, who perceives language when Camille speaks, but does not understand what he says. She exclaims, "I so much enjoy watching you speak" (*Ich seh dich so gern zu sprechen*; Büchner, 30). Celan describes how someone hears (*hören*), eavesdrops (*lauschen*), and watches (*schauen*), but does not listen properly when the conversation is about art:

> Genauer: jemand, der hört und lauscht und schaut ... und dann nicht weiss, wovon die Rede war. Der aber den Sprechenden hinhört, der ihn "sprechen sieht", der Sprache wahrgenommen hat und Gestalt ... und zugleich auch Atem, das heisst Richtung und Schicksal. (*Gesammelte Werke*, 188)

> More precisely, somebody who hears, listens, looks ... and then does not know what it was about. But who hears the speaker, "sees him speaking," who perceives language as a physical shape and also ... breath, that is, direction and destiny. (*Collected Prose*, 39)

Parallel to Lucile, the audience in Darmstadt might like to watch the poet speak, but Celan questions if they are able to grasp what he is saying. By placing his German audience in Lucile's position, he reveals his doubts about their ability to comprehend his words. He enjoins his audience not simply to listen to his metaphors and take pleasure in his verse, he also

11 We are again close to Freud's description of the uncanny, which includes the image of getting lost in the dark. The uncanny "would always be that in which one does not know where one is ..." ("The Uncanny," 21).

implores them to become mindful of his pause of breath and counterword (*Gegenwort*; *Gesammelte Werke*,, 3:189).

During a visit to Düsseldorf in 1955, Celan described in a letter to his wife the fate that had befallen the German language and discussed his anxieties concerning the difficulties of an encounter with the Other, in particular his German audience:

> Die Sprache, mit der ich meine Gedichte mache, hat in nichts etwas mit der zu tun, die hier oder anderswo gesprochen wird, meine Ängste in dieser Hinsicht, genährt durch meine Schwierigkeiten als Übersetzer, sind gegenstandlos. Wenn es noch Quellen gibt aus denen neue Gedichte (oder Prosa) hervorsprudeln könnten, so werde ich sie nur in mir selber finden und nicht etwa in den Gesprächen, die ich in Deutschland mit Deutschen auf Deutsch führen könnte. Dieses Land, ich mag es überhaupt nicht. Ich finde die Leute erbärmlich. Natürlich gibt es Ausnahmen, doch sie sind selten, und um sie zu treffen, brauche ich mich nicht in Deutschland aufzuhalten. (*Gisèle Celan-Lestrange*, 1:75)

> The language with which I construct my poems has nothing to do with the one that is spoken here or elsewhere; my anxieties in this respect, increased through my difficulties as translator, are groundless. If there are still sources from which new poems (or prose) could arise, then I would find them only in myself and not in the conversations that I could have in German with Germans in Germany. I do not like this country at all. I find the people pitiful. Naturally there are exceptions, but they are rare, and in order to meet them, I do not need to spend time in Germany. (my translation)

Celan makes a distinction between the German language he uses to both write and translate his lyric and the language he hears spoken in Germany, which Heidegger would refer to as idle chatter (*Gerede*).[12] By setting apart his language, which is infused with "darkness," a "terrifying silence," a "counterword," and "pause of breath," from the one he hears in Germany, Celan prompts us to ask to what extent the audience could ever know what his speech (*Rede*) is about.

A translator by profession, Celan's anxieties and concerns returned in a series of letters during the 1950s, when he was busy translating texts by such writers as Cayrol, Char, Artaud, Rimbaud, Blok, and Mandelstam. He emphasizes that much of his anxiety stems from his task as a translator, and in a letter from 1955 to his editor regarding his translation of Picasso's play "Desire Caught by the Tail," he describes what such a task entails:

12 Heidegger warns that discourse has the potential of becoming *Gerede*, or idle chatter: something spoken is heard and then passed on by the hearer without him or her ever really getting "to the bottom" of what was spoken. According to Heidegger, this type of discourse severs the individual from his/her primary relation to the uncanny (*Being and Time*, 167–70).

Picasso's text has to be not only translated, but also—if I may misuse a term of Heidegger's—translocated [*übergesetzt,* "carried across"]. You see: for me what is involved sometimes is a sort of ferry service. So may I hope that for the payment of my work not only the lines but also the oar-strokes will be counted? (qtd. in Felstiner, *Paul Celan,* 94)

All translation, as Celan emphasizes in his letter, is a carrying across, not just between two languages, but also between two spaces: that of the translator and that of the foreign text. There is a double movement. As the original text is brought into a foreign language, the reader of Celan's translation is also taken into the foreign space of this text. Yet what is most striking about Celan's description is that he places himself in the role of the oarsman Charon, who received payment for ferrying the dead across to the underworld. In his discussion of translating Sophocles into German, Heidegger described how every translation must involve "the transition (*Überschritt*) from the spirit of one language (*Sprachgeist*) into that of another" (*Hölderlin's "Der Ister,"* 62). Celan too maintains this formulation in which translation entails the movement of a ghost (*Geist*) across thresholds. But one should not limit this transferral only to languages. Celan's appropriation of Heidegger's metaphor, including spatial connotations and ghosts, could also be applied to the movement of Celan himself; he is the Jewish Other who steps across spatial as well as temporal boundaries to transport a message to his German audience.

In 1959, shortly after completing his Mandelstam translations, Celan clearly describes the uncanny nature of the encounter with the Other's poem in a letter to his editor, Gelb Struve:

Sehen Sie, bitte, in diesen Zeilen nur den Versuch, mir den Eindruck zu ver-gegenwärtigen, den ich bei meiner Begegnung mit den Gedichten Mandelstams hatte: den Eindruck des unabdingbar Wahren, das seine Sinnfälligkeit und seinen Umriss der Nachbarschaft eines Äussersten und Unheimlichen verdankt, das, ebenso lautlos wie vernehmlich, mitspricht—und wohl auch über das Gedicht hinausspricht. (Hamacher and Menninghaus, 11)

See, please, in these lines only the attempt by me to represent the impression that I had through my encounter with Mandelstam's poems, the impression of the in-alienable truth that is owed to its maturity of meaning and its contour of the neighborhood of an outermost and uncanny, that, just as soundless as audible, speaks with—and speaks out even over and above the poem. (my translation)

Just a year before being awarded the Büchner prize, Celan employs a language similar to the one he uses in "The Meridian" to describe how his translations try to reach this uncanny and outermost region of Mandelstam's poems in his search for an encounter and conversation with the Other. Celan's words about the difficulties of translation help chart a path

for how his poems need to be processed by his German audience: Celan also requires from the recipient of his poetry an act of translation. While the task of translation was a source of anxiety for him, Celan now transfers this anxiety onto his readers, who are confronted not simply with the lexical difficulties of Celan's language, but also with the abysses and terrifying silences of the Breathturns pervading his poems.

As his drafts of "The Meridian" substantiate, Celan was suspicious that his readers were clinging to the beauty of his metaphors and the aesthetics of his poetry instead of contemplating the history behind them. He feared that Germany was turning to him in order to show that the Jewish Other had been integrated back into the space of German culture and that Germany had fulfilled the task of mourning. But as he demonstrates in both his Bremen and his Büchner speeches, Celan resists through his poetic language any attempt by his readers to "occupy" either him or his poems. Although he uses the term "Besetzbares" in both speeches, and one might hear the military associations of "occupation" in this word, the psychoanalytic concept of cathexis provides another way of understanding it. Cathexis refers to the process in which the psychic energy invested in a lost or compromised object is transferred to a new object. However, a reversal transpires in which the "Jewish warrior" (*Jüdische Krieger*), a term Celan had used to describe himself in a letter to his wife after he returned from a trip to Germany (*Gisèle Celan-Lestrange*, 1:282), occupies the German language and resists being appropriated or cathected onto by his German readers.[13] In effect, Celan, through his poetics of the Breathturn, undermines any Medusian gaze that might try to take hold of either his alterity or the event that brought about the destruction of his home and family. The semantic ruptures of the poem, which indicate the place of poetic dismemberment, are meant to possess an apotropaic function like that of a Medusa's head and force the reader to turn away from the "terrifying silence" of the poem and reflect on the date of effacement.[14]

13 Celan also concludes the letter with the lines: "My Jewess, I embrace you. Hug for me my son, a Jew, who, along with us struggles (*kämpft*)" (282). Maintaining a militaristic tone in choosing the word *kämpfen*, Celan refers to his wife and child as Jews even though she herself was raised Catholic.

14 The word *Apotropaic* derives etymologically from the Greek word *apotrepein* ("to avert"), the prefix *Apo* meaning "away from" and the verb *trepein* meaning "to turn." The head, apart from the body, functioned as a talisman to ward off evil.

Departing from Heidegger's *Feldweg*

In his drafts of "The Meridian," where he unequivocally discusses the import of *Umkehr* (reversal) in relation to the Holocaust, Celan's proximity to and distance from Heidegger become most evident to the reader. Certain key terms from drafts of the speech, which he ultimately removed from the final version, disclose his response to Heidegger's failure to think through the connection between the uncanny and the Holocaust. At the point of intersection, Celan constructs an ethics of alterity in relation to the unhomed Jewish Other. More specifically, the uncanniness that is thematized in "The Meridian" and that unfolds throughout Celan's poetry is specifically linked to the destruction of this Jewish Other at Auschwitz. Celan's use of two words that he edited out of the final version of the speech, *Umkehr* (reversal) and *Verjuden* (to become Jewish), are particularly revealing. Like Heidegger's terms "*Umkehrung*," "*Abkehr*" and "*Katastrophe*" in his "Ister" lectures, Celan's *Umkehr* also entails meditative thinking upon the path of poetry. However, Celan replaces Heidegger's mythopoetic origins and catastrophe of Being with a traumatic departure from the history of the death camps. *Umkehr* now refers to the process of remembrance in which the poem confronts its reader with the date of the Jewish Other's effacement.

Celan unmistakably identifies his implicit conversation with and critique of Heidegger by using a single word at the conclusion of the *Umkehr* and *Verjuden* section of his draft: "country paths" (*Feldwege*):

> Umkehr—dazu scheint es ja nun doch zuviel Einbahnstrassen zu geben.—
> Gegenverkehr und Umkehr, das ist zweierlei aber auch auf den Feldwegen
> scheint es, ach, wenig Gelegenheit dazu zu geben. ("Meridian Tbg," 131)

> Reversal—there appear to be too many one-way streets. Opposing traffic and reversal are two different things, but also upon the country paths there appears, oh, to be little opportunity for it. (my translation; underlining in original)

In Heidegger's commentary to "Gelassenheit," titled "Conversation on a Country Path about Thinking," a conversation unfolds among a scientist, a scholar, and a teacher on a pathway where the mystery of Being is revealed through meditative thinking. Responding to the scientist's dilemma of how to represent the nature of thinking the place where Being discloses itself, the scholar replies, "Probably it can't be re-presented at all" (*Discourse on Thinking*, 67). Instead, one must "look away" from traditional modes of thinking that are based on representational thought and phenomenology (58). This rejection of representational modes of thought enables Heidegger to distance himself from any process that could poten-

tially result in the reification of Being. Although he contends that the process in which Being reveals itself unfolds in history, it is a history "which does not consist in the happenings and deeds of the world. Nor in the cultural achievements of man" (79). Thus, in the history of Being, Heidegger is able to sidestep not only the markers of cultural progress, but also the moments of historical catastrophe. As the philosopher himself discusses along his country path, his conversation about the disclosure of the mystery of Being takes place "far from human habitation" (60) and outside of history. The dialogue on this path must eventually break off because "we again near human habitation" (87).

Celan, however, departs from Heidegger's country path that heads toward Being in order to show how the path in the poem leads instead to the effaced Jewish Other of the Holocaust. Although Celan's image of the Medusa is consistent with Heidegger's concerns regarding the dangers of reification, Celan is troubled by the threat of the Other's reification. As he demonstrates in "The Meridian" draft, Celan suspects that his German readers have reduced the Holocaust dead to the single figure of Sulamith from "Todesfuge." The reification of the Holocaust Other through metaphor leads Celan to propose a turning away (*Umkehr*) from the beautiful figure of Sulamith toward the terrifying faces from Auschwitz and Treblinka.

While he may have discerned in Heidegger's *Umkehr* the total absence of any encounter with the Other, Celan detects in his German readers an over-identification with the Jewish Other; the intention to mourn for the victims of the Holocaust threatens to trigger a forgetting of their very annihilation and of the agents of their annihilation. In the section of his draft where he questions Heidegger's *Umkehr* upon his pathway, Celan presents another flight from memory carried out by those who turn to him and his poetry:

> Deine Umkehr—was ist das? [...] Ist es das Wort von der Mandeläugig-Schönen, das ich dich, auf das opportunste variiert, wiederholen höre? Erst wenn du mit deinem allereigensten Schmerz bei den krummnasigen und mauschelnden und kielkröpfigen Toten von Auschwitz und Treblinka und anderswo gewesen bist, dann begegnest du auch dem Aug und seiner Mandel. Und dann stehst du mit deinem [...] verstummenden Denken in der Pause, die dich an dein Herz erinnert, und sprichst [nicht]. davon. ("Meridian Tbg," 127)

> Your reversal—what is it? [...] Is it the word about the almond-eyed beauty that I hear you repeat with the most opportune variations? Only when you experience your innermost pain with the hooknosed, Jewish-jabbering, deformed dead of Auschwitz and Treblinka and elsewhere, then you meet the eye and its almond. And then you stand with your [...] muted thinking in the pause that you remember in your heart and speak [no longer]. of it. (my translation)

In his description of those who repeat "das Wort von der Mandeläugig-Schönen," Celan alludes to Germany's fixation on the figure of Sulamith.[15] He stresses the distinction between reciting lines from the poem and remembering what it is actually about. While the poem may have become an object of ritual in Germany, Celan requires a second turning-about to recollect the dead. Turning away from beauty, one must face instead with one's "innermost pain" the dead of Auschwitz and Treblinka. Wrenching apart the contraction *Mandeläugig* (almond-eyed) and replacing it with the "eye and its almond" (*Aug und seiner Mandel*), Celan accentuates not the eye's shape but the bitterness of the almond that accompanies it. With the presence of this sorrowful eye, Celan constructs a possible face-to-face encounter that shifts from one's relation to a beautiful form to an encounter with the effaced Other of the death camps.

Celan extends his critique of Germany's fascination with Sulamith to the question of mourning: "Whoever is prepared only to mourn (*nachzu-weinen*) for the almond-eyed beauty, he kills her too, the almond-eyed beauty, another time," and "buries her ... deeper into forgetting" ("Meridian Tbg," 127–28). Although his word choice for mourning (*nachweinen*) may capture the belatedness of this act, where mourning transpires after (*nach*) a period of time has passed, Celan in fact fixes on the very absence of mourning and memory in relation to the Holocaust dead fifteen years after the end of the war. His critique of how Germany was processing its past intensifies when he describes how contemporary German textbooks misappropriated "Todesfuge" for classroom discussions: "Black milk of morning ... that is *no longer* a figure of speech or oxymoron. It is *reality*" (Schwarze Milch der Frühe ... das ist *keine* Redefigur und *kein* Oxymoron *mehr*, das ist *Wirklichkeit*; 158). Celan vehemently rejects the metaphoric status attributed to his poems and asserts that those who foreground metaphors not only overlook the inherent darkness of his lyric but also obscure the reality of his poems.[16] He emphasizes how inappropriately this very history was being transferred to the next generation in Germany. While German schoolchildren were learning about metaphor by studying "Todesfuge" and that "Sulamith was a name from the *Balkans* ... a name from the Song of Songs" (158), the traumatic history at the root of the

15 As Felstiner remarks, the almond is Celan's trope for the Jewish Other, and Celan first used the almond in his poem "Zähle die Mandeln" (*Gesammelte Werke*, 1:178). The almond conveys both biblical allusions and a sense of bitterness, and Felstiner describes how "[a]lmonds now betoken Jewishness for Celan" (*Paul Celan*, 63–64). See also Celan's poem "Vor einer Kerze," where he uses the term "ein schmaler, mandeläugiger Schatten," referring to his mother (*Gesammelte Werke*, 1:110). The poem moves from the figure of a mother saying the blessing over candles to the lighting of memorial candles for the dead.

16 Celan is citing from an essay by Peter Seidensticker and Wolfgang Butzlaff that examines the function of oxymoron in "Todesfuge" (36).

poem was not being conveyed at all. In effect, this transformation of Su-lamith into a metaphor, which contributed to the very forgetting of this history, constitutes a Medusa's gaze that both reifies and takes possession of the Other. Celan, drawing on the dual lexical meaning of the word "Über-tragen" (literally "to carry over") and its etymological associations with metaphor and translation, insists that his poems possess an "anti-metaphorical character" and are "untranslatable" (*unübertragbar*); a gulf forms between the reader and the poem that cannot be bridged over (*überbrückt*; 125). By rejecting the status of metaphor, Celan underlines in-stead the abyss that opens up between the poem and its recipient.

Instead, a face-to-face encounter with the Other is only possible, Celan insists, by turning away from the Song of Songs' Sulamith and to-ward "the dead of Auschwitz and Treblinka" (127). While he had upheld the possibility of an encounter with foreign poets through translation, he now underscores the immense difficulties that arise for the reader who, in seeking an encounter with the Other in his poetry, stands before an un-bridgeable rupture. Heidegger's *Feldweg* dissolves into the figure of the *Judengasse*—a historical site consisting of faces inhabiting the death camps—where Celan replaces the almond-eyed beauty with the "hook-nosed resident of the stinking *Judengasse*" (127). Suspicious of any em-pathic identification that his German readers might try to establish with the content of his poem, and by association with the poet himself, Celan confronts them with his Breathturn that leads away from metaphors and Sulamith and toward the eye of the effaced Other constituted by the pauses and breaks of the poem ("Meridian Tbg," 127). The Breathturn, which Celan explicitly refers to in his drafts of "The Meridian" as an *Um-kehr* ("Meridian Tbg," 30, 127), is associated not with a fleeing, but with a going toward the exterminated. This *Umkehr* is central to his concept of *Verjuden*, becoming Jewish, which he recommends to his German audi-ence as a means of understanding poetry.

In his essay "Catastrophe" Lacoue-Labarthe claims:

> As for Celan's determination of the humans, what would it/he be without a rela-tion to Being, that is—I will come to this—to time? Even if the "Meridian" is, as we may plausibly allow, partially addressed to Heidegger, that is not sufficient reason to hastily read into it an "ethical" response to "ontology." The human is in no way an "ethical" category, and moreover, no category of this kind can resist against the question of Being. (154–55)

But Celan's speech does indeed break free from these ontological con-cerns in order to foreground an ethics. While Lacoue-Labarthe may argue that the human is not an ethical category, Celan's merging of the uncanny with the 20th of January and his use of the term "*Verjuden*" in his drafts of

the speech accentuate the ethical import unfolding in his poetics. He writes, "I consider it recommendable ... becoming Jewish, that seems to me a way to the understanding of poetry" (*Ich halte Verjudung für empfehlenswert ...Verjudung, das scheint mir ein Weg zum Verständnis der Dichtung*; "Meridian Tbg," 131). Becoming Jewish is neither a religious, nor a cultural, nor a political act, but like Lyotard's concept of "the jews," *Verjuden* entails the process of becoming Other. But Celan's imperative, which compels the reader to approach the site of catastrophic history, confronts his reader with the impossible tasks of either identifying with the effaced Other or fully incorporating into memory the traumatic time of the Other's erasure. He continues, "*To become Jewish*: it is becoming other, to stand for the other and its secret" (*Verjuden*: Es ist das Anderswerden, Zum-anderen-und-dessen-Geheimnis-stehn; 131). The process of *Verjuden*, in essence an ethical category, does not indicate an empathic identification with the Other; in fact Celan stresses the very disruption of this process. "To become Jewish" is to be bound to the effects associated with the strange (*Fremde*), an alienated-I (*ein-befremdetes-Ich*), and ultimately with the uncanny (*das Unheimliche*) (*Gesammelte Werke*, 3:195).[17] Counter to any attempt to complete the task of mourning (*nachweinen*) for this "almond-eyed beauty" or of identifying with this Jewish Other, the scenes of both poetic and historical erasure are themselves unbridgeable.

The mode of what I am calling the Holocaustal uncanny, which is provoked by poetry's semantic gaps, points to the moment of a possible ethics constituted by the recognition of difference. This topos does not signify the site of a union with, identification with, or substitution for the traumatized Other; rather, these poetic ruptures are the markers that prompt the reader to become aware of the unbridgeable distance between oneself and this Other. By exploding any imaginary identification or union with those murdered in the Holocaust, the Holocaustal uncanny draws attention to the process of a perpetual mourning. The affect indicative of Celan's uncanny, depicted in the shudder of Celan's nervous finger upon his childhood map or in the reader's encounter with the aporia left by a missing, dismembered, or foreign word in the poem, is the antecedent to the process of recollecting irrecuperable loss left in the wake of catastrophic history.

17 Before he defines *Verjuden*, Celan writes the single fragment "Novalis." Later in his draft, Celan formulates, "Novalis: philos.= Heimweh," thereby alluding to Novalis's statement, "Philosophy is homesickness—the compulsion to be everywhere at home." Thus Celan forms the link between becoming Jewish and a sense of homesickness, of being homeless and thus *unheimlich* ("Meridian Tbg," 130).

Mourning and Translation

I wish to conclude this analysis of "The Meridian" with a poem that was written just weeks before Celan's award speech in Darmstadt. In my view this poem evokes such an encounter with the Holocaustal uncanny; the question regarding incomplete mourning and translation is the focal point of "Die Schleuse."[18]

DIE SCHLEUSE	THE SLUICE
Über aller dieser deiner	Over all this
Trauer: kein	Grief of yours: no
zweiter Himmel.	second heaven.
.
An einen Mund,	To a mouth
dem es ein Tausendwort war,	for which it was a thousandword,
verlor-	lost—
verlor ich ein Wort,	I lost a word
das mir verblieben war:	that was left to me:
Schwester.	Sister.
An	To
die Vielgötterei	polygoddedness
verlor ich ein Wort, das mich suchte:	I lost a word that sought me:
Kaddisch.	*Kaddish.*
Durch	Through
die Schleuse musst ich,	the sluice I had to go,
das Wort in die Salzflut zurück-	to salvage the word back into
und hinaus- und hinüberzuretten:	and out of and across the salt flood:
Jiskor.	*Yizkor.*
(*Gesammelte Werke*, 1:222)	(*Selected Poems*, 151)

The act of translation is immediately conveyed in the poem's title; a lock-gate or sluice is a device that controls the flow of water between different channels or passages. As a verb, *schleusen* means to transport ships through these locks and out to sea. In Celan's poem the reader is transported behind a flood of tears (*Salzflut*) to the realm of the dead inhabited not by ghosts, but by lost words. Like his depiction of the poet as ferryman, Celan enacts a return to the underworld by going across the poem's perforated line and into a place of loss. To read beneath the points of the first strophe indicates movement into the space of mourning. "Die Schleuse"

18 "Die Schleuse" was written on September 14, 1960, a month before he gave his "Meridian Speech" on October 22, 1960.

is a response to an Osip Mandelstam poem Celan had translated a year earlier, "Das Wort bleibt ungesagt, ich finde es nicht wieder" ("The word remains unsaid, I no longer find it"). Moreover, through this intertextual link Celan indirectly inscribes the figure of Antigone into the space of "Die Schleuse" (see Olschner, "Poetic Mutations of Silence"). With its "palace of shadows," "an empty boat," "crazed Antigone," and "Stygian memory," Mandelstam's poem revolves around the interplay between mourning and language, depicting the repercussions that arise from the law that forbids the burial of Polyneices. The law prohibiting mourning the dead initiates not only Antigone's madness and the collapse of the natural world into chaos, the absence of mourning also triggers the breakdown of language, where the forgetting of words leads to silence.[19]

Going into the Stygian depths of the underworld in "Die Schleuse," Celan does not return there in order to rescue the dead, but searches instead for lost words. While we might think of Orpheus returning to the underworld to recover Eurydice, in the poet's journey to the realm of the dead Celan plays the role of Charon, the conveyer of shades to the underworld. However, he now transports his readers into the space of the grave. "Die Schleuse" focuses on a series of lost words, and unlike the death of Antigone's brother, one of these missing words is "sister," Celan's trope for his poetic muse. But while the word remains both unspoken and irretrievable in Mandelstam's poem, Celan finds a word in his shift from Greek to Jewish mourning.

In a draft of the poem Celan had originally used the word *Schwermut* in place of *Trauer*, which suggests that he acknowledged the distinction, like Freud and Heidegger, between mourning (*Trauer*) and melancholia (*Schwermut* or *Melancholie*).[20] Yet the *Trauer* that opens this poem is already tempered by the absence of any consolation as seen in the lack of a second heaven. Furthermore, one may recall from "The Meridian" how Celan responded to the desire of Büchner's Lenz to walk on his head. Celan writes, "A man who walks on his head, ladies and gentlemen, a man who walks on his head sees the sky below, as an abyss" (*Wer auf dem Kopf geht, meine Damen und Herren, der hat den Himmel als Abgrund unter sich; Collected Prose*, 46/*Gesammelte Werke*, 3:195). Any suggestion of a potential redemptive space elicited by the word "*Himmel*" at the beginning of the poem is undermined by Celan's association of heaven with an abyss. The poem ultimately confronts its German reader with an impossible task of

19 The scene described in Mandelstam's poem seems to allude to the words of the blind seer Teiresias in *Antigone*. This uncanny figure, who, despite his blindness, can still read the catastrophic signs of nature, in particular the "unfamiliar sounds" and "savage cries" of birds "in a strange outlandish language," interprets these "ill-omened voices" as stemming from Creon's refusal to bury the dead (see Sophocles, *Antigone*, 152–54).

20 See Celan's drafts of the poem in *Die Niemandsrose*, 28–29.

mourning bound to this abyss. The sluice with its *"Salzflut"* serves a dual function. While it spatially connotes the sense of a Styx-like crossing-over into the land of the dead, the flood of salt becomes a symbol for tears; the movement occurs behind the eyes and into a space of grief. Although not commencing with the word *Schwermut,* the poem's very development demonstrates something akin to melancholia.[21]

Indirectly calling into question Heidegger's thoughts on memory and mourning, Celan replaces Hölderlin's "Andenken" and "Mnemosyne"— Heidegger's words for remembrance—with a Hebrew word, *Jiskor,* meaning "may He be remembered." In "Andenken" (1802) Hölderlin takes the reader to the place where memory is consumed, "The sea takes and gives memory" (Es nehmet/ und giebt Gedächtniss die See). But in "Mnemosyne," which begins with the poet almost losing his language in foreign lands, the poem ends with both the death of Mnemosyne (the goddess of memory and mother of the Muses) and the lack of mourning: "... dem/ Gleich fehlet die Trauer."[22] Likewise in "Die Schleuse," the multiple losses that govern the poem lead the reader into a melancholic space. The poem consists of two essential parts: "All dieser deiner Trauer" and "Verlor ich ein Wort." In turn, the dotted line between the first and second stanzas separates the *Ich* and *Du* of the poem. There is an Other who mourns (*deine Trauer*) and a poetic I who follows a trajectory constituted by loss. This line is a mark of separation or a Speech-Grille (*Sprachgitter*) between the *Ich* and *Du.* Yet the poem is not about just any conversation between oneself and the Other; it is one that essentially revolves around the possibility of mourning. In this transposition into the space of grief, the poet searches for the remnants of what was lost. The loss, which centers on three words—*Schwester, Kaddisch* and *Jiskor*—moves from a particular individual who needs to be remembered to words that are necessary for a recollection and mourning over loss to occur. The loss of *Schwester* has less to do with the forgetting or vanishing of the word. Instead, as the term *Tausendwort* conveys, the poem explores an exfoliation of language. One word, "sister," explodes into a thousand sisters, which indicates both the multiplicity of loss and the volatility of language's ability to signify what it wishes to denote. Celan calls into question the stability of the symbolic order. In his own ironic melding of a new language, he commu-

21 In his essay on "Mourning and Melancholia" (1917) Freud describes melancholia as an "open wound." In opposition to mourning, melancholia indicates a pathologic response to loss, where the subject is unable to let go of the lost object and re-cathect onto new ones (174).

22 For various readings regarding the question of mourning and melancholia in Hölderlin's "Mnemosyne," see Anselm Haverkamp's *Leaves of Mourning* (37–55), Paul de Man's *Rhetoric of Romanticism* (60–65), and Jacques Derrida's *Memoires for Paul de Man* (3–45).

nicates through *"Tausendwort"* both the very fragmentation of language and the sheer magnitude of the lost object.

The loss of the Aramaic word *"Kaddish"* intensifies the tenor of an inability to mourn the sister and thus perpetuates the lack of consolation. Moreover, *Kaddish* denotes not simply the Jewish prayer for the dead; it is also a prayer that sanctifies God's name. By losing this word the poet fails to praise the name of God, and hence widens the gap of a potential salvation already initiated by the absence of a second heaven. But *Kaddish* unfolds on multiple occasions throughout a religious service; the word also designates a liturgical pause. Celan does in fact retain this function of *Kaddish* by turning the word into a lyrical pause or Breathturn. Similar to the visual rupture of the dotted line in the poem, he uses foreign words as semantic gaps to interrupt the reading of the poem.

Although the absence of *Kaddish* may seem to suggest inconsolable loss, "Die Schleuse" does not replicate the devastating close of Hölderlin's "Mnemosyne," where the poem is inundated with scenes of mythic loss, madness, suicide, the death of memory, and thus the death of poetry itself.[23] Celan rescues the word *Jiskor* out of the *Salzflut*. On one level, an Orphic-like venture unfolds in which the poet goes to the land of the dead to rescue not a person but a word: *Jiskor*, the Jewish ritual of mourning. But by delivering his reader into this space of the dead and leaving them with an untranslated word, Celan also performs the task of Charon. In his "Task of the Translator," Benjamin speaks of the"[e]normous danger inherent in all translation: the gates of of a language thus expanded and modified may slam shut and enclose the translator with silence" (*Illuminations*, 81). Celan transports his reader across to the other side of this sluice and to the untranslatable. This is the moment of the Breathturn, when the reader either remembers how this silence came about, thus fulfilling the process of *Jiskor* by recalling the catastrophe, or remains abandoned in this poetic rupture.

The recovery of *Jiskor* suggests the potential memory of a date, which also entails the possible encounter with the effaced Other who speaks its own time. As Celan writes in "The Meridian," "Even in the here and now of the poem ... even in this immediacy and nearness (*Nähe*), the otherness gives voice to what is most its own: its time" (*Collected Prose*, 50). By underscoring this sense of proximity, Celan subverts any suggestion of substituting oneself for the Other, and in so doing he preserves both the alterity and the time of the Other. The foreign word is not merely a symptom of Celan's uncanny; it is a mark of difference, in particular of a Jewish alterity that resists being either excised or appropriated by its recipient. Signifying

23 In Hölderlin's poem the deaths of Patroklos, Achilles, and Ajax are followed by the death of Mnemosyne herself, the mother of the Muses and thus of poetry.

the figure of Otherness, the foreign word recalls the date when this Other
was annihilated by the "death-bringing speech" of the German language
(*Gesammelte Werke*, 3:186). By inserting the untranslated word into the text,
the German language and its readers are taken through an estrangement.

At the beginning of "The Uncanny," Freud reflects on the use of for-
eign languages in order to understand the etymological roots of the word
Unheimlich. One of the first words he examines is the Greek word *Xenos*,
and he reveals a lexical correspondence between the strange (*Fremd*) and
the foreign (*Fremdartig*, 22). Although he begins to form a connection be-
tween the uncanny and translation, Freud claims that foreign dictionaries
contribute nothing to this investigation of the uncanny, because "we
speak a different language. Indeed, we get the impression that many lan-
guages are without a word for this particular variety of what is fearful"
(21). Despite Freud's failure to delineate the relation between translation,
the foreign, and the uncanny, Celan's conceptualization of the uncanny
forms such an interplay between these terms, and one may recall from his
Bremen speech how Celan traced the etymological origins of *denken*,
danken, *eingedenk sein*, and *andenken*. Yet his search for lost words does not
lead to a German word for memory; instead, he replaces *Andenken* with
the foreign word *Jiskor*. Left untranslated, *Jiskor* becomes the aporetic
moment constitutive of poetic anxiety and the uncanny.

In *Cinders* Derrida designates the cinder as the remnant of memory's
annihilation and declares that in our encounter with ash, "We are wit-
nesses of a secret, we are witnesses of something we cannot testify to, we
attend the catastrophe of memory" (392). Joined to Derrida's analysis of
this failure to give testimony to what was witnessed, we find as well the
impossible task of mourning. Like Derrida's ash, which signifies all that
remains of the Holocaust Other's proper name annihilated by fire, *Jiskor* is
Celan's remainder for a trauma that the reader can neither fully integrate
into memory nor entirely mourn. The word indicates how absolute
mourning (*Kaddish*) and memory of the dead remain incomplete. At the
poem's final Breathturn, marked by a Jewish word of remembrance, the
reader undergoes the process of *Verjuden* that Celan recommended in his
draft of "The Meridian." The affect of the Holocaustal uncanny induced
by the closing word's foreignness makes possible an ethical moment
where *Jiskor* brings about a *Verjuden*, a self-estrangement in which there is
no bridge, metaphor, or translation between oneself and the effaced
Other.

In the "remembered pauses" (*erinnerten Pausen*) of the poem ("Merid-
ian Tbg," 127) we encounter not the face of beauty but that of terror, or
what Celan, borrowing from Büchner, names the "hippokratisches Ge-
sicht" of the poem. The Hippocratic face (*facies hippocratica*) is the facial

expression that immediately precedes a person's death, the death mask, and Büchner writes in a letter, "I am terrified for myself. The feeling of being dead was always above me. All humans make the Hippocratic face, the eyes glazed over (*verglast*) ..." (Büchner, 166).[24] In yet another image of the Medusa, Celan describes this Hippocratic face of the poem as "Medusenhaft" ("Medusian"; "Meridian Tbg," 179). The anxiety-provoking gaps of the poem lead neither to identification with nor an absolute mourning for the Other, but are designed to invoke a sense of dislocation or alienation in the reader. Guiding his reader into a space of exile and away from the mimetic qualities of art, metaphor, and the image of Sulamith, Celan re-directs the reader toward an encounter with the "hook-nosed, hunchbacked, Jewish-jabbering, [deformed] dead from Treblinka, Auschwitz" (*krummnassigen, bucklichten und mauschelnden [und kielkröpfigen] Toten von Treblinka, Auschwitz*) ("Meridian Tbg," 128). In effect, his poetics of the Breathturn is a shield that both repels and undermines any Medusian gaze that might try to seize the alterity of the poet, the Holocaust, or the effaced Other of his poems. His semantic ruptures and fissures, the very topos of poetic dismemberment, are apotropaic and are meant to compel the reader to turn away from the "terrifying silence" of the poem so that she may recognize the impossible yet necessary task of recollecting and mourning the time and place of historical effacement.

In the chapter that follows I turn to the Hippocratic faces that fill the screen in Resnais's film *Nuit et Brouillard*. The visual material of Resnais's documentary, including some of the most iconic images stemming from the Holocaust, played a decisive role in the construction of collective memory in post-war Germany. Yet even more significant for this study, it was Celan who translated Jean Cayrol's French commentary for the German version of the film. In essence, Celan's translation guides the German audience across the fences and into the terrain of the death camps. In addition to investigating Celan's translation of the French commentary into German, it is also of interest how Celan translates the visual images of the film into the poetic material of his poem "Engführung," written shortly after his translation of the film's commentary. The Hippocratic faces that look at the spectator in the film inhabit the semantic breaks that unfold throughout the poetic terrain of "Engführung."

24 Benjamin, too, discusses this "*facies hippocratica* of history," which is central to our "allegorical way of seeing" (*Origin*, 166). I return to this figure of the death face of history in my analysis of Libeskind's Felix Nussbaum Haus in chapter 6.

Chapter 4

Celan's Cinematic: Anxiety of the Gaze in *Nuit et Brouillard* and "Engführung"

In his compact response to a questionnaire sent to him by the Flinker Bookstore in Paris in 1958, Celan began by reflecting on the divergence of German and French poetry and concluded that German lyric was moving along an entirely "different path" (*Collected Prose*, 16).[1] Celan ascribed this divergence to the impact that "the most terrible things in memory" had on both the German language and on the faculties of perception. As a result of this catastrophic history, contemporary German poetry could no longer speak the language that "many ears expected to hear." Describing how German poetry both mistrusted beauty and how its language had become "grayer," Celan replaced issues of lyric tradition with his concern about "the darkest moments of memory":

> If I may search for a visual analogy while keeping in mind the polychrome of apparent actuality: it is a "grayer" language, a language which wants to locate even its "musicality" in such a way that it has nothing in common with the "euphony" which more or less blithely continued to sound alongside the greatest horrors. (16–17)

While claiming that some readers may have desired to hear the "euphony" and "beauty" of the lyric tradition, Celan invokes the "region of the visual" to describe what had transpired within the German language when something actual came "before the eye" (15). German poetry does not reach a dead end but travels another path.

Celan implicitly admonishes his German audience for focusing on the form and musicality of his poetry and, as discussed in the previous chapter, passing over its disturbing content.[2] The intention of the "I" that

1 I sometimes modify Waldrop's translation for fluency. The original text can be found in Celan's collected works (*Gesammelte Werke* 3:167–68).

2 John Felstiner provides an excellent account of German critics who praised Celan for his musicality while they simultaneously avoided the history behind his poems. Hans Egon Holthusen, for example, described Celan's poems as "self-inspired," "purely lexical configurations," "not meaning but form," "absolutely musical effects," and repeatedly compared Celan to Mallarmé. Brought by critics into the debates concerning "engaged" and "pure"

speaks this grayer language—and Celan is referring not only to himself but to anyone who writes in German—should be to provide a "particular angle of reflection, outline, and orientation [to] the most horrible events [dem Furchtbarsten]," and not to obfuscate the truth of this history by rendering it "poetical" (*Collected Prose*, 17). Instead, this grayer language, which "names, posits, and tries to measure the area of the given and the possible" (16), strives to be "truthful" and "factual," and attempts to orient its reader to the traumatic events of recent history. But Celan concedes that the language in which he writes has become tainted. At the end of his letter, he describes his search for a particular reality against the backdrop of these terrifying events. We recall his remarks in Bremen, also in 1958, where he described how he had to follow a path to this reality through a language that was itself wounded by reality. Thus, poetry conveys the reality of such a wound by enacting its own self-wounding.[3]

In Celan's critical description of poetry after Auschwitz, where the euphony sounds alongside the most terrible things ("einhertönte"), one hears Adorno's reflections on art after Auschwitz in his *Meditationen zur Metaphysik*, where he describes how the SS drowned out (*übertönen*) the cries of their victims with "Begleitmusik" (accompanying music) (Kiedaisch, 60).[4] A few years later Adorno also remarked, "After Auschwitz there is no word tinged from on high, not even a theological one, that has any right unless it underwent transformation" (*Negative Dialectics*, 367), because he believed that art after the catastrophe was caught in a double bind. Despite his earlier and often misunderstood remarks concerning the status of poetry after Auschwitz, a position he reassessed on several occasions after encountering Celan's lyric, Adorno never argued that art had to be jettisoned. Instead, he insisted that it must recognize that it cannot escape the very barbarism from which it issued, nor can it atone for a culture that could not hinder the Holocaust. To him, the reality of Auschwitz in the midst of the traditions of philosophy, art, and the enlightening sciences proved irrefutably that culture had failed.[5]

In the following passage from his *Aesthetic Theory*, Adorno conveys his distrust of art after the discovery of the death camps: "In its disproportion to the horror that has transpired and threatens, it is condemned to cyni-

poetry, Celan was placed into the category of pure poetry and euphony, a label he struggled with throughout his poems (*Paul Celan*, 79).

3 Celan describes how the contemporary poet goes toward language "with his being [Dasein]," toward a language that has been "wounded by and in search of reality [wirklichkeitswund und Wirklichkeit suchend]" (*Gesammelte Werke*, 3:186).

4 This collection contains excerpts from Adorno's writings on poetry and art's relation to the Holocaust.

5 Adorno emphatically declares, "All culture after Auschwitz, including its much needed critique, is garbage" (*Negative Dialectics*, 359).

cism; even where it directly faces the horror, it diverts attention from it" (234). Instead of providing us with the truth or meaning behind what happened, art obviates the most recent horrors with its representations, or what Adorno derisively refers to as "a photograph of the disaster [Unheil]" (19). The focus of his mistrust centers on the visual representation of the catastrophe and, in particular, he names photography: the most mimetic type of representation. Dismissive of such mimetic forms of art that tend to promise a direct mediation or access to the horrors that befell the Other, Adorno proposes a new aesthetic that would divulge to its audience and to itself its own inescapable failure to convey that horror.[6] By distancing himself from a mimetic impulse in the artwork, Adorno rejects photography's claims to authenticity in representing the disaster. How then does the artist escape this predicament if the very tradition from which he or she emerges is severely damaged by this historical trauma? What is the task or possibility of art in the aftermath of the Holocaust? Proposing a turn to abstract and hermetic forms of art in his *Aesthetic Theory*, Adorno extols the works of Samuel Beckett and Celan. He died before writing on Celan as he intended, but his analysis of Beckett points to the "other way" shared by both Beckett's and Celan's poetics.

Adorno regarded Beckett's *Endgame* highly because it clearly rejected any mirror-like reflection of reality. In his "Trying to Understand *Endgame*" he wrote, "The name of the disaster [Unheil] can only be spoken silently" (*Notes on Literature*, 2:126; see also "Trying to Understand *Endgame*," trans. Michael T. Jones). Demonstrating that it understands its own incomprehensibility, the structure of *Endgame* reveals the very annihilation of its meaning emerging from an epistemological crisis in the aftermath of the Second World War and the Holocaust. The disaster or "Unheil" is conveyed not through images, photographs, or other art forms that gesture toward authentic depictions of historical catastrophe, but through a language that has been radically altered and struggles with its silences and paratactic disturbances. In Beckett's new idiom, consisting of repetitions, fragmented words, and pauses, the catastrophes of the recent past infect

6 Because Adorno's own exploration of mimesis is so expansive, I will keep my analysis here brief. His concept of mimesis does have positive associations specifically in relation to poetic language, for in poetry there is an unattainable striving for an "impossible" language (*Notes on Literature*, 2:197). See for instance his concept of mimesis in relation to Hölderlin's poetry and its desire to name. While Hölderlin seeks a language prior to communication—that is, a "pure language"—the poet recognizes the very impossibility of attaining such a language. The necessary failure in this poetics is captured in the paratactic disruptions that punctuate Hölderlin's later poems. Adorno gains access here to the ethical implications behind a poetics where Otherness cannot be subsumed through language. In effect, Hölderlin's poetry is one that preserves alterity.

the present as well as the future. The aporia of history is inscribed in the syntactic disruptions and stuttering of poetic language itself.

So Adorno shared Celan's concerns as expressed to the Flinker Bookstore regarding the making "poetical" or "transfiguring" (*verklären*) of the most horrible events in history (*Collected Prose*, 16). As he cautioned in *Notes on Literature*, "Through the aesthetic principle of stylization ... an unimaginable fate still seems as if it had some meaning; it becomes transfigured ["verklärt"], with something of the horror removed" (Kiedaisch, 54). Both the poet and the philosopher were wary that the horror behind the most terrifying elements of history might be lost once the artist or poet attempted to confront this horror through his or her respective media. How then could the poet's language engage with these terrors of memory without compromising the very content of this traumatic history?

In the "Paralipomena" to his *Aesthetic Theory*, Adorno describes how Celan's poems "want to speak of the most extreme horror through silence. Their truth content itself becomes negative. They imitate a language beneath the helpless language of human beings, indeed beneath all organic language; it is that of the dead speaking, of stones and stars ... The language of the lifeless becomes the last possible comfort for a death that is deprived of all meaning" (322). According to Adorno, Celan, like Beckett, distanced himself from symbolic representations by violating syntax and grammar in order to expose the restrictions language faces in the midst of catastrophic history. When confronted with the memory of the death camps, the syntactic operations of language—which had itself been wounded by this trauma—do not avoid the violence of the past, but mimic it by exposing these very wounds; poetic language discloses the risks of its own negation by becoming silent. One recalls from "The Meridian" how the poem has a "strong tendency towards silence ... It constantly calls and pulls itself back from an 'already-no-more' into a 'still-here'" (*Collected Prose*, 48–49). Celan's poems do not investigate the *topos* of a particular image; they demonstrate the very process through which the image is disfigured. As Werner Hamacher aptly describes in his essay "The Second of Inversion: Movements of a Figure through Celan's Poetry," there is a suspension in the semantic function of language whereby it "turns into the image of its own interruption" (237). The communicative function of language, where the poem reaches toward the Other, is thrown into doubt.

The polemic that Adorno constructs between his suspicions regarding mimetic art and his approval of a poetry that resembles the language of "the dead speaking, of stones and stars" is central to Celan's own reflections on the tensions between art and poetry discussed in the previous chapter. In particular, I am thinking of how at the moment of historical

violence, Celan's figure for the visual arts falters and he clearly articulates his rejection of both beauty and mimesis: when the Medusa's head dissolves, the "moment [Augenblick]" of a "terrifying silence" arises in the poem (*Collected Prose*, 47). One recalls how the Medusa's head was first linked to "the finest, most intimate paintings [schönsten Bilder] of the old German masters." It is this very mimetic quality of art, art's desire to grasp the "natural as the natural" (42), which Celan is critiquing throughout "The Meridian." Although poetic language might seem to conform to a visual awareness with its acute sense for "detail, outline, structure, and color" (50), Celan's emphasis on the visual ultimately becomes the very breakdown of perception. His earlier concerns regarding the euphony and musicality of poetry in the midst of "the most terrifying" moment in history are replaced now by a terrifying muteness.[7]

Celan's reflections on tonality, visual representation, memory of a terrifying history, and the divergence between French and German lyric poetry in 1958 can be explored in a project he had completed in the fall of 1956. These two distinct cultural spaces, French and German, encountered one another in Celan's translation into German of Jean Cayrol's commentary on Alain Resnais's film *Nuit et Brouillard* (*Night and Fog*, 1955/56). I am particularly interested in the impact that Resnais's film had on Celan's translation of the commentary; furthermore, the very tensions concerning memory and representing the Holocaust that unfold in Celan here also play out in his poem "Engführung" (1958), which was shaped by his translation of *Nuit et Brouillard*. In "Engführung," completed around the time he was responding to the Flinker questionnaire, Celan shows "the other way" lyric poetry had to take in relation to this traumatic past, the tradition of lyric poetry, and the visual arts. Both Resnais and Celan's texts are reflections on a post-Holocaust optics in relation to those murdered by the National Socialists. The dispersion of the body in *Night and Fog* requires that it be recomposed and re-membered by the spectator.

I propose that Resnais's use of a cubistic optics in *Night and Fog* stems from his earlier project concerning French colonialism in Africa, *Les Statues meurent aussi* (1953), which examines the colonial as well as the museal gaze that reduced the Other and her culture to mere objects. While Resnais's camera did not enter the death camps to commit similar acts of reification of this traumatic history or the exterminated Other, the film's narrative ultimately brings about the very thing Resnais set out not to do: it erases the identity of this Other. By circumventing the unique status of

7 "Das Furchtbare" is a term Celan repeats in his Flinker letter ("Neben dem Furchtbarsten," *Gesammelte Werke*, 3:167), in his Bremen Speech ("Durch furchtbares Verstummen," 3:186), and in "The Meridian" ("ein Furchtbares Verstummen," 3:195) in order to convey the most terrifying moment in history: the death camps.

the Jewish Other within the death camps, *Night and Fog* becomes complicit in what it critiques: it forgets the Jewish Other who inhabited the center horrors within the death camps. Although Resnais's *Night and Fog* inadvertently perpetuates the very mechanisms of repression it sets out to analyze, Celan's adaptation of Cayrol's commentary deftly positions the reader and the German audience on the threshold between memory and repression. The mnemonic process in Celan's translation of the commentary and in his transposition of filmic material into "Engführung" keeps the history of the death camps open and exposed. Disavowing any idea of working through the past, Celan wished to destabilize the reader/spectator's relation to the texts and to the traumatic history unfolding within them.

The leitmotif of both Resnais and Celan centers on the cinematic and poetic de-structuring of a landscape: the aesthetic object par excellence of modern painting. Both artists deform this recurrent topos into mere traces. Resnais's cubistic style of abstraction is produced by means of multiple transitions between documentary black-and-white footage from the past and color film shot at Auschwitz in the present, and the layering of sound: non-diegetic music composed by Hans Eisler and an emotionless voiceover written by a poet who had been a French resistance fighter and an inmate in the Mauthausen concentration camp. Resnais's goal is to expose the points of suture in the narrative through a layering of perceptual affect, and he used such techniques as the shock of close-ups and the use of contrapuntal music to subvert the diegetic unity of the text.[8] While classic cinema strives to hide its cuts or cover them over in order to make a seamless narrative, Resnais wished to destabilize any such seamlessness in *Night and Fog*. Through the multiple layers of discordant sound and image, he tried to decompose filmic space in order to make the viewer cognizant of these breaks in continuity and draw attention to the spectator's inability to master or contain the abstracted object (the extermination) through her gaze. But despite the incessant critique of the image throughout *Night and Fog*, Resnais could never completely abandon his use of them. Images, constructed through both the cinematic lens and photography, are always present in his documentary.

In his "Paralipomena" to his *Aesthetic Theory* Adorno compared Celan's poetry to abstract art, especially painting. Drawing an analogy between Celan's and Kafka's treatment of expressionist painting, he de-

8 Although Resnais may claim that Eisler used his contrast between sound and image to provide hope—"the more violent the images, the gentler the music" (Insdorf, 37)—I find such a position highly problematic and inconsistent in regard to various scenes within the film. For instance, as the camera investigates the crematoria and peers inside the abyssal opening of an oven to show bones and ash, melodious sounds of flutes follow its movement. This disconnect between image and sound stresses the spectator's total inability to synthesize into a whole what is being shown.

clared, "Celan translated into linguistic terms what happens to landscapes when they become more and more abstract, more and more like inorganic matter" (322). Even though this description captures concisely what unfolds in both the film and the poem, I would claim that each artwork comes closer to what happens in Cubism. The movement began with an interest in landscapes and African sculpture, ultimately shifting to the portrayal of human forms. *Night and Fog* is a meditation on a landscape, albeit not the French countryside of *Les Demoiselles d'Avignon* (1907), where Picasso first dismantled three-dimensional space. But the film explores the disfigured landscape of the death camps and the people who occupied them. Just as Cubism's invention of a new visual language did not try to imitate or represent nature directly, Resnais's film does not claim to know the essence of genocide. Instead, it reveals what happened at the site of the death camps through myriad traces. *Night and Fog* fulfills what the critic and filmmaker Eric Rohmer once said about Resnais: that he is a cubist because he reconstitutes reality after fragmenting it (Insdorf, 38). The effect of this fragmentation, according to Rohmer, is the very blurring of the past with the present. Similarly, Celan's cubistic form is bound to the layering of memory which produces a sense of temporal dislocation between past and present for the poem's recipient. Like an object depicted in a work of Cubism, where the instability of perspective makes mastery of the object impossible, history is not something that can be mastered by Celan's poetic *topos*. [9]

While he was wary of the mimetic impulse behind visual art's claims to authenticity, Celan's poetics constantly struggles with perception and space. By dismissing a "musical" language that "poeticizes" and contains a "euphony" the German reader may wish to hear, Celan clears the way for a more factual language that seems to take on the characteristics of visual forms of representation. As his response to the Flinker questionnaire re-

9 My analysis of the interplay between the landscape and visual culture in Celan has benefited from Ulrich Baer's compelling study of Celan and Baudelaire, *Remnants of Song*, particularly his chapter on Celan's landscape poem. But while Baer foregrounds Celan's engagement with the Romantic landscape, I believe that the rejection of the epistemological frame is more evocative of a cubistic form. Baer describes how the event has been "unmoored from its location" and argues that the experience splinters into catastrophic shock consisting of "fragmented perceptions of the surroundings" (226). Celan's move to abstraction illustrates his attempt "to order the representation of experiences that destroyed the notion of a proper setting" (235). Counter to Baer's claim that Celan is looking for a "safe place" from which to frame, situate, and address the corruption, loss, and subsequent precariousness of the notions of belonging and place (217), I suggest that this sense of positioning constitutes a confinement, or narrowness, that is meant to invoke spatial anxiety in the reader. As Lacoue-Labarthe asks, "Was Celan able to situate not himself, but us vis-à-vis 'it'?" (*Poetry as Experience*, 9). Epistemological space has been radically altered and Celan is foregrounding instead an ethical import behind the reader's encounter with scenes of impossible mourning that are linked to the destruction of the Other.

veals, visual terms such as "gray language," "polychrome," and "visual realm," along with a concern "to measure a particular area," attest to the specular as well as spatial dimensions of poetry (16–17). Despite his employment of such visual components and analogies, Celan's poetry is ultimately an assault on both mimesis and the construction of images, and he underscores their removal through the very undermining of perception. In his incessant questioning of the interplay between poetry and perception, Celan finds in a cubistic mode an optics that is compatible with his poetics.

Why is a cubistic lens so relevant to a post-Holocaust aesthetics? For one thing, such a gaze, as I discussed in chapter 1, is ethical at its core.[10] It cannot synthesize the multiple parts of a phenomenon, nor does it claim to subsume the event, the landscape, or the disfigured Other that passes through its lens; rather, the optics of Cubism denote the impossibility of totalizing either the Other or the alterity of the trauma that brought about the Other's effacement. The syntax of Cubism revolves around the fragmentation of form and the natural world, where the very ambiguity of pictorial space is depicted through geometric shapes. Disavowing an accurate reconstruction of the natural world, Cubism presents this world through pieces and fragments and the distortion of objects. The artworks of Cubism can no longer be described as mimetic, for they do not intend to correspond with objects in the world and the spectator is prevented from integrating what s/he sees into a completed object or image. The disruption of the epistemic structures, which are necessary to synthesize an experience, brings to the surface questions regarding one's ethical relation to trauma. Like the inability to integrate trauma into memory, one's encounter with alterity is itself contingent on the interruption of a phenomenological framework. Cubism is thus the representational form needed to probe the subject's encounter with the traumatic residue left in the wake of the Other's effacement.[11]

10 I developed the relation between a cubistic optics and ethics through the works of Levinas. If ethics is an optic, as Levinas claims, then his gaze is consistent with Cubism. In his *Existence and Existents* (1947), he stresses the connection between ethics and modern art's relation to the world. For Levinas, modern art is about neither beauty nor the visible; rather, he describes the representation of modern painting as a "deformation" consisting of a "breakup of continuity" (55–57).

11 In *Screening the Holocaust* Ilan Avisar contends that Resnais modeled his use of images of the mass graves and mound of bodies to particular iconographic artworks, such as Michelangelo's *Last Judgment* and Rodin's sculpture *Gates of Hell*. In addition to specific artistic works that might have influenced Resnais's filmic medium, I am also interested in a particular optic frame (cubist) through which he asks his spectators to engage with the presentation of catastrophic history (see Avisar, 11).

Resnais and the Visual Arts

Before he was asked by the Committee on the History of Deportation of the Second World War in France to make a documentary on the Holocaust, Resnais had made a series of experimental documentary films which were engaged with the visual arts, especially painting and sculpture: *Van Gogh* (1948), *Paul Gauguin* (1950), *Guernica* (1950), and *Les Statues meurent aussi* (1953). Each of these films had a particular impact on *Night and Fog* (1955/56) with regard to the questions they asked concerning both representing and looking at scenes of personal and historical trauma.[12] In addition to probing film's relation to the visual arts, Resnais continuously returned to cinema's relation to representing historical trauma, including the bombing of Guernica, French colonialization, and the legacies of Auschwitz and Hiroshima. The spectator's access to the traumatic spaces of history in each film is mediated through an optics consistent with Cubism.

In his *Guernica* Resnais explores not the Adornian question of whether painting after Guernica was possible, but rather examines how Picasso's aesthetic trajectory was influenced and transformed by the aerial assault on the Basque city. The film illustrates how the development of Picasso's art from his Blue Period to *Guernica* (1938) underwent a radical aesthetic rupture which Resnais attributed to unprecedented historical violence. As Ray Armes describes the film, "Fragments of photographs, painting, and sculpture are welded together into a visual rhythm and set against an aural rhythm of music and verbal poetry bound together in a tone that combines documentary realism with pure lyricism" (39). Armes's description captures the cubistic style that Resnais's film imitates with its collage of photographs, newspaper clippings, and paintings interconnected by a dissonant soundtrack. Despite the lyricism that Armes sees in the film, the quick, staccato-like montage of documentary images and words interspersed with Picasso's own artworks constantly draw attention to its disjointed rhythm. Resnais employs these cubistic techniques in order to convey the difficulties the filmic medium has in looking at, processing, and representing the historical catastrophe of Guernica's bombing. Like the massive size of Picasso's *Guernica*, which reflects the painting's visceral component that attempts to overwhelm the viewer, the fragmentary style and dissonant sounds in Resnais's film are also meant to problematize the position of the spectator.

12 Resnais's next major film after *Night and Fog, Hiroshima mon amour* (1959), begins by examining the space of the museum in Hiroshima. Resnais focuses on the photographic exhibitions depicting the destruction in the aftermath of the atomic blast.

If *Guernica* was concerned with the status of the image after a catastrophic event, Resnais's next film, *Les Statues meurent aussi* (1953), explores the role of the spectator confronted by such representations of traumatic history. In the year before the filming of *Night and Fog*, Resnais examined the transformation of sacred traditional objects from Africa after they had been appropriated from indigenous communities and placed in museums back in France. Once removed from their cultural context, these artifacts functioned no longer as sacred objects infused with religious import, but were reduced to only their formal properties. His analysis of these statues returns the filmmaker to one of the original objects of study of the cubists: African sculpture, but his analysis of these sculptures does not celebrate the simplicity of form or the interweaving of the artwork with nature. Instead, through a quick montage alternating between ritual statues and African villagers, Resnais shows how those brought under the rule of colonialism themselves became mere objects. With their meaning extinguished, the spiritual objects, metonymies for the people and culture who made and used them, become commodities within the space of the museum.

Resnais's critique of French colonialism is simultaneously a reflection on the subject's gaze when s/he is confronted with the Other. Whether it is the colonialist or filmmaker from France who observes the inhabitants of an African village or the museum visitor who looks at the exhibits from Africa, each gaze turns the Other into a dead object. Yet another gaze enters into this dynamic: Resnais draws the film's spectator into an act of complicity whereby the viewer participates in the objectification of the Other through his/her gaze. Caught in a double bind, the spectator is forced to reflect on his/her responsibility for the Other; to refuse to look or to avert one's eyes is itself symptomatic of failing to remember or acknowledge the process in which the Other and their homes were appropriated. The gaze that leads to the reification of the Other and her culture shifts to the forgetting of the Other through the act of looking away. The film posits the spectator's own potential guilt in relation to both the act of looking that helps transform the Other into an object and the refusal to look, which signifies an act of forgetting the Other's destruction.

How does the gaze explicated by Resnais in *Les Statues meurent aussi* impact the holocaustal gaze of *Night and Fog*? As in *Les Statues meurent aussi*, Resnais continues with questions concerning the implications of looking at the effaced Other. But does the camera's gaze in *Night and Fog* incriminate itself with regard to what Resnais set out to critique in *Les Statues meurent aussi*? Does he run the risk of turning the Jewish victims and their bodies in *Night and Fog* into mere figurines like what happened to the statues in *Les Statues meurent aussi*? Robert Michael asks,

> If *Night and Fog* can work in French resistance fighters and Spanish Republicans unjustly deported from France and cruelly murdered in Mauthausen, why can it not identify the special and prime targets of the Nazis—the Jews, who die there not in the hundreds or in the thousands, but in the millions? (37)

In my view *Night and Fog* falls into the very problems that Resnais explored in *Les Statues meurent aussi*; it effaces the Jewish bodies a second time, not through the optics of the camera but by elisions in Cayrol's narrative. One could read the intention of withholding the Jewish identities of the victims as an ultimate rejection of the National Socialist ideology and its racist understanding, which reduced the Jewish Other to a mere trope, a mark of difference that necessitated his/her extermination. But Resnais's use of visual cues, the catalogue of images shown in the film and the film's central location of Auschwitz, mark this space as a site of Jewish catastrophe. His turning to iconic images of the Judeocide—the Warsaw Ghetto child with raised arms, France's station for Jewish deportation, the myriad yellow stars—and the use of places associated predominantly with Jewish victims would corroborate the idea that Resnais's intention is actually to unmask the identity of these particular victims. But without a linguistic act that articulates such uniqueness, there is instead an implosion of identification; specificity is lost in favor of a universal message.

Lyotard succinctly portrays the first deaths of the Jewish victims at the hands of the National Socialists:

> The individual name must be killed (whence the use of serial numbers), and the collective name (Jew) must also be killed in such a way that no we bearing this name might remain which could take the deportee's death into itself and eternalize it. This death must therefore be killed, and that is what is worse than death. For, if death can be exterminated, it is because there is nothing to kill. Not even the name Jew. (*Differend*, 101)

Night and Fog inadvertently brings about a second death by withholding the Jewish identities of the bodies, and the Jewish bodies become mere objects or props when divested of their proper name. Although the film conveys the destruction of the Other by showing those murdered by the Nazis, it does not uncover the unique content of the genocide being shown. Except for a passing mention early in the film of a "Jewish student from Amsterdam," one victim who is placed alongside a litany of other victims of the National Socialists, the reason for their systematic extermination—that they were Jewish—is left unspoken. The very questions Resnais probes in his film on colonialization come back to haunt the bodies strewn across the landscape in *Night and Fog*. The unique identities of these corpses are taken away from them as the bodies are placed within a context that universalizes the destruction of the Other. In *Night and Fog* it

is not the image that is repressed—the bodies of Jewish victims—but rather it is the word "Jewish" that identifies the specificity of the crimes and its victims that is missing.

Before examining the material in the film—what it shows and narrates—I will briefly discuss the debates around which the film made its debut at the Cannes Film Festival in the spring of 1956. The tensions regarding whether or not it should be screened at Cannes shed light on the historical conditions at the time when Celan was entrusted with translating the film. But these very conditions regarding historical memory and the Holocaust also disclose reasons for which the poet found it necessary to transpose the filmic images and ideas from *Night and Fog* into "Engführung." Before the festival began, the German government lodged a formal protest against the inclusion of Resnais's film. In an era defined by Adenauer's attempts at reconciliation in Europe, German officials, concerned with the Federal Republic's reputation abroad, feared that the film would open wounds and expose Germany's shame to the international community. Although French government officials eventually removed the film from the festival's main venue, *Night and Fog* was shown to an invited audience in a Cannes auditorium.

Despite the protest that arose over the potential screening of *Night and Fog* abroad, the German government strongly endorsed the film's circulation in Germany in the summer of 1956. The German press agency negotiated with Argos Films, who owned the rights to the film, to have a version made available to the German public, and Jean Cayrol chose Celan to translate his commentary into German. In his detailed study of the German reception of *Night and Fog*, Ewout van der Knaap provides an excellent analysis of the film's history from 1956 to the present. According to him, it served as a sign of Germany's "becoming aware of what had been considered inconceivable" and increased "public awareness of the politics of deportation and extermination" (47). Emphasizing the epistemological implications of the film, van der Knaap claims that "in German public discourse the concept of the Holocaust was known before the homicide of the Jews generally was denominated with the 'H-word'" (47). Even though direct verbal references to the Jewish victims were limited to but one moment in the film, van der Knaap asserts, "Contemporary viewers knew which groups were deported and understood the vast majority to be Jews" (18). But it is exactly *public* discourse about the Holocaust that is missing during this period of supposed reconciliation throughout the 1950s. While the film's images might have been recognized as "Jewish" by their German viewers, the silence within the narrative regarding these victims was replicated in the lack of any sustained public discourse that engaged with the Holocaust, especially by members of the government. Such

a silence reveals not the unconscious process of repression, but rather
willful obfuscation of the past.

Van der Knaap turns to one particular spectator of the film, Celan,
and claims that he certainly must have recognized the Jewish topography
unfolding in *Night and Fog*. But while Celan might have heard a Jewish
resonance behind particular geographic locations in the film, his transla-
tion of Cayrol's commentary and his writing of "Engführung" demon-
strate his own misgivings about the role of the Holocaust in the space of
German collective memory. To watch the film, or for that matter to recite
"Todesfuge," is not equivalent to knowing, understanding, or remember-
ing the genocide against the Jews of Europe. The juxtaposition of Ger-
many's protest against the film at Cannes and Germany's support for
screening the film at home is symptomatic of what Adorno would in 1959
call the country's "neurotic" relation to the past ("Coming to Terms,"
116). This neuroticism, according to Adorno, consisted of defensive ges-
tures, the play between massive and diminished affect, the tendency to
denial, and empty discourse and gestures to articulate the most atrocious
memories. In order for the past to be processed and for the fascist residue
still present in society to be removed, Adorno stressed that enlightenment
was contingent on two components: an education accompanied by the
structures of Freudian psychoanalysis (127). While *Night and Fog* was in-
tended by the German government to fit into this process of what
Adorno labels "democratic pedagogy"—the film was shown to members
of the government and the military and to high school students—there
was no guarantee that viewing it would lead to individual enlightenment
with regard to the past. Conversely, it was possible that such pedagogy
would become a "tiresome duty" (126) and bring about either resistance
to memory or a false sense of closure to the past.

In terms of the universalizing message present in *Night and Fog*, which
essentially left unspoken the unique position of the "Jewish Question" in
German racial policy, there was no assurance that the film alone would
counter anti-Semitism or recall the Judeocide. Discussing the role of
pedagogy, Adorno asserted, "Essentially, it is a matter of the *way* in which
the past is called up and made present: whether one stops at sheer re-
proach, or whether one endures the horror through a certain strength that
comprehends even the incomprehensible. For this task it will, however, be
necessary to educate the educators" (126). For Adorno, the structures of
Freudian psychoanalysis were imperative for this movement toward indi-
vidual reflection. I would claim that Celan's translation of the film and his
transposition of the filmic material into the poetics of "Engführung" re-
veal "a way" in which he attempted to "educate the educators." However,
both Celan's translation of Cayrol's commentary and "Engführung" are

devoid of any therapeutic aims that suggest a mastering of the past; instead, the poet confronts his German audience with their very failure to engage with the past. Both his translation and the poem are meant to counter Germany's deflection of responsibility for the genocide, the selective remembering of the past and the message of universalism present in the film. Rather, both texts call attention to the displacement of the Jewish Other in the space of postwar German memory.

Celan and the Visual Arts

In a series of correspondence from 1957, Hanne Lenz had asked Celan if he were interested in translating Edgard Morin's book on film, *Le Cinéma et l'homme imaginaire*. The book, as described by Lenz, examined the phenomenology of film, including the development of photography, the transition "from frozen to moving image [vom starren zum bewegten Bild]," the aesthetic methods of film, such as editing, and the psychology of the movie spectator (Lenz, 76). In his first response to Lenz, Celan wrote that he had indeed looked through Morin's book but hesitated to accept the offer because he "hardly has a relation to film"(79). He had asked for twenty-four hours to think over Lenz's offer, and in his next letter he stated more emphatically that he could not accept the translation on two grounds. First, he wrote, "What do I know about film" (81), a rather curious remark considering he had just the year before translated the commentary to *Night and Fog*. His refusal is also puzzling in light of the phenomenology of the visual arts, the questions regarding images, the techniques of cutting, and the spectator's encounter with the artwork—all central to Resnais's film and fundamental to Celan's poetics. Celan's second reason illuminates what may have been the real motive for his refusal. He informed Hanne Lenz that he had met a man from Morin's circle at a meeting of writers in Vézelay, France, the year before (April 28 to May 2, 1956), and found this individual particularly unsympathetic. At the time, Celan had written to Lenz that he detected an anti-Semitic atmosphere at the gathering. Even though Morin was himself not present, he was tainted by his association with someone who was there, and this connection became for Celan the final reason for his decision not to translate Morin's book. The anti-Semitic climate that Celan perceived as so prevalent in Europe in the 1950s and early 1960s affected not only his poetry, but also

what he would chose to translate and with whom he would publish his poetry.[13]

Despite Celan's own doubts concerning his relation to film, he was indeed affected by visual artists. Just as Resnais's interest in the visual arts influenced his making *Night and Fog*, visual culture had influenced Celan's poetry even before he translated Cayrol's script. He had already written an introduction to the surrealist sketches of Edgar Jené (*Edgar Jené und der Traum vom Traumes*, 1948), translated Picasso's play *Desire Caught by the Tail* (1954), and written his ekphrastic poem "Below a Painting" (1955). In 1952 Celan married the graphic artist Gisèle Lestrange, and in 1965 the two released a series of his poems accompanied by her lithographs. Yet despite the impact that painting had on Celan's poetry as seen in his engagement with the works of Picasso, Géricault, Van Gogh, Rembrandt and Chagall, Celan said in an interview with Hugo Huppert in 1966 that *Graveurkunst* (engraving), a visually abstract art consisting of cutting and lines, had the most profound influence on his poetics. Similar to his rejection of euphony in his Flinker letter, in his conversation with Huppert Celan disavowed poetry's connection to music and claimed, "I don't musicalize anymore, like at the time of the much-flaunted 'Todesfuge,' which has been practically threshed over in many a textbook" (Huppert, 320). By drawing attention to "Todesfuge," he used the example of the Holocaust poem par excellence and again described the misappropriation of his poem in German schoolbooks as the point from which he wishes to break. After two decades of its circulation in Germany, Celan believed his poem was contributing to the very objectification of the Holocaust that he was trying to resist.

Moving away from euphony, Celan continues, "I try linguistically to give back in language at least extracts of this spectral analysis of things, showing their varying aspects and interrelationships with other things ... Unfortunately, I am unable to show these things from a comprehensive angle" (320–21). Language behaves like light, searching, testing, and examining the things of the world to reveal their multiple perspectives: the whole becomes dispersed and resists being unified. Celan's language, like the composition of Cubism, tries to observe things by showing them from "various angles [Sichtwinkeln], breaks and divisions [Brechungen und Zerlegungen]" (320). Unable to reveal "comprehensively [allseitig]" the thing being observed, Celan can only depict the object in cuts. Although he was aware that critics described his poetry as abstract, Celan claimed that in

13 James Lyon provides the details to what Celan experienced at the conference in Vézelay: "He heard a German writer in a private conversation say, 'I can't stand to smell Jews,' a remark that triggered protests from German friends there whom Celan considered decent (Heinrich Böll, Rolf Schroers)" (*Celan and Heidegger*, 61–62).

the strictest sense of the term—with regard to a "theory of knowledge [Erkenntnis-Theorie]"—it is not abstract. Nor are his poems "objectless art [gegenstandslose Kunst]," for there are indeed multiple objects behind his poetry: people, places, dates, other artworks, or, for instance, a landscape (320).

Referring in this way to perception, objects of experience, and theories of knowledge, Celan used philosophical terminology reminiscent of Kant's *Critique of Pure Reason*. For Kant, an experience consists of concepts that are themselves constructed out of the subject's relation to the world through the faculties of perception: "[a]ll experience does indeed contain, in addition to the intuition of the senses through which something is given, a *concept* of an object as being thereby given, that is to say, as appearing" (126). In turn, these objects—whether they are things or events—consist of representations that can be accessed through the senses. Furthermore, the imagination is central to Kant's notion of experience, for it is the imagination that is needed to synthesize the parts of an experience into the whole experience:

> Since every appearance contains a manifold, and since different perceptions therefore occur in the mind separately and singly, a combination of them, such as they cannot have in sense itself, is demanded. There must therefore exist in us an active faculty for the synthesis of this manifold. To this faculty I give the title, imagination. (144)

Mediating between sense and cognition, the imagination accesses an experience through its representations and becomes ineluctably bound to memory as the subject forms a representation of an experience. Kant requires the faculty of the imagination to pull together the reproduced representations of past experiences, which he labels recognition ("wiedererkennen"), so that present experiences can be grasped. Forming images ("Bilder") out of what was first perceived through the senses, the imagination organizes these images through the unity of apperception: the faculty that forms the links between the imagination and understanding. The ability to have an experience in the present is based on one's ability to recall past experiences, and this dynamic exchange between perception, apperception, and imagination provides the necessary structure for understanding an experience or an object.

However, Celan's poems—which he described in "The Meridian" as emerging from a traumatic date—are not *Bilder*; rather, they show the disintegration of *Bilder*. Like Resnais's film, "Engführung" reconstitutes reality after fragmenting it. The trauma of the death camps has radically altered the subject's relation to the events that took place inside their spaces. By undermining the reader's faculties of imagination, sense, and

apperception, Celan calls into question the very tools needed for the rec-
ollection of a past experience. The filmic and poetic landscapes of *Night
and Fog* and "Engführung" are not in and of themselves abstract; but the
event associated with this place—the mass exterminations in the death
camps—invades these texts and transforms their respective topographies.

But while *Night and Fog* unintentionally protracts the very structures of
repression it attempts to critique, the objective of "Engführung" is to trap
the reader within the traumatic history unfolding within its lines and to
disrupt any illusion that the past can be mastered. In his discussion of
"Engführung," Peter Szondi remarks that section 7 of the poem indicates
the moment when the poem returns to where it begins, "The forgetting of
those whose memory the poet took upon himself to preserve" (64). This
point of departure is "the memory of the dead, [which] lies at the origin of
Celan's entire poetic oeuvre ... the reality of the death camps" (33).
Where these components of memory and forgetting collide, Celan draws
on figures and terminology consistent with Cubism.

Van Gogh's *Cornfield with Crows*: Crossing Film and Poetry

Despite its mistrust of images, *Night and Fog* begins like a painting. The
opening scene and accompanying narrative sets up the image of serenity
that the film as well as Celan's translation of Cayrol will try to subvert:
"Auch ruhiges Land [Even a peaceful land]" (79).[14] Celan uses the word
Land ("land" or "country") instead of *Landschaft* ("landscape"), which
would have come closer to a literal translation of the French *paysage*, and
thus he immediately situates the German spectator within a possible en-
counter with a particular place: his or her homeland. The film, through
visual and narrative strategies, undermines both the peacefulness of this
opening shot of the landscape and the very activity of spectatorship.
Countering the landscape's tranquility, the film's goal is to bring about
"the true dimension again" of the camps: "uninterrupted anxiety" (83).[15]
In the opening sequence of the film, the narrative voice moves from the
unspecified place, "Auch ruhiges Land," to definite destinations that situ-
ate the viewer in the film's topography: Struthof, Oranienburg, Auschwitz,
Ravensbruck, Dachau, Neuengamme, and Bergen-Belsen, a litany of

14 I will be using Cayrol's commentary to the film and Celan's translation, which are located in
 Celan's *Gesammelte Werke*, 4:79–95. Unless otherwise noted, the English translations are my
 own.
15 Later in the film we hear, "Kein Bild, keine Beschreibung gibt ihnen ihre wahre Dimension
 wieder: die ununterbrochene Angst [No Image, no description can reproduce for you their
 true dimension: uninterrupted anxiety]" (83).

places also meant to produce an acoustic anxiety through the very act of naming. The aural shock attached to these names is accompanied by visual terror. In the opening sequence, the screen frames the blue sky with black birds flying over yellow fields, and the shot remains stationary for a moment. Then the serenity of the scene is upset as the camera, suspended above the landscape, gradually drops down to reveal the barbed wire of the desolate camp. The spectator is oriented in both time and place: the aftermath of the extermination.

Before the camera guides the spectator into the camp, the opening filmic image appears to be a citation of one of Van Gogh's paintings. Resnais cinematically illustrates through this initial image the scene from Van Gogh's *Cornfield with Crows* (1890). At this key moment in the film with the citing of Van Gogh's painting, the resonance between Resnais and Celan is most pronounced, and Cayrol's own text becomes secondary. In their respective treatments of Van Gogh, there is a correspondence between Resnais and Celan's reflections regarding mimesis and traumatic memory. As in the rejection of the Medusa's head, neither Resnais nor Celan is concerned with art's mimetic impulse in terms of reproducing natural scenes such as landscapes, or in representing the terrifying events of history. In terms of their encounters with the Holocaust, both poet and filmmaker try to represent the limitations of the mnemonic process in relation to traumatic history.

It is not in the scope of this analysis to examine in depth the interplay between the composition of film, painting, and poetry, or how one work is the evocation of the other. However, the key thematics in Celan's poem provide direction to his encounter with Resnais's film. Often there is a tendency to read the painting in a biographical manner, which both Resnais and Celan in fact do: the painting is interpreted as Van Gogh's suicide note. The artwork, with its bright yellows, oranges, reddish browns, greens and blues, depicts a cornfield with a flock of birds moving from the painting's center perspective across the cornfields and towards the right-hand corner's vanishing point. At the upper center of the canvas is a sun, while lower on the horizon a second sun descends. Two distinct paths intersect the field, and a third path, going toward the right of the canvas, is abruptly cut short.

Resnais's first experimental film, *Van Gogh*, ends with this particular painting. Despite Van Gogh's own use of vibrant colors, Resnais explores the painter's self-destruction through black-and-white reproductions of his paintings, probing figuratively the interior spaces of the painter's consciousness. He does not set out to explain the paintings, but examines art's ability to capture personal trauma. Although incorrectly, many critics have called *Cornfield with Crows* Van Gogh's last work, and Resnais himself

uses it in this manner: the painting functions as his suicide note. Although the opening landscape of *Night and Fog* from 1955 looks peaceful, Resnais infuses it with an ominous quality through his cinematic depiction of the painting. Breaking out of the frame of Van Gogh's motionless artwork, the camera begins to move through this deathly terrain. The opening scenes of the landscape are always mediated and framed behind barbed wire or alongside abandoned railroad tracks; each trace becomes a compass that orients the spectator within this post-traumatic *topos*.

Splitting the opening lines of Cayrol's script, Celan models his translation of the film's beginning with his own poetic style. By separating the opening line from the paragraph's five remaining lines, he conveys the series of spatial, temporal, and visual ruptures that unfold throughout the film. After he lists the series of camps, ending with Bergen-Belsen, Celan concludes the line with a colon; the line is broken and this blank space following the colon signifies the very acts of erasures that transpired in these sites. But in addition to the stylistic resonance that Celan's translation shares with his poetry, such as the frequent use of enjambment, ellipsis, and neologisms, Celan also cites within his translation his own poem on Van Gogh's painting.

Like Resnais, Celan was interested in *Cornfield with Crows*, and he wrote an ekphrastic poem on it a year before he translated *Night and Fog.*[16] With his translation of the film's first two lines and its image of the landscape, there is a collapsing of three forms of representation in relation to Van Gogh: film, painting, and poetry. By encrypting the opening line of his poem into the screenplay, Celan recalls his own engagement with Van Gogh's painting. "Auch ein Feld mit ein Paar Raben drüber, mit Getreidehaufen und Erntefeuern [Ravens above it, with piles of grain and harvest fires]" (77) echoes the "Rabenüberschwärmte Weizenwoge [Corn wave swarming with ravens]" from his poem "Below a Painting." While Cayrol uses the French word *corbeaux* (crow), Celan chooses "Raben drüber [Ravens above]," which recalls the "Rabenüberschwärmte" from the poem. By alluding to his own Van Gogh poem at the onset of *Night and Fog*, Celan emphasizes the tensions that open up between the visual and linguistic modes of representation in the film.

16 Celan inscribes Van Gogh in three other poems—"Weissgrau" (*Gesammelte Werke*, 2:19), "Mächte, Gewälten" (2:209), and "Nach dem Lichtverzicht" (3:142)—but he is not engaged with particular paintings in them; rather, the focus is on Van Gogh's act of self-mutilation and his descent into madness marked by the cutting off of his ear. After Celan had lamented in a letter how unproductive the year 1956 was for him, Hermann Lenz wrote back praising his poem "Unter ein Bild": "This verse, that indicates a new way, refutes most pleasantly any words of yours regarding a 'wordless year'" (Celan/Lenz, *Briefwechsel*, 53).

UNTER EIN BILD

Rabenüberschwärmte Weizenwoge.
Welchen Himmels Blau? Des untern? Obern?
Später Pfeil, der von der Seele schnellte.
Stärkres Schwirren. Näh'res Glühen. Beide Welten.

BELOW A PAINTING

Corn wave swarming with ravens.
Which heaven's blue? Below? Above?
Later arrow, that sped out from the soul.
Stronger whirring. Nearer glowing. Two worlds touching.

(*Selected Poems*, 99)

What is the significance of the two worlds in the poem and what insight does it give us with regard to *Night and Fog*? In terms of the painting itself, the "Both worlds" could literally refer to the two worlds characterized by the two suns and possibly signify the world of the living and of the dead. As the doubling within both poem and painting reveals, a particular visual mirroring takes place. With its "waves of wheat" and the blueness of the other heaven beneath the sky, Celan constructs something sea-like that mirrors the sky. The opening neologisms of the first line render audible what Van Gogh makes visual. In addition, this mimetic relation is perpetuated in the bond between the painting and the poem that the reader can imagine unfolding beneath the painting. Celan's use of the accusative preposition emphasizes movement—the poem is being written or read. Despite the illusion of motion and wind effected by Van Gogh's magnificent swirls and brush strokes, the painting is actually static.

Celan's poem ends with the phrase "Beide Welten"; the structural division implied by the two worlds that Celan perceives in the painting extends to the two textual worlds of poetry and painting. But as the title suggests, "Unter ein Bild" favors the text beneath the painting, that is, the poem. We can re-apply this interplay between two forms of representation to Resnais's film and its linguistic accompaniment. By citing his Van Gogh poem in the commentary, Celan acknowledges the presence of the two worlds that Resnais pictures in his film: the inside of the camp and the landscape outside its borders. Moreover, this spatial opposition is reflected in the temporal division between the time of the camps and their aftermath. Analogous to the interplay between Van Gogh's painting and "Unter ein Bild," Celan's translated commentary, as well as "Engführung," functions not only as an ekphrastic rendering of *Night and Fog*, but each text addresses poetically what Resnais cannot do cinematically. While Celan's commentary to the film and "Engführung" are critiques of

mimesis, Resnais himself is unable to abandon his use of the image. Celan, on the other hand, disposes of the image in order to foreground instead semantic traces.

"Beide Welten": Inside the Camps

In one particular scene that encapsulates this sense of both worlds, a black-and-white shot taken from within the camps shows a bucolic panorama of rolling hills, trees, and a small village. Celan's translation is as follows:

> Worauf dann auch die eigentliche Welt, die der stillen Landschaf-
> ten, die der Zeit *vorher* erscheinen kann—ganz nahe sogar.
> Für den KZ-Häftling besitzt sie keine Wirklichkeit. (87)

> Then the actual world, that of the quiet land-
> scapes, that of the time *before,* can appear—entirely near.
> For the prisoner of the KZ it possesses no reality.

But as the narrator continues, there is a second world positioned across from this "real" world. The inmates belong to another world that was "closed off" to them ["abgeschlossene Welt"] (87). While Celan reiterates the word "Welt," Cayrol selects two different words, "Monde" and "Uni-verse," to refer to this picturesque landscape. "Paysage," which Celan had translated as "Land" ("land" or "country") at the opening of the commen-tary, is now translated as "Landschaft" ("landscape"). What we cannot hear in the film's voiceover is conveyed visually through the presence of barbed wire. The camera, positioned inside the camp, looks through the barbed wire and toward a village in the distance surrounded by a peaceful landscape. The serenity of the scene is fractured by the presence of barbed wire and guard towers. To convey this disfiguration of place, Celan breaks the word: "Landschaf- / ten." He also reveals his thoughts regarding the image's status within the film. Cayrol uses the French word "image" (86) to describe how the landscape outside the camp appeared to the inmates, but Celan writes instead that to them it does not possess a "reality [*Wirk-lichkeit*]". Through his substitution of words, Celan associates the image with only an illusion of reality.

Nonetheless, the primary concern for Resnais and Celan is not the world beyond the fence, but the "closed-off world" of the camps. How can the artist convey the inside of this space, that is, present the spectator with its image? Earlier in the film, where Resnais explores the reality of in-side the camp, Celan uses *"Wirklichkeit"* in place of Cayrol's word *"réalité"* (80). However, it is no longer an image inside the camp, but a trace ["les

restes"] or remainder ["übrig"] as the camera moves across the remains.[17] Yet once the camera crosses into the camp's interior, we are told that this image or illusion of reality cannot be captured:

> Die Wirklichkeit der Lager: die sie geschaffen haben, ignorieren
> sie, und die sie erleiden, können sie nicht fassen. Und wir, die wir
> nun zu sehen versuchen, was übrig blieb ... (81)

> The reality of the camps: what they had created and ignored,
> and what those that suffered this reality, they cannot comprehend it. And we,
> who try to see what remains left behind ...

Despite the three shifting subject positions in relation to this inside—the perspectives of the perpetrators, the inmates, and the film's spectators—this interior, according to the commentary, resists or evades comprehension. The camera reveals the stony and wooden remains of the camp that are surrounded and framed by lush grass and blue skies. While the French commentary is concerned with the spectator trying to uncover ("découvrir") these remains, Celan's emphasis is on perception: we try to see ("sehen") the traces. He again underscores the significance of these traces by writing them into his translation; diverging from Cayrol's commentary, he inserts an ellipsis at the end of the line. His grammatical adaptations of the original text redirect his emphasis from listening to the narrator to the act of reading the text.

In the next section of the film, when the camera ventures further into the camp's interior and enters the empty barracks, the word "image" (82) is once again used by Cayrol, but now Celan employs "Bild" (83). The image, a word that Cayrol had used to describe the landscape outside the camp (the world of the past), cannot be uncovered for the camp's interior. When describing the landscape outside the camp, Celan is referring to a time *"before"* (*"vorher"*) something transpired. Although he does not directly identify what this *"before"* refers to, he uses italics to draw the readers' attention to the temporal import of this space; it refers to a topography that is simultaneously connected to the time of traumatic history. As the camera enters an empty barracks and slowly scans the vacant bunks, Celan writes,

> Diese Holzblocks, diese dreistöckigen Bettgestelle, diese Schlupf-
> löcher, wo man den Bissen herunterwürgte, wo selbst schlafen sich
> in Gefahr begeben hiess: kein Bild, keine Beschreibung gibt ihnen
> ihre wahre Dimension wieder: die ununterbrochene Angst. (82–83).

17 For an excellent discussion regarding the inside of the camp, see Shoshana Felman's exploration of Claude Lanzmann's *Shoah* in chapter 7 of *Testimony: Crises of Witnessing in Literature, Psychoanalysis, and History*.

These wooden barracks, these three-tiered beds, these hiding-
places where they choked down scraps of food, where sleep itself
was dangerous: no image, no description can give to you
their true dimension again: uninterrupted anxiety.

But while the commentary may call into question the status of both the
image and verbal description, the film does not withhold from the specta-
tor either image or description of the camp's horrors. As Resnais interro-
gates both the discursive and the visual limits of the filmic medium, a
remnant in the present is indeed shown in the form of empty barracks,
glasses, suitcases, mountains of hair or shoes. Through the use of two sets
of colons, as compared to Cayrol's single employment of the colon in this
section, Celan stresses a movement into a more interior space. But the
"true dimension" that resides in this interior does not depend on the con-
struction of a particular image; rather the emphasis is on the affect of
anxiety.[18]

Leaving the barracks, the camera moves in color across grass, flowers,
and buildings illuminated by a blue sky. This scene, shot in the present,
dissolves into Resnais's use of black and white documentary footage of
the camp at night. The following lines accompanying the camera's move-
ment across the ruins of the camp capture the relation between the spec-
tator and this space of traumatic history. Celan's translation reads,

Ein verödetes Stück Land, ein gleichgültiger Oktoberhim-
mel:
das ist alles, was uns bleibt
um uns die Nacht hier vorzustellen... (83)

A desolate piece of land, an indifferent October-
sky:
this is all that remains for us
in order to imagine here the night...

Breaking up the paragraph, Celan transforms Cayrol's "autumn sky" into
the more definite time of "Oktoberhimmel [October sky]". But the sky is

18 In his discussion of the uncanny in *Night and Fog*, Andrew Hebard cites this description of
the barracks three times, but it is striking that he omits from his analysis the function of
anxiety in the passage. In fact, he elides the term "uninterrupted anxiety" and focuses on the
camera's movement along the row of beds and reflects on the impossibility of representing
the scene of terror. While Hebard probes spatial components throughout the film, he omits
any mention of the archival footage of the mass graves, wounded bodies, decapitated heads,
and mounds of corpses that punctuate the film. It is not the tracking shots and empty bar-
racks alone that provoke horror in the spectator; rather, the moment of specular terror in the
film arises through the sight of the iconic images of bulldozers pushing bodies into mass
graves, mounds of corpses, and the skeletal bodies of the survivors.

broken ("Him-/mel") as the obliterated land infects the fractured heavens above. Instead of using *Landschaft* or *Gelände* for Cayrol's word "terrain," a word Cayrol repeats here twice ("Un terrain pauvre devenu terrain vague" [82]), Celan again employs "*Land*," once more moving his German audience to associate this "obliterated piece of land" with their own disfigured homeland after the war.

But what is actually left behind to enable the spectator to imagine this terrifying night? While Resnais's camera alternates between showing us the remains of the buildings in the present and photographs of inmates staring at the camera from their bunks, Celan's translation challenges these images again. After he semantically breaks the sky ("Him-/mel"), he punctuates his line with another colon and a caesura. Moving away from the image, Celan leaves behind a mark of absence so that his readers can imagine what took place. This absence is both the visual and linguistic cue signaling not what the spectator needs to imagine ("vorstellen"), but the blank space shows the very impossibility of imagining what took place. As Freud wrote, "The first determinant of anxiety, which the ego itself introduces, is loss of perception of object (which is equated with the loss of the object itself)" (*Inhibitions*, 106). The absence after the colon, Celan's trace from the extermination, signals the point where affect (anxiety) replaces the image.

The "true dimension" ("wahre Dimension") of this traumatic space no longer consists of images; instead, mimesis is concerned with the affect of uninterrupted anxiety induced through the very disruption of the imagination.[19] In this act of "Vor-stellung" (re-presentation), which literally suggests placing something out in front of oneself, the spectator is confronted with mere traces ("Spuren"), pieces ("Stücke"), or ruins ("Übrig" and "Trümmer") of this decimated terrain that cannot be reshaped into a completed image. Caught in a double bind, the spectator's anxiety is provoked by the impossibility of representing the unrepresentable: to form an image of danger that subverted all experiential modes of perception.

In one scene that directly challenges the film's claim "Kein Bild, Keine Beschreibung ... ununterbrochene Angst," the camera moves out-

19 The film's commentary seems to inadvertently provide the key elements of repression: unremitting anxiety, the interdiction against translating images into words, and the elevated state of danger that once lurked in these places. According to Freud, the ego tries to get ready for a danger situation by representing the impending danger, that is, by placing it out in front ("vor-stellen") in order to prepare for its arrival. Even in this choice of words ("vorstellen"), there is a continuation of anxiety's connection to spatiality. Freud calls this representation a signal, where the present situation reminds the subject of the traumatic experience he/she had in the past (*Inhibitions*, 92). But for the spectator who cannot imagine the horrific scenes that will confront her in *Night and Fog*, there is no preparation for the danger. The conditions of repression and its constitutive affect of unabated anxiety begin to surface in the film's content and narrative.

side the ruins of a building that functioned as a prison in Auschwitz and
stops to focus on a metal grate. The narrative reads:

> Was hier vorgeht, bedarf keiner Beschreibung.
> Die Zellen sind so berechnet, dass man weder stehen noch liegen
> kann; tagelang werden hier Männer und Frauen gewissenhaft ge-
> foltert.
> Die Lüftungslöcher halten die Schreie nicht zurück. (93)

> What happens here needs no description.
> The cells are designed so that one can neither stand nor
> lie; for days on end, men and women here were conscientiously tor-
> tured.
> The airholes cannot keep back the screams.

Although unable to move within the cell, the narrator succinctly describes
what he has said needs no description. At this site of torture bound to
space, Celan breaks "ge-/foltert (tor-/tured)" and leaves it as a fractured
word constricted between two lines. Language demonstrates what the
camera is incapable of showing. But the depiction of this place of torture
concludes not with a visual description of the narrow space; instead, the
narrator returns to what is heard. While Cayrol had originally stressed one
cry ("le cri"), Celan changes this to the plural "die Schreie [the screams]"
in order to underscore both the number of those who were tortured and
the volume of sound emanating from the cells. The site of anxiety cannot
be penetrated by the spectator's gaze, nor is its aural concomitant (the
screams) heard in the film; instead, the spectator is obliquely asked to re-
imagine the space of torture and be receptive to the Other's cry connected
to this place. [20]

In a reversal of this relation between image and word, images are
shown where words break off. After one of the scenes capturing the af-
termath of an extermination, the camera moves on and shows "A look
into the store room" (95) and reveals multiple traces: hair, bones, and
skin.[21] In one of the most graphic scenes in the film, the spectator is

[20] In Celan's "The Industrious" ["Die Fleissigen"], a poem that is even more abstract and re-
fracted than "Engführung," he returns to the visual markers from *Night and Fog*. The poem
ends in the narrow space of an Auschwitz cell: "Die unbeschriebene Wand / einer Stehzelle:
// hier // leb ich / querdurch, ohne Uhr" ["The uninscribed wall / of a stand-up cell: //
here // live yourself / right through, with no clock"] (*Gesammelte Werke*, 2:151; *Selected Poems*,
293).

[21] Celan repeatedly uses the words "Blick" ("look") and "Sicht" ("sight") or their variation
throughout the film in order to foreground the act of looking (4:81, 87, 93, 97). The verbs
"blicken" ("to look") and "besichtigen" ("to catch sight of") turn to the nominative forms of
Augenblick, *Anblick*, and *Blick*; each connotes the sense of the viewer trying to freeze what
she sees, as if capturing a snapshot of the traumatic scenes.

shown crates of dead bodies, and the commentary can only stutter through what is filmed.

Aus den Körpern ... man bringt es nicht über die Lippen ...
aus den Körpern
stellt man Seife her.
Aus der Haut ... (95)

From the bodies ... one cannot bring it across the lips ...
from the bodies
one makes soap.
From the skin ...

But the narrator and Celan do indeed articulate the indescribable, and Resnais also shows the image of soap. The film is capable of showing and describing what it claims it cannot do. While the line "Aus der Haut ..." remains an ellipsis, the camera provides an image of skin used as drawing paper. In another scene that shows the process of "night and fog," the term used by the Nazis to express how unsuspected victims were rounded up in the middle of the night, deported and never seen again, Cayrol describes how the "dark transport" (86) takes its unsuspecting victims to where no one will ever know. The documentary footage shows a truck moving into the distance as smoke rises from a chimney on the horizon. Leaving nothing to ambiguity, Celan replaces Cayrol's line with, "Their goal is the crematoria" (87). If one fails to read the visual marks in the film, Celan's translation assists in re-orienting the spectator within its space.

Resnais's juxtaposing of indeterminate places next to multiple documentary images of victims and their traces helps concretize this landscape. Despite the abstraction of bodies that are either dismembered or entangled in mass graves, they have become iconic images that lend specificity to the place. Scenes of forced deportations, tattooed arms, mass graves, emaciated bodies, and shorn heads situate the landscape that Resnais films both temporally and spatially. The bodily remains become compasses that help localize the spectator within the film's topography. Resnais cannot himself make these landscapes abstract; instead, such an act of disfiguring the image is induced visually by means of his cuts and shifts between color and black-and-white, and through the presence of sound consisting of voiceover and non-diegetic music. The landscape that Resnais's camera keeps returning to throughout the film, although seemingly innocent, is in fact haunted by the genocide that permeated this space. Toward the end of the film, Cayrol's literal translation reads, "Nine million murdered individuals haunt this landscape" (96). Celan changes the line to, "Diese Landschaft: die Landschaft von neun millionen Tod" [This landscape: this

landscape of nine million dead] (97). Allowing his language to perform the
haunting, Celan withholds the verb of the sentence (haunt) and doubles
the word "landscape" (*pays*). While the corpse both anchors this place in
time and space, its presence dissolves the naturalness of the landscape and
points to the mechanized death that infiltrated and continues to haunt this
place. Any mimetic impulse to reproduce the naturalness of the landscape
is subverted as the innocence of place shifts to displays of excessive hor-
ror.

The Face and the Trace

Although Celan's text maintains an open interpretation on the page, once
it is placed within the film his lyric-like commentary surrenders part of its
autonomy to the filmic image. But at the same time, his adaptation also
exerts some control over these images; an interdependence develops be-
tween the visual and the linguistic text. Celan's translation aims to trans-
form the landscape of extermination into a text that the spectator not only
sees, but must also read. In his translation, the centrality of the filmic im-
age is replaced with that of the trace. Stressing the link between the ef-
faced body and the act of writing, Celan underscores a relation between
effacement of the Other and the task of reading his/her trace upon the
landscape.

Before the film moves into the camp and the history of the Third Reich
through the device of documentary black-and-white footage, the camera, in
color, follows train tracks in the present: 1955. The narrator remarks:

> Dieselbe Bahnstrecke heute: Tageslicht und Sonne. Langsam
> schreitet man sie ab—auf der Suche wonach?
> Nach einer Spur der Leichen? (79–81)

> The same tracks today: daylight and sun. Slowly
> one inspects them—searching for what?
> For a trace of the corpses?

Shifting from Cayrol's use of extended paragraph form, Celan breaks up
the text and emphasizes the trace of the corpse. There are multiple traces
that the spectator is learning to read in the film's depiction of the victim
and his/her erasure. What do the letters "N/N" signify on the back of an
inmate or what do particular colors worn by the inmates mean? But the
film also teaches the spectator to collect, read and decipher the signs [*Zei-
chen*] from the bodies and the marks left behind by their erasure. We see
throughout the film the very reduction of the person into a trace, whether

through the use of language, the displaying of body parts, or the very destruction of the body into ash and bone. *Night and Fog* presents the spectator with the process in which the face of the Other is erased and its traces are left behind for the viewer to re-construct.

One of the first faces of a victim that looks back at us is that of a child being deported on a train, and adjacent to her face written on the door of the cattle car we read: "74 pers." Once the door is closed, the face vanishes and an arm protrudes from a slot in the train. The truncated body is juxtaposed alongside the abbreviated text. This relation between face and trace functions as a focal point to the film. The face of the Other who occupies the first half of the film—the victim of the camps—is replaced by their physical remains in the film's second half. These faces undergo a transformation as the face of the living is replaced by that of the dead. The face is a corporeal trace of the Other that vanishes throughout *Night and Fog*. While the individual, stripped of face and name, is lost in the crowd, Resnais passes the responsibility on to the spectator to belatedly recuperate these faces from the remnants left behind and to reconstruct the process of the Other's effacement. Reminiscent of Levinas's ethics, the trace is the focal point of the ethical relation to the Other in Resnais's film and Celan's poetry.[22] While the face for Levinas adheres to the onset of ethical responsibility, Resnais uses the face in his film to depict the very collapse of this responsibility for the Other. In Levinas, a visualization of the face turns to the imperative of listening to the Other. Similarly, in *Night and Fog* the recuperation of an ethical relation to the victims commences with the imperative addressed to the spectator to read these traces at the moment when the voice becomes mute.

In one of the first scenes in which the camera enters the traumatic past of the camp through the specter of black-and-white documentary film, the commentary describes the scene of terror made up of rifle butts, searchlights, barking dogs, and the crematorium spitting forth its flames. But none of what is described is shown. Instead, the narrator remarks, "*ein erster Blick auf das Lager:/ ein anderer Planet*" [A first look at the camp: another planet] (81). The first "look" is a close-up of an inmate's terrified face whose horrified gaze fills the screen. Resnais cannot show the scene but relies on the description accompanied by its indirect reflection upon the inmate's face. The shot is accompanied by a sudden burst of music that adds to the shock. Instead of seeing the described scene, an indirect reflection of the inmate's horror of what he sees confronts the spectator's

22 Levinas remarks that, "A face is a trace of itself" (*Otherwise than Being*, 91). Yet it is not the actual phenomenological seeing of the face—its marks, wrinkles, and features—that denotes the rise of ethical obligation in Levinas; rather, the ethical occurs when the vision of the face is missing and a listening occurs.

vision. The spectator has entered, "another planet" (81). To underscore the importance of this arrival into a totally new place, Celan breaks up Cayrol's original paragraph into two succinct lines; after his use of the colon, there is once again a blank space. The reader is placed before a visual mark of absence: the historical void left behind in the genocide's aftermath.

In one particularly graphic use of documentary footage from the camps, the camera enters the space of Auschwitz's "hospital" and moves from bed to bed looking upon the sick and dying. As the camera focuses on one particular gaze that stares back at the viewer, the narrator remarks that some inmates "mit offenen Augen sterben" [Die with open eyes] and that "Zuletzt haben alle das gleiche Gesicht" [In the end all have the same face] (89). The face-to-face encounter with the Other is replaced by an encounter with scenes of erasure. The camera traps the spectator's gaze by remaining fixed on the face of a dead inmate. Each image freezes the acts of degradation, oppression, and persecution in which alterity was destroyed within the camps. By the film's end, the camera takes the spectator to the edge of the mass graves, where her gaze encounters the effaced Other. These faces in the film do not make possible the conditions of a Levinasian ethics of the face, but show the very destruction of these conditions.

During a sequence in which Resnais attempts to illustrate the process of extermination through a series of archival photographs that are shown one after another, Cayrol's narrative describes what is unfolding and adds, "These pictures [images] were taken shortly before extermination" (92). Despite the fact that the photographs used by Resnais are disconnected from one another in terms of the date and location of the murders, his visual narrative is held together by the commentary. Celan's translation, attempting to convey the hurriedness of the scene being depicted, relies on an elliptical phrase devoid of a verb, "Wenige Augenblicke vor einer Liquidierung ..." [A few moments before a liquidation...] (93). Celan again withholds the word for "image" [Bild] and instead uses an ellipses and line-break to foreground the very disillusion of images. Nonetheless, Celan is rejecting neither the specular implications of the scene nor the act of looking; visuality is contained in the "glances of an eye" [Augenblicke] before the extermination. The reader of his commentary is compelled to see or read these acts of effacement in the markings of Celan's text.

Resnais tries to convey visually this necessity of reading by shifting his tracking shots to close-ups of an object, and this strategy of montage prompts the spectator to read the traces of the dead scattered across the

terrain.[23] Celan's translation accentuates the act of reading through his choice of words: *Spuren* (traces), *Zeichen* (sign), *Verzeichnisse* (ledger), *gezeichnet* (marked), *aufgelesen* (collected) and *Auslese* (selection). The resonance between these words is not contained in Cayrol's original French words (*marquée, signe, register, selection*, and *trie*). The bodies that carry various signs (tattoos, scars, burns, and wounds), which are evidence of the crimes, ultimately become mere traces. As the camera focuses on their wounds, the signs of the bodies scattered across the filmic landscape are what the audience is intended to read: "Es sind Frauen darunter, Die für Leben gezeichnet bleiben" [There are women among them, who will be marked for life] (91). Inside the gas chamber the destroyed body leaves its mark upon the walls: "Das einzige Zeichen—aber das muss man ja wissen—ist die von Fingernägeln gepflügte Decke. Beton lässt sich erweichen" [The only signs—but people must know this—is the ceiling ploughed by fingernails. Concrete can be softened] (95). The camera proceeds to show marks on the stone walls of the crematorium, and the narrator assures the viewer that these images have already been impressed within him or her as well, thereby attesting to the archival status of both the description and the marks themselves.

The traces left behind by the fingernails are linguistically configured again in the "Hunderte von Verzeichnissen" (91), the "hundreds of ledgers" within which the names of the inmates are written and crossed out with red ink. Celan conveys this erasure of the Other when a ledger full of crossed-out names is accompanied by the literal French translation, "red means death" (90). Avoiding such a translation that would require the rhyme "Rot heisst tot," Celan writes instead, "Durchgestrichen heisst tot" [Crossed out means death] (91). His translation instructs the viewer to read the crossed-out names in the ledgers [*Verzeichnissen*] that spread over into the filmic landscape. As a hand leafs through the pages of the book, freeze-framing makes the names of the victims, their profession, nationality, and religion legible: Moses, Jakob, Chaim, and Izak, all from Poland. The word *Jude* appears besides the crossed-out names, a word that the film's narrator says only one time.

In one of the most disturbing sequences of the film, the camera alternates among a series of six shots showing decomposing corpses, a row of decapitated bodies, and two close-ups of the heads themselves. After multiple images of heads cut off by the screen or frame, they are now severed from the bodies. In the final shot of the scene, and the film's climax of visceral horror, a close-up of a barrel containing decapitated heads stares

23 See Hebard's "Disruptive Histories: Toward a Radical Politics of Remembrance in Alain Resnais's *Night and Fog*," where he formulates a link between how a tracking shot pauses momentarily on an object and the snapshot from a camera (95–96).

at the camera: the disembodied heads trap and freeze the gaze of the
viewer. At the film's Medusian moment, nothing is concealed from the
viewer, who looks and is caught looking by the dead. There is a shift be-
tween seeing and being seen, and it is now the gaze of the dead that petri-
fies the viewer as he or she is struck by the close-ups of the heads.

By the end of the film, Resnais's camera returns to the decimated
landscape of Auschwitz in the present, moving across a field of flowers
and architectural remains. The camera stops and focuses on a pond of ash
near the ruins of the crematoria. The opening image of the film had sus-
tained the illusion of a "peaceful landscape," even if just for an instant.
However, by the end of Night and Fog, this same place is now unrecogniz-
able. Twisted metal and broken concrete slabs from the gas chamber jut
out of the ground, and the remains of a now-defunct watchtower appear
in the background. As the camera looks upon a topography rendered ab-
stract by the vestiges of unprecedented historical mass murder, it is the
narrative that maintains coherence and orients the spectator in time and
place. Cayrol constructs a parallel between this decimated landscape and
the spectator's waning memory. The literal translation of Cayrol's text
reads, "As I speak to you, the icy water of the ponds and ruins is filling up
the holes of the charnel house. A water as cold and dim as our own poor
memories. War is sleeping, but with one eye always open" (96). The fad-
ing of memory is in turn accompanied by the vanishing of the image,
"And there are those of us who sincerely look upon the ruins today, as if
the old concentration camp monster were dead and buried beneath them.
Those who pretend to take hope again as the image fades, as though there
were a cure for the plague of the camps" (96). For Cayrol, the loss of the
image becomes the marker for the risk of historical repression and the po-
tential threat of future genocides.

Nevertheless, Cayrol at the same time reinforces the idea of historical
closure by constructing a linear narrative via three dates interspersed
within his commentary: 1933 (Hitler's rise to power), 1942 (when the pol-
icy of extermination was legislated at Wannsee) and 1945 (the liberation of
the camps). In his study of Celan's translation of Night and Fog, David
Coury underscores several times that "the past relentlessly threatens to in-
vade the present" (66). But counter to his assertion that Celan's transla-
tion of the film was a "warning against a future invasion of the past into
the present," (59) Celan's adaptation of the commentary reveals that the
past continues to bleed into the present and Celan rejects any laying to
rest of this past. In fact, he upholds the persistence of this haunting not
only in order to counter the forgetting of the dead, but also to make one
receptive to the contemporary horrors that were plaguing the present
moment in history. More specifically, Celan sustains the wounds of this

landscape and their continued haunting in the present through a particular elision in his translation. With the first two dates, Celan does not use the numerals but writes out the numbers (*neunzehnhundertzweiundvierzig* as compared to 1942), thereby pulling his readers' attention to the significance of recalling one's dates. But "1945" is conspicuously absent from his commentary. By withholding the date of the war's end, Celan counters any sense of closure to the history unfolding in the film; in so doing, he constructs a continuation between the traumatic past and the present of 1955. The event cannot be integrated within any closed narrative.

Celan's translation of the closing section is striking. Like Cayrol, he preserves the gravity of forgetting the past and retains his previous use of "*Bild*" for Cayrol's "*image*".

> Und es gibt uns, die wir beim Anblick dieser Trümmer aufrichtig
> glauben, der Rassenwahn sei für immer darunter begraben,
> uns, die wir dieses Bild entschwinden sehen und tun, als schöpfen
> wir neue Hoffnung ... (97–99)

> And here we are, who in looking at these remnants honestly
> believe that the racial madness is forever buried beneath them,
> we who see this image disappearing and act as is we are recovering
> new hope ...

Analogous to his formulation "No image, no description," Celan again employs the word "*Bild*" within the context of its very negation. However, he adds something as well. In addition to the fading away of the image, the spectator also *sees* it disappear and thus becomes implicated in the vanishing of this historical scene. Reflecting on the failure of memory, Celan focuses on the inadequacies of both the image and visual perception. The concluding words of the narrative again emphasize and critique this perceptual collapse:

> Als glauben wir wirklich, dass all das nur
> *einer* Zeit und nur *einem* Lande angehört,
> uns, die wir vorbeisehen an den Dingen neben uns
> und nicht hören, dass der Schrei nicht verstummt." (99)

> As if we really believe that all of that belonged
> to only *one* time and only *one* country,
> we who look past the things near us
> and do not hear that the cry is still not silent.

The audience fails both to see and to listen to the traces left behind. It is the spectator who looks past these horrors and does not hear the cry from beneath the ruins. While *Bilder* are replaced with *Trümmer*, the visual accent

(*Anblick* and *Bild*) is replaced by the aural (*Schrei*) at the very close of the film. Consistent with my study of what transpired in the trajectory of "The Meridian," the question of sight that dominated the film shifts in the end to the inability to hear the Other who is near us and continues to scream. Celan's adaptation of the closing section of the film makes it clear that his commentary is aimed at his German audience. The "ruhiges Land (*paysage*)" (peaceful land) becomes by the film's end "nur *einer* Zeit und nur *einem* Land (*pays*)" [Only this *one* time and only in *one* land]. Employing italics for only the second and third time in his translation, Celan simultaneously stresses to his reader the singularity of these crimes while at the same time he gestures toward the possibility that these crimes might return again to some other place in the future.

Similar to the demolition of the body, the Other's voice also undergoes disfiguration. At this site of a catastrophe, the effaced do not speak, but instead scream in the aftermath of the Holocaust. As the images fade from memory and the spectator looks past the horror, s/he also fails to hear the cries beneath the ruins. Although the film begins with the claim, "Das Blut ist geronnen, die Münder sind verstummt" [The blood has dried, the mouths are mute] (77), in the last line the mouth is no longer mute—rather we do not hear its cry. While the French ends with "sans fin" (without end), Celan closes with "The scream is not mute" (99) and "mute" [*verstummt*] draws attention to the poet's own engagement with the "furchtbares Verstummen" left in the aftermath of the Holocaust. The singularity of the scream heightens the very precariousness of the Other's vanishing. Celan shifts the film's incessant questions about seeing and the failure of sight to the inability to hear. It is not a voice but rather a scream that does not end. Our senses fail to perceive the Other, an individual who is near us and continues to scream.

At the point when the victim's voice is disfigured into a scream, Celan forms a new word out from their ruins. Once again, it is Celan's translation that needs to be heard by the audience. Cayrol asserts that the "old concentration camp monster" is buried beneath these ruins of the camp (98). Avoiding such a fantastic image of a monster, Celan targets the German audience with his neologism *Rassenwahn* or "racial madness" (99). The word is meant to provoke his listeners to recollect the German conception of race along with the race laws from Nuremberg that led to the policy of extermination legislated at the *Wann*see conference in 1942. The word *Rassen* along with the encoded phonic play between *Wahn* and *Wann*see become direct references to both the "Aryan master race" and the "inferior Jewish race" that was buried beneath the camp ruins and passed over in Cayrol's commentary.

Although the film thinks towards one's responsibility for the Other, what Levinas describes as victims of the same anti-Semitism in his epigraph to *Otherwise than Being*, the theme of anti-Semitism is essentially left out of the film. As Ilan Avisar asserts in *Screening the Holocaust*, *Night and Fog* "ignored the attempted genocide of the Jews ... It forgets the Jews" (15). On one level, the film shows its own shortfall of memory as seen in its elision of the Jewish victims. Moreover, we must situate Resnais's film in its socio-historical context of the Algerian War for Independence against France and France's struggle to maintain colonial control in Southeast Asia. While the film may remember France's own violent treatment of the Other in 1955, *Night and Fog* evades the singularity of the Jewish victims who appear throughout the film. Resnais warns his audience of the possible parallels that might occur between the horrors of the most recent past and the contemporary military situation in the French colonies. But by universalizing suffering and equating all the victims of National Socialist crimes with one another, the film renders invisible the multitude of Jewish victims it exhibits.

Resnais's film becomes complicit in its own act of forgetting the Jewish dead and thus inadvertently contributes to the very structures of repression it wishes to critique. The calling by name of the Jewish victims in the film, configured visually by numerous yellow stars, the use of iconic photographs documenting the deportation and extermination of Jewish victims and the word "Jude" written next to crossed-out names in a ledger, is heard only once in the film alongside a litany of other victims: Stern, a Jewish student from Amsterdam. Freud describes how repression consists of "denying mental representations ("Vorstellungs-Repräsentanz") access to consciousness" ("Repression" 148). For him, the interdiction that prevents a representation from becoming a memory stems from the absence of a corresponding word-representation. In *Night and Fog* it is not the image that is repressed—the bodies of the Jews—but rather what is missing is the word "Jewish," a word that identifies both the specificity of the crimes and its victims. I contend that Celan's translation of the screenplay and his poem "Engführung" (1957/58) respond to the crossing out of the Jewish victim not only in Resnais's film but also in contemporary German memory. If *Night and Fog* wishes to return the body's trace, "Engführung" returns to the reader the cry of the Other. This is a particularly Jewish cry absent from the film, and according to Celan, it is a cry that Germany failed to hear in his poetry.

Going into the Narrows: Celan's "Engführung"

Echoing and condensing into seven words what Cayrol's script unfolds in a six-line paragraph, Celan commands his reader to enter "Engführung's" poetic landscape. Furthermore, he lays out visually within the poem the opening scene of the film. In our act of reading the first word, "Verbracht," we begin, unbeknownst to us, our movement into the camp's uncanny terrain:[24]

VERBRACHT ins	TAKEN OFF into
Gelände	The terrain
mit der untrüglichen Spur:	with the unmistakable trace:

After a momentary focus on the sky at the onset of Resnais's film, the camera drops down to show the barbed wire of the camp. Following the title "Engführung," the poem begins with an asterisk (*Sternchen*) and drops the first word ("Verbracht") halfway down the page. Like the opening of the film, the poem compels the readers' eyes to move downward from a textual sky toward the terrain. In his translation of Cayrol's opening lines, Celan places the verb *hinführen* at the end of the paragraph to emphasize this act of being taken into the concentration camp against one's will; it is this movement that gestures to the deportation enacted at the beginning of "Engführung." Both the viewer and reader are aware that something entered before them into this landscape. As Resnais's camera shows railroad tracks covered over with grass, Celan's translation of Cayrol's script reads, "Ein eigentümliches Grün bedeckt die müdegetretene Erde" [A curious green covers the tired-trodden ground] (77). The film's narrative, describing how the concealed traces upon the ground have already been traversed, is echoed in the poem's "terrain with the unmistakable trace," which again intimates that someone or something had entered into this space of the "blackened field" (line 14) before us (see *Selected Poems*, 118-31, for Felstiner's translation, used here).

Like Resnais, Celan brings the reader into this landscape to search for what left these marks behind. By reading across the colon, one sees that the colon is itself the mark of a threshold through which the reader enters this landscape consisting of various traces.

24 As Celan himself claimed, his poem's central motif consists of the "time bombs" that are spread across the textual landscape of the poem. In effect, the poet attempts to sabotage the very act of reading the poem. See Theo Buck's *Muttersprache, Mördersprache,* 121.

Gras, auseinandergeschrieben. Die Steine, weiss,
mit den Schatten der Halme:
Lies nicht mehr—schau!
Schau nicht mehr—geh! (lines 5–8)

Grass, written asunder. The stones, white,
with the grassblades' shadows:
Read no more—look!
Look no more—go!

"Engführung" operates by way of an imperative that must be broken. The reader is confronted from the onset of the poem with a double bind consisting of a command to stop reading: a command whose very disobeying is necessary for an approach to the Other to transpire. And yet these commands do not so much order us to stop reading and looking as challenge us to read, see, and go towards nothing. In a draft of the poem Celan had written "Lies nicht" and added in pencil "mehr" ("Sprachgitter," 88). When interpreting the syntax of "nicht mehr" as a direct object, not as an adverb, the imperative is not to stop reading, but to read what no longer remains. One is faced with the task of reading grass torn asunder and white stone: traces of a decimated landscape and un-engraved stones.[25]

The dual commands to stop reading and looking creates an ambiguity in this poetic landscape: is it a text being read or an image being looked at? Szondi describes the place of the poem as both a text and scene, and he refers to the one who engages with this poem as a "reader-spectator" ("Leser-Zuschauer"; 31/348).[26] Yet Szondi claims that this poem is neither a conventional text nor image, and continues by asserting that Celan's text refuses to conform to reality; instead, "Poetry is ceasing to be mimesis, representation: it is becoming reality. To be sure, this is a poetic reality ... we are no longer to 'read' this text nor to 'look' at the picture it might

25 For a compelling analysis of what it means to see nothing in relation to traumatic history, see Cathy Caruth's study of Resnais's *Hiroshima mon amour*, where she discusses "a new mode of seeing" the "event" of trauma (54). Caruth writes, "A new mode of seeing and listening—seeing and a listening *from the site of trauma*—is opened up to us as spectators of the film ... What we see and hear, in *Hiroshima mon amour*, resonates beyond what we can know and understand; but it is in the event of this incomprehension and in our departure from sense and understanding that our own witnessing may indeed begin to take place" (56). Caruth's concise description of what the seeing (or reading) of nothing implies in Resnais's film can also pertain to the reading of nothing in Celan's poetics. This new form of witnessing entails the disruption of phenomenological and epistemic relations to historical trauma; it is a rupture that opens up into an affective response. In Caruth's reading of Resnais, this response is a twitch or a tremble, a shudder, a slap, or an uncanny sensation that acknowledges a site of history that has yet to be recalled (25–56).

26 "Durch die Enge geführt," in *Gesammelte Werke*, 2:345–89. I will be using "Reading 'Engführung,'" the translation of Szondi's essay by Susan Bernofsky, with Harvey Mendelsohn.

be describing" (31/349). Insisting that the poem is not a description of this place but *is* this place, Szondi, following Celan, asks the reader-spectator to enter into this textual landscape. He maintains that Celan is determined to respect the reality of the death camps and not to use this *topos* to construct a "poetic image" [poetisches Bild] (31/349). Instead, "Engführung" does not set out to represent the death camps but depicts how the dead should be remembered.

Although the poem does indeed describe a mnemonic process, I would argue that "Engführung" foregrounds the very destruction of the image in order to accentuate the current flight from memory, that is, the circumvention of memory of the death camps in 1958. By de-structuring the landscape's image, Celan replaces any notion of a poetic image with that of its trace, thereby attesting to the lack of an *Erinnerungsbild* (memory image) within the poem. In particular, through the explosion of grammar, designated by punctuation "marks" (asterisks, colons, dashes, and parentheses) and torn words, Celan's insertion of these shapes and disfigured forms attest to his cubistic poetics. Like Resnais's layering of disconnected senses that arise through the use of non-diegetic music, a monotone, emotionless voiceover accompanying horrific scenes of violence and the shift between color and black-and-white film, Celan's cubistic poetics includes neologisms, poetic stammers and ruptures, and geometric patterns of grammatical marks. In turn, the layering of these components is refracted through the repressed past toward which Celan positions his reader. Confronting us with the task of reading the remnants of effacement, Celan inserts the traces of words and bodies within the linguistic marks and trauma-inscribed stones scattered throughout the poem.

As the very title "Engführung" suggests, the poem, like *Night and Fog*, revolves around spatial anxiety. "Eng-Führung," literally meaning to be led into a narrow space, invokes the etymological link between *Enge* (narrow) and *Angst* (anxiety). Celan's translation of *Night and Fog* is written like a poem, and consists of ellipses, line breaks, caesuras, and neologisms; "Engführung," completed two years later, was influenced by both the film's images and its narrative. But contrary to Cayrol's use of proper names throughout his commentary—the names of camps, the cities of deportation, Auschwitz's Block 11—Celan's objective is to describe this sense of place through radical abstraction. Celan asserts in the second stanza that this place "has no name" (lines 19–20), after the reader has already crossed into this uncanny landscape that is systematically being taken apart.

Celan's distortion of the object of anxiety (the place of the death camps) is consistent with Freud's notion of disfigurement, which is also referred to as displacement or dislocation ("Entstellung") in his theory of

repression. In *Inhibitions, Symptoms and Anxiety* Freud claims that a representation for trauma is not lacking, but rather the representation is unrecognizable: the traumatic experience has undergone a distortion that renders the experience unfamiliar to the faculties of perception. Freud describes a danger-situation as a "recognized, remembered, expected situation of helplessness" (102); however, the anxiety left in the wake of a traumatic experience has not been synthesized into memory and could potentially result in a repetition of the trauma in its altered form. The trauma is neither remembered nor recognizable.[27] Instead of placing something before us, and one may again recall the literal meaning of "Vor-Stellung," the representation of the unrepresentable place of the Holocaust in "Engführung" consists of an ever-changing, disfigured landscape marked by a certain "indefiniteless and lack of object" (102).

Celan's thematization of historical repression in "Engführung" unfolds at the moment when he employs spatial components consistent with Cubism. The seventh section begins:

Schoss an, schoss an.	Shot out, shot out.
Dann—	Then—
Nächte entmischt. Kreise,	Nights, demixed. Circles,
grün oder blau, rote	green or blue, red
Quadrate: die	squares: the
Welt setzt ihr Innerstes ein	world sets its inmost
im Spiel mit den neuen	at stake with the new
Stunden.—Kreise	hours.—Circles,
rot oder schwarz, helle	red or black, bright
Quadrate, kein	squares, no
Flugschatten,	flight shadow,
kein	no
Messtisch, keine	plane table, no
Rauchseele steigt und spielt mit. (126–40)	chimney soul rises and joins in.

Like *Night and Fog*, Celan's poem reflects a post-Holocaust optics onto the dead and the landscape they inhabit. The dispersion of a particular phenomenon in a cubistic text, whether it is of a landscape or person, resists a totalizing re-composition by the reader. Something remains missing. Because Cubism provides a new frame of perception for looking at the traumatized Other, whereby the structures of Cubism and traumatic memory intersect, the reader-spectator becomes responsible for re-

27 For a more in-depth analysis of the interplay between dislocation, repression, and anxiety in Freud, see Samuel Weber's provocative analysis in *The Legend of Freud*, 75–98. Weber aptly describes in his study how anxiety emerges when the "ego seeks to represent the unrepresentable" (92).

membering the fragments and ruins of catastrophic history that resist be-
ing synthesized into a whole. With its shapes and colors detaching from
one another, Celan does not form a poetic image, but probes the disinte-
gration of a particular phenomenon. As the "flight shadow" and "chimney
soul" indicate, not only are the objects themselves missing, their traces are
also absent. Celan depicts this structurally within his poem, as each miss-
ing figure is followed not by the object that it is negating, but by a line
break. This disfigurement of space is emphasized yet again by Celan with
the negation of the surveyor's table (*Messtisch*): an instrument used to
measure and map the angles of a landscape. The place in the poem cannot
be measured, for it has been both physically and conceptually transformed
by catastrophic history.

The structure and content of this stanza—opaque, fragmented, and
steeped in intertextual allusions—along with the stanzas that come di-
rectly before and after it, attempt to blend two scenes of historical catas-
trophe: Hiroshima and the death camps. The poem commands the reader
to approach these two distinct sites of ash and night, where the traumas
are now pressed into the stone. In both catastrophic moments—
Hiroshima and Auschwitz—history leaves it cubistic imprints behind; the
shadows burned onto walls of stone in Hiroshima ultimately shift to the
grooves left by the bullets in the Black Wall of Auschwitz (Block 11). The
reader becomes a spectator who is taken to these ghastly surfaces and is
confronted with the aftermath of graphic scenes of violence. The blank
stones of the opening stanza, which ordered the reader to approach, now
have the traces of the Other's annihilation inscribed on them:

Orkane, Par-	Hurricanes, par-
tikelgestöber, es blieb	ticle flurry, there was still
Zeit, blieb,	time, still,
es beim Stein zu versuchen—er	to try with the stone—it
war gastlich … (95–99)	was welcoming …

Pressed onto stone are the forms of the incinerated, who left their shad-
ows on walls and sidewalks in Hiroshima. The poem enacts the splitting
of the atom with the splitting of the word "*Par-/tikelgestöber*": a word that
was originally left whole in a draft of the poem. This is the first of only
four instances in which words are "written apart" in the poem. But as
other critics have correctly posited, Celan also constructs here a scene of
the gas chamber, where the "Orkane," or cyclones, recall the pellets of
Zyklon-B crystals that fell from holes in the ceiling of the gas chamber,
whose stone walls are engraved with the marks left behind by the victims'

fingernails.[28] The poem begins to mix two particular moments in which alterity was effaced.

Stanza 6 ends with a figure that encompasses both scenes of historical erasure: something "shot upward." Celan relies on the reader to construct or visualize the picture of the rising mushroom cloud, to give form to an iconic image that has been rendered abstract within the poem.[29] But "Schoss an" also points ahead to the "bullet trap" of the buried wall in stanza 8; the reader must recall the multi-valance and interconnections of the word *anschiessen* at the ruins of the crematoria. Two sites of mass annihilation become intertwined in relation to one word. Celan is not equating the two events with one another; rather, through the disfiguring of images the poet calls into question mimetic forms of representing traumatic events. While he may appeal to his readers' visual archive, Celan simultaneously transforms the poem's images into abstractions through the layering of a word. Challenging one's passive relation to images, the poet requires the reader to disentangle these distinct historical sites of trauma. In stanza 8, where Celan again tears a word apart ("Ho-/sianna"), the reader-spectator is led to the buried wall and confronted with the task of reading the grooves, or engraving, upon Auschwitz's execution block: the Black Wall. Like the form of the stretto in which themes come closer together by way of repetition, in "Engführung" words are both repeated and become layered in their multiple points of reference. At the very most narrows of the poem, which suggests proximity between the reader and alterity, stone mediates the place of a possible encounter.

The end of the seventh section closes "No / chimney soul rises and joins in." The eighth stanza repeats this line but withholds the *Rauchseele*, a word that encapsulates the traces left from two distinct historical burnings: Hiroshima and Auschwitz:

28 See for instance Theo Buck's *Muttersprache, Mördersprache*; Joel Golb's "Reading Celan: The Allegory of 'Hohles Lebensgehöft' and 'Engführung,'" in Aris Fioretos' *Word Traces*; and also Fioretos' essay "Nothing: History and Materiality in Celan," in the same book.

29 In *Hiroshima mon amour*, Marguerite Duras, the author of the script, had originally inserted a mushroom cloud as the opening image of the film. Resnais, however, removed this image and relied on the viewer to connect the word "Hiroshima" to the iconic image that did not need to be shown. The inclusion of the image would have been redundant.

Steigt und	Rises and
spielt mit—	joins in—
In der Eulenflucht, beim	At owls' flight, near the
versteinerten Aussatz,	petrified lepra,
bei	near
unserm geflohenen Händen, in	our fugitive hands, at
der jüngsten Verwerfung,	the latest rejection,
überm	above the
Kügelfang an	bullet trap on
der verschütteten Mauer: (142–51)	the ruined wall:

The absence of *Rauchseele* executes the very movement that the word itself connotes: disappearance. The poem's tendency to repeat at the beginning of each new stanza the last lines of the previous one does not simply produce a stammer here, but enacts the very idea the missing word thematizes: the destruction of the Other, who is transformed into a trace. The responsibility is again placed on the reader, who must recall what is rising at the start of the stanza; the body has been reduced to smoke.[30] Instead of taking us upwards into the clouds, "Engführung," concentrating on what lies beneath this landscape, leads us toward the place of extermination.

In *Night and Fog* the camera guides the spectator to Block 11 and its execution wall. Resnais's visual narrative consists of a photograph of the shooting block from a distant perspective, followed by a close-up of the black wall with the shadow of a hanging post reflected on its facade. Next to the shadow one sees circular marks left behind by the bullets: the *Kügelfang*. This execution wall, once concealed from our gaze, becomes both visible and audible in the poem. Celan employs the same word he used in his translation for the wall in Cayrol's commentary. An exact verbal echo from the film appears at the poem's climax:

Sie haben ihren Galgen, ihr Tötungsterrain.
Der den Blicken verborgene, für Erschiessungen eingerichtete Hof
von Block elf; die Mauer mit Kugelfang. (87)

They have their gallows, their execution ground.
Hidden from the gazes, a specially constructed yard for shooting
in Block XI; the wall with bullet trap.

30 With "Steigt und spielt mit," Celan employs a remnant from his signature poem *"Todesfuge,"* from which he wished to disassociate himself. The line recalls the blue-eyed man who plays with his snakes and commands his Jews to play death more sweetly, "dann steigt ihr als Rauch in die Luft / dann habt ihr ein Grab in den Wolken da liegt man nicht eng" [you'll rise up as smoke to the sky / you'll then have a grave in the clouds where you won't lie too cramped] (*Gesammelte Werke*, 1:39/*Selected Poems*, 33).

In varying drafts of the poem, Celan first described the wall as "remembered" [*erinnert*], but he crossed the word out and replaced it with "torn down" [*abgetragen*] ("Sprachgitter," 96). In its final version Celan uses *verschüttet* to describe the wall, a geological term associated with concealment or burial. Delivering one to the place of excavation, Celan forces his reader to assume the role of an archaeologist to uncover what was hidden [*verborgen*] from our view.

At the point of poetic anxiety, at "Engführung's" Black Wall, Celan guides the reader to history's abyss of mass graves. Above this place of catastrophe an "Eulenflucht" takes place. But Hegel's symbol for historical contemplation—the owl's flight at dusk—turns away from an encounter with the death camps, that is, the place of an ethical and historical rupture. The owl's flight is actually a fleeing [*Flucht*] that marks the moment when the poem thematizes repression in relation to the trauma of the death camps. Moreover, the flight from history occurs at the poem's site of spatial anxiety. Freud interprets the act of flight as equivalent to repression (*Inhibitions*, 11). The repressed experience is not forgotten, but rather deprived of its affect of anxiety from which one flees. Entering the space of anxiety, the reader confronts the traces of both a historical and an ethical catastrophe, where the wall marks the site left buried in German memory: the place to where the Other was deported and murdered.

At the very most narrows of the poem, voices transform into the screams emanating from the wall's grooves. As these marks become visual, they are also heard:

Sichtbar, aufs	Visible, once
neue: die	again: the
Rillen, die	grooves, the
Chöre, damals, die	choirs, back then, the
Psalmen. Ho, ho-	Psalms. Ho, ho-
sianna. (144–49)	sannah.

Counter to Levinas's claim that "In the approach of a face the flesh becomes word, the caress a saying" (*Otherwise than Being*, 94), Celan reverses the approach to the Holocaust dead. The word as trace now becomes a corpse, or as he writes, "A word—you know: a corpse" (*Gesammelte Werke*, 1:125). At the poem's *Eng-Führung*—a word suggestive of proximity and anxiety—the Other is conveyed in a word that denotes a dismembered body. The poet, by tearing apart a Hebrew word, Ho-sianna (Help us, Lord), shows what happened to the Jewish body in the film. Adorno writes, "Foreign words are the Jews of language" (*Minima*, 141) and one

recalls Celan's use of *Yizkor* and *Kaddish* in "Die Schleuse."[31] The Jewish
body/word is rendered simultaneously visual and aural at the place of ex-
termination. This body becomes "visible" in its readability as a scream.
"Hosianna," both a poetic stutter and a victim's cry, attests to the ethical
collapse of history, whereby the wounded body manifests itself in the dis-
figured word. The reader arrives before a wall engraved with the geomet-
ric patterns cut into the stone by bullets. The effaced Other's trace, a mark
of traumatic history, is recovered by reading the rills in the wall left behind
by the killing.

The opening word of the poem, *Verbracht*, has prompted critics to
make the claim that the reader was undergoing a deportation within the
text. Such an interpretation might intimate that Celan is encouraging an
act of empathic identification between the reader and those whose traces
are scattered throughout the poem's landscape. But I would propose that
at the poem's narrowest point, at the place most suggestive of proximity
to the Other, any illusion of undergoing a deportation like those reduced
to ash upon this terrain is shattered. Instead, one is confronted with the
Other's trace that is meant to induce in the reader Celan's call for *Ver-
juden*; it is a becoming Other that is predicated upon a sense of estrange-
ment and non-identification with the poem's traumatic residue.

On several occasions in his drafts of "The Meridian" Celan repeats
the need to go into the narrows and he writes, "Poems are narrow pas-
sages [Engpässe]" and "No expansion [Ausweitung], only constriction
[Verengung]" (150). We are reminded of Celan's suggestion to his readers
to break free from art and enter into one's innermost narrows (*allereigenste
Enge*; *Gesammelte Werke*, 3:200). This is the moment in "The Meridian"
when mimesis and forgetting are disrupted and the date of the Other's ef-
facement undergoes a possible recollection. In "Engführung" the poten-
tial encounter with the effaced Other materializes at the poem's most con-
stricted point: "Ho-." Yet this word-ruin indicates not only the vulnerabil-
ity of language; the break in the word along with its repetition also signi-
fies the incessant attempt by the effaced Other to be both heard and re-
membered by the poem's recipient.

What could not be read upon the stones at the poem's opening is now
legible in the wall's grooves, that is to say, in the traces of the choirs'
psalms from "that time," where sound becomes visible in its readability.
The task to collect the sought-for traces of the body in *Night and Fog* shifts
to the unspoken imperative to hear the Other's cry in the poem. But what
do we hear?

31 In addition to describing foreign words as the "Jews of language," Adorno also employs a
string of other analogies and compares foreign words to "tiny cells of resistance," "scape-
goats of language," and "death's heads" (see *Wörter aus der Fremde*, 224, 218, 221).

Ho, ho-	Ho, ho-
sianna.	sannah.
Also	Therefore
stehen noch Tempel. Ein	temples still stand. A
Stern	star
hat wohl noch Licht.	may still give light.
Nichts,	Nothing,
nichts ist verloren.	nothing is lost.
Ho-	Ho-
sianna. (156–65)	sannah.

We hear a mangled word emanating from the place of extermination: "Ho, ho-/ sianna." While the opening commands of the poem shift between reading, seeing, and going, "Engführung's" unspoken command is to listen to the Other. The visual traces left on the wall, the circular marks, correspond to the o-o-o sound of the stanza: ho/ ho/ noch/ wohl/ noch/ verloren /ho. Celan translates the grooves left by the bullets into the scream. We are hearing not a prayer but a torn elegiac cry for help. At the narrows of the poem, the site of spatial and linguistic constriction, the word is cleaved, almost silent. One arrives at the Other's scream and the Holocaustal uncanny.

However, the o-sound is not only elegiac; it is also an aspirate, that is, a breathing out that signifies a turn of breath. Once again, Celan's *Atemwende* is associated with a foreign word. Yet "Ho-/sianna" can never be spoken or read without interruption. At this linguistic mark between what is "vocal and voiceless," an encounter with the Other unfolds. In relation to the discussion of "The Meridian" in the previous chapter, the break of the Hebrew word, which is indicative of an act of violence, is again evocative of Celan's figure of the Hippocratic face of poetry. The o-o-o is not the word of Sulamith, but signifies instead the locus where the reader encounters the Other's death's face. The word "Ho-/sianna," which is simultaneously foreign and broken, is a mark of difference that resists appropriation by the poem's recipient; in addition to preserving the alterity of the poem, the word also locates the site of historical trauma.

As a distinct temporal transformation unfolds from a space of ash and night (lines 53–56) to that of early morning, an encounter consisting of listening develops by the end of stanza 8:

In der Eulenflucht, hier,	At the owls' flight, here,
die Gespräche, taggrau,	the conversations, daygray,
der Grundwasserspuren. (166–68)	of groundwater traces.
*	*

In this "day-gray," the hour before waking, the reader inhabits a space similar to that of the pre-conscious realm, where something becomes discursive and formative. By examining the other drafts of this section of the poem, we behold what evolves into conversation. Celan had written:

Im Verkohlen.	In the charring.
Gespräche, rasch,	Conversations, quick,
mit den Grundwasserspuren.	With the groundwater traces.
("Sprachgitter," 101)	

The presence of the charred one, the *Rauchseele* who has been turned to (*r*)*asch* [ash], confirms the location; we are situated by the crematorium with its unmistakable traces. The conversations with the groundwater traces upon this terrain position us near the ash-infused pond by Auschwitz's crematoria: one of the final images in *Night and Fog*. But Celan, similar to his replacement of Cayrol's "grass" with the word "green" in the commentary, again decides to preserve abstraction by moving from the concrete object of ash to the use of color: gray.

As the "day-gray" suggests, something is coming to the light of day; the groundwater traces rise to the surface of the terrain. Celan has constructed a liminal space—suspended between repression and memory, the familiar and unfamiliar—reminiscent of Freud's composition of the preconscious. Freud claims that an event becomes preconscious when it is "connected with the word-presentations corresponding to it. These word-presentations are residues of memory. They were at one time perceptions, and like mnemic residues they can become conscious again" (*The Ego*, 10). At the place where the mnemic residue scattered across the poem originates, the site of the burning, what was once perceived there could be formed into memory only if the image is attached to its corresponding word.

In "Engführung" the potential move to consciousness stems from the presence of visual residue connected to *verbal traces*, not to images.[32] The

<hr/>

32 In my discussion of these two forms of perceptual residue, aural and visual, I am referring to Freud's description of how an event becomes preconscious. Freud writes, "Verbal residues (*Wortreste*) are derived primarily from auditory perceptions, so that the system Pcs. has, as it were, a special sensory source. The visual components (*visuelle Bestandteile*) of word-presentations are secondary, acquired through reading ... in essence a word is after all the mnemic residues (*Erinnerungsreste*) of a word that has been heard. We must not be lead ... to for-

visual components of something read are now primary. In turn, these visual components are simultaneously discrete sounds that are not only optical traces made up of the materiality of letters on the page and the fragmentation of words, but are also acoustic (o-o-o). Celan's translation of the end of *Night and Fog* reads, "We who look past the things near us and do not hear that the cry is still not silent (nicht verstummt)" (99). At the site of an ethical collapse, Celan provides the scream. Imploring his reader to be receptive to the Other's cry, he substitutes the dead bodies with a torn word; in turn, the songs of the dead are perceived in the wall's bullet trap. The word of the murdered body corresponds to the cry, the o-sound that visualizes the bullet trap. The intended voice of the Other, who is trapped at the site of extermination with nowhere to flee, gives forth a prayer for help, but this prayer devolves into a scream.

Similar to the way traumatic memories are often described in visual, photographic, or cinematic terms—flashbacks, snapshots, dreams, imprints, images etched in the mind—Celan's poetry is driven by this visual impulse, a language that is compelled to become "detail, outline, structure, color" (*Collected Prose*, 50). However, these elements do not combine to form a complete or totalized image; rather, "Engführung" shows what happens to images in the space of traumatized memory. Because the Holocaust breaks conventional modes of perception, in particular seeing, images are replaced by marks of disfigurement. Although those effaced during the Third Reich become the warning signal of what could befall the Other in French colonies in South East Asia or North Africa in *Night and Fog*, there is a universalizing effect in which the remnants left behind from the Holocaust become interchangeable with other potential victims; as the Jewish bodies lose their alterity, the event of the Holocaust is deprived of its historical specificity.

In contrast, the traces that occupy Celan's poem, like the cubistic components of a painting, are not reducible to any poetic image. Ash functions for Celan as the trope that can never be reconfigured into an image. It marks the place where the proper name, the identifying mark of the Other, is annihilated. But in addition to signifying the remnant of trauma and indicating what remains of the excised proper names in Celan's translation of *Night and Fog*, ash becomes for Celan what Derrida would call "the catastrophe of memory" (Derrida, *Points...*, 392). The trace of ash signals the unassimilability of the traumatized remains of the Other,

get the importance of optical mnemic residues (*optische Erinnerungsreste*), when they are of things, or to deny that it is possible for thought-processes to become conscious through a reversion to visual residues..." (*The Ego*, 10–11). Word residues are themselves like mnemic residues and can become conscious once again. See, for instance, Celan's poem "Hörreste, Sehreste," where he formulates a direct link to Freud's writings on repression, consciousness, and preconsciousness (*Gesammelte Werke*, 2:233).

where neither the event of annihilation nor its victims can be sublated by the reader. We are neither partaking in nor inheriting the Other's trauma when reading "Engführung"; instead, trauma remains something entirely foreign and irrecuperable in our encounter with the poem.

In the last section of the poem, the reader is taken to where the conversations of ash disappear. In their vanishing, the conversations are replaced with two dashes, grammatical marks that convey an omission or a pause:

<div style="display:flex">
<div>

 *

(- - taggrau,
 der
 Grundwasserspuren-

Verbracht
ins Gelände
mit
der untrüglichen
Spur:

Gras.
Gras,
auseinandergeschrieben.) (170–80)

</div>
<div>

 *

(- - daygray,
of
 groundwater traces—

Taken off
into the terrain
with
the unmistakable
trace:

Grass.
grass,
written asunder.)

</div>
</div>

While asterisks and dashes indicate the omission of words or letters, what is the role of the parentheses at the end of the poem? The parentheses, the insertion of an explanatory phrase that could otherwise exist separately, functions not as a grammatical tool to de-emphasize what came before it—the eight previous stanzas of the poem—but traps the reader in its space. In the parentheses' structural narrows, the reader enters the "allereigenste Enge" of the poem (*Gesammelte Werke*, 3:200). The dashes, whose German name literally means "thought lines" (*Gedankenstriche*), replicate the mnemic traces of the absent words that provoke the reader to recall what is missing.

The insertion of the poem's opening lines at its ending confronts the reader with an ethical shudder. Somewhere between memory and repetition, the once unfamiliar landscape is becoming both familiar and terrifying. Szondi remarked that the way one remembers the prayers of the time of "the most recent casting out ... determines who one is and what one does today" (78). By returning to its starting point, the poem has constructed a circle, yet its form is changing. The opening four lines extend to eight lines and create a staccato tone between one- and two-line verses. Though some might have fled the place of the trauma, Celan turns to the reader who is situated before the remains of this ethical catastrophe inside

the parentheses. In the day-gray of dawn, the reader moves toward consciousness as the trace gestures to, but is not yet, memory. What was beneath the ground now rises to the surface. However, what transpires at the poem's conclusion is neither a fulfillment of reason in history (Hegel) nor a construction of a space of therapy to bring about closure through the poetic mastery of trauma.[33] The reader instead becomes aware of the very impossibility of escaping the anxiety induced through the non-site of this ethical catastrophe. Ending where he/she begins, the reader enters into a loop, deported once again into its traumatic landscape.

Through the thematic as well as material associations developing between *Night and Fog* and "Engführung," Celan's goal with regard to translating filmic traces into poetic traces is twofold: in addition to withholding from his readers a therapeutic model to master or put to rest the traumatic past, Celan is also trying to safeguard the Jewish Other from further modes of objectification. Rejecting the universalist message of *Night and Fog*, Celan recuperates in "Engführung" the radical alterity of the Holocaust dead lost in the film. Celan takes his reader into the narrows of the poem and situates her before the Other's traces: bullet holes, ash, smoke, and a torn, foreign word. In turn, these poetic traces indicate the moment of an ethical inflection that places responsibility for listening to the Other's cry onto the recipient of the poem. Celan does not allow his readers to forget that the extermination was in fact undergoing a forgetting.

Celan's rejection of the reification of the Holocaust dead, which turned the victims into frozen images and contributed to the forgetting of the extermination, approaches Lyotard's description of Lanzmann's *Shoah*:

> Representing "Auschwitz" in images and words is a way of making us forget this. I am not thinking here only of bad movies and widely distributed TV series, of bad novels and "eyewitness accounts." I am thinking of those very cases that, by their exactitude, their severity, are, or should be, best qualified not to let us forget. But even they represent what, in order not to be forgotten as that which is the forgotten itself, must remain unrepresentable. Claude Lanzmann's film *Shoah* is an exception, maybe the only one. Not only because it rejects representation in images and music but because it scarcely offers a testimony where the unpresent-

33 See Joel Golb's article "Reading Celan: The Allegory of 'Hohles Lebensgehöft' and 'Engführung.'" Golb reads Celan's poem as an allegorical quest emerging from violence and moving towards a utopian future: "Celan is repetitively telling a kind of story ... the poet's quest to master a traumatic past by evoking a utopian point of its recovery" (190). He argues that Celan's poems "enact a desire to escape" a particular history (191). But counter to Golb's claim, the poem is not mastering a traumatic past; instead, "Engführung" attempts to trap the readers within its anxiety-provoking space. Although Golb probes the historicity of words in the poem, he leaves out of his analysis the very point of origin from which the poem embarks: Europe 1958. Despite Golb's position that allegory desires to master history, it is this very sense of mastering history, of a *Vergangenheitsbewältigung*, that Celan himself vehemently rejected.

able of the Holocaust is not indicated, be it but for a moment, by the alteration in the tone of a voice, a knotted throat, sobbing, tears, a witness fleeing off-camera, a disturbance in the tone of narrative, an uncontrolled gesture. So that one knows that the impassive witnesses, whoever they might be, are certainly lying, "play-acting," hiding something. (*Heidegger*, 26)

Celan's own "disturbance in the tone of narrative" and "uncontrolled gesture" manifest themselves as stutters or bifurcations ("Ho, Ho-/sianna") and by marks that indicate the place of an erasure (the dash or the asterisk). Moreover, the parenthesis that concludes "Engführung" does not simply repeat or contain a mirror image of the poem's opening lines; instead, the poem sets out to subvert the image by deforming "Engführung's" very opening. Such deformations interspersed throughout the poem are acts of resistance against the fetishizing or reification of the Other, which in turn functions as a resistance against the forgetting of the Other. By the close of the poem the reader undergoes an uncanny recognition that is triggered by an acoustic déjà-vu: one has the sense that she has been through this landscape before. But as Freud himself describes the experience of déjà vu, "what is looked for is never remembered."[34] Led into the elegiac loop at the end of "Engführung," one's ethical comportment to the Jewish Other upon the holocaustal terrain of the poem is constituted by this perpetual search for an impossible memory of the Other's effacement, a search for a memory that is devoid of closure.

34 Although the déjà-vu is strikingly similar to elements of the uncanny, Freud does not discuss it in his essay from 1919. However, in his study *The Uncanny*, Royle's examines how Freud linked the two in *The Psychopathology of Everyday Life* (Royle, 173). See Royle's chapter "Déjà vu" in *The Uncanny*, 172–86.

Chapter 5

Re-Figuring Celan in the Paintings of Anselm Kiefer

Textual Mourning for Celan in Bachmann's *Malina*

Around the time of the Jewish holiday of Passover in April of 1970, Paul Celan left his apartment in Paris and leapt into the Seine. His body was discovered a couple of weeks later a few miles downstream from the bridge near his home from which he supposedly jumped.[1] By submerging himself in the river, Celan transformed himself into his image of a *Flaschenpost*. Shortly after his suicide, another poet and a friend of Celan's, Ingeborg Bachmann, received this message in a bottle, and his drowning in the Seine is an event that she returned to a year later through her writing in her novel *Malina* (1971). Composed of a polyphonic narrative, the novel revolves around a love triangle: Ivan, Malina, and the female narrator, referred to only as "I." On an historical level Bachmann's novel is a reflection on the failure of her homeland, Austria, to confront its fascist past and its role in the Holocaust. Her exploration of this repressed history unfolds simultaneously with her narrative of female oppression; ultimately, the destruction of female subjectivity is juxtaposed to the fascist subjugation of the Jewish Other. While the novel follows the disintegration of the Ich and her identity, in the second chapter an act of empathic identification between the Ich and the lost Other unfolds. In this chapter, "The Third Man," telling of the narrator's terrifying dreams of persecution at the hands of her father, her identity merges with Jewish civilians waiting to be deported to the camps.

1 See Celan's poem "Und mit dem Buch aus Tarussa," where he envisages his leap into the Seine:

Von der Brücken-	From the bridge-
quader, von der	stone, from which
er ins Leben hinüber-	he bounded over in-
prallte, flügge	to life, fledged
von Wunden,—vom	by wounds,—from the
Pont Mirabeau.	Pont Mirabeau.
(*Gesammelte Werke*, 1:287)	(Felstiner, *Paul Celan*, 286)

In these dreams, she is tortured, raped, silenced, and finally killed by an image of her Nazi father. As Kloch-Klenske suggests, the trope of the menacing father who is linked to fascism originates with Bachmann (see Kloch-Klenske). In this complex web of dreams, the narrator's personal history of abuse inflicted by patriarchal violence coalesces with the historical violence of the Third Reich, where her father serves as the central perpetrator. In the following passage, she describes her father as a Nazi guarding loading ramps:

> Er trägt den rotten Henkersmantel ... mit schwarzen Stiefeln vor einem elektrisch geladenen Stacheldraht, vor einer Verladerampe, auf einem Wachturm, er trägt seine Kostüme zu den Reitpeitschen, zu den Gewehren, zu den Genickschusspistolen, die Kostüme werden in der untersten Nacht getragen, blutbefleckt und zum Grauen. (246)

> Now he is wearing a hangman's red coat and climbing up the steps, now he is wearing silver and black, with shiny black boots, standing in front of electric barbed wire, in front of a loading ramp, inside a watchtower, he's wearing his costumes to fit the riding crops, the rifles, the execution pistols, his costumes are worn in the deepest night, bloodstained and horrible. (154)

Because her image of patriarchal oppression merges with fascism, the abused female is aligned with the Jews.[2] The climax of this conflation transpires when the father leads the Ich into the gas chamber and she suffers the fate of the Jews: "I am in the gas chamber, that's what it is, the biggest gas chamber in the world, and in it I am alone"[Ich bin in der Gaskammer, das ist sie, die grösste Gaskammer der Welt, und ich bin allein darin] (*Malina* 114/182). In this act of substitution for the Other, the narrator takes the place of the Jews.

 Though it is not in the scope of this analysis to explicate the function of gender in *Malina,* and the relation between fascism and the patriarch, I do want to consider *Malina* for what it claims about the possibility of merging with the Jewish Other.[3] Further, Bachmann confronts Austria's repressed traumatic past in her dreamscape by inscribing Paul Celan and

2 Bachmann had once said, "Ich habe schon vorher darüber nachgedacht, wo fängt der Faschismus an. Er fängt nicht an mit dem Terror, über den man schreiben kann, in jeder Zeitung. Er fängt an, in den Beziehungen zwischen einem Mann und einer Frau, und ich habe versucht zu sagen ... hier in dieser Gesellschaft ist immer Krieg" (qtd. in Kretschmer and Schardt, 118–19).

3 For excellent analyses of gender in Bachmann's *Malina,* see for instance Sigrid Weigel's "Ein Umzug im Kopf" and Sara Lennox's "In the cemetery of the murdered daughters: Ingeborg Bachmann's 'Malina.'" Also, in his afterword to the English translation of *Malina,* Mark Anderson extends this analysis of female oppression beyond the scope of fascism and adds, "We are close to a solution to the crime committed at the end of the novel where one woman's suffering merges with the mass murders of modern history" (235).

his poems into her narrative. Probing Bachmann's transposition of Celan into literature can help us understand Anselm Kiefer's use of Celan's lyric in his artwork. For Bachmann Celan functions as a paradigmatic figure of this traumatic past, and his verse assists her in facing Austria's repressed history. The narrator describes her inability to speak as symptomatic of what she calls her "memory disturbances" [Ich will nicht erzählen, es stört mich alles in meiner Erinnerung] (11/24), and these memory disturbances are a reflection of Austria's own inability to confront its violent past. Her "unavoidable dark history"[eine unvermeidliche dunkle Geschichte] (8–9/19) is itself an indication of Austria's repression of its National Socialist past.

This interplay between Celan and Bachmann serves as my template for investigating the translation and inscription of Celan in the realm of Kiefer's artworks. Like Bachmann's, Kiefer's probing of the relation between the artist's identity, traumatic history, representation, and translation ultimately revolves around Celan's poetry, and eventually, in the late 1990s, Kiefer juxtaposes Bachmann's lyric to Celan's in the painting *Der Sand aus den Urnen* (1997). Through this juxtaposition of the German and the Jew, Kiefer is not suggesting reconciliation or an overcoming of traumatic history; instead, the past continues to have a haunting presence. Like Bachmann with *Malina*, Kiefer transforms the surface of his canvas into an uncanny site by conjuring up Celan's ghostly traces in order to question and provoke Germany's amnesiac state to recognize its own responsibility with regard to the effacement of the Jewish Other in contemporary German culture.

Austria's very refusal to engage with this history is eloquently captured by Bachmann's narrator in the following passage,

> One must suffer away [ableiden] the past completely, it's not yours and not mine, but who's asking whether it is, you have to put up with these things, other people just don't have the time in their countries … because they lack a language … I will tell you a terrible secret: language is punishment. It must encompass all things and in it all things must again transpire according to guilt and the degree of guilt [Schuld]. (60/98)

In *Malina*, Bachmann takes on the task of mourning that her country itself had shirked. She attributes the failure to mourn and remember this past to the dissolution of language, a language rendered highly suspect and deficient in the aftermath of the war. While the narrator states that one must mourn the past ["Man muss die Vergangenheit ganz ableiden"], a confrontation with this sorrowful past can only unfold within the space of language or in some other symbolic form. In her attempts to mourn both this historical catastrophe and the personal loss of her friend, Bachmann

questions the very possibilities of and limits to the act of mourning. But the narrator does not claim that she has run up against the imaginative limits before this historical trauma; rather, her struggles against an impulse toward silence stems from the corruption of the German language after the Holocaust. Carrying the guilt of its past, it is a language that has been compromised and poisoned by the very crimes it helped bring about. Once again it is the image of the Nazi father who attempts to silence her confrontation with this past, "My father is reaching for my tongue and wants to pull it out, to stop anyone here from hearing my no ..." (115/184). Although the problematics of the past are addressed with the father/daughter dynamic, this tension between memory, mourning, and the compromised position of language unfolds most explicitly in those sections where Bachmann remembers Celan.[4]

Celan becomes for Bachmann the figure around whom traumatic memory is constructed on both the personal and the historical level. She not only reflects on the poet's death, the novel's "I" uses Celan's ghostly figure to remember the European Jewish catastrophe. Although never called by name, Celan's identity is formed through traces of his poetry linked to biographical clues accompanying Bachmann's figure of "the stranger" along the way to his drowning. The poet appears in two parts of the novel: the narrator's fairy tale, "The Mysteries of the Princess of Kagran," where she tries to write her utopian, "beautiful book," and again in the chapter composed of her dreams, "The Third Man," where she engages directly with Holocaust imagery and Celan's death. As Mark Anderson writes in his afterword to *Malina*, the fairy tale is a link between the "narrator's personal sufferings to the historical oppression and exile of 'ancient peoples'": the Jews (233). Ultimately, the fairy tale's mythic space melts into the nightmarish history of the dreams. The narrator exclaims towards the end of the novel, "I can no longer write the beautiful book" (201/320). Instead, her fragmented narrative ultimately dissolves into an inarticulate scream that obsessively mourns both the loss of the Other and of her own identity.

Celan's surfacing in the fairy-tale narrative of the first chapter is marked by the figure in the long black overcoat, which ultimately becomes a Siberian Jewish overcoat in the dream. He is the stranger who comes to rescue the princess in flight from her kingdom. Unfolding like a fairy tale, the legend transpires in a mythic time, yet is set in historical places. The princess's home is along the Danube and the river courses through the tale. Her movement along the labyrinthine tributaries of the river takes

4 For a more detailed investigation of the use of Celan's poetry in *Malina*, see Böttiger's *Orte Paul Celans*, 79–114. For other essays that examine the interrelation between the two poets, see Böschenstein and Weigel's *Ingeborg Bachmann und Paul Celan: Poetische Korrespondenzen*.

her to places she does not recognize: the Theban heights and the still un-named spurs of the Carpathians. She has moved eastward along the river. Ultimately, the lost princess is rescued by a stranger in a black mantle who sings "in a voice never heard before" (37/63). After getting lost a second time and arriving "where the river led into the kingdom of the dead" (39/67), she is once again rescued by the stranger, whom she describes now as "the light of a ghost"(39/67) from this "Totenreich." Before his departure, the stranger reveals to the princess his identity: "My people is older than all peoples of the world and is scattered in the four winds" (40/68). The stranger describes the Jewish people in the midst of the Di-aspora. Before the fairy tale ends, the princess tells of a utopian moment of reunion in 2000 years, when the two shall meet again: "It will be farther up the river, again there will be a great migration, it will be in another cen-tury, let me guess? It will be more than twenty centuries from now …" (40/68). But the moment of the union will be anything but utopian. The princess informs the stranger that there will be another "Völkerwan-derung," anticipating Europe's Jewish communities and Celan's own exile and flight from Romania via Budapest to Vienna, where Bachmann and Celan met in 1947. Throughout the fairy tale, Bachmann employs imagery from Celan's own verse to identify him as the stranger: poems that fre-quently use images depicting both union and desire. The poems she cites throughout this section of the novel come from the cycle of poems "Sand aus den Urnen," from the collection *Mohn und Gedächtnis*. Celan had writ-ten many of these poems during his time in Vienna (1947/48), when he met Bachmann. But while Bachmann may seem to use these poems to suggest the possibility of a future union, the place of this reunion occurs during the time of deportation and death in the dreams.

The space of the dream is the place where the "I" again encounters the stranger, and where Bachmann contemplates the meaning of both personal and historical trauma. In one of the central dreams, Bachmann places the "I" alongside Jewish prisoners waiting to be deported, and the narrator re-unites with the stranger in a crowded barracks shortly before deportation. The time is winter, the season of Celan's own deportation, and the narrator, identifying herself as a Jew, prepares herself for deporta-tion:

I'm wearing the Siberian Jewish Coat like everyone else. It's the middle of winter, more and more snow is falling on us, and my bookcases are collapsing under-neath the snow, the snow is burying them slowly, while we all await deportation, and the photographs which are standing on the bookshelf get wet, pictures of all the people I have loved, and I wipe away the snow, shake the photographs, but the snow keeps falling, my fingers are already numb, I have to let the snow bury the photos. (126/193)

Bachmann uses one of the poet's most cherished images, snow, to construct a metaphor of the play between memory and forgetting. Books and photos, traces of memory, are being buried in the snow. In her trope for memory work, the narrator digs beneath the snow in an attempt to uncover what is concealed in its depths. Bachmann's depiction of the deportation simultaneously shadows a process of translation unfolding in the dream, and it is Celan himself who undergoes a ghostly transformation in the dream. He is constantly being refigured through a series of permutations. After being buried in the snow as a picture and then appearing in the deportation [*Abtransport*] as the stranger in the barracks wearing his "starry mantle, blacker than black" (126/202), the "I" tells what the stranger says to her: "Think about the Stadtpark, think about the leaf, think about the garden in Vienna, about our tree, the Paulownia is blooming" [Denk an den Stadtpark, denk an das Blatt, denk an den Garten in Wien, an unseren Baum, die Paulownia blüht] (127/203). The *Paulownia*, a favorite tree of Celan's, encodes the stranger's name (Paul Celan).

The conversation between the stranger and the narrator revolves around the stranger's command to her to remember ("Denk an" echoes the verb *andenken*, "to remember"). Bachmann carries out this act of memory by inserting in the spaces of her fairy tale and deportation dream traces from the poet's biography and from his poems. She recalls members of his family, including his son François, who died days after his birth. Bachmann also remembers Celan's battles with mental illness and his frequent hospitalizations throughout the 1960s. Perhaps one of the most evocative images used in the dream is the presence of the "Turk's-cap lilies" [*Türkenbund*], the prevalent symbol in his "Conversation in the Mountains," his prose piece that revolved around his missed encounter with Adorno at Sils-Maria in the Swiss Alps in 1959 (see Pöggeler, 157, 271ff.). Now it symbolizes the moment of Bachmann's encounter with Celan. Finally, the *Blatt* returns at the end of dream as a "vertrocknetes Blatt" (desiccated leaf/piece of paper) pulled from a river. A messenger, a Hermes-like figure, arrives from the "Totenreich" (realm of the dead) with the *Blatt* for the narrator.[5] The message informs her of the stranger's death by drowning, and thus Bachmann links the events of the Holocaust to the poet's suicide. The image of the books and pictures of the men she loved, including the stranger who recedes into the snow, transforms into a drowning by the end of the dream.

By drowning in the river, the stranger turns into the image of a *Fla-schenpost* washing up on the margins of Bachmann's text. In this final act

5 The double meaning of *Blatt* recalls the opening of *Corona*: "Aus der Hand frisst der Herbst mir sein Blatt: wir sind Freunde" [Autumn nibbles its leaf from my hand: we are friends] (*Gesammelte Werke*, 1:37/*Selected Poems*, 29).

of translation, where "übertragen" ("translate") is echoed in the messenger's "überbringen"("bring over"), the submerged body comes to the surface as a dried-up leaf or paper (*Blatt*): the *Flaschenpost* is delivered to the "I":

> Ich muss Ihnen eine Nachricht überbringen ... Aber er zeigt mir ein vertrocknetes Blatt, und da weiss ich, dass er wahr gesprochen hat. Mein Leben ist zu Ende, denn er ist auf dem Transport im Fluss ertrunken, er war mein Leben. Ich habe ihn mehr geliebt als mein Leben. (203)

> I have some news for you ... But he shows me a desiccated leaf, and I know he has spoken the truth. My life is over, for during the transport, he has drowned in the river, he was my life. I loved him more than my life. (127)

The river that the princess follows in the fairy tale leads towards the realm of death, and this "Totenreich" transforms during the deportation in the dream sequence into the death camps at the end of the journey along the river. "It was not the Danube but it was another river" (127), points to both the Buk River in the southern Ukraine where the Jews of the Bukovina, including Celan's family, were deported, and ahead to the Seine, where Celan drowned.[6] A layering of potential geographical locations is created through the withholding of the river's name. By the end of the deportation dream not only do the boundaries between the "I" and the stranger draw closer to one another, but temporal and spatial points also converge, where Bachmann relates the stranger's death during the deportation to the poet's death in the Seine. She reflects on the causal connection between the Holocaust, the stranger's madness, and the drowning since the trauma. The "Wahnsinn" or madness that the "I" expresses before she is told by the stranger to remember the Paulownia is followed by the stranger's own pointing to his head directly after he tells her to think of the leaf: it is a gesture that suggests Celan's own bouts with mental illness in the aftermath of the Holocaust.[7] Madness, death, and unabated mourning begin to coalesce around the figure of the Paulownia.

6 In another dream sequence the narrator describes how she reaches the Black Sea through the flow of the Danube River. Where the river meets the sea, she is devoured by her father, who has turned into a crocodile: "At the mouth of the Danube I disappeared into my father's jaws. But three drops of my blood, my last ones, did flow into the Black Sea" (147/235).

7 The "I" describes how she is becoming mad: "I'm going mad" (127/203), and shortly afterwards she says of the stranger, "I see how he points to his head. I know what they have done with his head" (127/203). She recalls Celan's numerous hospitalizations in France, where he underwent shock treatment on several occasions. See Celan's poem "Temple-Pincers" [*Schläfenzange*]: "Temple-Pincers / eyed by your cheekbone. / Their silver gleam / where they bit in" ["Schläfenzange,/ von deinem Jochbein beäugt./ Ihr Silberglanz da,/ wo sie sich festbiss"] (*Selected Poems*, 235/*Gesammelte Werke*, 2:21).

The Paulownia, the *Blatt* carried by the messenger and given to the "Ich," is itself a potentially poisonous leaf.[8] Like so many other plants in Celan's botanical lexicon—*Beifuß, Herbstzeitlose,* and *Wolfsbohne* to name a few—the Paulownia when taken in excess can become toxic. It is the memory of this catastrophic history, both its excess or very lack, which threatens the narrator and her homeland. Her own affective comportment by the dream's end is imbued with a sense of melancholia, where the stranger's death is figuratively construed as her own loss of life and the dissolution of herself as a subject.

Alexander and Margarete Mitscherlich attributed the post-war melancholic disposition of the Germans, and by association the Austrians, to the inability to mourn the loss of the father-figure Hitler. In contrast, in *Malina* the narrator's grief and its potentially self-destructive consequences stem from her over-identification with the victims. It is the Jewish Other whom she fails to incorporate as the lost object into the space of her memory (see Mitscherlich). For the narrator it is both an excess of memory and her over-identification with what was lost that become symptomatic of a melancholia culminating in the fragmentation of the "I" by the novel's end. At the conclusion of *Malina*, the narrator recedes into the crack of a wall, a movement that functions as a sign of her own entombment within the strictures of a traumatic history remaining unincorporated in memory; the dead overwhelm the very space of her memory. The *Blatt* that she is ordered to recall, a metonymy for both the personal loss of the poet and the collective traumatic memory of the murdered Jews, functions as a pharmakon in Derrida's sense, for it has both homeopathic and potentially poisonous effects on its receiver.[9]

8 Celan himself uses this tree in "La Contrescarpe," a poem that remembers his experience of *Kristallnacht* as he traveled through Berlin on his way to Paris to study medicine in 1938:

Über Krakau	Upon arrival in Berlin
bist du gekommen, an Anhalter	via Krakow,
Bahnhof	you were met at the station by a plume
floss deinen Blicken ein Rauch zu,	tomorrow's smoke already. Under
der war schon von morgen. Unter	the Paulownia trees
Paulownien	you saw the knives erect, again …
sahst du die Messer stehn, wieder…	(*Glottal*, 16)
(Gesammelte Werke, 1:283)	

9 I am using here Derrida's concept of the pharmakon from his text "Plato's Pharmacy," in *Dissemination*. The pharmakon displays particular ambivalent qualities of poison and cure. For another application of this term in relation to postwar Germany's interrogation of its past, see Eric Santner's excellent analysis of mourning and melancholia in German cinema in *Stranded Objects: Mourning, Memory, and Film in Postwar Germany*. I will return to Santner in the next section of this chapter.

The Return of Paul Celan

With the issues of how Celan and his poetics have been translated into a literary text and how the tensions between memory and mourning the Holocaust dead coalesce around the figure of Celan foregrounded, I turn now to probe how Anselm Kiefer both confronts the poisonous totems of the German tradition and attempts to integrate Celan's leaf into the space of his canvases. I begin by reviewing the status of Celan in Germany immediately after his death.

True to the definition of a ghost, Celan departed in order to return, and one sees this in the posthumous collections of his poetry that appeared throughout the 1970s. In poems from *Lichtzwang* (1970), *Schneepart* (1971) and *Zeitgehöft* (1976), Celan underscores a linguistic reduction where language approaches a vanishing point delineated by the poet's repeated use of ellipses, caesuras, and fractured and foreign words. Shortly after his death, Celan's reception began to expand in Germany, France, and North America, as is clear from the numerous journal and newspaper articles and books that examined Celan's lyric via shifting methodological frames. Many of these studies concentrated on the hermetic nature of Celan's poems and read him as an existentialist poet. While critics and scholars did not fail to mention Celan's relation to the horrors of the Holocaust, they generally turned away from the historical traces in these poems in order to concentrate on the semantic functions taking place within the lyric.[10] In an essay from 1985, the German literary critic Marlies Janz remarked that Celan had receded from German consciousness throughout the 1970s. This is an interesting formulation considering the numerous essays published on Celan throughout the decade. I would argue that it is rather the historical sense of Celan's lyric that had been ignored during this era. What recedes from consciousness is not Celan but his connection to the Holocaust, and as Janz herself claims, the post-war orientation that Celan represented was no longer of importance in the 1970s. However, during the 1980s critical interpretations of Celan begin to read his poetic language in terms of his continued struggle with how to remember and reconfigure the Holocaust.

What then was happening in Germany during the 1970s? We witness the generation of those children born after the war (*die Nachgeborenen*) turning to a confrontation with their parents: the generation of the perpetrators. But while attention was directed toward those responsible for the

10 As James Lyon wrote in his introduction to the issue on Celan in *Studies in Twentieth Century Literature*, while North American scholarship tended to focus on the role of the Holocaust in Celan's poetry, German reception of Celan turned to the linguistic, philosophical, and ideological features of his lyric.

crimes of the Third Reich, the victims were being overlooked.[11] This turn in literature has been called "Father Literature" and was developing during the 1970s, most evidently in Bachmann's *Malina* and Christa Wolf's *Kindheitsmuster (Patterns of Childhood)*. Within the visual arts a similar development took place. During this period Anselm Kiefer engaged with the cultural fathers of German art by placing onto his canvas such figures as Casper David Friedrich, Kant, Fichte, Wagner, and Heidegger in relation to the aftermath of National Socialism. He examines how the events of the Third Reich contaminated his cultural inheritance as both an artist and a German citizen born after the war. But at the beginning of the 1980s Kiefer's focus changed, witness his paintings centered on Celan's poem "Todesfuge." That which had been forgotten or repressed—the Holocaust and its Jewish victims—is given figuration by Kiefer through the fragments of Celan's most renowned poem. To use a term from Bachmann, Kiefer assumes the task of "suffering away the things" from Germany's recent past—the very task that led to a melancholic collapse and disintegration of the "I" in *Malina*.

Much of my analysis here implicitly revolves around the question of whether or not there is a *Trauerarbeit* unfolding in Kiefer's works. Do his artworks display a genuine work of mourning, or do they collapse into a melancholia that obsessively mourns the traumas of the past? In her study *Anselm Kiefer and Art after Auschwitz*, Lisa Saltzman describes Kiefer's engagement with Germany's Nazi past in the following way:

> In these images, then, it would seem that Kiefer commits the undignified act of conflating his own sense of loss with that of history's, and Germany's, original victims. In the end, what is carried out, if only belatedly and symbolically, is that very work of mourning which the Mitscherlichs prescribed, the grappling with the loss of a paternally indexed ego ideal. But we do not see the work of mourning projected beyond the narrow confines of Kiefer's own impoverished sense of identity. Whether historically inevitable or individually determined, the mourner becomes melancholic, and the possibility for a positive or future identity is consumed by the repetitive operations of an artist unable, or unwilling, to configure the traumatic kernel which is the repressed history and memory that is his father's, his country's, and his own. (74)

According to Saltzman any act of mourning for the Jewish Other gets displaced onto the artist himself, who becomes emblematic of the Mitscherlichs' postwar German subject. But this traumatic kernel is indeed opened by Kiefer. Germany and its avoidance of this history becomes the subject of his artworks. Kiefer's patrimony is not only the tainted cultural icono-

11 For an excellent overview of this struggle between the two generations, see for instance Michael Schneider's essay "Fathers and Sons, Retrospectively," and Jean-Paul Bier's "The Holocaust and West Germany."

graphy left behind by his predecessors, he is also left with the responsibility to mourn these objects, and ultimately to mourn the Jewish victims themselves. Andreas Huyssen comes closest to describing what is unfolding in Kiefer's *Margarethe/Sulamith* Paintings: "In these paintings, where Kiefer turns to the victims of fascism, the melancholy gaze at the past, dominant in the architecture paintings, is transformed into a genuine sense of mourning. And Kiefer's seemingly self-indulgent and narcissistic obsession with the fate of painting reveals itself here in its broader historical and political dimension" (40). While Huyssen is correct in his assertion that there is an active form of memory work developing throughout Kiefer's paintings, I contend that Kiefer's goal is to undermine such a notion that the past can be worked through, or that closure is possible. It is exactly this sense of a *Vergangenheitsbewältigung*, that the past can be mastered, that Kiefer strives to undermine.

Kiefer's artistic development from 1969 to 1980 can be read as both a struggle with his parents' generation, the perpetrators, and with the cultural inheritance left to a German artist living in the aftermath of Auschwitz. Drawing on Eric Santner's discussion of transitional objects in his study on postwar German cinema, *Stranded Objects*, I suggest that we witness in Kiefer's artworks his own search for transitional objects—objects that can be employed to negotiate the compromised position of other cultural symbols poisoned by their association with the National Socialists. The very possibility of identity construction for both the individual and nation relies on the availability of such objects. As Santner claims,

> The core dilemma is that the cultural reservoir has been poisoned, and few totems seem to exist which would evoke such traumatic ambivalence that only a global foreclosure of all symbolic legacies would prevent further contamination. To carry out their labors of self-constitution the second and third generations face a double bind of needing symbolic resources which, because of the unmanageable degrees of ambivalence such resources arouse, make these labors impossible. (45)

Such symbolic legacies as the romantic landscapes of Casper David Friedrich, the legend of the Nibelungen, Goethe, and Wagner have been defiled by being appropriated by the National Socialists. The names, dates, landscapes, and signs that adorn his paintings from the 1970s are the "stranded objects" that Kiefer puts on display before his German audience as he attempts to question, critique, and finally decathect from these national symbols. By decathexis I mean the process in which the psychic energy invested in an object that has been lost or compromised is redirected to new objects. I will return to this term when examining one of Kiefer's earliest projects, *Besetzung* (1969), where he poses in photographs

in places throughout Europe and performs the Hitler salute. I contend
that Kiefer, a member of the *Nachgeborenen*, finds in Celan's poetry the per-
fect incarnation of a transitional object to take the place of the cultural
iconography rendered toxic by the events of the Holocaust:

> The conditions under which stable cultural identities may be consolidated have
> indeed with and since the Holocaust become radically different; the symbolic or-
> der to which a German is subjected, that is, the social space in which he or she
> first learns to say "*ich*" and "*wir*," now contains traces of a horrific violence. [But]
> the conventional sites of identity formation have become destabilized, have be-
> come more and more *unheimlich* ... (Santner, *Stranded Objects*, 51)

Kiefer demonstrates in his art an ongoing confrontation with the com-
promised social space in which identity construction unfolds, that is, with
what Santner would call "the phantasmatic kernel of the Third Reich."
Through his technique of layering the canvas with various materials and
media—wood, sand, lead, ash, photos, quotations, and paint—Kiefer ren-
ders abstract the familiar sites of his studio in Buchen and the forests and
landscapes of Germany. Ultimately, it is not Freud's model of the uncanny
that arise here; rather, the parameters of the Holocaustal uncanny unfold-
ing throughout Kiefer's artworks that confront the Nazi past culminate
with his inscription of Celan's poem. Moreover, it is the poetic fragments
from Celan that provide orientation to what is unfolding upon the canvas.
Kiefer lures the spectator into the space of the dead. The frame of the
artwork splits open and our gaze is consumed by something abysmal.
Breaking the division between interior and exterior, Kiefer reframes the
conventions of his media by doing violence to the frame.

Kiefer's aesthetic strategies follow an anti-therapeutic model; like
Celan, the painter constructs traumatic scenes that the spectator can nei-
ther overcome nor master. We follow the path that the artist sets before
us and expect to read or see something; instead, destroying our position as
conventional spectators, the artist disrupts the voyeuristic gaze and leads
us into scenes of erasure upon his canvases. Before examining Kiefer's
translation of Celan's poetics, I will trace some of the steps leading to his
encounter with Celan and the Holocaust. We can see from the shifting
terrain of Kiefer's artworks the transformation of conventional modes of
the uncanny to the Holocaustal uncanny, which culminates in one of
Kiefer's most evocative paintings, *Sulamith*, from 1983.

Kiefer's Reception in Germany

At the time when his popularity was expanding internationally, the response to Kiefer from German critics was anything but positive, some going as far as calling him a proto-fascist (see Eduard Beaucamp, "Die Verbrannte Geschichte"). In an article written in 1984 for the *Frankfurter Allgemeine Zeitung*, Eduard Beaucamp described Kiefer as a "Tabubrecher," for his paintings resorted to the same names, images, dates, and myths that the Nazis used for their political grounding. Beaucamp reads Kiefer's works as celebrations of the very national myths the Nazis abused, describing his paintings as mythic constructions running wild: "The painter attempts to include the most recent German history and the present, that is the Second World War along with the ravaged and divided Germany, in the world of myth and their spaces of consecration" [Der Maler versucht auch noch die jüngste deutsche Geschichte und Gegenwart, also den zweiten Weltkrieg und das zerstörte und geteilte Deutschland, in die Mythenwelt und ihre Weiheräume einzubeziehen]. While Beaucamp believes that Kiefer is attempting to reclaim the mythic past for the present, he fails to see that in Kiefer's painting the mythic names, dates, and landscapes are not nostalgically mourned by the artist, nor does Kiefer provide a redemptive promise of their return. Instead, his paintings tear off the layers of mythic concealment and oblivion to reveal the National Socialists' misappropriation of art and the poisoning of these cultural artifacts. One of Kiefer's most revealing representations of his rejection of both myth and art's transcendent powers is seen in his figure of Icarus in a painting titled "Icarus—March Sand" (1981): it portrays a palette with wings crashing into a field of fire in Brandenburg. For Kiefer the flight of art crashes not into the sea but into the fire-ravaged fields of German history. It is neither the radiance nor the idealism associated with the sun that poses the danger to art, but the fires of history, which threaten to consume the artist.

Beaucamp mistakenly believes that Kiefer's *Trauerarbeit* is directed towards such legends as Parsifal and the Nibelungen, when in fact the artist is revealing the destructive repercussions of these very myths. Kiefer illustrates how the political seizure of these myths helped contribute to historical catastrophe. What then is the "taboo" that Beaucamp sees Kiefer breaking? Beaucamp critiques Kiefer's use of National Socialist architecture in his paintings of the 1980s and sees the artist celebrating the works of Troost, Kreis, and Speer.[12] What Beaucamp fails to mention is that as

12 Speer's design of the Reich's Chancellery courtyard is reflected in Kiefer's *Dem unbekannten Maler* (1983*)* and *Athanor* (1983/84). Speer's main tribunal at the Zeppelin Field in Nürnberg

Kiefer is using such architecture in his works, he is simultaneously return-
ing again and again to Celan's "Todesfuge," where in the end Celan's Su-
lamith is memorialized in the space of Kreis's Tomb for German Soldiers
(*Sulamith*, 1983). Neither Celan nor the Holocaust is mentioned in Beau-
camp's article, and perhaps the real taboo that Kiefer has broken is his
confrontation with the genocide of the European Jewish community.
Contrary to what Werner Spies calls an "overdose of teutonic zeal,"
Kiefer is searching for the right dose of these poisoned totems to insert
into his paintings as part of his continual *Trauerarbeit*. His project does not
revolve exclusively around a personal mourning for the compromised
tools of tradition that the German artist has been left with; his art also
opens up the path towards a historical mourning for fascism's Jewish vic-
tims. The reactions of such critics as Beaucamp and Spies reveal the deep-
seated anxiety in Germany during the early 1980s when confronted with
not simply the National Socialist past, but in particular the events of the
Holocaust.

In the early 1970s Kiefer represented the space of his wooden studio
in the Black Forest. This series of works, referred to as the attic paintings,
depict wooden spaces filled with religious, mythic, and historical iconog-
raphy: quotes and symbols from the *Nibelungenlied* and Wagner adorn
these works. We can read these interiors as not simply the places where
cultural memory is stored away, but more exactly they signify the places of
a repressed memory. These spaces with their Wagnerian themes alluding
to Parsifal and Siegfried—and hence with a Wagnerian anti-Semitism
looming in the background—resemble theater stages. The spectator's per-
spective is that of the audience looking at a stage devoid of actors. Kiefer
puts on display here the stranded objects of German cultural history. Con-
trary to Mark Rosenthal's claim that Kiefer is trying to stare down the
ghosts of Germany's past and reclaim its romantic tradition (22), to my
mind there is no redemptive moment in these works.

In *Nothung* (1973), named for the magical sword from the *Nibelun-
genlied*, the artist takes Wotan's sword found by his son Siegmund in the
trunk of a tree and thrusts it into the wooden floor of his studio. Above
the sword is the name *Nothung*, and beneath the beam of the ceiling are
written Siegmund's words: "Ein Schwert verhiess mir der Vater" (My fa-
ther promised me a sword). While Kiefer now places himself into this
chain of inheritors, he transforms the steel of *Nothung* into a papier-maché
prop stuck into the stage floor.[13] We are reminded of Freud's essay "Rec-
ollection, Repetition, and Working Through": "The past is the patient's

is reproduced in *Die Treppe* (1982/83), while Kiefer's turns to Troost's House of German Art
in Munich in his *Dem unbekannten Maler* (1980).
13 One can also hear a wordplay in which *Nothung* resonates with the English word "Nothing."

Nothung (1973). Oil and charcoal on burlap, with oil and charcoal on cardboard. Permission of the Anselm Kiefer Studio. Courtesy of Fondation Beyeler

armory out of which he fetches weapons for defending himself against the progress of analysis, weapons that we must wrest from him one by one" (160). Setting these weapons on the stage in order to disarm Germany of its toxic myths, Kiefer's goal is to reveal this repressed kernel of German history to the audience standing before his paintings.

The passing on of the father's sword, part of the artist's patrimony, becomes a passing on of his crime: blood stains the blade. This murder weapon leaves its traces upon Kiefer's other canvases: the tainted land-scapes, Margarethe's straw hair, Sulamith's breasts. There is something uncanny about this space, not only because a lost object reappears, but because the object Kiefer chooses to place into the scene has a Freudian resonance to it: the phallic image of a bloody sword. Although Freud's uncanny has at its core the fear of castration, what is symbolically repre-sented in Kiefer's painting is not castration anxiety, but rather the fear of losing the ability to represent oneself, individually or collectively. The symbolic order of Kiefer's patrimony has been severely damaged. Yet the cultural legacy has not been rendered totally powerless: Kiefer transforms the sword into a tool to critique this very tradition and to point to the jeopardized position of its cultural signifiers.

Kiefer's Act of Decathexis: Lost Objects and Landscapes

Before closely examining Kiefer's interrogation of Celan's ghostly return, I want to trace some of the integral steps along the way to his encounter with Celan's poetry, the preliminary stages through which the artist must go in the process of decathecting from Germany's cultural artifacts, like *Nothung*, that have become tainted by history. In one of his earliest pro-jects, titled *Besetzung* (1969), Kiefer poses in photographs in places throughout Europe and performs the Hitler salute. While *Besetzung* trans-lates into the English concept of an army's occupation of another land, it is also the word from Freud that we translate in English as cathexis. As Kiefer explained in an interview, he had to first become a fascist before he could reject it: "I identify myself neither with Nero or Hitler. But I have to go with a small piece in order to understand the madness. Therefore, I make this inauthentic attempt to be a fascist" [Ich identifiziere mich weder mit Nero noch mit Hitler. Aber ich muss ein kleines Stück mitge-hen, um den Wahnsinn zu verstehen. Deshalb mache ich diese unei-gentlichen Versuche, Fascist zu sein] (Hecht and Krüger, 52). This act of cathecting onto one of the primary signs of National Socialism, a gesture that was (and is) itself illegal in Germany, ultimately transforms in the works that follow into a de-cathecting from the cultural symbols of fas-

cism. The emblems, dates, places, and names in Kiefer's paintings are the memory traces that signify an irretrievable past, but it is a past that is a point of neither melancholic fixation nor a nostalgic gaze towards what is lost. Kiefer demonstrates through his rejection of these signifiers an active engagement with the cultural tropes and weapons of Germany under fascism. Before his attention shifts to the victims, Kiefer presents throughout the 1970s the cultural objects and names that helped to contribute to the erasure of the Other.

Who or what is the focal point in these photographs? Kiefer, I would argue, is probing the boundaries of identity as a German in relation to his past. Despite taking on the costumes and gestures from the past, he struggles with questions pertaining to self-identity by examining his subjectivity in relation to national identity, culture, and history. He investigates this very crisis of identity formation in relation to the cultural iconography rendered toxic by the crime of the National Socialists. Despite Kiefer's turning away from the use of photographs and self-portraits prevalent in his work of the 1970s and his turning to landscapes and wooden interiors, his early works have been read as stemming from a narcissistic impulse in the painter. But I believe Kiefer begins with this self-reflexive, inward turn as a point from which he will break. As he stated in an interview, "To a certain point in time, it is more important to think about oneself before one can speak about the other" (Burckhardt and Beuys, 114).[14] But while critics might consider these earlier works signs of Kiefer's solipsistic project or an act of displaced mourning, such claims become less credible over the course of his career.[15]

During the 1970s Kiefer shifts from the interior spaces of his studio to the landscapes of his homeland, from a personal space to a collective one signifying *Heimat*. Although these German landscapes are infused with flowing golden fields and small towns, they are depleted of their power to serve as cultural signs of national identity, tainted by the presence of fire and blood. In a painting from 1974 titled *Maikäfer, flieg* ("Cockchafer, Fly") Kiefer juxtaposes a burning landscape to a German nursery rhyme, bringing the catastrophic scene illustrated directly into relation with German history. The song begins, "Maikäfer, flieg, der Vater ist

14 Such a position is consistent with Levinas's ethical subject who is both responsible for and persecutes the Other. "The more I return to myself, the more I divest myself, under the traumatic effect of persecution ... the more I discover myself to be responsible; the more just I am, the more guilty I am" (*Otherwise than Being*, 112). In Kiefer's positioning of himself in *Besetzung*, he is still speaking about his relation to the Other in these photos. By identifying himself with the perpetrator, he acknowledges as well his responsibility for the Other's suffering.

15 For a particularly strong critique of Kiefer's engagement with Germany's past, see Benjamin Buchloh's essay "A Note on Gerhard Richter's October 18, 1977."

Maikäfer, flieg (1974). Oil on burlap. Reproduction permission from the Anselm Kiefer Studio. Location unknown.

im Krieg, die Mutter ist in Pommerland, Pommerland ist abgebrannt"
[Maybeetle fly, the father is in the war, the mother is in Pomerania, Pom-
erania is burned up]. Going back to the Thirty Years War, the nursery
rhyme's pathos intensified after the Second World War when the eastern
territories, Pomerania, were lost. Whether Kiefer intended it or not, the
painting intersects with Celan's poem "In the Air," which also employs
the rhyme. While poem and painting are encounters with an uncanny
moment that confronts the historical loss of home, both Celan and Kiefer
are also reflecting on their cultural inheritance: how can one paint or write
poetry with the cultural material of Germany in the aftermath of the
Holocaust? Celan's poem begins:

> Looming
> up there moves the banned one, the
> burned one: a Pomeranian, at home
> in the maybeetle song [*Maikäferlied*] that stayed motherly bright-
> bloomed at the edge
> of all cragged
> cold winterhard
> syllables...
> gone home [*heimgekehrt*] again to
> uncanny [*den unheimlichen*] anathema
> that gathers the dispersed ...
> (*Selected Poems*, 211; translation modified)

What does it mean to be at home in the *Maikäferlied*? Celan's poem, like
the rhyme, tells of the destruction of home, of exile and cremation. Home
is now located in the sky. While we might hear in the title "In the Air" the
line from "The Meridian," "There is something uncanny in the air we
breathe," we should also connect this to "Todesfuge" with its "Grave in
the Air." The uncanniness in the air we breathe stems from those who
have been turned to ash and smoke. Deprived of graves, the most un-
canny are those who have risen into the clouds. Despite all that has taken
place, Celan intimates that a time of growth out of the burning and winter
is possible as seen in the "sommerlich" (summerly) and "hell-blütig"
(bright-blossoming). And while hell-blütig (bright-blooded) may temper
the appearance of summer, Celan wishes the reader to hear via paronoma-
sia a potential blooming through a correspondence with the word Blüte,
(blossom). Celan returns to the most basic language of the nursery rhyme
and reflects not on words, but rather on their simplest components: the
syllables. Language, although "nursed on a sun-steered pain," begins to re-
form. Removing the song from the context of the German landscape,
Celan re-shapes this childhood rhyme to fit into the context of the Holo-

caust. Pomerania and the Pomeranians now become Celan's tropes for those Jews banished from their homes and exterminated.

Unlike the heavens in Celan's poem, the sky in Kiefer's massive work *Maikäfer, flieg* (220 x 300cm) is only a thin line in the painting. The focus is on the terrestrial. Most of the surface is covered with a thick layering of black and white oils that undulate horizontally across the canvas. The spectator is positioned, as it were, at sea with the white oils functioning as the crests of waves, which appear to be breaking away from shore and towards the spectator, driving him/her away from the expected safety of the shore. In the precariousness of this scene, we are kept at a perpetual distance from the horizon; our homecoming is turned upon itself.[16] But as our gaze approaches the horizon we realize, as fire rises out from the ground, that the waves are actually the furrows of burning fields. We now move towards a small town resting on the horizon. When we finally reach the woods, we read the inscription of the rhyme in the blue-gray of the horizon. The rhyme fixes us spatially and temporally in the painting: Germany, or more specifically, Pomerania, in the aftermath of the war. At this thin space and time of dusk, we are immediately brought into the memory of the war, of lost homes, exile, and death.

It is at this moment, with this particular gaze, that we enter the uncanny dimension of the painting. We cross into the landscape in search of safety, but our gaze is confronted by the burned fields of winter. Only the effacement of the vista comes before our eyes. Before we reach the vanishing point of the painting, where the rhyme mediates the space between earth and heaven, our eyes must move across the devastated countryside to get to it. Trees and homes catch fire and parts of the field carry traces of blood. The words themselves seem to be burning, lifting like smoke towards the frame of the painting. One wonders if, by focusing on the destruction of *Heimat* and of the rhyme itself, Kiefer is transforming Germany into the victim in the painting. I do not think the loss of Pomerania is the painting's subject. The artist does not gaze longingly at his or Germany's past, nor is there any self-pity that is evoked in this painting. Rather, in his brutal look at history, Kiefer ask the spectator: What can possibly grow out of this field sown with the ruins of German culture? While a nursery rhyme functions as a link between child and parent, a

16 In his *Anselm Kiefer and the Philosophy of Martin Heidegger,* Matthew Biro provides a compelling analysis of the horizon in Kiefer's landscape paintings. He asserts that the horizon is the endpoint through which the spectator's self-reflexivity is constituted (51). But while Biro is correct in claiming that historical self-identity unfolds in relation to the horizon and the rhyme, where the spectator comes to know the time and place of this abstraction through the reading of the rhyme, I am arguing that Kiefer also desires to undermine the position of the spectator by directing her/his gaze towards the space of destruction. Self-identity is compromised by the traumatic loss that comes into focus on the landscape's horizon.

song before sleep, and offers comfort to the child before the parent's departure, there is no consolation in this painting's nightmarish images.[17]

Similar to Celan's claim that only in one's mother's tongue can one express the truth, Kiefer is using the iconography of his land to reveal the effects that historical catastrophe had on these symbols. How does one say the lines to this nursery rhyme knowing the historical reality of Pomerania? It is not just a place occurring in a folksong or lullaby, it is an area destroyed as a result of war. Counter to what Arthur Danto claims, these lines would be anything but mystifying to a German audience. Instead, Kiefer is prompting his audience to re-imagine the words he inscribes on the canvas in relation to his catastrophic scenes of history.[18] In an article written for *Artforum* in 1982, Donald Kuspit reflects on the turn in contemporary German art toward its cultural legacy stating, "So we go back to our fathers in order to redeem the sons—to give them a fresh lease on artistic life by reminding them of their great cultural past" (65). Kuspit mistakenly interprets a redemptive move in Kiefer's use of the cultural symbols and names of the past in his artworks. On the contrary, Kiefer does not display the ruins of the past as a gesture toward a possible redemption; his objective, as seen in his metonymic gesture to the loss of Pomerania in the lullaby, is to connect German national identity not to its mythical but to its historical legacy. Only by first exposing the lies of National Socialism and traveling its topography as a means to examine Germany's cultural roots can the artist ultimately encounter the victims of fascism and begin to confront their loss. Kuspit continues by labeling Kiefer a part of a new German Romanticism, but I suggest that it is from this very inwardness of Romanticism that Kiefer wishes to escape. His works reveal an attempt to break out of the inward confines of art, witness his exit from the mythic studio/theater paintings into the landscapes of the mid- 1970s, where his works become both more historically centered and

17 While Anne Brailovsky is correct to assert that Kiefer's paintings escape an accusation of nostalgia, I disagree with her position that his works operate within the context of a *Vergangenheitsbewältigung* a "mastering of the past" that she sees mediated through Brecht's concept of a *Verfremdungseffekt*. Instead of undergoing a distancing before Kiefer's artworks, the spectator's body is constantly being consumed by the sheer magnitude of his canvases and sculptures. Neither Germany's traumatic past displayed in these works nor their monumentality can be mastered or controlled by the spectator's gaze. Kiefer's objective is to thwart or frustrate any notion that the spectator experiences something therapeutic before these artworks.

18 In one of the harshest critiques directed at Kiefer's paintings, Arthur Danto remarks that there is a farce of heavy symbolism in Kiefer, "Since symbols no more than names wear their meanings on their faces, knowledge of what a symbol means is something one has to be told … Kiefer's symbols are purely external, the kind you look up in books" (27).

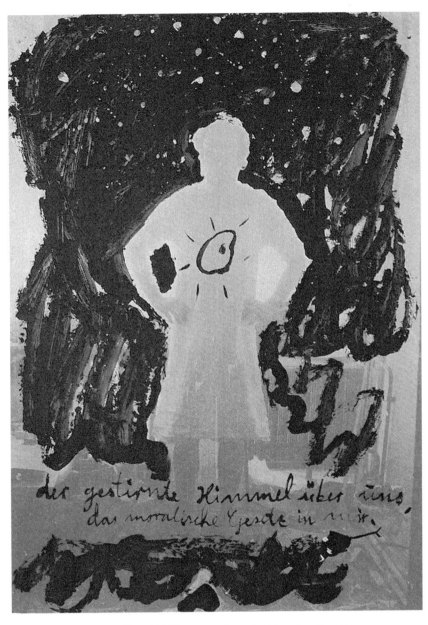

Der gestirnte Himmel (1980). Photograph (1969), with acrylic and emulsion.
Permission of the Anselm Kiefer Studio. Courtesy of Fondation Beyeler.

politically engaged. As Kiefer remarked to Kuspit in an interview, "My content may not be contemporary, but it is political."[19] Any fragmentation (national, subjective, or historical) that Kiefer wishes to confront cannot find its *Aufhebung* through a Romantic art, nor does Kiefer ever intimate that such an overcoming is possible.

Contrary to what Kuspit may claim, Kiefer is not calling for a revival of national traditions, but demands that the spectator see how these very traditions were abused, contaminated, and rendered ineffectual through the Holocaust, the tradition of Romanticism among them. In addition to Romanticism's impulse toward inwardness and its link to National Socialist myths of *Heimat*, Kiefer's turn in 1981 to Celan shows how these national myths and philosophical movements surrounding Romanticism also contributed to the destruction of European Jewry. The goal of the National Socialists was to fulfill idealism's attempts to erase difference, first by instituting laws of separation, forcing the Other to wear yellow stars and live in ghettos. Finally, the Other, whose name was replaced with a number, was deported to death camps where s/he was murdered and reduced to ash. Kiefer's encounter with Celan is an attempt to compel his German spectators to re-imagine the process of the Other's erasure by employing the very cultural traces that helped institute the extermination.

Remembering Celan, Remembering the Holocaust

After a series of paintings where art, symbolized by a palette, is equated with a fire that consumes in its path Germany's spiritual heroes, its landscapes, and legends, Kiefer begins to translate Celan's "Todesfuge" into visual imagery from 1981 to 1983. In a work from 1980 titled *Der gestirnte Himmel* (*The Starry Heavens*) he depicts the tension in this transition from his confrontation with the stranded objects of the artist's cultural heritage and the necessity to represent and remember the victims of the Holocaust. How can he represent this burning through a contaminated symbolic order? In *The Starry Heavens* Kiefer returns briefly to photography, using a photograph taken from around 1969. The artist poses comically in a white nightshirt, hands on his hips, reminiscent of the photos from *Besetzung*. He appears ghostly as black paint is smeared around his pale out-

19 See Jeanne Siegel, *Art Talk. The Early 80s*. We are reminded of Hegel's own critique of Romantic art, where he saw a widening gap between the inner and the external worlds. It is this very gap that Kiefer wishes to avoid in his own artworks. While Romanticism reflects on the state of a deferred redemption, Kiefer dispels any sense of a redemptive quality in his artworks.

line. Although not performing the Hitler salute, Kiefer evidently is alluding to a time when he explored the perpetrators of fascism.

Painted across the artist's nightshirt is the image of a palette. Beneath him is scrawled part of Kant's closing lines from his second *Critique*: "der gestirnte Himmel über uns, das moralische Gesetz in mir" (The starry skies above us, the moral law within me).[20] Thus, Kiefer's symbol for the artist is no longer equated with burning but with Kant's moral law. Kiefer appears to mock one of the most sublime quotes of German idealism and to turn it on its head. While Kant links his formulation of the moral law to questions of the sublime, which is itself bound to questions regarding the limits of representation, by placing the palette within himself Kiefer rejects the Kantian dictum against representation. He makes the breaking of the proscription against representation the new law. Art's imperative is now to represent and memorialize the burning committed during the Holocaust. The artist substitutes his palette for the moral law, interweaving his aesthetic program with ethics. It should come as no surprise that the first works after *The Starry Heavens* are those centering on the Holocaust. Furthermore, in addition to inscribing vestiges of Celan's poem upon his canvases, Kiefer's landscapes and interior spaces resonate with traces from iconic Holocaust photography: images that contain what Barbara Zelizer calls an "atrocity aesthetic."

As Zelizer discusses in her study of Holocaust photography, *Remembering to Forget: Holocaust Memory Through the Camera's Eye*, there is an archive of atrocity images (railroad tracks, barbed wire, mass graves, Auschwitz's gateway) that collective memory draws from and re-circulates: these are the "visual cues" of atrocity (207). The public recognizes the traits of this particular aesthetic, which includes malnourished victims, implements of torture, mass graves, and remains of the dead, signaling the Holocaust. But Zelizer asks if we have reached a saturation point in relation to these images, where their very re-circulation alongside contemporary occurrences of mass murder and genocide have numbed the spectator to scenes of atrocity from both the past and the present—Rwanda, Bosnia, Cambodia. Zelizer describes how this recognition of past images in present scenes of terror triggers a habituation of memory. Her primary concern is that these iconic photographs, when viewed through a "lens of habituation" (214), are leading to a normalization of this act of looking. In turn, this habituation causes a lack of reaction in the spectator, where the photographic representation "undoes the ability to respond" (220). As a result, new forms of looking at these scenes of extermination and efface-

20 "Two things fill the mind with ever new and increasing wonder and awe, the oftener and the more steadily we reflect on them: the starry heavens above me and the moral law within me" (*Critique of Practical Reason*, 169).

ment of the Other are required, as Kiefer renders abstract these very images upon his canvas.

Kiefer's paintings, in particular those in the Margarethe/Sulamith series, depend on this very recognition by the spectator of an atrocity aesthetic that centers on the trace: hair, ash, gas chambers, railroad tracks. His paintings are meant to elicit from the spectator a return to this mnemic archive of images that have become part of the public domain. Relying on such photographic traces, Kiefer guides the spectator to sites of terror by means of poetic inscriptions. It is Celan's iconic poem "Todesfuge," disfigured by Kiefer, that brings into focus the very abstraction and diffusion of these images that permeate his artworks. While Kiefer adorns his canvas with an atrocity aesthetic that he renders opaque through layering of material and painterly blurs, his objective is to elicit from the spectator a break from this "lens of habituation," see anew these sites of destruction, and reflect on their historical significance within a contemporary frame. In effect, Kiefer effaces these traces in order to create a new optics with regard to looking at the Holocaust. His *Margarethe/Sulamith* paintings try to break free from the repetitive gaze at images from the camps as well as how we hear/read Celan's poem. He estranges these iconic scenes of Holocaust photography and poetry in order to provoke remembrance of the past and to recuperate lost affect required for the preservation of memory.

Kiefer's use of photographic traces in his paintings demonstrates Marianne Hirsch's concept of postmemory in "Surviving Images." As Hirsch tells us, one possible effect of an overexposure to these photographs is that they risk becoming clichés, divested of their symbolic power. Through their repetitive showing, they could lose their ability to induce affect, in particular empathy. These images are re-invested with meaning and affect, and become potential "vehicles of working through a traumatic past" only through the displacement and recontextualization in new media (218). Postmemory is based not on the invisible, but on the barely visible that provokes an uncanny shudder at what is vaguely familiar. For instance, Hirsch turns to Spiegelman's *Maus* to investigate the transgenerational space of remembrance in which the father's memories are "adopted" by the son. Iconic photographs from the Holocaust are reconfigured in the graphic comic in Artie's telling of his father's story of the Holocaust.

Cynthia Ozick claims, "The more narrowly we look into the perplexing lens of Auschwitz, the more painful will the perception be. It is moral ease to slide from the particular to the abstract" (153). In her personification of this site of terror, pain overwhelms the spectator who looks into the eye of Auschwitz. Furthermore, this act of looking at "authentic" depictions of Auschwitz—and we can assume from her choice of words that

Ozick is referring to photographs and their claims of verisimilitude and proximity—is bound to a moral import that diminishes in more abstract forms of representation. But counter to her assertion that abstract representations of the Holocaust are lacking in moral significance, I would agree with Zelizer that there is a waning of a "testimonial imperative" in the photograph, a waning that gives rise to another imperative emanating from abstract forms of art such as Kiefer's.[21] As he himself said about his artworks, painting has an entirely other law with regard to these scenes of terror. His paintings do not claim to possess authenticity, nor do they provide testimonial evidence to the crimes; instead, Kiefer warps such authentic images in order to provoke the spectator to re-imagine these traumatic scenes to which they have become accustomed.

In an interview that he gave shortly before his relocation from Germany to France, Kiefer discussed the distinction between the representation of terror in photography and painting:

> Everything represented loses immediate terror [*unmittelbaren Schrecken*], because it was represented. A transformation was experienced. It is no longer to be substituted for factual terror. A painting [*Bild*] is never the illustration of terror. It is not a photograph. When the painting is not an illustration of terror, then an entirely other dimension comes into the painting. The work of art stems from its own laws. At the same time its representation of terror speaks its own laws and values. (see Hanstein)

The law that Kiefer is referring to can be traced to his *Starry Heavens*, where the media of photography and painting merge. The law that governs those paintings [*Bilder*] that confront the terror of the Holocaust is one that rejects both Kantian interiority and the prohibition against making images. There are two components to this ethics; while the artist must represent or configure the catastrophe through techniques reminiscent of Kant's concept of negative representation, the spectator must re-imagine these scenes of extermination and complete the image that Kiefer leaves effaced.[22] Through the act of negative representation, Kiefer assails the spectator's desire to see something. At the site of a trauma, he disfigures

21 Zelizer borrows the term "testimonial imperative" (150) from Sidra DeKoven Ezrahi, who claims that these atrocity photographs of the camps possess an imperative that requires from the spectator an act of bearing witness to the horrors depicted (*By Words Alone*, 21).

22 See chapter 1 here, where I explicate Kant's notion of "Negative Darstellung" from his analysis of the sublime in the *Critique of Judgment*, in relation to visual rupture in Freud's concept of the uncanny. For Kant, negative representation marks the limits of sensibility, which is accompanied by the breakdown of the faculty of imagination. With this disruption of vision in Kant, specular anxiety arises. The break in representation does not signify the advent of the sublime, but becomes the symbolic context for what needs to be interpreted by the reader/spectator.

the remnants of the catastrophe not in order to shield the spectator from something horrible, but to force him/her to remember and reconstruct the historical void left behind by the Holocaust.

Kiefer's techniques of layering the material, blurring the image, and inscribing poetic texts on the canvas are meant to break the lens of habituation that contributes to the sense of historical amnesia Kiefer sees pervading Germany's lack of confrontation with its past. The ethical moment implemented in Kiefer's artwork arises at the mark of specular disruption, when the spectator is compelled to re-figure what had been withheld or rendered into a blur upon the canvas. While the spectator is left with the responsibility to translate these painterly traces into the images of historical (not poetic) effacement, there is still the risk that such a translation is not made and the traumatic past remains obscured. For Kiefer, the work of memory is analogous to an act of excavation, and as he remarked in an interview, "I think vertically and one of the plains reached was Fascism. Yet I see all of these layers [*Schichten*]. I tell stories [*Geschichten*] in my pictures in order to show what is behind the history. I make a hole and go through it" (West, 75). In his *Margarthe/Sulamith* series, Kiefer ultimately lures his audience through the layers to what is interred beneath the canvas: the Jewish dead.

In my introduction to this book I mentioned how Sidra Ezrahi described Germany's recitation of "Todesfuge" as a "incantational procedure rather than an intended text." Ezrahi also comments on Kiefer's paintings, labeling them a "cultural space devoid of significant moral tension" ("'The Grave in the Air,'" 268, 275). But contrary to her claim, a moral tension does in fact govern these paintings. The moral tension in Kiefer's work is conveyed through the opposition between the act of representing the Holocaust and the cultural objects the artist chooses with which to do so. Turning to Celan's metaphors that have fallen into a state of misuse, Kiefer highlights the poetic imagery and figures of "Todesfuge" in his works. I suggest that what happens in his paintings is similar to what Celan believed about his wife's lithographs that accompanied a collection of his poems: "In your etchings I recognize my poems again. They enter into them in order to remain in them" [In Deinen Stichen erkenne ich meine Gedichte wieder, sie gehen in sie ein, um in ihnen zu bleiben] (qtd. in Buck, *Bildersprache*, 10). Kiefer's works make recognizable again what had been lost, first by taking the poem through an estrangement consisting of a disfiguration of quotes, imagery, and material. So what we can recognize in Kiefer's painting is not only the poem, but also what it stands for: it is an epitaph for all that was reduced to ash.

Throughout this chapter I have read what Huyssen referred to as a possible "narcissistic obsession" (40) as a necessary part of Kiefer's at-

tempts to face the Holocaust. Kiefer takes the stranded objects of German culture through a process of decathexis and clears the path for reflection on the Jewish victims. I believe that through Celan's verse Kiefer finds his transitional object for the cultural artifacts rendered toxic by the Holocaust. But something else is transpiring in these paintings as well: Celan himself is taken through a change. Kiefer turns to a poem regarded by many to be the paradigm of Holocaust poetry. It has become Celan's poetic signature. Yet after four decades of its recitation in schools and at commemorative functions, what has become of the relation between poem and audience? Kiefer, however, will not cite directly Celan's signature line "Der Tod ist ein Meister aus Deutschland"; rather, the paintings themselves become backdrops of destruction emanating from Germany. Like Celan's other central motif in "Todesfuge," the focus of the paintings will be on Margarethe's and Sulamith's hair. The disfiguration of Celan's poem, conveyed through the use of poetic fragments that focus on a corporeal trace, signifies both the uncanny return of the trauma and the configuration of the Other as victim.

In his essay on translation, Walter Benjamin remarks that translation transpires during times of crisis. What then is the crisis in 1980 that brought Kiefer into the role of translator in Germany? It is a crisis of memory where the focus on the perpetrators shifts to an attempt to identify with the victims of the Final Solution. Many scholars and historians have attributed this transformation to the showing of the American television mini-series "Holocaust" in Germany in 1979. As Peter Märtheshei-mer describes the effects of the show on the German public, the viewer was freed

> from the horrible, paralyzing anxiety that has remained repressed for decades, that we in truth were in league with the murderers. Instead we are able to experience, as in the psycho-drama of a therapeutic experiment, every phase of horror—which we were supposed to have committed against the other—in ourselves ... to feel and suffer it—and thereby finally in the truest sense of the word to deal with it as our trauma. "Holocaust" offered us the role of the patient instead of compelling us to take the role of the analyst, a role which we have been incapable of assuming. (qtd. in Herf, "The 'Holocaust,'" 41)

I do not wish to suggest that Kiefer was influenced by the showing of the television series; rather, I believe that the trajectory of his paintings throughout the 1970s had already demonstrated a growing inclination toward this encounter with the victims of the Third Reich, and perhaps the climate was simply ripe in Germany, brought on ironically enough by the American culture industry. But Kiefer's paintings do not provide the spectator with a therapeutic space that would enable either a working-through

of the loss of the murdered Other or a mastering of the traumatic past. Nor is there any fantasy of experiencing the horrors that befell this Other. Counter to Märtesheimer's use of the phrase "our trauma" to refer to Germany's relation to the extermination of Europe's Jews, the trauma of the death camps along with the effaced Other remain irrecuperable in Kiefer's works. Instead, Kiefer perpetually exposes his audience to scenes of trauma that can be neither completely remembered nor forgotten. Heeding Celan's admonitions from his drafts of "The Meridian" where he warns against turning to the "Almond-eyed beauty" in order to mourn [nachweinen] over her extermination, Kiefer may name the Other who has been reduced to ash, but he withholds presenting the return of something beautiful in his works. Kiefer, adhering to Celan's call to turn toward the dead of Auschwitz and Treblinka, confronts the spectator with railway tracks, burning fields, the form of a faceless, bloodied woman with ashen hair, and an empty stone interior with a flame.

How does Kiefer read "Todesfuge" and translate Celan and his poem into figures upon the canvas, both of which can then function as metonymies for the Holocaust victim? Celan writes his phantoms into his poems as erasures, quotes, missing lines, foreign and fractured words, and Kiefer does the same with "Todesfuge." The poet becomes a ghostly image, not a painted form, and is configured through traces of his poetry along with the images of smoke, fire, ash, and hair. The quote is a return of the absent one's voice that the spectator needs to discern. While Kiefer shifts between the images of Margarethe and Sulamith in his paintings, I concentrate here primarily on the figure of Sulamith because she is Celan's and Kiefer's trope for the incinerated European Jewish community.[23] Although the setting of the Margarethe paintings remains relatively unchanged, burning fields comprised of straw and ash, the Sulamith paintings undergo a conspicuous transformation: they move from ravaged fields, to modern high-rise apartments, to a burial chamber, and finally

23 Before engaging with Sulamith, the Jewish victim, Kiefer examines her murderous counterpart, Margarethe. His paintings of Margarethe from 1980 to 1981 remain relatively unchanged with regard to the images portrayed: expansive and desolate landscapes infused with straw catching fire. What changes is his use of inscription. The title of and script in the paintings from 1981 change from *Margarethe,* to *Dein blondes Haar, Margarethe* to *Dein goldenes Haar, Margarethe.* Our first association with the name Margarethe is Goethe's heroine (Gretchen) from *Faust,* whose bed in prison was made of straw and whose purity was destroyed through her love for Faust. Kiefer returns to this cultural icon, Gretchen, where straw functions as a sign for her golden hair, and sets it aflame. But this metonymy is not only for her hair, or for the *Heimat* about to be incinerated; in addition, Margarethe represents Goethe himself, another cultural figure who was compromised by the National Socialists. We recall the proximity between his home in Weimar and Buchenwald. While Sulamith's name is not present, we behold her appearance in the ashen streaks outlining the gold of the straw.

leaden books in *Sulamith* (1990). Kiefer's paintings explicitly link the destruction of *Heimat* with the extermination of the Jews. The burnt land carries in its soil the traces of the lost Other.

In one of his earliest depictions of Sulamith, *Dein aschenes Haar, Sulamith* (1981), Kiefer duplicates the landscape from an earlier painting, *Dein goldenes Haar, Margarethe* (1981), with its fields of burning straw, vanishing sky, small village, and tracks in the field moving towards the horizon. But while in the *Margarethe* painting the inscription rests in the fields, in *Dein aschenes Haar, Sulamith* the words rise into a thin horizon like the rhyme in *Maikäfer, flieg.* In their black, child-like scrawl the words appear to lift off the canvas like smoke from the fields. Sulamith becomes the product of the burning as Kiefer captures the moment before she vanishes. Contrary to the verse in "Todesfuge" "there you won't lie too cramped," this narrow slit of sky becomes the receptacle for the incinerated Sulamith. Accenting the land, the place of the crime, and not the diffusion of the Other in the sky, Kiefer captures the moment before Sulamith is lost. Our gaze falls on the German countryside, its fields and small towns: the symbol of *Heimat* is reduced to ash and its Jewish Other, the banished one, rises like smoke off the canvas.

In *Dein aschenes Haar, Sulamith* (1981) Kiefer returns to the use of lines; they do not go straight ahead, but diagonally to the upper-left corner of the painting. These visual cues draw our gaze away from the center of the painting and guide us to a liminal space near the horizon. The lines naturalize both our glance and the experience of looking away from the center and toward the side. While we are not taken to this place unwillingly, our expectant gaze is nonetheless subverted. The horizon of the painting is not infinite sky and space: it is a thin, dull-gray line of dusk, as in many of Kiefer's landscape paintings during this period—*Margarethe* (1981), *Die Meistersinger* (1981), *Nürnberg* (1982). Something phantomlike hovers on the horizon. With the blurring of imagery, the unfocused structures on the horizon, the layering of oils, and the use of iconographic material like ash upon the canvas, Kiefer takes his painting through an abstraction. Whither do the lines of the painting transport us?

Like *Maikäfer, flieg* the quotation provides both locus and time to the decimated landscape. The line from Celan helps to orient the spectator, both spatially and temporally, within the wide expanse of the canvas. At the painting's vanishing point we are taken to the place of extermination and into the Holocaustal uncanny. Theo Buck remarks that although one wishes to see loading ramps in these fields, the spectator is forcing something upon the canvas that is not there (*Bildersprache*, 30). Yet I believe cultural memory is already influencing the way the spectator reads the burned landscape. While the poem's setting is that of a concentration camp, in

Kiefer's landscape paintings of Margarethe and Sulamith, it appears as if we are outside the camp and are about to be delivered by the lines to its gates. These phantom associations of the camps, of deportation lines in the countryside, are not engendered only through Celan's poem, but by the photos that Habermas says have been burned into Germany's memory: the tracks leading to Auschwitz. Habermas writes,

> Contemporary history remains fixated on the period between 1933 and 1945. It does not move beyond the horizon of its own life-history; it remains tied up in sensitivities and reactions that still always have the same point of departure: the image of the unloading ramp at Auschwitz...has been burned into our national history entered the consciousness of the general population only in the 1980s. (*The New Conservatism*, 229–30)[24]

With his use of such terms as "not move beyond," "tied up," and "burned into," Habermas's description of contemporary German history is consistent with an image of a compulsion to repeat a traumatic memory; it is a memory that lacks integration in consciousness and thus carries the potential of coming back to haunt the collective memory of a people. Examining how Auschwitz has become the event burned into German history, Habermas perceives the dangers of trauma becoming the focal point of national identity when it is not fully integrated into historical consciousness. His words appeared at a time when Germany was enmeshed in the 1986/87 *Historikerstreit* and Auschwitz's afterimage was undergoing a deformation in German memory.

During the *Historikerstreit*, or the German Historians' Debate, which began in the summer of 1986, conservative historians in the Federal Republic such as Ernst Nolte, Andreas Hillgruber, and Joachim Fest attempted to re-contextualize the Nazi past. In their accounts of the Third Reich the policies of annihilation that culminated in the Final Solution were marginalized. The extermination of the Jews was placed outside the traditional framework of historiography, where the nature of the crimes had been considered without historical precedent. Instead, the Nazi crimes were situated alongside what Hillgruber perceived as a double threat. First, Germany's military actions were deemed preemptive with respect to the Red Terror of the Soviet Union. Through such a causal connection, the past was relativized; Auschwitz was said to have derived from the Gulag. And second, the genocidal acts of the Nazis were placed next to both the expulsion of Germans from the eastern territories and the dismembering of the German nation, which Hillgruber claimed had been

24 See also Kiefer's *Eisen-steig* (1986), which depicts train tracks resembling the tracks of Auschwitz-Birkenau. Matthew Biro provides an excellent reading of this painting in "Representation and Event: Anselm Kiefer, Joseph Beuys, and the Memory of the Holocaust."

the Western Allies' objective even before the start of World War II.[25]
While the traditional historical perspective had been to identify with the
victims of National Socialism, Hillgruber asked his German audience to
empathically identify with those Germans forced from their homes in the
eastern territories and with the German soldiers who protected the home-
land from the advancing Soviet troops.

In contrast to the manner in which the Holocaust was thus rendered
peripheral during the *Historikerstreit*, Kiefer confronted his audience five
years prior to this controversy with the centrality of the death camps in his
Celan paintings, which prefigured Habermas's invocation of Auschwitz's
train tracks in 1986. Relying on the haunting archival images of the camps
that are rendered diffuse through the techniques of blurring and the layer-
ing of material on his canvas, Kiefer's optic, consisting of a central per-
spective, compels the spectator to bring into focus the Jewish dead who
haunt the terrain of his paintings. While Celan had used language as his
primary mode to estrange the reader, it is ironic that Kiefer turns the
opacity of Celan's language upon itself to bring into focus the abstract
material and content of his paintings. Although Ezrahi sees Kiefer's use of
Celan as a self-limiting procedure, stating, "Celan's text remains superim-
posed upon German culture and resistant to being co-opted into a more
open, organic, intertextual dynamic" ("Grave in the Air," 267), the in-
scriptions on the paintings serve to elucidate the images, and without
them the paintings would remain abstract, their meaning suspended
amidst the dreary colors of the canvas. Word and image reflect back upon
one another, and Celan's text not only provides light to the decimated
landscapes and figures on the canvas, but as Kiefer's use of Sulamith will
show, the artist is also providing his own hermeneutics of the poem's rela-
tion to contemporary Germany, rescuing the poem, the poet, and the vic-
tim from cultural oblivion.

If the *Margarethe/Sulamith* landscape paintings depict the time and
place of the trauma, the next painting in the series, *Dein aschenes Haar, Sula-
mith* (1981), links Sulamith to contemporary German society as the setting
shifts to the city. Sulamith's wounded body returns and sits naked in front
of a row of modern high-rise apartment houses. Blood and her cascading
ashen hair conceal her face and gaze. No eyes peer back at the spectator,
who is left to look at the dead. Hair and blood flow downward across her
breasts, stomach, and legs towards the edge of the canvas and threaten to
pour out of the frame; the traces of the crime are about to cross into the
realm of the spectator. Kiefer's layering of hair also extends upward to-
wards the gray sky in the painting, and the artist is again alluding to the

25 For in-depth analysis of the *Historikerstreit*, see Friedlander's *Memory, History and the Extermina-
tion of the Jews of Europe*, as well as LaCapra's *Representing the Holocaust*.

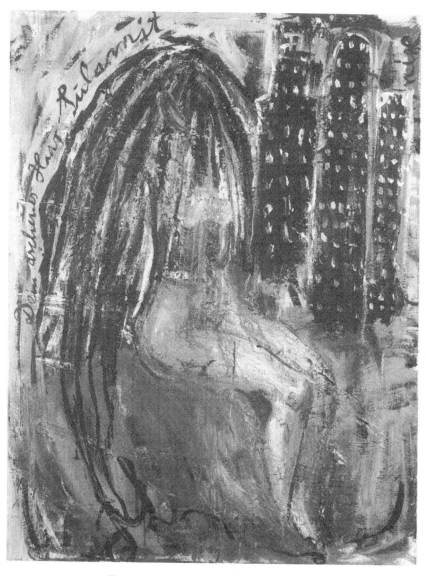

Dein aschenes Haar, Sulamith (1981). Oil on canvas.
Reproduction permission from the Anselm Kiefer Studio. Location unknown.

photographic images of the piles of hair left behind at the extermination camps. Hair, a recurring trope in Celan's poetry, is a central image of mourning, and we can interpret the amassing of hair around Sulamith's crouching body as a testimony to her inconsolable sorrow. In addition, the traces of blood, parts of words, and strands of hair stand for the Other who does not return our gaze, for her hair conceals her face.

Kiefer places at the painting's center Sulamith's breasts, partly covered by her black hair and flow of blood. One's gaze is drawn to the first love object of the child. But the breasts in Kiefer's painting, like those metonymically represented through "black milk" in Celan's poem, are unable to sustain life. The breasts should remind us again of Kiefer's attempts at decathexis and his search for substitute objects. The metaphor of black milk is Kiefer's ashen hair strewn across the blood-covered breasts. Kiefer's transitional object for the missing Jews of Germany becomes Celan's poem reconfigured in the space of the painting.

The poetic inscription reverses direction and climbs vertically along her hair, mediating between that and the small backdrop of a darkening sky. Now the name Sulamith is missing an *H* as language becomes part of the incineration. The moment when the name becomes erased, concealed, or repressed is also the time when the bloodied body returns like a phantom. The windows facing outward toward the body suggest that the crime and its attempted erasure do not go by unseen. While we may move away from the place and time of death and recall how the Nazis tried to leave nothing behind from their crimes, the traces of the extermination are burned into the present. These buildings, prefiguring the sepulcher from *Sulamith* (1983), tower above the figure like tombstones as her feet emerge from a swirl of smoky-gray oils. It appears as if the body is rising out of the ground.

At the same time he was using imagery from "Todesfuge," Kiefer was also representing architectural projects of the National Socialists, such as his paintings *To the Unknown Painter* (1982), *The Stairs* (1982/83), and *Interior* (1981). These works are modeled after Albert Speer's Reichschancellery and the stage from his Zeppelin field design. Many of the buildings associated with National Socialism were either destroyed or razed after the war, and the mountains of rubble left behind were used in the re-building of the decimated cities. As James Young remarks on what happened to the buildings in Berlin associated with the Gestapo shortly after the end of the war,

> Many feared that if the ruins of the Gestapo-Gelände were left, they might even be readopted by former SS soldiers as a memorial not to what they had perpetrated, but to what they had lost. Better, in the eyes of municipal authorities, to wipe the topographical slate clean of past crimes and suffering before starting

anew. As the Germans had been liberated from the Nazi scourge, the land itself would now be liberated from all traces of the past, from the burden of memory. (*Texture of Memory*, 84)

The past, in effect, was effaced through the process of re-construction. With the obliteration of these primary sites associated with Nazi leadership, Kiefer again relies on the postmemory context of the photographic image to provoke in the spectator a memory associated with these places. Except for the title "The Unknown Painter," which produces an aural recognition of a memorial site associated with an unknown soldier, the inscriptions to the paintings do not contextualize the spaces being depicted. Instead, the spectator is asked to form associations to this Nazi past through the visual signals indicative of these very projects; with their massive columns, grandiose interiors, temple-like form, and sheer monumental proportions, the architectural structures—all of which are modeled after Greek or Roman classical architecture—are evocative of the works of Hitler's architects: Speer, Troost, and Kreis.

In his analysis of Kiefer's architectural works, Huyssen eloquently portrays the postmemory composition of these paintings: "Being confronted with Kiefer's rendering of the interior of Albert Speer's Reichschancellery was therefore like seeing it for the first time, precisely because 'it' was neither Speer's famous building nor a 'realistic' representation of it" (221). Beneath the layering of material (oil, acrylic, shellac, straw, and woodcuts) there lies a photographic trace, and Kiefer's objective is to subvert the original intentions of these monumental buildings. While Hitler might have claimed, "Whoever visits the Reichschancellery must have the feeling of walking before the Gods of the World" (Schütz, 332), through his aesthetic techniques of blurring, inscription, and sedimentation, Kiefer transforms these temples of the gods into tombs of traumatic memory. It is from such places of the past that the policies of the Third Reich were enacted and honored that Kiefer re-constructs in his *Sulamith* painting from 1983.

The use of Nazi architecture and Celan's "Todesfuge" collide in *Sulamith* (1983), where a memorial chamber used to honor the Nazi dead, the design for German soldiers in the Berlin Hall of Soldiers by Kreis, becomes a room that commemorates instead their Jewish victims. I propose that this painting is the culmination of the Holocaustal uncanny. The spectator must cross not only the sedimentation of material—oil, ash, straw, and wood—but also the layering of distinct forms of representation: architecture, the photograph of Kreis's design, poetic inscription, and painting itself. Utilizing these multiple boundaries of material and media, Kiefer leads the spectator into the recesses of traumatic memory. He transforms the very instruments that were used to erase traces of Jew-

Sulamith (1983). Oil, acrylic, emulsion, shellac, and straw on canvas, with woodcut. Permission of the Anselm Kiefer Studio. Courtesy of Fondation Beyeler.

ish culture and its people into a memorial space in the painting. The fire at the back of the hall resembles a seven-flamed menorah, and there is a name carved in stone in the left-hand corner of the painting: Sulamith. The place signifies both erasure and remembrance. While we may be reminded of the wooden interior and columns of *Nothung*, the space from *Sulamith* is of brick, unable to be destroyed by fire.

The tracks of the field in *Dein aschenes Haar, Sulamith* (1981) turn into the crisscrossing lines on the chamber floor in *Sulamith*. Kiefer returns to the use of classical line formations that take us again towards a center horizon. The artist, however, subverts such a perspective. Instead of the lines on the floor leading to an infinite horizon, we are taken into an enclosed space; our gaze is pulled towards the back recesses of the painting. The vertical lines on the floor resembling railroad tracks guide us into the tunnel of the painting. Blocked by the columns on both sides of the chamber, we cannot move to the left or right and are transported toward the vanishing point. While our vision may at first be overwhelmed by the sheer expanse of the canvas (290 x 370cm), the back recess of the painting gets narrower. Finally, we reach not an infinite space but flames. Our subject position in the room threatens to be consumed by fire.

If Kiefer obfuscated the structure at the end of the line in *Dein goldenes Haar, Margarethe* (1981) and in *Dein aschenes Haar, Sulamith* (1981), it is clear in *Sulamith* (1983) to where we have been brought. Moving from decimated fields, to urban settings, to an enclosed room set aflame, the end of the line is the all-consuming fire of the Holocaust. Kiefer takes us to the innermost narrows of the series, into the claustrophobic space of the chamber: there is no exit. Although the lighting is semi-darkness, the space is devoid of sky. The place for windows has been blackened, casting the canvas into a perpetual night. With its red brick and flame, the perspective of the room resembles the interior of an oven. Trapped in this space of burning, we have been drawn into the crypt and towards the flames of cremation. The scratches of the name adorn the ashen chamber like Celan's description of the shower rooms in his translation of Jean Cayrol's commentary from *Night and Fog*, "The only signs—but that one must surely know—is the ceiling ploughed by fingernails" (*Gesammelte Werke*, 4:95). This painting collapses the various stages of destruction into one space—deportation, murder, and erasure—and transforms the canvas into a potential memorial space.

Even language itself is taken through a vanishing, down to the solitary name on the canvas. Sulamith's name is neither written in the center of the painting nor does it mediate the space between land and sky. Barely perceptible, it is written in the upper left-hand corner, sitting precariously on the edge of the frame between tomb and spectator. The name is

scratched into her ashen remains on the blackened ceiling of the chamber. But memory of the dead is not definitive as the faint letters upon the wall run the risk of being overlooked. While Saltzman employs the works of Abraham and Torok to read the *Sulamith* painting as an act of entombment, which suggests the presence of repression, the body is not a fetishized object that Kiefer refuses to release. Sulamith's body, her hair, and her blood have all vanished in this painting. The only things present in the chamber are memorial flame and ashen name. It is not the gaze of the Other that Kiefer wishes to return in the Sulamith paintings but the Other's voice. As Robert Hughes remarks, a voice utters forth from the canvas: "Every square centimeter of those giant canvases is intended to speak." Kiefer, appropriating the spectral language from Celan, provides a voice from beyond the grave: a broken voice that rises out of ruins.

The return of the voice evokes de Man on prosopopeia, "the fiction of the voice-from-beyond-the-grave … the fiction of an apostrophe to an absent, deceased, or voiceless entity, which posits the possibility of the latter's reply, and confers upon it the power of speech." De Man continues, "Our topic deals with the giving and taking away of faces, with face and deface, figure, figuration and disfiguration" ("Autobiography as De-Facement," 76). In Kiefer's *Sulamith,* the ghost does not return a gaze, nor does she show her face. Instead, she attempts to speak. Her name echoes in the chamber. For de Man, when the dead speak, "The living are struck dumb, frozen in their own death." It is not a Medusa-like gaze that petrifies the observer, but the voice emanating from the canvas that turns the viewer to stone. By depriving us of the gaze of the Other, Kiefer forces us to look at fields of ash, smoke, a wounded body, and a name on the wall in order to provoke us into remembering the significance of these disfigurations in the artworks.

Kiefer constructs memorial objects where the writing of the name is an act of inscribing memory in the chamber, and by reading it the spectator enters the frozen world of the dead. The epitaph consists of what de Man, through Wordsworth, calls "the naked name"(76), where the language of stone obtains a voice. Prosopopeia is the trope of autobiography by which one's name is made as intelligible and as memorable as a face. What is spoken is the name of the Other who was erased through fire. Contrary to Saltzman's assertion that memory is encrypted in *Sulamith,* Kiefer's inscription of Sulamith's name in the sepulcher is an act of undoing an encrypted memory. The signs of Jewish life in Germany—its temples, books, holy script, and its people—have been turned into ash, and Kiefer will write in its remains the lost name. Sulamith's name becomes the inscription of the lost European Jewish community. Not merely the ash upon the walls, but her name itself is the metonymy of the lost Other.

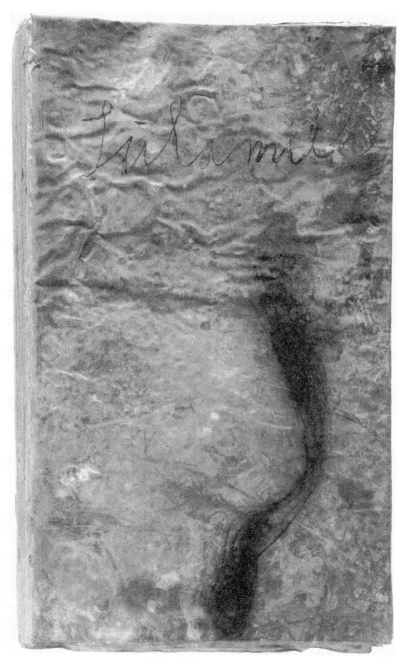

Sulamith (1990). Soldered lead and woman's hair.
Reproduction permission from the Anselm Kiefer Studio. Location unknown.

The painting's size pulls the spectators into its stony interior, trapping them inside this chamber and pulling their gaze back towards the memorial flame. But memory of who is being mourned is not definitive: the faint letters scratched into the wall might be overlooked.

Kiefer's use of Sulamith does not stop in 1983 in Kreis's vault; she returns in the book project of 1990 titled *Sulamith*. As Kiefer says about his use of material, "I use material more as colors. And the materials have their own life and have in themselves a spiritual meaning. I treat the images not like a painter, but like a sculptor" (qtd. in Kipphoff, "Das bleierne Land"). Kiefer shifts from the canvas to books of lead. His objective is to transform the grave in the air, where the body dissolves and is lost, into a leaden interior, where the body can be given proper burial. In *The Phantom of Hamlet*, Nicholas Abraham asserts that during a "transgenerational haunting," what we could ascribe to Germany's relation to the Holocaust, "The shameful and therefore concealed secret always does return to haunt. To exorcise it one must *express it in words*" (188). A traumatic event becomes "encrypted," and only through an act of writing, of inscription, can the "phantom effect" of the trauma, the return of the dead, be averted. Abraham states, "It is crucial to emphasize that the words giving sustenance to the phantom return to haunt from the unconscious. These are often the very words that rule an entire family's history and function as the tokens of its pitiable articulations" (192). But Abraham adds that this "phantom effect" can be confronted when it is established among the social practices along the lines of "staged words." Celan's "Todesfuge" provides the ghostly words that hang over Germany in the aftermath of the Holocaust, and through Kiefer's insertion of these "staged words" into his artworks—and we are reminded of the stage-like interiors of *Nothung*—he places the "phantom effect" into the social realm and thus open to works of mourning and memory.

Yet Kiefer's books are not filled with words or letters; rather, each page of these heavy leaden texts contains strands of black hair and ash: Sulamith's signature. The ghost is returned to the page of the book, not as a word but as a vestige of hair. This lock, indicative both of the remains of the dead and a sign of mourning, is placed into the book that bears the title *Sulamith*: the book becomes a tomb, its title the epitaph. How do we read these books? With the return of the phantom to its grave, one might try to read closure in Kiefer's traumatic narrative. But it is exactly this sense that the past can be mastered, this sense of a *Vergangenheitsbewältigung*, that Kiefer wishes to undermine. Through the presence of hair and ash, marks of disfigurement, something uncanny dominates these leaden books. Kiefer is not so much engaged with an act of writing as with erasing. We recall Freud's link between the uncanny and dismemberment:

"Dismembered limbs, a severed head, a hand cut off at the wrist, feet which dance by themselves—all these have something particularly uncanny about them, especially when they prove able to move of themselves" ("Uncanny," 49–50). The hair, a trace from the dead, does not leave the page, but the reader, by opening the book, enters into a tomb. While Kiefer first writes the absent Other through her name in the tomb, representation switches to metonymic displacement in his book project as hair and ash take the place of the word. The hair, triggering the process of memory work, provokes the spectator to re-trace these remnants back to their source: Kiefer guides us into a traumatic scene. Rather than try to escape the "phantom effect," his goal is to confront the spectator with the scene of a traumatic haunting. His leaden books, which memorialize the incineration, become signs of a struggle against cultural amnesia.

Coda: *Lichtzwang*

Throughout the 1990s and up until the present (2002), Kiefer has drawn on themes from Jewish mysticism.[26] His titles come from central terms and images from the Kabbalah and pre-Kabbalah Jewish mystical tradition. But at the same time that he was using Jewish mysticism in the 1990s, Kiefer returned again in his paintings to inscriptions from Celan and from Ingeborg Bachmann's poetry. In 1997 Kiefer inscribed both Celan and Bachmann in his painting *Der Sand aus den Urnen*, the name of the cycle of poems Celan wrote when he met Bachmann in 1948 in Vienna after his flight from Romania. Considering this is also the cycle from which "Todesfuge" stems, Kiefer forms an intermedial relation between this painting and those from the *Margarethe/Sulamith* series. The painting, 2.8 by 5.6 meters, takes up an entire wall of a gallery and depicts a desert scene that focuses on the ruins of a pyramid. But Kiefer is again gesturing toward Nazi architecture, this time borrowing from Kreis's design for the memorial to the German soldiers who fought in Africa.[27] Kreis's design mimicked the ancient Egyptian tombs. The top part of the structure is crumbling, and Kiefer writes at this point: "Für Ingeborg Bachmann." Reminiscent of the tracks in the field from his landscape paintings, there

26 For an excellent analysis of Kiefer's use of Jewish mysticism, see Saltzman's *Art after Auschwitz*, especially her readings of Kiefer's *Breaking of the Vessels* (1990) and his works on *Lilith* (1990). Donald Kuspit and Harold Bloom also have essays on Kiefer's *Merkaba* sculptures and paintings (2002). Kuspit argues that Kiefer's turn to these themes of Jewish mysticism is a continuation of the artist's "ongoing preoccupation with the Holocaust—indeed, his obsession with the Jews" ("The Spirit of Gray," <www.artnet.com/Magazine/features/kuspit/kuspit12-19-02.asp>; see also Bloom's introductory essay to the *Merkaba* catalogue.
27 See Kiefer's painting *Grave to the Unknown Artist* (1983), which also uses Kreis's design.

are again lines, now of stone, that evoke the image of loading ramps constructed diagonally across the sand. Celan's title appears within these tracks in Kiefer's familiar scrawl. Sand, covering the entire canvas, starts to obscure the historical ruins being depicted.

In this space that reflects the risks of forgetting and the decay of memory, Kiefer remembers two poets who struggled with the precariousness of German memory. The painting, while representing the risk of a fading memory, is also at its core a memorial. The dedication to Bachmann and the words from Celan across the loading ramps frame the painting. But there is much ambiguity to Kiefer's artwork. Who or what is being mourned? Does this painting recall the Austrian melancholic consumed with the catastrophic past of her nation or does it focus on the Jewish poet, who was overcome by this same history yet from an entirely different position? Is this a site of mourning for Germany or for the victims of the Holocaust? Finally, does Kiefer construct an analogy between these poets or form a scene of reconciliation between German and Jew?

I do not believe Kiefer equates the poets with one another or their respective subject positions in relation to the Holocaust; like Sulamith and Margarete, who are never on the same line of Celan's poem, Bachmann and Celan remain separated in Kiefer's painting as well. This separation is also maintained by means of that with which the two are associated, Bachmann with the pyramid which preserves the body, and Celan with the urn, which recalls those reduced to ash. One is an image of entombment, while the other is of the missing body. Kiefer does not conflate the notion of victim here, but underlines the unbridgeable gap between the two figures through what happens to the body. Kiefer is identifying himself here with neither the German nor the Jew; instead, he aligns himself with the task of the artist who must "suffer away the things of the past." As the tombs dissolve and the contents of the urn spill out onto the canvas, the dissipation of memory of the dead leads to the return of their traces. As Kiefer demonstrates, this task of representing memory and mourning does not end in Sulamith's tomb, in her leaden books, or in desert pyramids. In this ceaseless process of recollection, Kiefer struggles with the transience of memory. But by returning to the scenes of traumatic history, Kiefer's gaze, while melancholic, is not frozen in some repetitive loop. Kiefer exhibits mourning with variation as the place and inscription for the dead transform over time.

I want to conclude this chapter with a few comments on one of Kiefer's most recent paintings that utilizes Celan's verse: "Light-Compulsion" [Lichtzwang] (1999). Almost twenty years after his painting of the Kant citation, Kiefer returns to the starry skies above. While his engagement with Kant's stars preceded his Celan paintings and his engagement

with the Holocaust, *Lichtzwang*, I believe, functions much like the *Starry Heavens* in regard to contemporary questions of German memorialization: it appeared during the climax of Germany's debates over how to memorialize the Holocaust at the end of the twentieth century. In *Lichtzwang* Kiefer turns to the starry skies above and Celan's single word to recall again the poet and the Holocaust dead. *Lichtzwang*, released in July 1970, was the last anthology of poetry that Celan saw through publication before his suicide in April. The poems in the collection are marked by a terse economy of words, where language is taken through a constriction. In contrast to the poems, there is nothing laconic about Kiefer's painting.

Kiefer, moving from the interior of his attic paintings, to ancient as well as Nazi architecture and terrestrial landscapes, now ascends toward a celestial architecture in *Lichtzwang*. In his depictions of the heavens in such paintings as *Lichtzwang*, *Merkaba*, *Andromeda*, and *The Secret Life of Plants*, the skies are massive, densely packed with swathes of stars. Although there is a return to Kant's sublime heights of the heavens, the inscription to Celan ("für Paul Celan") and the poet's word (*Lichtzwang*) on the canvas subvert such sublimity and pull this celestial place back into the historical realm. Like those who call Kiefer a Romantic, critics do not fail to mention the sublime in relation to his representations of the heavens, but I do not believe that he is saying that adequate memorialization of the Holocaust can only be conveyed through such monumentality. As his *Sulamith* paintings and book projects have demonstrated, Kiefer is also capable of capturing succinctly what is at stake in his varying modes of Holocaust remembrance. At a time when critics were claiming the advent of a Holocaust fatigue or waning of affect, and warning against the commercialization of the Holocaust or "Shoah business," the sheer size and materiality of *Lichtzwang* operates again within the modes of the Holocaustal uncanny. Kiefer, resisting both any stasis that might have befallen these familiar images of extermination and any habituation of the gaze toward these images, translates the now-familiar objects into new scenes of visceral terror. He forces the spectator to re-imagine the catastrophic history put on display from yet another perspective.

Lichtzwang is one of Kiefer's largest works, measuring 2.8 by 7.6 meters, and depicts the Milky Way galaxy. A massive white streak indicating the Milky Way's band of light, its millions of stars, traverses the canvas. The painting makes use of ash, glass, and paper cutouts of ghostly nightshirts that point back to Kiefer's attire in *Starry Heavens*. Fictive lines randomly connect some of these stars, while other lines form constellations, such as Orion and Cassiopeia. Kiefer has attached hundreds of numbered plates denoting NASA's cosmological ordering and identification of stars. The dedication is on the upper left-hand corner, "für Paul Celan." A mass

Lichtzwang (1999). Mixed media on canvas. © Anselm Kiefer. Courtesy Gagosian Gallery. Photograph by Robert McKeever

of red paint collects beneath the title *Lichtzwang*, written at the top and center of the canvas. At the very center of the Milky Way, Kiefer places a steel cage with discarded number plates piled inside it.

I will not attempt to probe all the allegorical implications of this layering of material in relation to Kiefer's works on Jewish mysticism. Instead, I want to examine what Kiefer is saying about Holocaust memory and representation on the eve of the twenty-first century. Despite the recondite nature of the word *Lichtzwang*, which is more remote than Celan's figure of golden or ashen hair, Kiefer's images translate the obscurity of Celan's neologism. With his use of black and white hues, Kiefer transforms the black milk of daybreak into the Milky Way: the band of light bisecting the night sky. The dead, who have been turned into ash and smoke, ascend to the clouds. Here, Kiefer illustrates, is their grave. The space of the dead, the use of number plates that recall those reduced to numbers in the camps, ash, broken glass, the stars, articles of clothing, and finally Celan's name traced in chalk among the stars all evoke a Holocaust aesthetics. Kiefer, drawing on the iconic materials of postmemory, allows this aesthetic to infect other non-terrestrial spaces. With its red trail seeping beneath the *Lichtzwang*, it looks as if the painting has sustained a wound: the crimes of the past bleed over into the celestial realm.

This history cannot be contained in a tomb, on a canvas, in a leaden book with hair, nor in an abstract sculpture in the heart of Berlin. Instead, through his twenty-five-year dialogue with Celan's poetry and his translation of linguistic tropes into visual ones, Kiefer both demonstrates the very compulsion of the artist to attempt to configure this traumatic past and recognizes the inadequacies behind such an act of representation. Kiefer extends Celan's figure of the investigation of place (*Toposforschung*) from the bloody interiors of Buchen and the catastrophic landscapes of *Heimat* to the cosmological abyss in the starry skies above. There is nothing comforting in this scene, as the word *Zwang* conveys the sense of not acting of one's free will.[28] The *Zwang* or compulsion is directed to the spectator's gaze who, even in turning to the heavens, cannot escape the remnants of the extermination. As Celan said in "The Meridian" with regard to where the act of *Toposforschung* transpires, it occurs "im Lichte der U-topie" (*Gesammelte Werke*, 3:199), in the light of the non-place or void. Like Büchner's Lenz, Kiefer turns the heavens into an abyss.[29] What is utterly despairing about this work, which threatens to trap the spectator's

28 One is reminded of the *Zwangsarbeiter* (forced laborers), a term that can be applied to Celan, who was interned in a labor camp. And one recalls Freud's concept of the *Wiederholungszwang* (compulsion to repeat), which is symptomatic of the failure to integrate a traumatic experience into memory.

29 "A man who walks on his head sees the sky below as an abyss" [Wer auf dem Kopf geht, der hat den Himmel als Abgrund unter sich] (*Collected Prose*, 46/*Gesammelte Werke*, 3:195).

gaze in its central metal cage where numbered plates accumulate like debris, is that Kiefer gestures at first to a celestial order through the numbering of stars and the forming of constellations, but he ultimately subverts such an order through his lines randomly connecting stars to one another without any purpose, form, or rationale. Instead, there is a breakdown of reason. The stars do not offer solace, nor does the spectator find an order to this universe.

Despite what seems to be an overwhelming closeness, Kiefer's Milky Way paradoxically depicts a scene that remains infinitely remote. Standing before *Lichtzwang*, the spectator's gaze is positioned between proximity and an unbridgeable distance. With the jarring of a phenomenology of perception that disrupts any passive gaze before his artwork, Kiefer presents the spectator with the ethical dimension of his visual tropes. Yet we encounter neither a Kantian aesthetics nor a Kantian ethics in *Lichtzwang*. The painting pulls the spectator into the depths of its familiar as well as foreign space where the traces of the Other, not of God's sacred light, are scattered. In this space signifying irrevocable loss, we are not subjected to Kant's moral law, but rather to a scene that recalls the very failure of this law. Kant's stars, signs of wonderment and awe, turn into visual figures of dread and horror. The *Zwang* or compulsion induced by the starry skies does not compel the spectator to turn to the moral law within or to reason; instead, the spectator recognizes the breakdown of this law and of reason, where the utopian is replaced by the *u-topos* of Kiefer's painterly void. Even within this celestial realm, Kiefer inscribes ash onto his canvas. While the countless points of light might seem to suggest hope, the spectator's gaze is trapped in an inconsolable space of loss, where each star signifies a mark of effacement that cannot be extinguished.[30] The task of the artist is passed on to the spectator, who is confronted with the impossible yet compulsory task of assimilating such loss into memory.

30 Kiefer, through Celan's poetry, returns thematically here to Jewish mysticism's notion of the breaking of the vessels: God tried to contain all the evil of the world in glass vessels, but the vessels shattered and evil escaped into the world. See, for instance, his sculpture *Breaking of the Vessels* (1990). This shattering of the vessels has been used to explain the source of the Holocaust in modern history. But the Kabbalah states that this evil can be contained, because the divine's "holy sparks" (nizozot) also fell into this world along with the evil. The process of containing the evil and restoring the vessels is named *tikkun olam*: the mending of the world. But with its open wound exuding blood, Kiefer's painting is devoid of any suggestion of redemption.

Chapter 6

Ghostly Demarcations—Translating Paul Celan's Poetics in Daniel Libeskind's Architectural Space

Trauma and the Forming of Cultural Identity

In the opening book of the *Aeneid*, Vergil describes Aeneas' arrival at Carthage soon after the destruction of Troy by the Greeks. Although Carthage is in the process of being built—a "kingdom in the making" (bk. 1, line 687)—with its half-built temples and homes it resembles a landscape of ruins. Central to the city's construction are the walls of the temple being built for the Goddess Juno, and Aeneas pauses to observe their making. He is shocked to see that the city's artisans are depicting on these walls the events of the Trojan War, which, through the penetration of the city's ramparts, lead to the destruction of Troy, the death of Aeneas' friends, and his own exile. As he stares amazed at the images upon the walls, Vergil, by means of ekphrasis, outlines what is represented upon them: the battles, its wounds, the destroyed city, and the dead.

Aeneas cannot pull himself away from the wall as the images of his traumatic past come back to seize him. Describing Aeneas as "staring amazed," Vergil writes,

> He broke off to feast his eyes and mind on a mere image ... to see again how, fighting around Troy, the Greeks broke through here ... He stood enthralled, devouring in one long gaze. (Bk.1, ll. 683–85)

In this scene that mixes the effects of pleasure ("feast," "enthralled," "devouring in one long gaze") with pain, Aeneas embodies the figure of a post-traumatized subject who tries to master his lost experience through compulsive repetitive acts of pleasure and discomfort. The shock of the war returns to him and the wall becomes a place of traumatic flashback; he sees himself again in battle, beholding anew the catastrophe of Troy. His gaze at the paintings repeatedly moves him to tears and sighs, and the narrative shifts between describing the sorrowful images upon the walls and Aeneas' own plaintive response to these images. His tears are mir-

rored upon the wall in the image of the weeping Trojan women "mournful and beating their breasts" (l. 655). In one of the text's most uncanny sections, Aeneas beholds himself on the wall, "He himself he saw" (l. 665). Yet his fixation upon these pictures does not reveal a narcissistic quality in his character; instead, through his critical gaze Aeneas attempts to derive meaning from the representations before him in order to comprehend the events of his past.

When Dido, the leader of Carthage, appears before him, "present and most beautiful form" (l. 676), his gaze remains consumed by the past images of horror: Greeks fleeing, the Trojan women mourning, Priam's extended hands in submission to Achilles and the death of Troilus, who, in his dying, drags his spear through the dirt and leaves behind S's upon the ground. This last image depicts how the trauma of war has left behind the traces of writing both upon the earth and in the poem. The marks inscribed by the spear in the dirt signify Troilus' writing his own epitaph, which is now reproduced in the image upon the wall. As Francoise Meltzer writes, the inscription left by the spear "is truly the image of an image: for the scribble of the spearhead at once mirrors the tragedy of Troy and the trace left by the tragedy—a trace the frescoes reiterate. This trace—inscription that is not writing per se, but rather recording—insists upon memory and therefore makes the slaughter of Troy an event with meaning" (55). Yet it is this very meaning embedded in the pictures upon the wall, this epitaph left in the dirt by the spear—the remnants of letters not yet words—that are the traces of historical meaning that Aeneas struggles to decipher throughout the epic.

Trying to behold what he was unable to grasp during the war, Aeneas attempts to understand belatedly the significance of these traumatic events and to re-integrate them into memory. However, by the end of the epic his inability to comprehend his history and to read properly the walls' images is evident in his compulsion to repeat the traumatic events themselves. One of the last pictures portrayed upon Carthage's walls is King Priam "all unarmed, stretching his hands out" in supplication to Achilles (l. 664). This act of supplication is repeated in the closing scene of *The Aeneid* as an unarmed Turnius extends his arms in submission to Aeneas. But Aeneas fails to remember Achilles' checking his rage during his exchange with Priam over the body of Hector, and he plunges his sword into Turnius' chest. The founding of Rome is marked by the slaying of a supplicating Turnius.

The Aeneid does not merely focus on Aeneas' search for self-identity, but examines as well the development of the historical identity and consciousness of a people; it also depicts Aeneas' attempts to grasp the historical meaning of Rome's founding in the aftermath of Troy's catastro-

phe. The function of the frescoes is to stimulate the observer to remember an historical event, but by the closing scene Aeneas appears to have forgotten what was represented on the wall. I would like to read the breach of the Trojan wall from a psychoanalytic perspective. Like the penetration of the inner/outer barriers (*Reizschutz*) of the trauma victim examined by Freud, the rupture of Troy's walls results in a trauma that has yet to be integrated into Aeneas' personal memory or into the historical consciousness of the survivors themselves. Although the trauma is repeated on the façade of Carthage's walls, Aeneas sees these images but fails to comprehend their meaning. The epic continues, "He found before his eyes the Trojan battles in the old war, now known throughout the world" (l. 619). He interprets this act of remembrance as a sign of fame, honor, and valor, whereby the subject of a destroyed city becomes a stimulus for art. Troy, its absence and erasure, comes back repeatedly throughout the text as a warning to Aeneas. Still, he does not grasp properly Troy's historical significance, as we see in the closing book with the slaying of Turnius.[1]

In contrast to Aeneas' confrontation with the walls and his lack of understanding the ruins of Troy, the walls serve a different function for the collective memory of Carthage. What do the walls tell us about the city that constructs them and for whom are they erected? How is Carthage forming its own collective identity through the pictures of an event on their temple walls, an event that they themselves were not directly involved in? While the walls serve to enclose a place of worship for the Goddess Juno, they can also be read as a war memorial; they provide Carthage with both a thoughtful remembrance of the war dead and a warning of what could become of their own city. Through a visual reconstruction and representation of a trauma, the wall becomes a reminder of a people and a city that had been reduced to ash.

Thus, the grounding of Carthage is bound to the collective memory of a catastrophe. As Aeneas himself remarks, "What region of the earth is not full of the story of our sorrow? They weep here for how the world goes, and our life that passes touches their hearts," and he refers to this history as "the story of our sorrow" (lines 625–26). Troy's destruction becomes an object of memory for Carthage and serves as the point of reference throughout the epic. The dead are memorialized upon the wall, not abstractly but clearly, through visual images and a linear narrative. The

1 Throughout *The Aeneid*, Aeneas is constantly given signs and messages, such as the prophetic words spoken by his father's shade in the underworld (Book 6) and the images inscribed on his shield by the gods (Book 8); both word and image reveal to Aeneas what the future of Rome entails. While his father tells him that Rome's mission is to battle down the proud and spare the conquered, these are the very words that Aeneas fails to remember in the closing scene of the epic when he slays Turnius.

event has been transcribed into history and art. However, Carthage ultimately fails to remember what was depicted on its walls as the city's construction is terminated after Queen Dido kills herself in grief over Aeneas' departure. As his ship sails away from Carthage in search of a new homeland, Aeneas interprets her funeral pyre emerging from the half-constructed city as a burning tower, an image that repeats the depiction of Troy's own conflagration.

Reading this scene from *The Aeneid* is significant to me because this closing chapter examines the collision of architecture, the cityscape, and traumatic history in two projects of Daniel Libeskind: his Jewish Museum in Berlin and the Felix Nussbaum Haus in Osnabrück. In Libeskind's transformation of the cities' terrain into a text, each museum functions as a space where architecture confronts the spectator with Germany's and Europe's vanished Jewish communities. Focusing on Jewish absence and the effects this loss has on each city's construction of cultural-political identity, the museums function in part as memorials; it is the memorial components of the buildings that will be at the center of my analysis. Unlike the walls of Carthage, Libeskind's Jewish Museum does not give us such a clear depiction of Berlin's catastrophe. The walls of the museum that configure the traumatic past are left empty. With its disrupted linear form, Libeskind's project presents an abstract depiction of history where both spatial and temporal representation are reorganized in relation to traumatic experience.

Like such cities as Troy, Sodom, and Jerusalem, Berlin has become a recurring trope in twentieth-century literature, visual culture, and philosophy. While both Rome and Carthage use the destruction of Troy as a central image in the founding of their respective identities, in his reflections during the debates in the 1990s surrounding the construction of a Holocaust Memorial in Berlin, Habermas reflected on the dangers that arise when a traumatic event becomes the focal point of national identity but the event itself has yet to be fully integrated into historical consciousness. He probes the meaning of Auschwitz in relation to German national identity half a century after the liberation of the camps. One recalls his comments during the *Historikerstreit* regarding Germany's fixation on the unloading ramps at Auschwitz; this was an image burned into Germany's national history but yet to enter the collective memory of the nation. For Habermas the purpose of the memorial would have less to do with memorializing those who were killed than with providing Germany after reunification with a space to confront its own historical discontinuities resulting from the Holocaust. The Memorial would both function as a symbolic expression for Germany's political self-understanding in the after-

math of Auschwitz and help those born after the war to confront the historical rupture.

According to Habermas, the function of the Memorial—the "Denkmal"—would be to help the Federal Republic connect to the years before National Socialism. Despite the difficulties of finding an adequate mode of representation, the Memorial would need to bridge this "fissure" (*Spaltung*) instead of providing the pretense of filling it. As Habermas states, "The purpose of this memorial cannot be to establish the Holocaust as the 'grounding myth of the Federal Republic' [*Grundungsmythos*]" ("Der Zeigefinger"). He warns against Auschwitz functioning as the mythic focal point of the origins of the Federal Republic of Germany. Although he reflects on the difficulties one encounters in representing what he calls the "Zivilisationsbruch" through aesthetic means, he argues that the act of symbolically presenting this historical fracture is essential for the construction of the German national identity.

In an article written for the *Frankfurter Allgemeine Zeitung* where he argues for the construction of a Holocaust Memorial, James Young, using a term similar to Habermas's figure of the "Spaltung," refers to the Jewish people as an "open wound" (*klaffende Wunde*) in the German psyche: the same metaphor Freud employs for melancholia in his essay "Mourning and Melancholia." Young posits, "The lack of the Jewish part of German culture remains a gaping wound in the German psyche—and as such it must also become visible in the unified landscape of the city" ("Gegen Sprachlosigkeit," 222). The Jewish culture that was once a part of Berlin serves as a lost object that needs to be configured as an absence. Young goes on to describe the missing Jews as a "void" (*Leere*) within German society that can be neither filled nor replaced; they signify an emptiness that must find expression within the city. Like Young's metaphor of the "*Leere*," in his Jewish Museum Libeskind spatializes this emptiness in the structures he names the voids: they are the places where the architect repeatedly confronts the spectator with the memory of Berlin's excised Jewish community. While Libeskind himself claims that "The museum is not a memorial, despite the fact that there are dimensions of memory built into it," the voids in the Jewish Museum are the melancholic spaces that confront the spectator with irrecuperable loss (*Jewish Museum Berlin*, 32).

Libeskind, a child of Holocaust survivors, was born in postwar Lodz, Poland, in 1946, became an American citizen in 1965, studied music in Israel, and has been a practicing architect in Berlin since 1989. Currently he resides in New York City, where his design for the World Trade Center site is being adapted for construction. Libeskind won the competition for the Jewish Museum extension to the Berlin Museum in 1989. Construction began in 1992, and thousands of tourists between 1997 and 2001

were drawn into Libeskind's magnificent architectural space even before there were any exhibits. Since its opening in September of 2001, the Jewish Museum has been one of Germany's most visited museums. In January 2006 it recorded its three millionth visitor (see <http://www.juedisches-museum-berlin.de>).

Unlike the ten-year debate that revolved around the Holocaust Memorial in Berlin, Libeskind's museum was overwhelmingly supported by the city. Aside from questions raised about financing a space in the museum that was devoid of exhibition ("the voids"), the selection of Libeskind's model was almost debate-free. The Jewish Museum was designed as an extension to the Berlin Museum, which occupies a Baroque administrative building that was built in 1735. The Jewish Museum's physical layout and its four parts—the old Baroque building of the Berlin Museum that houses the history of Berlin from 1870 to the present, the new Jewish Extension that examines Jewish culture in Germany, and the Holocaust Tower and the Garden of Exile and Emigration, which function as memorial structures—appear from an aerial view as detached spaces. The Jewish extension is entered through the Berlin Museum by way of an underground stairwell that leads into subterranean tunnels and hallways and opens up into the tower and the garden. Why does the Jewish Museum not have its own entrance or a bridge that connects the old and the new museums together? Such a subterranean entrance reveals the psychological structuring of the museum: the Jewish extension can only be entered by a descent through an underground passage, through a stairwell inside a void. It is as if the museum visitor were entering the unconscious space of Berlin's history.

Although Libeskind employs the strategy of negative representation in his structure of the void in the Jewish Museum, in the halls of the Felix Nussbaum Haus in Osnabrück, which was completed in 1998 and has also been one of the city's primary tourist destinations, Libeskind forces the visitor into proximity with the artwork and positions her face-to-face with figurative scenes of historical effacement and ruin. The structure of the void in Berlin shifts to the reduction of space in the Nussbaum Haus. In the paintings of the German-Jewish painter Felix Nussbaum, the spectator reads in his self-portraits a disjointed narrative that functions as his epitaph from within the shifting spaces of this catastrophic history. Nussbaum, born in Osnabrück in 1904 and murdered in Auschwitz in 1944, painted from inside this destruction during his years of flight, exile, imprisonment, and hiding. His self-portraits, executed while hiding in Belgium from 1939 to 1944, construct an elegiac narrative of geographic displacement and his struggle with the threat of self-erasure as the specter of National Socialism extended across Europe. We behold the slow disinte-

gration of the artist's face as he documented the events of his plight dur-
ing the years of the Third Reich. In both museums Libeskind constructs
two distinct sites of the Holocaustal uncanny that demonstrate a spatial
anxiety vacillating between voids and constricted space.

Translating Anxiety into Architecture

According to Libeskind, the affective state of anxiety is a key component
in architecture, and he remarked in an interview that "architecture has an
anxiety-producing relation to language because what is built is a transla-
tion" (Wagner, 135). But through his use of the term "translation," Libes-
kind is not simply referring to how the draft or a blueprint of a building
becomes actualized. Translation also refers to how one crosses into an ar-
chitectural space, such as a museum, and moves through its structure.
Moreover, the visitor's translation of space should include a sense of anxi-
ety. Indeed, our entrance into both of Libeskind's museums includes two
forms of anxiety. The specular terror in the Jewish Museum revolves
around what is not seen. The artworks and objects within the exhibitions
are disrupted by the empty walls of the voids; one sees through the win-
dow slits that cut into the exterior of the void walls the cavernous con-
crete vaults that indicate all that had been reduced to ash during the Holo-
caust. Conversely, in the Nussbaum Haus, specular anxiety arises through
the spectator's face-to-face encounter with Nussbaum's self-portraits. In
addition, the prevalent trope in the Jewish Museum—the void—is linked
to a spatial anxiety associated with the *horror vacui*. But in the Nussbaum
Haus spatial discomfort is conveyed through the reduction of space in-
dicative of a claustrophobia that is reflected both in the design of
Libeskind's narrow exhibition spaces and in the restricted spaces that are
portrayed in Nussbaum's paintings.

Similar to his thoughts on the relation between translation and anxi-
ety, Libeskind also forms a link between reading and anxiety that he asso-
ciates with the space of architecture. In his project *Three Lectures on Archi-
tecture: Reading, Remembering, Writing Architecture*, Libeskind builds a machine
that demonstrates how one's encounter with an architectural work con-
sists of the interplay between reading, remembering, and writing. Libes-
kind asserts, "I think the objects in architecture are only residues of some-
thing that is truly important: the participatory experience (the emblem of
reality that goes into making). You could say that everything we have is
that kind of residue. It is this experience that I would like to retrieve, not
the object" (*Space of Encounter*, 187). Libeskind begins with the experience
of reading architecture and as the model of his "Reading Machine" exhib-

its—reading involves a sense of anxiety: the individual turns a wheel with eight rotating books, and the books give the impression when they reach the top of the wheel that they are about to fall onto the reader's head, but they never fall. Libeskind describes the desired effect of this machine: "[The books] appear to be falling on top of you … It's a very uneasy feeling" (191). The process of memory work begins with an instant of reading bound to an anxiety, and Libeskind translates this unsettling experience into architectural space in the forms of vertigo, labyrinthine halls, *horror vacui*, and claustrophobia.

Although one might at first think of Kafka's writing machine from "In The Penal Colony," where reading and the comprehension of the machine's inscription upon the body are bound to pain, Libeskind transposes a spatial and optical anxiety into his architecture that is distinctively suggestive of Celan's poetics. Celan, akin to Libeskind and Kafka, repeats this connection between reading and pain throughout his poems. At the end of "The Meridian" he re-enforces this connection by citing his poem "Stimmen":

Stimmen vom Nesselweg her:	Voices from the nettle path:
Komm auf den Händen zu uns.	*Come on your hands to us.*
Wer mit der Lampe allein ist,	Whoever is alone with the lamp
hat nur die Hand, draus zu lesen.	Has only his hand to read from.
(*Gesammelte Werke*, 3:201)	(*Selected Poems*, 412)

The line addressed to the reader upon the *Nesselweg*, a path of pain, is itself the site of an *Atemwende*; Celan repeats Lenz's counterword (*Gegenwort*), that is, his call to walk on one's head and have heaven above him as an abyss: "A man who walks on his head, ladies and gentleman … sees the sky below as an abyss" [Wer auf dem Kopf geht …, der hat den Himmel als Abgrund unter sich] (47/195). The hands that approach an area of pain recall Celan's "nervous finger" [unruhigem Finger] (54/202) that searches on the map for the place of his origins and finds instead discomfort in the very loss of place: a displeasure that is associated with a memory of the map's spatial rupture. The pain of poetry hinders the forgetting associated with art. In the above strophe, reading too becomes associated with pain, as the reader must cross through a path overgrown with nettles. The poem repeats what "The Meridian" presents as the core to poetry's function: one must go along this path towards an abyss (*Abgrund*) in order to encounter the Other. But instead of hearing the Other's voice, we encounter the "terrifying silence" of the Breathturn. We must heed Lacoue-Labarthe's words that poetry is not silence but exemplifies the pain of art and of language ("Catastrophe," 140). The poem recalls through its dark

language, ellipses, and fractured words the time and place of the Other's effacement.

Libeskind is not merely translating his architectural designs into a building, but in our acts of reading, seeing, and going through the winding hallways of his museums, their ghostly quality resonates with Celan's poetic structures of the uncanny. Similar to Benjamin's description that "A translation issues from the original—not so much from its life as from its afterlife," Libeskind's translation of Celan becomes another instantiation of how one conjures his ghost in the realm of the visual arts (*Illuminations*, 71). But the anxiety that arises through our encounter with his architecture is generated not merely through the translation of one aesthetic form into another (poetry into architecture). Anxiety arises in the spectator when s/he becomes aware of the historical trauma configured in the materiality of Libeskind's architecture.

How are Celan's poetics re-interpreted in Germany at the time of re-unification? While Libeskind's museums reveal how one translates Celan in contemporary Germany, Celan's poetry also helps me "read" the lines of the museums. I employ the poet's concept of *Toposforschung* from "The Meridian," where he searches for the "place of poetry," to enter Libeskind's various projects, both his completed ones and blueprints, in Germany. In the shift to the architectural equivalent of Celan's uncanny, the disruption of reading and looking transforms into a disruption of art in our walk through Libeskind's buildings. My contention is that Libeskind's architectural projects focusing on German-Jewish history allow the visitor to enter into a text that is like Celan's poetry. In my analysis of Libeskind's museums, I follow Celan's command to read, see, and enter the uncanny sites of his poetry in the space of architecture, where the reading and seeing of absence in Celan's poems ultimately transform into entering the nothing of Libeskind's voids.

For both Libeskind and Celan the specular dislocations in their respective voids force the spectator to turn inward in order to re-configure the traumatic past. In the claustrophobic spaces of the void bridges in the Jewish Museum, the spectator beholds the void through window slits and Libeskind subverts any pretension of witnessing or entering into the historical void. Provoking and misleading the individual who steps into the halls of the museum, the architect denies the spectator a passive encounter with the artwork. We are constantly confronted with the challenge to read the museum objects alongside architectural absence. Libeskind's buildings, like Celan's poems, are interspersed with pitfalls that break off any linear act of reading or walking. Any attempt on behalf of the visitor to immerse herself in the exhibitions is undermined by the unsettling design of the museums.

Like Celan's comparing poetry to a message in a bottle in his Bremen Speech, in his essay "Fragments from Utopia" Libeskind also employs the figure of the *Flaschenpost* to describe how the architecture of a city becomes an act of writing: "We need to send a message in a bottle. Perhaps someone may find it" (*Radix-Matrix*, 152). Libeskind configures Berlin as a message in a bottle whose topographic layout, including the Jewish Museum, needs to be read by the city's future inhabitants. Our movement through architecture, whether in Vergil's Carthage or Libeskind's Berlin or Osnabrück, functions as an exercise in reading and translating the traumatic traces of the past. Architecture becomes a document of the trauma of the Holocaust and makes possible a confrontation with this lost experience for those who enter its space. As Libeskind claims, "We are witness to the events in which the architecture of presence turns into the architecture of absence" (*Radix-Matrix*, 141), and through engagement with architectural voids, the visitor is confronted with the traces of historical erasure. In the Jewish Museum, we follow the path that the architect sets before us and expect to see something on the walls. But Libeskind destroys the museal gaze within these spaces; he puts absence on display. Celan's Breathturn, the place of a "terrifying silence," returns in the anxiety-provoking voids of the museum. By naming his Berlin museum project "Between the Lines," Libeskind links his design to geometrical space and to acts of writing and reading. The voids are positioned between the two lines extending through the museum, one a zigzag and the other a disrupted straight line that intersects the museum's body; these are the spaces that we must see and read as we cross over them.

Likewise, in Libeskind's Felix Nussbaum Haus, the spatial metaphors associated with anxiety and melancholia, that is, the link between topophobia (anxiety of space) and the representation of melancholia in Nussbaum's later paintings, are reconfigured architecturally within the very spaces that exhibit them.[2] The decentering design of the Museum—its narrow halls, irregular windows, lack of light, dead-ends, crypt-like spaces, and blind corners—does not simply mirror architecturally Nussbaum's use of space. As we follow Nussbaum's struggle with and anxiety over constructing his identity, our own subject position repeatedly breaks down in a building Libeskind aptly names "Museum Without Exit." He assaults not only the spectator's orientation through claustrophobic architecture, but also subverts her vision within the building. Neither poet nor architect

2 My use of the term "topophobia" draws on Anthony Vidler's fascinating study *Warped Space: Art, Architecture and Anxiety in Modern Culture*, where he discusses architecture's relation to spatial phobias. Turning to the theoretical writings from such figures as Freud, Simmel, Kracauer, and Benjamin, and the architectural projects of Rachel Whitehead, Toba Khedoori, and Daniel Libeskind, Vidler examines the spatial conditions of agoraphobia and claustrophobia in relation to modern life within the city after 1870.

nor painter invites his respective reader-spectator to enter the poem, museum, or painting to enjoy a therapeutic experience with the Holocaust. One does not undergo a catharsis in these distinct texts, but experiences a series of perceptual woundings.

Finally, Libeskind's description of what he calls "the participatory experience" of architecture, an experience that is infused with a sense of apprehension, is also at its core melancholic. By using this term I am not drawing on Freud's distinction between the pathological disposition of melancholia and the normality of mourning; rather, I am interested in the structure of melancholic loss, which results in an unassimilable remainder being left behind. According to Libeskind, the visitor's experience of reading and translating architectural space also entails the presence of a residue or trace that is withheld from her. Similar to my discussion of Celan's leaving untranslated the epigraph "All poets are Yids" and the Hebrew word *"Jiskor"* at the end of "Die Schleuse," Libeskind also confronts the spectator with unassimilable traces, ruins, and voids within his halls. Rejecting any empathic identification with these scenes of annihilation, Libeskind's halls, Celan's poetics, and Nussbaum's paintings demonstrate the impossibility of entering into the catastrophic spaces of history. Through a series of semantic, visual, and architectural dislocations in Libeskind's projects, we are left only with traces that gesture back toward the scene of traumatic loss. There is a rejection of any totalizing of the Other or of the history that brought about the Other's effacement. Instead, Libeskind puts on display, to use Derrida's phrase, the task of an impossible mourning (*Memoires*, 6).

Beginning with the structure of the Jewish Museum in Berlin, I now enter each museum in order to probe how these sites construct their respective narratives of melancholia in relation to specular and spatial anxiety. In addition to underscoring how Libeskind inserts the figures of cartography, ruins, and the affective tonalities of anxiety and melancholia into these buildings, I also explore how he inscribes Celan's poetics into both of these museums. His translation of Celan is twofold. First, he grounds the conceptual basis of his museums on the figure of poetic disruption established in "The Meridian," where art and mimesis are suspended by poetry's Breathturn. And second, Libeskind also concretizes Celan's poems and the poet himself within the *topos* of his museums. However, although he may place into stone both Celan and his poetics, Libeskind reifies neither the poet nor his poems. Similar to Kiefer's engagement with Celan's lyric, the poet is rendered once again into an abstraction. While the spectator might encounter the haunting fragments of Celan throughout these museums, whether in the faint residue of a poem upon a wall, an etching in a courtyard, a tree bearing the poet's name, or

the structure of a *Sprachgitter* within the crossing lines of a museum, the affective tonality consistent with Celan's poetics of the Breathturn—the mark of the Holocaustal uncanny—permeates the interstices of these structures.

Entering The Jewish Museum in Berlin

In his penetrating analysis of Celan's poem "Engführung," Peter Szondi discusses the substitutive acts taking place in the opening stanza,

> Taken off into
> the terrain
> with the unmistakable trace:
> Grass, written asunder. The stones, white
> with the grassblades' shadows:
> Read no more—look!
> Look no more—go!
> (*Selected Poems*, 119)

The landscape found within the poem functions as something textual with its traces, grass written asunder and the white of the stone. As Szondi states about Celan's "Engführung," "Poetry no longer describes 'reality,' but rather itself becomes reality" ("Reading Engführung," 32). Although not explicitly mentioning "The Meridian," Szondi's depiction of poetry's break with mimesis illustrates the uncanniness of poetry, which, as I have shown in chapter three, arises from that speech. When mimesis and representation dissolve—as seen in the vanishing of Celan's trope for representation, the Medusa's head—poetry ensues. In "Engführung" the dead are not returning, but the reader turns toward them. Approaching the white stone, described by Szondi as a possible gravestone or blank page, we are faced with the task of reading a void: how does one read or see a blank? In "Engführung" nothing remains to be read or seen on this stone devoid of epitaphs, and the poet commands us to move on. But where is one to go?

Over the last decade numerous critics have traversed the space of Libeskind's museum, taking with them their respective maps to help navigate the winding halls. In 1994, before its completion, Johannes von Moltke entered the building and examined what he called the "legibility of a non-space within the spatial discourse of architecture" (98). Von Moltke's own act of *Toposforschung* is multi-layered. Before his walk through its space, von Moltke explored the shifting meaning of the museum's textuality as being contingent on the context in which it was displayed. After walking through the actual building, he posited that his experience within

this space was now subject to new "interpretive parameters." Even with the models and sketches fresh in his mind, von Moltke described his disorientation as he encountered the disruptive spaces of Libeskind's voids: they are the architectural structures that are meant to convey the historical tension of German-Jewish relations. Reading the museum on a metaphorical level, von Moltke claims that the "museum-as-metaphor" refuses to succumb to any narrative that foregrounds a symbiotic relation between Germans and Jews (96). The architect constantly subverts such a narrative throughout the museum with his voids in order to reinforce what Libeskind calls a "series of open narratives" of German-Jewish relations (98).

While von Moltke employed Libeskind's own models and diagrams of the museum as his compass in the building, James Young orients himself with Freud's theory of the uncanny in order to help him through the halls and to answer the question, "How does a city 'house' the memory of a people no longer at 'home' there?" (*Memory's Edge*, 152). Freud's model of the uncanny and its connection to the process of repression helps Young forge the link between the repressed history of Germany's voided Jewish community and Libeskind's architectural voids. For Young, the uncanny represents the condition of contemporary German culture coming to terms with its Jewish absence. Young asserts that those visitors who seek Berlin's history in the Berlin Museum, to which the Jewish Museum is connected by a tunnel, will now have to find this history in "the larger haunted house of Jewish memory" (*Memory's Edge*, 183). As Young declares, one learns about Berlin's past only in relation to its Jewish past.

Young's analysis of the museum, I believe, alters the building into a space of therapy for the visitor: the very type of architectural model that Libeskind tries to undermine through his project. The architect rejects any attempt by the city to transform its memory politics into a *Wiedergutmachung* through the grounding of a Jewish Museum. His goal is to disrupt the transformation of the museum into a site of empathic identification with the victim. We are not undergoing a process of healing by walking through the museum's uncanny spaces. In contrast to Freed's Holocaust Museum in Washington, D.C., where one takes on the identity of someone else and carries identity papers of an actual victim, we do not willfully surrender our subject position in Libeskind's museum. Instead, the architect takes it away from us by withholding objects from our gaze and destabilizing our ability to orient ourselves in his building.

Young goes on to construct his therapeutic reading of the museum by claiming that the voids call into consciousness that which has been repressed. Yet this notion of repression becomes problematic in connection with a city that continues to erect museums and memorials dedicated to the history of Berlin's missing Jewish community. While the focal point of

repression may have been central to Libeskind's museum model in 1989, which won him the original project competition, the symbolic politics of the city have profoundly changed over the last two decades; the topographic significance of the museum shifts not only with the location where it is experienced, as von Moltke has shown, but also with the historical moment in which the museum is encountered.

My own experience of Libeskind's Jewish Museum is more correctly expressed by Anthony Vidler, who describes the museum as an "implied architectural rereading of Benjamin" (*Space of Encounter*, 223), not in relation to a particular text of Benjamin's, but in terms of his reflections on the subversion of sight. According to Vidler, the "traditional perspectival 'optical' framing of the city and its monuments, the loss of perspective in relation to modernity," tends toward a "haptic model of architectural experience" (223). Similar to both Celan's haptic model of poetry, where the poem is compared to a handshake or a voice calling forth from the path of nettles, and Levinas's visceral depiction of ethics, in which "[t]he visible caresses the eye. One sees and one hears like one touches," Libeskind's architecture interacts with both the spectator's sense of sight and his/her anxiety of space.[3] Vidler continues, "Libeskind's ellipses, his wandering paths, and warped spaces without perspective and ending blindly can only be seen as so many tests of our ability to endure the vertiginous experience of the labyrinths that, as Nietzsche had it over a century ago, make up the form of our modernity" (224). This description, with its ellipses, paths, and loss of sight, re-enforces the resemblance to Celan's poetics and to the Holocaustal uncanny, whose affect is bound to a perpetual mourning that returns again and again to scenes of irrecuperable loss.[4]

3 See Levinas's "Language and Proximity," 118. Similarly, Celan describes in a letter to Hans Bender how poetry is a "Handwerk" and writes, "Only true hands write true poems. I see no principle difference between a handshake and a poem" [Nur wahre Hände schreiben wahre Gedichte. Ich sehe keinen prinzipiellen Unterschied zwischen Händedruck und Gedicht] (*Collected Prose*, 26/*Gesammelte Werke*, 3:177). In addition, in his second essay on Blanchot, Levinas writes, "Blanchot's properly literary work brings us primarily a new feeling: a new 'experience,' or, more precisely, a new prickling sensation of the skin" (*Proper Names*, 143).

4 Libeskind's Jewish Museum is not, as Eike Geisel claims, a "grotesque tombstone, a mausoleum supplied with burial goods, and turned into a site of frivolous exercises" (qtd. in von Moltke, 100–1). Nor would I argue along the lines of what Aleida Assmann tells us about *Totenmemoria*: that the burial and the erecting of monuments for the dead arise not only out of a sense of respect for the dead (Pietas), but also as a means of avoiding their dangerous return: "Die Pietät der Totenmemoria antwortet auf ein universales kulturelles Tabu. Die Toten müssen begraben und zur Ruhe gebracht werden, weil sie sonst die Ruhe der Lebenden stören und das Leben der Gesellschaft gefährden" (*Erinnerungsräume*, 38). On the contrary, Libeskind's architecture incessantly attempts to sabotage any sense of comfort in relation to this past; the epitaphic spaces of his museums continually unwrite themselves in order to destabilize any position on behalf of the spectator to fulfill a work of mourning within his halls.

Celan's poetry and Libeskind's architecture struggle with the disloca-
tion of perception. While the reader-spectator who approaches Celan's
poetry or enters Libeskind's museums may see her- or himself as a secon-
dary witness to the Holocaust, both artists try to undermine this position
by assaulting the subject's senses with a missing line of poetry, the empty
wall of a museum, or a narrow, dimly lit hall. Destroying our position as
conventional spectators, both the poet and the architect lead us to a space
that reflects our own negation as spectators. Furthermore, there is a sense
of spatial disturbance as well. In Celan's *Toposforschung* of poetry, he des-
perately looks for the site of the "terrifying silence" of all that happened.
His repeated search for a "Hier" ultimately leads the reader toward a "U-
topie," that is, the absence of place mentioned in "The Meridian" (*Gesam-
melte Werke*, 3:196). Analogous to Celan's poetic tears, Libeskind's hallways
guide the spectator toward the structural voids of his architecture.

While Amos Elon may refer to Libeskind's Jewish Museum as a "be-
wildering maze" (43–44), Celan's poetic template provides me with a
sense of orientation inside the museum's configuration of trauma. Libes-
kind's theoretical writings and drafts of his architectural projects are
steeped in references to Celan's poetry, and he names a collection of es-
says and project descriptions after a poem of Celan's: *Radix-Matrix*. By us-
ing this poem as his title, Libeskind forms a direct link between his archi-
tectural works and Celan's poetics. What is it about the poem that appeals
to Libeskind and how could it possibly shed light on his architectural in-
stallations? In "Radix, Matrix" Celan takes his reader to a scene of geno-
cide and concentrates specifically on the murder of his mother. In effect,
her death becomes the matrix, or womb, from which his poems originate.
The poem's title, left untranslated in its original Latin, reminds us again of
Celan's tendency to employ foreign words throughout his poetry; he shifts
the responsibility of translation to the poem's recipient, whose very act of
reading the poem makes possible the disclosure behind its foreign title.

What can the poem tell us about Libeskind's reflections on architec-
ture after Auschwitz? First, while the Latin word *Radix* refers to the root
of a plant, *Matrix* is Latin for womb. The poem's focal point, revolving
around the question of origins, is eventually bound to the figure of the ab-
sent mother. Although "Radix, Matrix" may begin with a rhyme, the
poem eventually turns into an atonal stutter: "Back then, when I wasn't
there, / back then, when you / paced off the field, alone" [Damals, da ich
nicht da war, / damals, da du / den Acker abschrittst, allein ...] (*Selected
Poems*, 166–67). The reader might first associate the "da" with the Freu-
dian word for the child's joy over the mother's return. However, in
Celan's poem the "da" marks the place of separation between the poet
and his mother; walking alone onto a field, she eventually takes the form

of "the murdered one" who stands "black in heaven." With the image of her murder along with the extermination of her race [*Geschlecht*], the poem makes a direct reference to the Judeocide.

But it is the opening and closing lines of "Radix, Matrix" where the link between the architect and the poem is most evident. In addition to tying the loss of the mother to the foundation of his poem, Celan also connects her absence and the advent of the poem to the destruction of home. Her voice emanates from this void and, in turn, Celan ultimately directs his readers into the structural equivalent of this uncanny caesura at the end of the poem. The poem begins, "As one speaks to stone as you to me from the abyss, from a homeland con- / sanguined." In this dialogic relation that recalls the reader's encounter with the blank stones from "Engführung," the subject's address to stone is followed by the Other's voice, ultimately revealed as the effaced mother, who speaks from the very absence of place, from a homeland [*Heimat*] that is now devoid of ground [*Abgrund*]. Although the poet may describe this dialogue as an encounter with the Other [*du*], he depicts the very fragility of such an encounter by breaking the word [Be-/gegnet]. Each of these components—homelessness, stone, the site of historical catastrophe, and the fractured encounter between self and Other—are inscribed by Libeskind in his architectural projects. In particular, his museums revolve around this fragile encounter between the catastrophic narrative unfolding in his hallways and the visitor who traverses as well as reads these abyssal spaces.

In the closing verses of "Radix, Matrix" the parallels between Libeskind and Celan are most evident. The poem's penultimate stanza reads,

> Yes, like one who speaks to stone like
> you
> with my hands grasp into there, and into the nothing [Nichts], such is what is
> here:
>
> this fertile soil too gapes [klafft], this
> going down
> is one of the
> crests growing wild.

What follows the "here" of Celan's poem executes the very scene it describes. The poem opens up [klafft] like a wound. Likewise, with its gaping chasms, narrow passageways, and empty walls, Libeskind addresses stone through an architectural semantic that is consistent with Celan's poetry. His construction of this "Nichts," the nothing or void of architecture is the place to where he guides those who enter his museums. Crossing into a textual space and confronted with the past, the spectator is taken

through an estrangement in her approach to the voids—substitute trauma sites—within the Jewish Museum. Breaking any consensual practice of working through trauma, Libeskind repeatedly shatters our position as subjects by undermining our vision and orientation in his hallways. Contrary to Elke Dorner's assertion that Libeskind metaphorically reconstructs through the exterior blank walls of the voids in the Jewish Museum the *Reizschutz* of Berlin, which was penetrated by the trauma of the war, the denial of representation functions neither as screen nor as *Reizschutz*, it is itself the gap through which the spectator unknowingly crosses into the space of shock and anxiety (15). Though they prevent us from falling into the chasm below, the blank walls become an assault on our vision as the architect subverts our museal gaze.

By reading Celan's poetry or entering Berlin's Jewish Museum, the reader/spectator expects to enter post-traumatic spaces that engage with the Holocaust and anticipates an encounter with the terror of National Socialism. Yet we are not entering the museums of concentration camps that supply our collective memory with the material images of barbed wire, piles of shoes, hair, traces of the extermination. While we may expect or even want to see these palpable ruins in representations of the Holocaust, both poet and architect deny our gaze any such images. Instead, Libeskind tells us that he puts absence on display upon the walls of the voids: "The past former fate of catastrophe of the German-Jewish cultural symbiosis completes itself today in the sphere of the not-visible ... and it is this part of the 'not seen' that should become visible not externally but through inner vision" (*Radix-Matrix*, 101). Although this withholding of representation becomes the paradigmatic move of Holocaust literature and visual media, I am trying to shift the discussion to the crisis of perception that the spectator faces in her entrance into these projects.

Similarly, in the Nussbaum Haus the very kinship of space in Nussbaum's paintings and the galleries in the museum conspires to disrupt any passive engagement with the artwork. By animating these paintings through the design of the museum, Libeskind wishes to induce in the spectator anxiety through a series of visual and spatial fissures. While Penny McGuire argues that the museum is a curator's nightmare that undermines the exhibitions and interferes with our reception of the artwork, I maintain that Libeskind places the space of painting and architecture in constant dialogue with one another. The museum serves as a conduit that facilitates our interaction with the artwork, whereby the spectator becomes a participant in the forming of meaning between painting and architecture. The museum historicizes or frames claustrophobia as scenes of voids: the dominant trope of post-Holocaust aesthetics. Similar to Lanzmann's description of *Shoah* being a "film of fear" and a "trip toward

anxiety," the Nussbaum Haus opens up a topography of fear.[5] While the spectator encounters in the claustrophobic spaces of Nussbaum's self-portraits his anxiety-laden gaze, she must also try to re-imagine the threat that remains concealed outside the painting's frame.

Inscribing the Void in Architecture

Analogous to Celan's depiction of how one reads or speaks to stone, which is itself a metonymy for tombstones, Libeskind discusses in an essay his visit to the white stones of the Jewish cemetery of Weissensee in Berlin (*Space of Encounter*, 204). It is a ghost story devoid of ghosts, for those who anticipated being buried in Weissensee either fled into exile or were murdered in the camps, and his experience in the cemetery informs our encounter with the blank walls in the Jewish Museum. Libeskind reflects on the emptiness of the cemetery and the bare gravestones that were never engraved. Because the tombs were never engraved, there is nothing there to be read. Like Celan's white stones in "Engführung," Libeskind is able to "see" something on these stones, something that is absent: a people who had hoped to be at home in Berlin and who had left behind tombstones with their unfinished stories. He reads these blanks as signs for the future writing and reading of missing epitaphs that belonged to the lost generations of Berlin's Jews and of the hopes they had for a future in the city. Considering the emptiness of the cemetery along with their empty gravestones, the architect translates these wordless stones into the stony silence of the voids where nothing can be read. Those who return to the tombs are not the families of the individual's who erected these tombs, for they were either killed or fled into exile. Libeskind tells us that those who return are "witnesses of another kind" (204).

Libeskind's voids simultaneously point to the fissure in German-Jewish culture in the aftermath of the catastrophe and function as bridges that take us repeatedly into time and representation, over the gap left behind by the catastrophe. But while our entrance into the museum may show our willingness to enter a space where the trauma can be confronted, Libeskind undermines any voyeuristic desire to see traces of the extermination, displaying instead vast spaces of emptiness. His translation of the tombstones shifts to our translation of the voids as we go across them in order to read and see their absence. The names and dates that should have been cut into the stone are found by Libeskind in the *Gedenkbuch*, a book

5 See Shoshana Felman's excellent analysis of Lanzmann's *Shoah* in *Testimony: Crises of Witnessing in Literature*, 223.

with all the names, dates, and places of death of Europe's Jewish communities; Libeskind refers to this book as one of the textual influences behind his museum. Though never actualized, Libeskind's intention to fill the walls of the voids with these names attests to the memorial dimensions of this space (*Jewish Museum Berlin*, 30–31).

Like Weissensee's tombstones, the Jewish artifacts salvaged after the catastrophe and displayed in the museum point not to what is there, but to what is missing, and Libeskind writes, "Physically, very little remains of the Jewish presence in Berlin—small things, documents, archive materials, evocative of an absence rather than a presence" (*Extension*, 61). These remnants, such as religious objects, have lost their day-to-day function and serve as metonymic reminders of the lost community that had once used them in Jewish rituals. Two axes on the bottom floor of the building form an X over the place set aside as exhibition space for these objects that were salvaged in the aftermath of the Holocaust.[6] With this axis (X), architecture becomes an act of writing. The X marks the spaces hollowed out by ash and exile, where the intersecting halls that form an X constitute an act of erasure of what lies beneath their crossing. These halls signify the poles of European Jewish history in the aftermath of the Holocaust. One hall leads to the Garden of Exile and Emigration; the second ends in the Holocaust Tower. A third path leads up a stairwell into the exhibitions of Jewish history and towards the vestiges of Jewish life in Berlin.

But while Libeskind may claim that "we are witness to the events in which the architecture of presence turns into the architecture of absence" (*Radix-Matrix*, 141), he undermines the standard act of witnessing by subverting our vision in the museum and by destabilizing our orientation along slanted halls, in claustrophobic spaces, and within the disorienting columns of the Garden of Exile and Emigration. In assaulting our gaze through the withholding of exhibits, the architect prevents the visitor from having a passive encounter with the history of Jewish life in Berlin. Libeskind stressed in an interview that a visitor to the museum is unable to say, "I was there. I saw what happened" (Dorner, 16). Instead, the visitor must come up with her/his "own interpretation" of Jewish life and the

6 The museum visitor sees in these halls a wide range of objects such as suitcases, folded towels, dishes, passports, and letters written shortly before deportation. One object displayed in the hall leading toward the Holocaust Tower is a wallet belonging to the 70-year-old Walter Blumenthal. We are told that the wallet, containing a card with Blumenthal's name and a photograph of a child and a woman, was thrown from a truck occupied by Jews being deported. Along the hallway that ends in a cenotaphic structure meant to recall all that was destroyed, this retrieved wallet, a *Flaschenpost* immersed among other objects, provides the name of one such victim who vanished along this pathway.

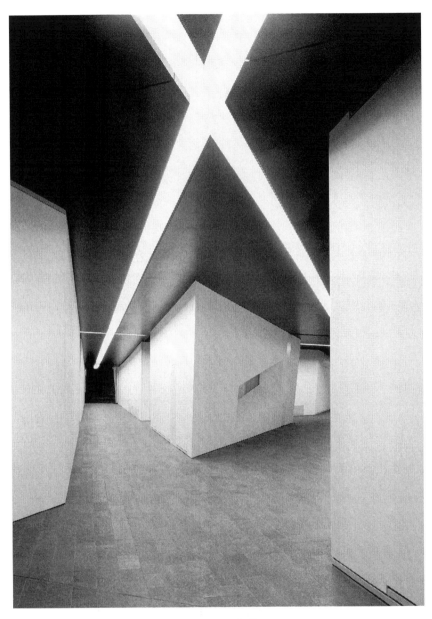

X-Axes, The Jewish Museum, Berlin. © bitterbredt.de

rupture of that life in Berlin. Libeskind stresses repeatedly the lack of perception that one experiences in the museum, "The past former fate or catastrophe of the German-Jewish cultural symbiosis completes itself today in the sphere of the not-visible," and he describes how what remains unseen should become visible not externally but through "inner vision" (*Radix-Matrix*, 101). The voids and their crypt-like nature become places of potential memory of what has been forgotten. The return of the void throughout the museum is a repetition of an absence, a repetition of a trauma that needs to be transformed, or translated, into memory.

Translation is not only an act of writing but becomes an act of reading as well. While Libeskind translates the missing lines of the tombstones into the voids of the museum, providing figuration to lost time, our own encounter with this space becomes an act of seeing or reading what is not upon the walls. How does our experience with the void become a form of reading and translation? Libeskind answers this question in his discussion of the Greek word for "in between" in his reflections on Berlin's Jewish cemetery. Tracing the etymological link between words, Libeskind describes how "in between" comes from the Greek word *metaxi*, which he says also means "experience." But in his Jewish Museum, which he names "Between the Lines," Libeskind acknowledges that nothing (Nichts) occupies this "in-between" of the museum's voids (*Radix-Matrix*, 160). We experience the catastrophe of all those lost names by passing through spaces devoid of artworks or representations. Similar to the absence of a linear narrative upon the graves, the voids are blank spaces that, cutting vertically into the museum, disrupt both representation and temporal continuity along the horizontal axis of the museum. While Libeskind translates the tombstones, the visitor must translate the voids—go across them in order to read and see their emptiness.

Kant's figure of the line, along with its connections to temporality, consciousness, the imagination, and one's epistemic relation to experience in his *Critique of Pure Reason* sheds light on why Libeskind subverts linearity in his museums. For Kant, the totality of a subject depends on the subject's ability to pull the world together into a string of concepts through a transcendental act of synthesis of the surrounding space. When this process of figurative spatialization collapses within the subject, the ability to frame an experience is also lost:

> To know anything in space (for instance, a line), I must draw it, and thus synthetically bring into being a determinate combination of the given manifold, so that the unity of this act is at the same time the unity of consciousness (as in the concept of the line); and it is through this unity of consciousness that an object (a determinate space) is first known. The synthetic unity of consciousness is, therefore, an objective condition of all knowledge. It is not merely a condition that I

myself require in knowing an object, but is a condition under which every intuition must stand in order *to become an object for me*. For otherwise, in the absence of this synthesis, the manifold would *not* be united in one consciousness. (*Critique of Pure Reason*, 156)

The concept of the object is pulled together through the drawing of this imaginative line. While this visual metaphor becomes the foundation of the unity of consciousness, when such a line is lacking, the subject remains a cluster of disconnected points and thus undergoes a sense of fragmentation. Kant asserts, "Only in so far as I can grasp the manifold of the representations in one consciousness, do I call them one and all *mine*. For otherwise I should have as many-coloured and diverse a self as I have representations of which I am conscious to myself" (154). Kant employs this image of the line earlier in his depiction of temporality as being akin to the spatiality of a line: "Time is nothing but the form of inner sense, that is, of the intuition of ourselves and of our inner state ... We represent the time sequence by a line progressing to infinity" (77). Such a spatialization of time helps the subject reform objects internally within consciousness. Kant calls this act "schematization" and schematization is itself a product of the imagination that helps form a link between an image [*Bild*] and a concept [*Begriff*].[7]

In his outline of the Jewish Museum and description of the project, Libeskind rejects Kant's model of linear time; the imagination and temporality have been broken. Since the experience associated with a traumatic event has been lost, ruptured time will require a re-spatialization. Although for Kant consciousness and experience are contingent on linearity's relation to what is present, traumatic shocks destroy the linear model. Thus, these shocks necessitate a re-configuration of space in its relation to traumatic history.[8] In opposition to Kant's figure of the line, Libeskind is

7 Kant writes, "This representation of a universal procedure of imagination in providing an image for a concept, I entitle the schema of this concept" (182). In chapter 1 I examine in greater detail the concept of time in Kant in relation to the sublime and the disruption of temporality. At this temporal rupture the aesthetic act of the imagination reaches its limits. I connect this break in temporality with Freud's concept of trauma, where the lost experience is bound to a missed moment in time.

8 Anton Kaes examines the disruption of narrative linearity in relation to representations of the Holocaust in his study of Syberberg's film *Hitler—A Film from Germany*. Kaes writes, "A deep gulf separates history as experience from its re-presentation. What is present can never be identical with the presentation itself ... Syberberg's complex sound-image collages neutralize the linear progress of time and bring history to a standstill. Instead of the 'horizontal' development of a story, we have a vertical structure in which various levels of meaning and association coexist and resonate on many levels and in many voices." Kaes's claim is that since narrative tries to rationalize or explain an experience, narrative linearity must be broken to attest to the traumatic nature of the event and the impossibilities of reducing the catastrophic event into a simple narrative form (210).

affected by what is not there or what was not experienced. Discussing the diachronic and synchronic modes of museum space, Rosalind Krauss describes the postmodern museum as purely spatial. While a museum in which a particular narrative unfolds within its halls is diachronic, those museums that limit their space to a single experience are called synchronic. The latter forgoes history for the intensity of experience. Also, the spatial constructs of the synchronic museum displace the temporal structuring of the museum, and Krauss concludes that the subject's "field of experience is no longer history, but space itself" (17).

Contrary to Krauss's argument, Libeskind's museum inserts historical time into the intersecting lines of his project. Since the museum is emblematic of the ruins of a traumatic event and Libeskind describes how "The new extension is conceived as an emblem where the not visible has made itself apparent as a void" (*Extension*, 61), the line appears tortuous and fragmented. By combining diachronic with synchronic modes of presentation within the museum, Libeskind configures the lost time of historical catastrophe through the collision of the two lines at the void bridges. The vertical lines that repeatedly cut the museum halls are the places where history comes to a standstill, where the synchronic moment of trauma suspends diachronicity. This intersection between synchronic and diachronic museum models can again be seen in the Nussbaum Haus. The structure that Libeskind names the "Timecut" disrupts the exhibitions on the top floor of the museum in order to signify the suspension of painting in 1944, the year of Nussbaum's deportation to Auschwitz. This cut in time, which refers to the traumatic period culminating in Nussbaum's capture and murder by the Nazis, might seem to exhibit the markings of Krauss's description of a synchronic museum. But despite its focus on the works of one painter, Libeskind wishes the spectator to extend the invisible lines of Nussbaum's trajectory to the countless narratives of all the nameless others who suffered the same fate.

Void and Breathturn

Libeskind's museums intersect on several levels with Celan's conceptualization of poetry from "The Meridian." Like Celan's child's map with its missing place, the Jewish Museum begins with a phantom map of Berlin upon which Libeskind traces the addresses of its departed residents. He starts by connecting the points of people's names associated with Berlin, Jews and non-Jews, such as Varnhagen, Schönberg, Celan, and Benjamin. It is revealing that even though Libeskind inserts Celan's name onto Berlin's map, the poet had never lived in the city. Instead, Libeskind is influ-

enced by poems Celan wrote remembering his visits to the city.[9] While
both poet and architect search for places on a map, the locations them-
selves are missing: the maps have been reconfigured by the catastrophe of
the Second World War. However, Libeskind's lines do not form a merid-
ian on his map of Berlin; rather, a hexagonal and irrational line system un-
folds through the connection of names, and these lines take the form of
what Libeskind describes as a disfigured Star of David. This malformed
star serves as a graphic model of the museum (*Extension*, 59).

Libeskind's museum is built in such a way that the spectator's gaze is
ruptured, thereby diminishing our ability to locate ourselves; a casual walk
through the museum becomes something perceptually and spatially disori-
enting. The building's slashed windows, slanted, narrow, serpentine halls
undermine the standard subject position produced by the museum interi-
ors. But the most profound disruptions in the building are the six voids
that intersect the exhibition space along the halls. These are blank spaces
that cut vertically into the museum, interrupting both representational and
temporal continuity along its horizontal axis. No exhibits are allowed on
the exterior walls of the voids. Celan's ripped meridian that is bridged by
poetry becomes Libeskind's "Between the Lines" in both a geometric and
a linguistic sense: lines that are simultaneously intersected and bound by
voids. In the void, like the space of the Breathturn, representation ends
and an act of provocation begins. It is the uncanny space where the past is
repeatedly encountered throughout the museum and attests to what is not
there. Neither Celan nor Libeskind attempt to fill these spaces; they focus
instead on how silence and voids become the places where the reader-
visitor encounters the historical rupture of the Holocaust.

Describing his Jewish Museum, Libeskind states, "I wanted to make a
building that was not only a representation of culture and art, but was in
itself a mechanism to interpret them by walking through it, by looking out

9 See for instance Celan's "Du Liegst" and Peter Szondi's exegesis of the poem in his studies
 on Celan. The poem arises out of a trip Celan made to Berlin in 1967 and a walk he took
 with his friend Szondi through the city during Christmas time. How are the events experi-
 enced by Celan and Szondi in Berlin transformed once they are inserted into the space of
 poetry? With its references to the murder of Rosa Luxemburg and Plötzensee (the place
 where those who conspired to kill Hitler on July 20, 1944, were executed), the poem ex-
 plores how the serene landscape of Berlin could coexist with the horrors of the Nazi past.
 Having been a "witness" to the poem's construction, Szondi reveals the hidden context of
 the poem along with its traumatic residue, and he warns that a narrative containing all the
 facts does not amount to a reading or interpretation of the poem (see *Celan Studies*, 83–96).
 In contradistinction to Szondi's reading, Gadamer's analysis of "Du Liegst" breaks free of
 such historical associations and investigates the process of how one immanently reads a text.
 The reader does not need to be privy to the information Szondi had in Celan's construction
 of the poem, but can arrive at an interpretation of the poem through the poetic language it-
 self. Instead of an historical analysis, Gadamer offers an ontological reading of "Du Liegst"
 (see *Gadamer on Celan*, 127–47).

of windows, by opening doors, by traversing space" ("Trauma," 45). We follow the uncanny paths of Jewish life in Berlin, marked by both the common objects and the artworks left behind, to their vanishing points in the voids. Like the path of art described in "The Meridian," the space of representation as presence shifts to that of absence, as the voids become the suspension of exhibits along the hallways. What begins as an interpretive walk through the museum as we read the objects around us is disrupted once we cross the blank walls of the void bridges. Like Celan, Libeskind is interested in the topography of absence, of a u-topos. His project is an architectural response to what he calls a "history of ash" that has left behind a void in place of Germany's missing Jewish communities ("Trauma," 50).

Although they are the spatial centers of the museum, the voids do not provide orientation and direction; instead, they contribute to the estranging effects that occur along the labyrinthine halls of the museum. Like the way Celan guides the reader towards the gaps of his poems, Libeskind subverts the traditional ways a spectator is visually in control in a museum. We follow the path devised by the artist and expect to see or hear something. By the time we realize where we are, it is too late to turn back. The normal subject position is jarred, and the conditions evoking the uncanny arise. The text, whether a line of poetry or a museum exhibition, suddenly vanishes; a perceptual dislocation ensues.

Before even entering the museum, we encounter Celan in one of the memorial spaces on the grounds of the museum. Between the Holocaust Tower and the E. T. A. Hoffmann Garden (Garden of Exile and Emigration), both of which memorialize those unhomed during the Holocaust, we walk across the Celan Courtyard. Libeskind asked Celan's wife Gisèle Celan-Lestrange, a graphic artist, to design the yard, and it cuts through the museum's body, intersecting the space between the old and new museums. The design, titled *Kristallsplitter* [Crystal Fragments] consists of jagged cuts that resemble glass shards carved into granite. Some of the half-circle forms are raised, and they consist of various darkening hues: white, gray, and black stones which were laid on November 9, 1992, the fifty-fourth anniversary of *Kristallnacht*. This date is memorialized in the Celan Courtyard, where its design repeats the cuts in the building façade that serve as windows; it is as if the splinters have fallen to the ground below and have transformed the glass of the pogrom into the stone of the memorial.

In the original design of the Celan Courtyard, the space included two engraved stones bearing Celan's own words: "Tod" and "Meister" (*Extension*, 55). The etching in the granite would make the visitor reflect on the connection of these words taken from a line of poetry that was familiar to

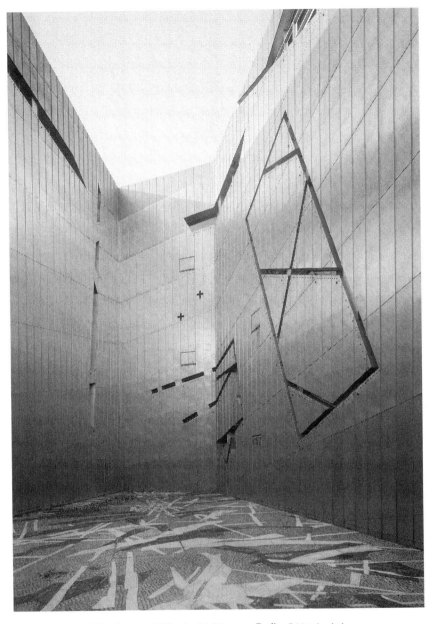

Celan Courtyard, The Jewish Museum, Berlin. © bitterbredt.de

many visitors: "Der Tod ist ein Meister aus Deutschland." The image of broken glass becomes a marker for the beginning of the final catastrophe that befell Berlin's Jewish community and the fragments from Celan's poem announce its endpoint. The stone-laying of the museum (November 9, 1992) and the date of the original museum project competition (November 9, 1988) fulfill Celan's concept of the poem needing to be mindful of its dates.

But the courtyard does not only refer to Celan's "Todesfuge" within its design. Libeskind also remembers Celan's first encounter with Berlin in his poem "La Contrescarpe," and in doing so he reinforces the link between the city and history's catastrophic fires. Beginning with the foreign words in the French title, Celan commemorates the origin—the place and date—of his own exile in Paris. La Contrescarpe is an area in Paris close to where Celan worked. While the French word refers to the protective walls of a fort, the area has also served as a gathering point among the homeless in the city, that is, a shelter to those without homes.[10] Likewise, by commencing with these foreign words, the poet situates the reader in unfamiliar territory in order to induce a similar sense of being ungrounded. To be in exile is itself a form of translation, where one moves from the place of the familiar into the foreign. Later in the poem, Celan will again use French in parentheses to mark a date—"*Quatorze / juillets. Et plus de neuf autres*"—July 14, the date of the French Revolution. He connects this feeling of estrangement in the poem to a date along with the date's characteristic mode of uncanny returns. Underscoring the anniversary context of this revolutionary date, Derrida discusses the significance of Celan's making the July plural. By adding the inaudible French "s" to *juillet*, he forms a word-play. There are either nine other fourteenths of July or fourteen Julys plus nine more, that is, twenty-three Julys: twenty-three anniversaries of the return of the month ("Shibboleth," 36–37). The poem was written in 1962 and, while fourteen Julys could refer to Celan's arrival in Paris in 1948 (on July 14), the nine other years point to the time between Celan's move to Paris and his first visit to the city, in 1938. Celan, like Libeskind in his Celan Courtyard, commemorates the year his loss of home began: November 9, 1938.

Using indentation, Celan accentuates the event that the middle section of the poem revolves around. By graphically separating this section from the other lines on the page, he draws the reader's attention to the passage:

Upon arrival in Berlin,
via Krakow,
you were met at the station by a plume of smoke,

10 See notes to the poem in *Paul Celan. Die Gedichte*, edited by Barbara Wiedemann, 710.

tomorrow's smoke already. Under
the Paulownia trees
you saw the knives erect, again.
 (*Glottal Stop*, 16)

Celan remembers the plumes of smoke he saw during his train ride through Berlin on his way to Paris to study medicine on the morning after *Kristallnacht*. But even if one were not aware of this biographical information, the indentation of the passage, which signifies a break with the rest of the poem, is conjoined to linguistic markers that point to something ominous; the references to smoke and a knife are linked to a topographic connection between Krakow (the city not too distant from Auschwitz) and a train station in Berlin. The reader is asked to mediate these poetic traces in order to uncover what Derrida would call the crypt or secret of the date ("Shibboleth," 35). The knife, while a possible botanical reference to the shape of the tree's foliage, also conveys the image of something threatening situated above a tree that contains the poet's name. The path of this first journey by train, from east to west, is eventually reversed, and the smoke from Jewish businesses and synagogues that rose over Berlin and other German cities points ahead to the ash from the crematoria that would rain on Krakow.

Like Bachmann's *Malina*, where Celan's figure of the Paulownia is used in the section of the narrative that remembers both the deportation of the Jews and the death of the stranger/Celan, Libeskind includes within the courtyard a single Paulownia. The tree again becomes an anthropomorphic reminder of the poet standing among the commemorative shards of *Kristallsplitter*. Similarly, *La Contrescarpe* concludes with the poet's movement toward a crystal: "And, yet again,/ you know your destination—the one / precise / crystal." Although he does not directly name the date, Celan provides an indicator to where his poem returns: a particular crystal linked to a specific moment that does not simply return like a phantom year after year. The poet describes how he too, along with his reader, must go toward ("wo du hinmusst") and seek out this date. The poem ends with Celan's poetic reversal of the *fort-da Spiel*, where his "wieder da" gives way to a being gone (*hin*). By the poem's concluding word the reader too is transported from the foreignness of words along with the ominous scene of smoke, knives, and trains to a word that potentially locates and names the date of exile and ash: Crystal. Celan requires the reader to translate the word into the recollection of a date.[11]

11 Celan's arrival at this "genaue Kristall" also recalls one of the first poems he had written after he became a resident of Paris in 1948, "Kristall" (1950).

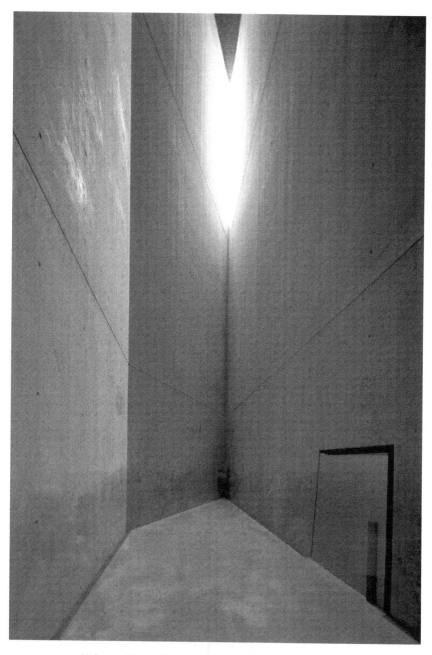

Holocaust Tower, The Jewish Museum, Berlin. © bitterbredt.de

The uncanny is not confined to a temporal theme—the return to the date—in this design of the Celan Courtyard, where a submerged trauma comes to light. In walking through the courtyard that is devoid of any marker explaining who designed this place, someone familiar with Celan-Lestrange's very distinctive style could recall the artist and her husband. Although her etchings are only about 18 inches by 18 inches, the intimate size of her works is turned into a monumental space, now covering the area of an entire courtyard. Taken out of both its frame and an exhibition space, the design becomes instead a space of exhibition. However, what is uncanny is not simply that the work has left its frame; rather, we ourselves step into a space that commemorates a traumatic event and become part of this massive aesthetic environment. While Celan-Lestrange produces an etching from a poem, the architect's objective is to produce an affect in the spectator from her design. The visitor is incorporated by the space of the artwork, surrounded by the jagged stones of the courtyard named after the poet.

In addition to walking through one of her artworks, if the inscription of the stones were included in the final design, the space would allow the visitor to step into Celan's signature poem, thereby adding to the multiple forms of translation occurring in the courtyard. Celan-Lestrange translated "Todesfuge" into an etching, and in turn, the architect made a sculpture out of the etching. The poem and lithostone used to print the etching become engraved stones in the yard, and the spectator too becomes part of this work of stone. One must both walk in this space and be an attentive reader of these two stones positioned unobtrusively in the design. The subject position of the spectator contributes to the comprehension of the entered text. With their German script, the stones are addressed to a particular audience. The design's abstractness, similar to Kiefer's Celan paintings, is made lucid through the use of Celan's poem. The inscriptions of "Tod" and "Meister" do not simply break up Celan's paradigmatic poetic phrase, but serve as interpretive devices for those who step into this abstract space and recall where death is the master: Deutschland. The friction of our movement in and reading of this space produces the text. Ironically, the fragmentation of the poem both makes possible the readability of the abstract work and locates its historical context.

The Holocaust Tower and the Garden of Exile and Emigration are two sites where we most clearly cross over the museum's "irrational lines" and into the realm of the Holocaustal uncanny. While we continuously approach voids and go across their bridges in our walk through the museum, we can actually enter them in the forms of the Holocaust Tower and Garden of Exile and Emigration. Even though both structures are connected to the bottom floor of the museum via doorways, each space lies outside

of the main building. Crossing the threshold between inside/outside, we enter the void. Within the Tower and Garden, the architect makes accessible what is interiorized in concrete shafts and traversed only by bridges that are encountered throughout the upper floors of the museum. We are given access to the catastrophe, however, not by seeing something, but through the feelings of disorientation and self-estrangement that the architect wishes to produce in the visitor. Even before we enter these two spaces, the architecture challenges our balance with narrow and slanted hallways. Libeskind assaults our body by leading us to two uncanny sites: the first is a claustrophobic, lightless tower, while the second is a labyrinth of 49 tomb-like pillars. The aim of both spaces is to confuse the visitors' relation to space.[12]

The very name of the Holocaust Tower coaxes the visitor to approach a site connected to mass murder. To gain entrance to the Tower one must go through a large metal door. The visitor knows neither what is on the other side of this door nor that in crossing the threshold, s/he is outside the building. Giving a provocative name to this space and concealing its contents behind the door, the architect wishes to arouse in the spectator a curiosity to see what is beyond the threshold. Yet behind the door there is no ash, no hair, nor any other remnant of the millions incinerated. Although Libeskind states, "This Void which runs centrally through the contemporary culture of Berlin should be made visible, accessible" ("Jewish Museum," 61), the Tower's void is not an area for exhibition. In this crypt-like space, the walls are empty, and the visitor is left to contemplate a three-story chamber of stone and to listen to the sounds emanating from outside.

Perhaps the closest we come to any explicit suggestion of the uncanny in relation to the museum is the E. T. A. Hoffmann Garden (the Garden of Exile and Emigration)—E. T. A. Hoffmann being the figure from whose writings Freud developed his theory of *das Unheimliche*. Despite this Freudian resonance, the phantom does not cross the line into our world

12 The recently constructed Holocaust Memorial in Berlin, designed by Peter Eisenman, is quite similar to Libeskind's garden of stone. But Eisenman's model is fifty times the size of the Garden of Exile and Emigration, and contains 2,500 treeless pillars. We see in his design another architecture of the Holocaustal uncanny, one that sets out to both estrange and consume the spectator within its concrete slabs. The goal of such architecture is to prevent the visitor from passively standing before the monument. We are forced to interact with the stone. Walking through these grave-like structures, the visitor is provoked to reflect on what is signified through this stone. A qualitative change to the uncanny occurs whereby the artist shifts from assaulting the spectator's vision to shocking the entire body through modes of estrangement and disorientation. We are no longer simply looking at the monument but are consumed by its size. It is an architecture that continuously tries to subvert the subject position of the spectator as a witness to the catastrophe. I will return in my conclusion to Berlin's Holocaust Memorial.

either from a book or across a frame; rather, we enter the realm of the uncanny. Like the Tower, the Garden is outside the museum. Again, we must walk down a long, narrow hall and exit the museum to enter this memorial space. The Garden commemorates those victims who either emigrated or were forced into exile during the years of the Third Reich. As Libeskind describes this space, his architecture is intended to disorient the visitor: "It represents a shipwreck of history" ("Jewish Museum," 41). Through his giant labyrinthine stone pillars, Libeskind wishes to convey the feeling of being adrift as experienced by someone who searches for a new home in the space of exile.

Celan attempts to bring about the same effect in "The Meridian," where his erratic search for home, which he calls "a type of homecoming," ultimately takes his audience to the place of an historical un-homing: the poet's destroyed home in the Bukovina. Undermining both perception and orientation, each artist attempts to bring about an estrangement in those who engage with these uncanny texts: an uncanniness that ultimately takes us to what Celan calls a "befremdetes-Ich" (estranged-I). But instead of remembering the finding of a new home, the Garden memorializes the experience of being lost or exiled by trying to produce the effect of being adrift among the 49 pillars. Although the descriptive name may suggest a pleasurable space, the Garden offers no consolation for the visitor. Lost amidst the oblique cement blocks towering over our heads, we find neither comfort nor safety in this space; we lose our ability to navigate through the labyrinthine construct. Our exit from the Garden returns us to the museum halls.

The anxiety-provoking spaces of the Holocaust Tower and the E. T. A. Hoffmann Garden are encountered in other architectural structures featured in the museum: the hallways and void bridges. We traverse bridges along the upper floors, bridges that contain beneath them the abyss of the voids. In the space of these bridges the spectator sees and reads an absence; the voids' bridges, which consist of empty black walls, contain small openings that allow us to peer into the chasm below and return us to the memorialization of historical erasure. History is neither repressed nor forgotten across these spaces, but manifests itself as black bridges suspended across chasms. Architecture, like poetry in "The Meridian," has the power to alienate, constantly provoking the visitors to remember where they are and what these spaces symbolize. Any passive encounter with the museum exhibitions is interrupted as we approach the voids. Hanging in empty frames upon the black walls, the voids are not simply the end of art, but part of the exhibitions: we are looking into

nothing. Similar to Celan's momentary suspension of the poem's voice, Libeskind destroys the museal gaze: nothing is present. [13]

Contrary to Rosalind Krauss's claim that there is a "waning of affect" inside the postmodern museum, our encounters with Libeskind's uncanny spaces are meant to return to the visitor feelings of disorientation and alienation through its design (Krauss, 14). While Libeskind constructed his museum in a way that subverts the visitor's gaze, he also wished to diminish her ability to figure out where she is. We are constantly de-centered in these halls that wind around, tilt, and intersect one another, unable to discern which way we are going. Libeskind makes experiential for the spectator the affect of being "unhomed." Wandering through skewed halls and narrow spaces that display the objects of the dead and exiled, we lose our equilibrium. Krauss remarks that space usurps the artwork in the postmodern museum: "The museum becomes a space from which the collection has withdrawn" (4). Libeskind, by contrast, places these two spaces in dialogue with one another in order to show how the "negative symbiosis" of German-Jewish culture relies simultaneously on the display of the objects and on their erasure.

The voids' vertical lines collide with the horizontal lines of the exhibition halls and form intersecting spatial bars throughout the museum. In the early stages of the museum's history, when it was still empty, there was a plaque that commemorated Celan before the visitor exited the bottom floor of the museum into the Garden of Exile and Emigration. The plaque drew the visitor's attention to Celan's image of the *Sprachgitter*, the grid of language, across which we try to encounter the Other. The poem "Sprachgitter" describes how eyes search for the Other behind the bars of speech—"Eyes round between the bars"—and we recall Celan's circuitous search in "The Meridian" for a "desperate conversation" with the Other. Modeled after this grid, the intersecting horizontal and vertical lines of the museum form a *Raumgitter*, or space-grille, of architecture. Libeskind's museum transfers this act to the visitors' eyes and she becomes the mediator who is faced with the task of pulling these two spaces —the traces of the traumatic past along with their erasure in the voids— into dialogue with one another.

13 Libeskind tells us that he modeled his voids after the second act of Schönberg's *Moses und Aron*, where the opera breaks off with Moses exclaiming, "O Wort, du Wort, das mir fehlt" [Oh word, you word that I am lacking]. The void becomes the space not where one searches for a divine word, but where one struggles to give expression to the traumatic depths of the Holocaust. For an excellent reading of this relationship between the museum and Schönberg, see Thomas Willemeit's article "Musik und Architectur bei Daniel Libeskind." Libeskind himself expanded on this relation between music and architecture in his *Chamberworks*, 28–46.

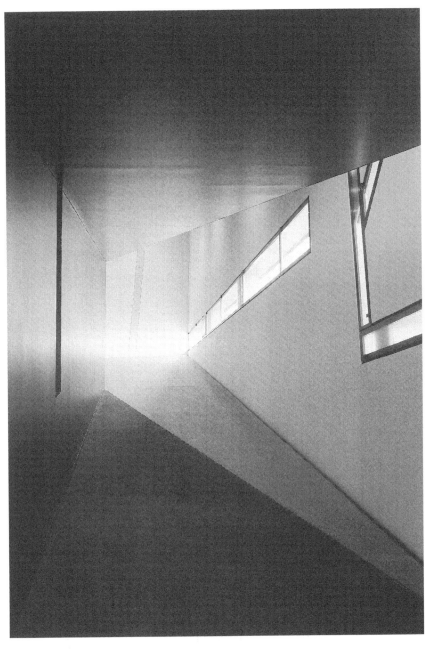

Void Bridge and Window, The Jewish Museum, Berlin. © bitterbredt.de

Before the exhibitions in the museum were installed, a central debate
revolved around who would control the meaning behind the museum's
walls, the architect or curator? Some critics feared that the museum design
would undermine the exhibitions and interfere with the spectator's recep-
tion of the displayed objects, that the curatorial perspective would be
threatened by the architect's own narrative built into his design of the mu-
seum. After the museum opened with its exhibits in September 2001,
some visitors got lost in the halls, unable to orient themselves within the
museum's architecture and its exhibits. In his critical review of the open-
ing, Amos Elon criticized the very lack of orientation in his walk through
the museum. He looked to the objects themselves as signposts to help
him find his way through the complexities of German-Jewish history and
argued that their haphazard arrangement prevented a coherent unfolding
of the historical narrative. He described the exhibition spaces as being
"crammed" with objects: "for visitors, the space is a bewildering maze of
crammed nooks and corners ..." (43). The most serious problem with the
museum, according to Elon, is the "curious scarcity of historical tension"
between German Jews and German Gentiles in its halls. Instead of at-
tempting to "dramatize" or explain the prevalence of Jewish hatred in
Germany throughout the centuries, Elon claims, the museum leaves this
tension unspoken.[14] However, I believe the narrow, labyrinthine halls,
slashed windows, and voids have not sabotaged the exhibitions in either
museum, but become necessary insertions that need to be juxtaposed and
read next to the recovered traces of Jewish culture. These are the spaces
where passive seeing is transformed into an act of interpretation.
Libeskind tells us that architecture evokes "[t]he missing experience or the
equivalent of experience of an absent architecture. In that sense they are
also documents of loss" ("Between Method and Desire," 22). Architecture
stands in place of all that was erased. The spectator's encounter with ma-
terial objects shifts to the seeing of absence upon the museum walls.

But perhaps Elon was simply looking in the wrong place for the reve-
lation of this tension that, as I have been arguing, is written into the inter-

14 In his discussion of the most prominent void, the Holocaust Tower, Elon raised one of the
primary concerns with Libeskind's architecture: "The trouble with such installations is that
the nearer they come to simulating reality, the greater the danger of their becoming kitsch."
While I agree with Elon that there is indeed a risk that the uncanny architecture may trans-
form the museum into a literal spook house, I believe Holocaust kitsch can be circumvented
when the affects of horror or estrangement are able to shift the responsibility to the visitor
to re-imagine scenes of effacement, that is, the historical tensions encased in the voids and
configured on the bottom hallways of the museum. The goal of this juxtaposition of empty
walls and the cultural artifacts of Jewish life is to provoke such a recollection of these scenes
of annihilation. While Elon may refer to the exhibition of recipes for matzo balls or Moses
Mendelssohn's spectacles as "merely cute," these seemingly mundane objects become poign-
ant reminders of the lost objects and ruins of Germany's Jewish community.

play between voids and installations. While Elon sees a "spirit of recon-
ciliation" unfolding in the museum, contrary to what I see as Libeskind's
own wish to destabilize any gesture of reconciliation, the movement be-
tween void and exhibition operates as the focal point of such historical
tension. We encounter on the second floor of the museum the very con-
flict of German-Jewish history that Elon searches for as we cross a void
and approach the display "The Emergence of Modern Judaism." In one
of the most stirring exhibits in the museum, the visitor is confronted by a
10- by 5-foot wall covered with hundreds of antique postcards of syna-
gogues throughout Germany. These postcards from such cities as Berlin,
Cologne, and Dresden show how the synagogue was architecturally inte-
grated into the space of the city. Each picture functions as a metonymy
for the hundreds of Jewish communities that found themselves at home
in Germany. But read next to the architectural void, these synagogues
conjure up in our mnemic reservoir images of their destruction during
Kristallnacht. The wall is itself a map that puts on display the hundreds of
voids spread across Germany. Libeskind's architecture is an attempt not
to explain the history of German-Jewish relations, but rather to provide a
device that allows the visitor to interpret, witness, and remember the
traumatic history left unseen within the fractured halls of the museum.

In her analysis of the Jewish Museum, Vera Bendt claims that "the
traumatic experience of the surviving part of the 'Jewish entirety' becomes
objects of the architect's treatment. Jews themselves, however, are not ob-
jects, whether living or dead" (in Libeskind, *Extension*, 47). Nonetheless,
we must read these "surviving parts" not simply as objects, but rather as
traces that do in fact point back to their owners and the homes where the
objects were previously kept. The traces provide a metonymic function
that attests not merely to the religious value of a menorah or the aesthetic
import behind a painting by Felix Nussbaum. These remnants point to a
lost community that once felt at home in Berlin. It is a community that
indeed stands as a lost object within the city: an invisible and uncanny
community that Libeskind wishes to display through this juxtaposition of
voids and exhibition halls.

Architectural Melancholia

Libeskind describes how his design for the Jewish Museum was influ-
enced by Benjamin's *Einbahnstrasse*, which "is incorporated into the con-
tinuous sequence of sixty sections along the zig-zag of Berlin, each of
which represents one of the 'Stations of the Star' described in the text of
Walter Benjamin" (*Extension*, 59). We cross both topographically and con-

ceptually with Benjamin in Berlin, where history is to be viewed not as a straight and continuous line, but as a state of perpetual rupture and disjunction. Benjamin's stations in "One-Way Street" end at the planetarium, where he reflects not on the wonder of the stars, but on the catastrophe and ruins left upon the landscape in the aftermath of the First World War. The stars have been displaced by the catastrophe of war and the dangers of technology, and Benjamin writes at the end of *Einbahnstrasse*, "Living substance conquers the frenzy of destruction [*Vernichtung*] only in the ecstasy of procreation" ("One-Way Street," 487). Although these images of ruin contain within them the pangs of a potential becoming in Benjamin's description from 1928, the word *Vernichtung* possesses a terrifying resonance after 1945. We need to read the interior of the museum, its vaults and exhibition halls alongside the building's emblematic form in relation to the city's identity: the emblem is of a deformed Star of David. With the interplay of Benjamin's concepts of ruins, emblems, and allegory, our first impulse might be to apply his thoughts on melancholia from his *Trauerspiel* to Libeskind's architecture. For Benjamin, the melancholic subject is abandoned in a landscape of ruins and fragments that need to be read. This fall into a history of ruins is central to the allegory of the Baroque tragedy. In turn, these ruins are tied to the possibility of redemption.

However, the reading of these museum ruins is indicative of a melancholia that is not based solely on Benjamin's theory of allegory and melancholia from his study of the German *Trauerspiel*; rather, the melancholic structure of the museum conveyed through the task of reading its ruins is a reflection of Benjamin's theses on the philosophy of history. Any utopic strain one might hear in the figure of the ruins in *Einbahnstrasse* or the *Trauerspiel* transforms into the *u-topos* left in the aftermath of historical effacement. In the Jewish Museum, the image of redemption embodied in the figure of the star shifts to Benjamin's reading of Klee's *Angelus Novus*: the angel of history gazes at the piling of debris from the past. Libeskind turns the spectator's gaze into the melancholic gaze of history where redemption is called into question. The melancholic optics unfolding upon these hallways is ineluctably bound to the architectural design itself. We behold in the museum the fragments of the past that attest not to presence, but to the attempts of the total erasure of a people and their culture. Libeskind takes the emblem of salvation and of hope and transforms it into a ruin, inserting it alongside other historical traces in Berlin's landscape.

The components of melancholia interspersed throughout the Jewish Museum are again encountered by the spectator's entrance into the Felix Nussbaum Haus in Osnabrück. While Libeskind transposes a spatial and optical anxiety central to Celan's poetics into the halls of his museum, the

blank spaces and voids of Berlin are replaced with configurations of Nuss-baum's dissolution in his self-portraits. In addition to his continued use of such figures as ruins, maps, and stars in the construction of his building, themes that emerge as well throughout Nussbaum's paintings, Libeskind also mirrors in the halls of the museum the constriction of space emblem-atic of these paintings. The ruins of his project—configured in the mu-seum's shape, Nussbaum's own vanishing figure within his artworks, the works themselves upon the walls, and the actual ruins unearthed in the excavation of the museum's landscape—all contribute to the melancholic strains of the museum. Within this haptic museum experience, where the halls force the visitor into proximity with the artwork, Libeskind positions the spectator face-to-face with scenes of historical effacement. But while the spectator might desire an empathic identification with these scenes of loss in the museum, through his architectural design Libeskind conspires with Nussbaum's artworks to thwart any fantasies on behalf of the specta-tor to fully assimilate these scenes of loss or to enter into their catastro-phic spaces. I again turn to Derrida on bereaved memory.

In his first lecture following the death of his friend Paul de Man, Der-rida expounds on the relation between narration and *Mnemosyne*, where the rhetoric of mourning is ineluctably bound to the question of memory. In addition to there being two modes of memory—*Erinnerung* and *Gedächt-nis*—Derrida distinguishes between two types of mourning, possible and impossible. In contrast to "possible mourning," which allows for the dead to be interiorized within the living and is described by Derrida as an act of betrayal to the lost Other, "impossible mourning" refuses to insert the Other into one's own "vault of some narcissism" (*Memoires*, 6). Turning Freud's polemic between mourning and melancholia against itself, Derrida now associates possible mourning with narcissism. In Derrida's analysis, the interiorization (*Erinnerung*) of the lost object (or the Other) becomes a mark of the subject's desire to overcome the loss and take hold of the Other as a memory. Conversely, for Freud melancholia, which indicates an inability to mourn, is linked to narcissism and a pathological disposi-tion that refuses to let go of the lost object.

While Freud described how the relinquishment of mourning was needed to free the ego's attachment to the lost object, Derrida insists that a perpetual haunting of the loss indicates the preservation of alterity. In his description of impossible mourning, which bears the hallmarks of Freud's melancholia with its sense of incompletion, Derrida does not wish to suggest something pathological; instead, he underscores the impossibil-ity of assimilating the Other into oneself. In Derrida's reading of de Man, "true mourning" exposes the "tendency to accept incomprehension," in which mourning is tied to the recognition of an unassimilated trace: the

mark of the Other. The "experience of mourning" begins with the "first" trace, before perception ever arises, and hence, before comprehension is possible (31).[15] In this description of mourning, the movement toward interiorization (*Erinnerung*) is countered by an act of memory (*Gedächtnis*) that makes "the inscription of memory an effacement of interiorized recollection" (56). Hence, mourning involves the interplay between two types of memory, where an act of writing, or the inscription of memory (*Gedächtnis*), simultaneously involves the erasure of remembrance (*Erinnerung*). In the Nussbaum Haus, I perceive a similar convergence of mourning and memory in Nussbaum's self-portraits, where the artist configures himself as one who is undergoing a process of effacement.

Analogous to my discussion of Kiefer's withholding of Sulamith's face in his paintings of "Todesfuge," I again turn to de Man's reflections on the trope of prosopopeia from his reading of Wordsworth's *Essay on Epitaphs*. Derrida also discusses this trope in his essay that remembers and mourns the death of his friend. Prosopopeia is "[t]he fiction of the voice from beyond the grave; an unlettered stone would leave the sun suspended in nothingness" (*Memoires*, 26) and confers the power of speech on the dead, whereby its voice addresses the living; it posits the possibility of the absent Other's response, a response that is itself a fiction. Eventually, this voice assumes "mouth, eye, and finally face," and since the word stems from the imparting of a mask or a face (*prosopon*), de Man describes how this voice from beyond the grave revolves around face and deface, figuration and disfiguration (27). In turn, Derrida underscores how de Man connects the voice from beyond the grave, of an epitaph, to the genre of autobiography.

The collection of paintings in the Nussbaum Haus is like a pictorial autobiography that tells the story of the Other's effacement. My interest in Nussbaum's artworks focuses on two central components. First, as the threat of capture loomed over him, Nussbaum depicted the constriction of space through the use of narrowing walls, where natural perimeters collapsed into restricted vanishing points in the paintings. And second, accompanying this anxiety of space, Nussbaum's works use a pictorial language of melancholia as seen in his use of ruins and melancholic figures and finally in his referencing of Dürer's *Melancholia I* in his last painting prior to his deportation and murder. The allegory that is unfolding in Nussbaum's paintings in the space of Libeskind's architecture is one of an

15 Derrida is referring to de Man's assertion in "Anthropomorphism and Trope in the Lyric" that "True 'mourning' is less deluded. The most *it* can do is allow for non-comprehension and enumerate non-anthropomorphic, non-elegiac, non-celebratory, non-lyrical, non-poetic, that is to say prosaic, or, better, *historical* modes of language power" (*Rhetoric of Romanticism*, 262).

impossible mourning, similar to what Derrida names in his reading of de Man's texts. But in the halls of the Nussbaum Haus, we encounter not a voice from beyond the grave, but the visual equivalent of a voice becoming silent or of an effaced epigraph from a gravestone: the disfiguration of the Other's face. In this reversal of prosopopeia, which for de Man indicates an epitaphic voice that assumes a visage, the stone of the Nussbaum Hallway adorned with traces of the artist's face now articulates something less than a voice. The attenuation of Nussbaum's face, conjoined to the ever-narrowing spaces within his paintings and Libeskind's hallways, is the visual concomitant to the terror of Celan's Breathturn. At the moment that marks both the figuration and disfiguration of the artist's face, the memory of the past is both inscribed as well as effaced within the museum halls.

Libeskind's museum provides the optic frame that contributes to what Benjamin would call "an allegorical way of seeing" Nussbaum's paintings.[16] Benjamin claims that in Baroque tragedy the ultimate objects of "melancholy immersion" turn into allegories, and that these allegories in turn deny the void (*das Nichts*) in which they are represented.[17] But while Benjamin discusses how the Baroque's image of the skull sets up the leap to resurrection, there is nothing redemptive about the objects adorning Nussbaum's canvas or in our allegorical gaze in the museum: our vision is fixed on the void. Despite the many ruins scattered across the canvases, it is the artist's threatened identity that becomes the primary fragment in these works. Nussbaum's pictorial narrative, shifting between erasure and self-affirmation, ultimately edges toward the eclipsing of the artist in Fascism's expanding shadow. In turn, the architect continues to assault not only the spectator's orientation through his claustrophobic architecture, but also assails her vision within the building. Our gaze is of the void,

16 See Benjamin's *Origin of the German Tragic Drama*, where he writes, "If the object becomes allegorical under the gaze of melancholy, if melancholy causes life to flow out of it and it remains behind dead, but eternally secure, then it is exposed to the allegorist, it is unconditionally in his power" (183–84).

17 "And this is the essence of melancholy immersion: that its ultimate objects, in which it believes it can most fully secure for itself that which is vile, turn into allegories, and that these allegories fill out and deny the void in which they are represented, just as, ultimately, the intention does not faithfully rest in the contemplation of bones, but faithlessly leaps forward to the idea of resurrection" (*Origin*, 232–33). In this penultimate section of the *Trauerspiel*, Benjamin repeatedly uses words that express abysses, interiorizations, turns and springs in order to map out not only the path of melancholic immersion and its overcoming, but also to delineate the movement of allegorical representation and its use of metaphors and tropes. By the close of the *Trauerspiel*, Benjamin conveys the notion of resurrection through the image of Golgotha.

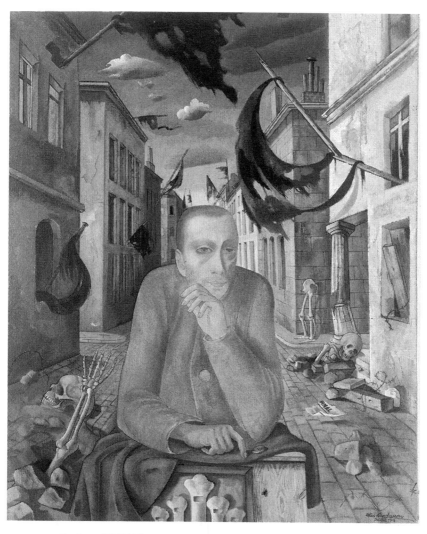

Orgelmann (1943/44). Felix-Nussbaum-Haus Osnabrück mit der Sammlung der
Niedersächsischen Sparkassenstiftung. © VG Bild-Kunst Bonn 2007

where the horror of being pushed up against scenes of annihilation or confined within narrow spaces transforms into a perspective of the *horror vacui*.

I will concentrate on several of Nussbaum's paintings from the period of his exile, flight, and hiding from the Nazis between 1939 and 1944 and explore how they intersect with Libeskind's architecture in relation to melancholic ruins and spatial anxiety. Ultimately, Nussbaum and Libeskind intersect at the point where Libeskind once inscribed Celan's poetry on the museum's wall. The attentive visitor can recognize traces of Celan's poems "Engführung" and "Todesfuge" along the last steps of the Nussbaum Hallway, immediately before Nussbaum's final paintings before his deportation to Auschwitz. Celan's poetic trace, barely visible, is like a ghostly voice that is suspended somewhere between erasure and arrival.

For Libeskind, ruins become a central part of Osnabrück's identity in relation to the museum. Like the Jewish Museum, the design of the Nussbaum Haus is modeled after a broken Star of David. We are reminded of the Yellow Star, Nussbaum's mark of identification, which continuously re-appears throughout his later works.[18] The ruin is also a leitmotif within Nussbaum's paintings, and the artist uses the image of ruins along with the constriction of space in a late self-portrait during his hiding in Belgium titled the *Organ Grinder* (1943); he depicts himself as a hurdy-gurdy man, his symbol for the exiled melancholic artist. The painting relies on a particular renaissance perspective, as the street of ruins moves toward the darkening horizon. Yet this viewpoint down the narrow street, a possible path of escape, is itself obstructed by Nussbaum's figure; he blocks the perspective of the street, which is adorned with tattered plague flags and ominous clouds hovering above the buildings. Furthermore, Nussbaum's body occupies the foreground of the painting, as his thinning face, with a hint of skeletal lines, gazes forlornly at the viewer and hinders our sight toward this horizon. His hand, which rests on an organ made of bones, points down to a fly beneath his finger. The image is one of resignation as the artist acknowledges the impossibility of escape: the flags signifying the outbreak of plague billow above his head. The wind carrying this plague approaches the artist, whose ruin-like figure is mirrored in the images surrounding him.

Of particular interest in this painting is the broken Doric column holding up a modern building on the right side of the canvas. While Nussbaum had once used classical motives in order to mock any nostalgic gaze for antiquity, referring to his painting of ruins in Italy as "an artistic joke,"

18 For the figure of the Jewish Star, see for instance *Selbstbildnis mit Judenpass* (1943), *Jude am Fenster* (1943), his draft of the painting *Die Verdammten* (1943), *Dreiergruppe* (1944), and *Jaqui auf der Strasse* (1944).

his use of ruins took a political turn after 1933 (Jaehner, 23). In this precarious image, the Doric column, a symbol of Western culture, is on the verge of collapse, and Nussbaum questions the function of art during a time of crisis. The focal point of the painting is the imminent ruin of the artistic subject himself. Once the column collapses, the fragments of history will consume the artist. X-ray photography of this painting has revealed that Nussbaum inserted the column, traces of blood on the wall, and skeletons climbing out of the earth *after* the painting had been finished. According to Benjamin, architectural ruins function as a sign of a vanished cultural prominence whereby "[i]n the ruin, history has physically merged into the setting" (*Origin*, 177). In the Baroque, the piling up of bones and architectural fragments suggests the expectation of a miracle. But in Nussbaum's *Organ Grinder*, these ruins do not point to some redemptive motif; rather, they indicate the inevitable collapse of the West as the dead come to the surface to give testimony to this catastrophic history.[19]

Cartography and Ruins

Similar to the map-like quality of the Jewish Museum, the design of the Nussbaum Haus is structured from the lines of Nussbaum's own fragmented topographic movement. Built in 1996, the four main structures of the museum are composed of three different materials, and each exhibition space is linked to a line from Nussbaum's biography that leads to various points of his life of flight, exile, hiding, and death. Libeskind describes how the oak structure, which contains the majority of Nussbaum's works painted in the 1920s and early 1930s, signifies the home he had to leave. This traditional wooden building possesses a trajectory that points to Osnabrück's former synagogue destroyed on *Kristallnacht*. Libeskind describes how this space is "violently cut" by the Nussbaum Hallway: an 11 meter high, 50 meter long and 2 meter wide hall containing the artworks he painted while in flight and hiding from the Nazis (*Space of Encounter*, 96).

19 In "A Berlin Chronicle," Benjamin describes how memory work is similar to an act of excavation, where fragments [*Trümmer* and *Torsi*] broken from the past provide belated insight into the future [*späten Einsicht*]. But Nussbaum's painterly gaze understands immediately the significance of the destruction surrounding him (*Reflections*, 26). Ruins were also uncovered in the construction of the Nussbaum Haus. During the initial stages of excavation and construction, Libeskind unearthed archaeological remnants of an arched bridge from the seventeenth century that had spanned the walls of the city. After uncovering the bridge, Libeskind moved the entrance of the museum so that the bridge would cross the space that divided the main gallery (the Nussbaum Hallway) from the structure of the Vertical Museum. This stone bridge is an architectural ruin and spans a cut that denotes the spatial mark of the Holocaust.

Der Flüchtling (1939). Felix-Nussbaum-Haus Osnabrück mit der Sammlung der Niedersächsischen Sparkassenstiftung.

This windowless, claustrophobic space is made of concrete, which is reminiscent of the voids in Berlin's Jewish Museum; again, this is a space that signifies exile and extermination. Libeskind positioned the direction of the hallway along an imaginary line forming a link between the hallway and Osnabrück's former Nazi headquarters. Finally, the Nussbaum Bridge, made of zinc, indicates a future that had been cut short and points both westward in the direction of Belgium where Nussbaum tried to elude the Nazis, and eastward to Auschwitz, where he was murdered. Libeskind names a fourth structure, also made of concrete and separated from these other buildings, the Vertical Museum. Like the Holocaust Void in the Jewish Museum, the Vertical Museum is another cenotaphic structure that indicates Nussbaum's truncated career as an artist: the works he was never able to paint.

Moreover, along with the constriction of space central both to Nussbaum's paintings and the museum's interior, the theme of cartography also appears frequently in Nussbaum's later paintings. In his works between 1939 and 1944 that adorn the museum walls, the visitor beholds Nussbaum's narrative of geographic displacements induced through the menace of National Socialism's expanding shadow across Europe. In *Der Flüchtling* (*The Refugee*, 1939), painted during his exile in Belgium, a man buries his face in his hands in desperation and sorrow. The title of the work places this ominous interior into a political light. Although we cannot see his face, we realize it is the artist himself who is represented through the identifying objects of his cane and bundle. Despite the painting's title, the image depicted is one of paralysis. This work comes after a series of still-life paintings (*Natur Morte*), and while he did not value the artistic merit of this art form, Nussbaum employed the genre as a metaphor for his personal situation. Like the lifeless objects he painted, often puppets and mannequins, the artist configured his own moribund nature in this painting. In one particular still life from this period, Nussbaum wrote the title of the painting across a book cover that lies next to a vase, an apple, and a ripped newspaper dated April 16, 1940, a few weeks before the Nazi invasion of Belgium on May 8, 1940. The headline reads, "Storm over Europe—War." The title of the book and the painting itself is "La nature morte de Felix Nussbaum." While the title could be translated as "The Still Life of Felix Nussbaum," one could also read the title as referring to Nussbaum's "dead nature," which is linked to the Nazi tempest moving across Europe.

In *The Refugee*, the interior of the room reflects the psychic structures of the artist's mind: he is trapped with no place to flee the Nazi threat closing in on him. The painting's other title, *Europäische Vision*, ties the painting to the question of a particular optic in Europe for a Jewish refu-

gee in 1939. The perspective opened up by the painting is that of an elongated room whose walls dwarf the artist. This extreme angle forces him into the periphery of the painting, squeezed between the walls, a massive table, and a darkening globe that sits on the table. It looks as if the walls are about to fall on top of him. Although the point of view from the front of the room may at first appear spacious, at the back of the painting the space becomes narrower. This contraction is also reflected on the globe's surface in which the expanse of Europe's contours is eclipsed by the shadow passing over its surface. Spatiality is dominated by a topophobia that oscillates between *horror vacui* and claustrophobia. The exterior, framed by the doorway's narrow renaissance perspective, provides a glimpse of a desolate horizon and barren landscape. Neither globe nor horizon can provide orientation or possible escape. [20]

The perspective in Libeskind's hall where *The Refugee* hangs mirrors the viewpoint in the painting. It appears as if the hall extends into the wall of the painting. At the back corner of the second floor, space contracts: the museum visitor moves from openness into the narrows of the corner. Above this space a thin cut of window lets us peer into the sky. Like the framed sky in the painting, our perspective is squeezed and the window provides no orientation. A wall to our right consisting of sharp corners breaks up part of the exhibition space and looms above us. The space closes in on us as we step into the spatial constructs like that of the refugee.

At the opposite end of the same exhibition hall where *The Refugee* hangs is Nussbaum's most renowned work, *Self-Portrait with Jewish Identity Card (Judenpass*, 1943). Again, the museum's narrow spaces intersect with the closing-in walls of the painting. The threat of erasure is augmented by his crossed-out nationality and illegible place of birth on his ID card. His origins are slowly being expunged. Although the artist appears to recognize that there is no way out, as he is squeezed into the corner, the paint-

20 In 1942 Nussbaum represented in a series of paintings and sketches his experiences from 1940 in an internment camp, St. Cyprien in Southern France, from which he escaped and fled back to Belgium. In *St. Cyprien (Gefangene in Saint-Cyprien*, 1942), Nussbaum alludes to the Renaissance theme of the Last Supper. But instead of finding bread and wine on the table, the focal point is a blank and tattered globe held together by barbed wire. The globe, replacing bread and wine, offers no hope of escape. Again, a shadow spreads across its surface. In his *Portrait of Three* (1943), three Jewish figures gather together in a narrow room. On the table is the yellow Star of David, and behind the three is a deteriorating map hanging on the wall. As the Nazi threat intensified throughout Europe, the spaces upon the canvases become more constricted.

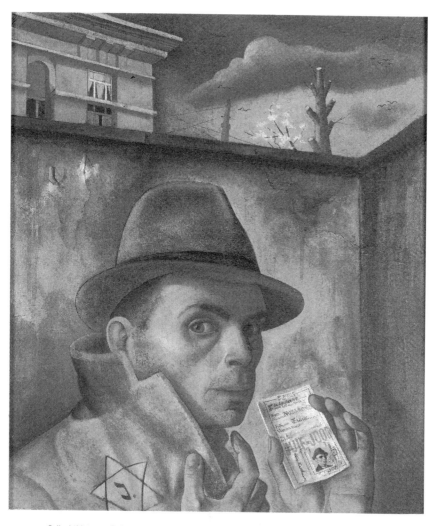

Selbstbildnis mit Judenpass (1943). Felix-Nussbaum-Haus Osnabrück mit der Sammlung
der Niedersächsischen Sparkassenstiftung. © VG Bild-Kunst Bonn 2007

ing does not show the collapse of his identity.[21] Despite his precarious position, the defiant artist depicts his face twice on the canvas and transforms a racist sign of exclusion into a sign to assert his identity. Employing the star for the first time, Nussbaum explicitly forms the link between his being trapped and being Jewish. Not only does he boldly display the yellow star from under his collar, but Nussbaum uses the word Jew three times: in the title *Judenpass* and on the ID card, in both French (*Juif*) and Flemish (*Jood*). Art serves as an act of resistance against erasure.

At the instant when the artist's subject position should be most threatened, he re-claims it. Asserting his identity as the victim by using in multiple languages the word "Jew" along with the mark of Jewish exclusion (the star), Nussbaum, at the museum's most provocative moment, places the spectator (assisted by Libeskind's halls) into the position of the transgressor. The lines of the halls are a continuation of Nussbaum's own provocative and disruptive mode of representing the crimes of the Third Reich. As the distance between viewer and painting collapses, the lines of the frame are erased. From the reduced perspective of the museum's contracting halls, Nussbaum's hand appears to go across the border of pictorial space and into ours. The spectator is cornered not only by Nussbaum, but also by Libeskind's walls. In relation to these walls, the spectator again stands in a comparable position to Nussbaum in the painting; we are pushed into the corner of the room. Trying to undermine the position of the witness, Libeskind assaults the spectator's perception in the halls.

During a period in which his face undergoes a series of disfigurements, where his paintings depict the irreparable loss of the face through its vanishing and concealment, the *Judenpass* self-portrait is an affirmation of the artist's identity. However, when viewed through a post-Holocaust optics, similar to looking at the faces of Jewish victims in documentary films that depict scenes from the Third Reich, Nussbaum's fate is read through the familiar markings of his yellow star, a figure that symbolizes exclusion, otherness, and extermination. Placed in relation to the star and his identification card, objects that would ultimately function as iconic traces of those murdered in the Holocaust, Nussbaum's juxtaposition of his face next to these remnants transforms him for posterity into a trace as well. Like one of the faces caught on camera of the countless victims rounded up, deported and exterminated, the face becomes a trace.

21 In *Judenpass* Nussbaum's visage occupies a similar position in the canvas as his face did in the painting *Angst* (1941), which depicted the outbreak of Germany's air war against England. The German Luftwaffe flew across Belgium's skies in their attack on England. Nussbaum, cowering in the corner of a wall beneath a night sky filled with stars and a barely visible airplane, holds his niece's face next to his. Behind them a newspaper announces the "Tempeste sur Europe" and the attack from the airplanes.

However, our encounter with the Other's face as a trace does not signify the Levinasian ethical moment when the Other in terror turns toward us and triggers within us a sense of responsibility for the Other; instead, the face provokes recognition of the utter failure of such an ethics and the Other's annihilation, whereby the spectator in her proximity to these traces is positioned before an abyss. At this Medusian moment when the spectator encounters his gaze, Nussbaum's look of terror freezes her. Here the Levinasian face is replaced with Benjamin's face of history that appears before us like a corpse: "In allegory the observer is confronted with the *facies hippocratica* of history as a petrified, primordial landscape. Everything about history that, from the very beginning, has been untimely, sorrowful, unsuccessful, is expressed in a face—no, in a death's face" (*Origin*, 166). Within the context of the historical ruins left in the aftermath of the Holocaust, Nussbaum's self-portrait signifies the face of the dead. But in our "allegorical way of seeing" this face, history neither becomes redemptive nor does the artist ask us to put ourselves in the place of the Other. Instead, the spectator recognizes in this face-to-face encounter with historical ruins the total collapse of any ethical imperative.

The museum functions as an archive that provides a painterly account of the steps leading up to the destruction of the Other. While the empty walls of the voids function as the Breathturns in the Jewish Museum, Nussbaum's Hippocratic face, which punctuates the hallways throughout the Nussbaum Haus, arrests both the spectator's gaze and the walk through the museum. If, as Anselm Haverkamp eloquently contends in his analysis of de Man on allegory, "The impossibility of mourning becomes the exemplary instance of the unreadability of writing" (*Leaves of Mourning*, 105), then Nussbaum's paintings are the pictorial equivalent of such an unreadable language upon Libeskind's walls. The specular structure of the paintings and the museum are indicative of the limitations to how one looks at the Holocaust. While the post-Holocaust frame provided by Libeskind's walls and hallways transform Nussbaum's face into a mnemonic trace of the exterminated, something also remains concealed on the other side of the walls that appear throughout Nussbaum's later paintings, walls that constrain the artist within the narrow spaces of his self-portraits; it is this outside region that not only ultimately consumes Nussbaum, but that also eludes the spectator's gaze. This beyond, or other side of the wall, points to both the all-consuming void of the Holocaust and the non-assimilable trace that exceeds all forms of interiorization. Thus, by indicating the limits to any anemnesic integration of this catastrophic space, these specular and spatial boundaries constitute the frame of an impossible mourning that preserves both the alterity of trauma and the effaced Other.

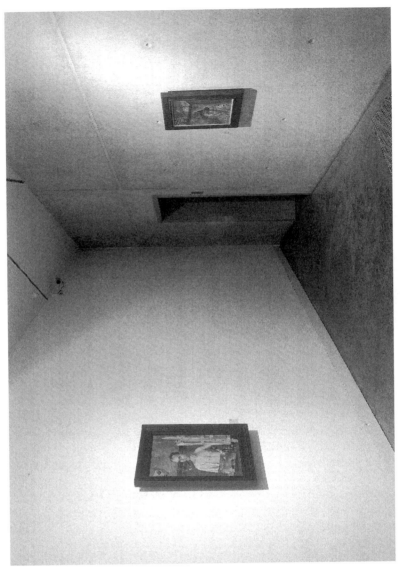

Felix-Nussbaum-Haus, Osnabrück. © bitterbredt.de

Unlike Nussbaum's *Judenpass* painting, there is a metal door through which the spectator exits and which leads into the Nussbaum Hallway. Although this hall might end with an X inscribed on the wall, its extended imaginary line points to the former National Socialist headquarters in Osnabrück. Throughout the museum, the visitor is continuously backed into corners and dead-ends. In this hallway we move into an even more anxiety-provoking space: a dimly lit, windowless, 300-foot sloping concrete corridor where an endlessly looping sound installation of a metal ball rolling across a metal track resounds. The auditory effect is that of an approaching train. At the most restricted point in the museum we have reached not representational limits but the legal limits of architectural space: the width here is two meters. Nussbaum's self-portraits and still lives prior to his being captured and deported to Auschwitz adorn this hallway. My interest here is in the last painting before the Nussbaum Bridge.

In *Die Verdammten* (*The Damned*, 1943/44) twelve figures cower before a wall adorned with a drawing of the dance of death. One of the twelve figures is Nussbaum, who alludes to his own image from *Self-Portrait with Jewish Identity Card*. But the artist's physiognomy has become attenuated and his eyes, which again stare at the spectator, are sunken into his face. Although his hand may grip the same yellow coat, it is now threadbare and the Star of David is missing. Nussbaum now wears the prisoner's cap that he had worn in the paintings that chronicled his experience in the internment camp St. Cyprien in 1940. Wooden planks jut out from a fissure in the street and look as if they are encasing Nussbaum. As his form vanishes, he inserts himself into the structure of an unfinished coffin. To the right of the wall behind Nussbaum is a narrow street lined again with plague flags and blocked by figures of death carrying coffins. The potential for escape is gone. The coffins are inscribed with the numbers 25,367 and 25,368: the almost exact number of Jews deported from Belgium.

Spatial anxiety converges in three modes of Holocaust art at this point in the museum: painting and architecture are mediated through Celan's poem "Engführung," which Libeskind had inscribed on the wall where the painting now hangs. The painting covers the verse:

Nahtstellen, fühlbar, hier
klafft es weit auseinander, hier
wuchs es wieder zusammen—wer
deckte es zu?

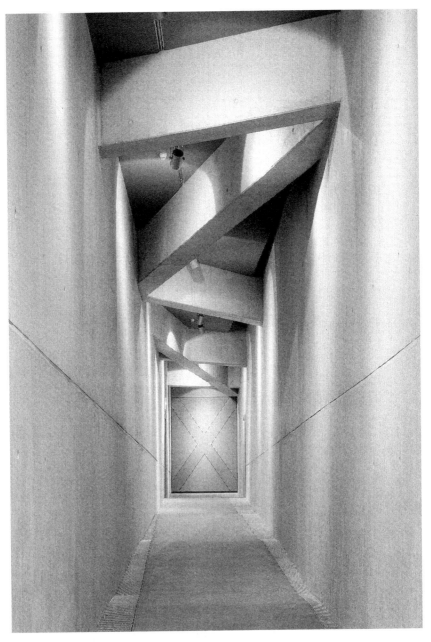

Nussbaum Hallway, Felix-Nussbaum-Haus, Osnabrück. © bitterbredt.de

Sutures, palpable, here
it gapes wide open, here
it grew back together—who
covered it up?
 (*Selected Poems*, 123)

How does the poem frame our position in the museum in relation to the artworks? The dead-end of the poem (Auschwitz's Black Wall) and of the painting (the narrow, plague-infused streets) are reflected in the X at the end of Libeskind's constricting hallway. What opens and closes here at the museum's sutures is the reconfiguration of a trauma along with its affect of spatial anxiety. The "here" to which Celan, Nussbaum, and Libeskind take us is abyssal, and with the opening and closing of this seam, we hear as well the open wound of Freud's depiction of melancholia. As I already discussed in chapter four, the word *Eng-Führung* suggests that one is taken into the innermost narrows of the Holocaust: the moment when *Enge* (narrow) or *Beengt* (constricted) shifts to *Angst* (anxiety). The potential encounter with the effaced Other materializes at the most constricted point in the text; in "Engführung," it was at the word ruin "Ho-." In turn, Libeskind's Nussbaum Hallway enacts a similar point of constriction, where the narrows of the hallway place the spectator face-to-face with the Other's vanishing. With the loss of perspective and depth, claustrophobia is accompanied by a look towards the *horror vacui* of history. The spectator's perception is driven into a corner as the paths of poem, painting, and hallway collapse into a restricted vanishing point that ends with erasure.

Reaching the X at the end of the hall, the spectator has no choice but to turn onto the Nussbaum Bridge, which does not span the void like the void bridge in the Jewish Museum does, but goes instead toward the abyss of the last painting: *Triumph of Death* (1944). The perspective offered by Libeskind's sloped bridge is that of one walking down into the painting's abyss. The walls that for twenty years had adorned Nussbaum's paintings and restricted his movement are knocked down in his final work, and we see what was closing in behind them: the void. The objects scattered across this landscape, which may remind one of Benjamin's description of the Baroque allegory that saw history as a "petrified primordial landscape" (*Origin*, 166), are not redemptive but symbolize the dead-end of culture. This is also the last wall of exhibition space and so we have reached the dead-end of the museum itself. The room's slanted floor gives the perspective as if one were looking down into a grave. While in his last work the artist quotes Dürer's *Melancholia I*, whose figure meditates on the ruins of artistic creation, Nussbaum, the melancholic organ grinder, stares at what Santner calls the "stranded objects" of Western culture. But it is not simply the cultural or stranded objects displayed in the painting that are

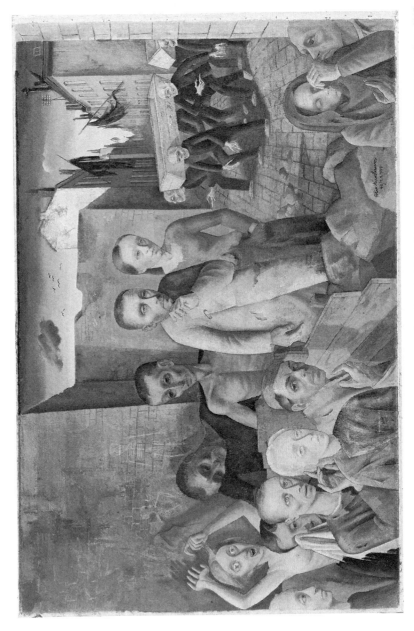

lost; Nussbaum's face deteriorates before our eyes. Evocative of Benjamin's angel of history, who reflects on the amassing of ruins in the midst of the apocalyptic violence of the Third Reich, Nussbaum's melancholic gaze in and before the canvas is devoid of hope. He understands immediately the significance of the cultural objects accumulating before his eyes and shows that they do not guide us to reason or the Enlightenment. His gaze is directed toward the compass that is placed next to the darkening globe, a broken clock, and an ominous damaged gasmask. For the first time in his paintings, Nussbaum provides direction with the compass and globe. They point to the northeast: the site of extermination.

Nussbaum often preserved his works by withholding his name from the canvas, sometimes painting over his signature. One might recall Adorno's reading of *The Odyssey* as the origin of modernity in the *Dialectic of Enlightenment*, when Odysseus denies himself his name in the Cyclops' cave in order to save himself. Yet in his struggle with erasure, intimated through the withholding of the name, there is potentially a similar fate to that of Derrida's image of the proper name turned to *Cinder*: "An incineration celebrates perhaps the nothing of the all, its destruction without return but made with its desire and with its cunning (all the better to preserve everything, my dear) the desperately disseminal affirmation but also just the opposite, the categorical 'no' to the laborious work of mourning, a 'no' of fire" (*Cinders*, 55). Fire is an obliteration of mourning, for the burning attempts to conceal all the remnants of loss and thus all possible traces of memory. Yet the ash left behind, like the paint concealing Nussbaum's signature, indicates the place of a proper name's erasure and of the Other's defacement.

The paintings within the Nussbaum Haus function both as artworks and as artifacts retrieved from inside the destruction, left behind by the artist for a future witness. Libeskind makes possible in his museum the reemergence of Nussbaum's proper name—the artist himself had said to a friend, "If I go under, don't let my works die, show them to people" (Jaehner, 56). Although the Nussbaum Haus makes possible the recuperation of both the ruins of history and the artist's proper name within the textual and social space of architecture, this space should not be reduced into some utopic or redemptive allegory. By placing the visitor on a path toward the Holocaust's non-site, Libeskind allows him/her to peer into an ethical catastrophe where the Other was abandoned. Is the spectator's ethical comportment before the abyss and the effaced Other one of testimony, witnessing, or mourning? In another analysis of cinder, Derrida writes, "We are witnesses of a secret, we are witnesses of something we cannot testify to, we attend the catastrophe of memory" (*Pointe*, 392). Perhaps this is what Libeskind means by his term "witnesses of another

kind." His prosthetic site is not meant to bring about any therapeutic engagement with the past, but indicates its very impossibility: what *Night and Fog* concluded in 1955—the scream continues to resound—"Engführung" revealed in 1958—the poem ends where it begins; the reader returns to its decimated terrain—and Kiefer demonstrated with his repetitive reconfiguration of Celan's "Ashen Hair Sulamith." Like Resnais, Celan, and Kiefer, Libeskind recognizes the impossibility of an historical closure to mourning. As the spectator walks down toward but never into the ruins of the West and faces the artist's melancholic gaze in the *Triumph of Death*, she must ultimately acknowledge the limitations of either imagining herself in the Other's place or mourning completely the ruins of this catastrophic history.

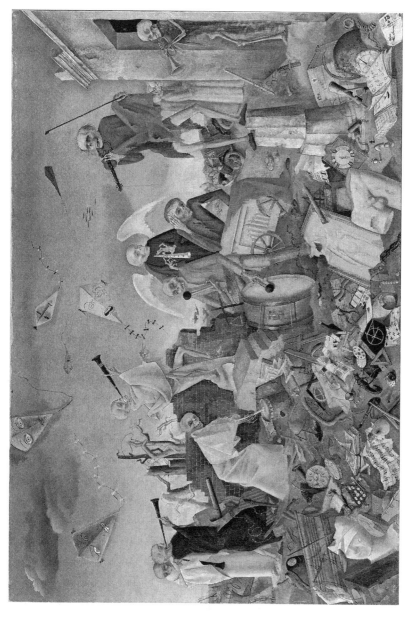

Triumph des Todes (1944). Felix-Nussbaum-Haus Osnabrück mit der Sammlung der Niedersächsischen Sparkassenstiftung. © VG Bild-Kunst Bonn 2007

Conclusion

Mnemosyne and the Ruins of History

Paul Celan in Tübingen

Celan had intended to use a passage from Dante's *Inferno* as an epigraph to his collection *Die Niemandsrose* and had written in Italian on one of the drafts to his collection: "Let the word be the mirror of the thing" (*Nachlass*, 358). Before he speaks these words in the depths of hell, Dante ponders the difficulties of conveying what he has seen and experienced during his journey into the Inferno.

> If I had rhymes as harsh and horrible
> As the hard fact of that final dismal hole
> Which bears the weight of all the steeps of Hell,
>
> I might more fully press the sap and substance
> From my conception; but since I must do
> Without them, I begin with some reluctance.
>
> For it is no easy undertaking, I say,
> To describe the bottom of the universe;
> Nor is it for tongues that only babble child's play.
>
> But may those Ladies of the Heavenly Spring
> Who helped Amphion wall Thebes, assist my verse,
> That the word may be the mirror of the thing.
> (Canto 32, 1–15)

Later Dante repeatedly tells of his anxiety that he may fail to communicate the horrors he has seen and experienced in this foreign world—that poetic language is inadequate to express this terror. Before he attempts the task (and we recall the place occupied by Levi's *Muselmann*, the drowned) he calls to the Muses, the daughters of Mnemosyne, to inspire his song and help him tell the sorrow and pain he encountered in hell. A few cantos earlier, Dante bemoans his poetic limitations when confronted with

the inferno; the ability to mourn is tied to the faculties of language and memory:

> At grief so deep the tongue must wag in vain;
> The language of our sense and memory
> Lacks the vocabulary of such pain.
> (Canto 28, 3–6)

Yet he lacks neither memory nor perception. Rather, the poet's anxiety stems from the constraints on his poetic capacity. We are again very close to Hölderlin's thoughts on Mnemosyne, poetry, and another scene of mythic loss: the battlefields of Troy and the death of memory. Hölderlin's poem begins,

> Ein Zeichen sind wir, deutungslos,
> Schmerzlos sind wir und haben fast
> Die Sprache in der Fremde verloren.
> ("Mnemosyne," *Werke und Briefe*, 199)

> A sign we are, without interpretation,
> Painless, and we have almost
> Lost our language in foreign lands.
> (*Hymns and Fragments*, 116)

I do not intend to make a conclusive statement about those issues surrounding the work of memory, mourning, and contemporary modes of representing the Holocaust in Germany. Rather, this conclusion is a series of gestures that both reflects back on my project and looks ahead toward future investigations and re-formulations of the central questions that have been explored throughout this book, questions regarding trauma's relation to translation, perception, affect, mourning, and memory.

Since Celan himself rejected the notion of a link between mimesis and poetry—consider his image of the dissolution of the Medusa's head in "The Meridian"—how do we understand his intended inscription "Let the word be the mirror of the thing?" How does the Dante epigraph function in relation to an inferno of history and a poet who was wary of any claims concerning the mimetic character of language? Celan's collection *Die Nie-mandsrose*—"The No-One's-Rose"—is dominated by place names and reflects on sites of biblical, poetic, and historical exile. Its poems depict the exile of his parents, of the poets Mandelstam and Petrarch, scenes of biblical and historical exile of Jews, and Celan's own loss of home. Approaching the liminal spaces of rivers, borders, and thresholds, he ventures repeatedly into the foreign: Zurich, Paris, Czernowitz, Vitebsk, Kra-

cow, Moravia, Eden, Colchis, and Babel. Yet inscribed into all of these places, Celan tells us in "The Meridian," is a January 20th.

In "Tübingen, Jänner" Celan tells of his visit in January 1961 to Hölderlin's home. The premise of homelessness imparts the poet's visit to Tübingen with an uncanny tone. Once again, he reflects on the themes of visual rupture, memory, failed representation, desired encounters, and refracted images:

TÜBINGEN, JÄNNER

Zur Blindheit über-
redete Augen.
Ihre- >>ein
Rätsel ist Rein-
entsprungenes<<-, ihre
Erinnerung an
schwimmende Hölderlintürme, Möwen-
umschwirrt.

Besuche ertrunkener Schreiner bei
diesen
tauchenden Worten:

Käme,
käme ein Mensch,
käme ein Mensch zur Welt, heute, mit
dem Lichtbart der
Patriarchen: er dürfte,
spräch er von dieser
Zeit, er
dürfte
nur lallen und lallen,
immer-, immer-
zuzu.

(>>Pallaksch. Pallaksch.<<)
(*Gesammelte Werke*, 1:222)

TÜBINGEN, JÄNNER

Eyes talked in-
to blindness.
their—"a
riddle, what is pure-
ly arisen"—, their
memory of
floating Hölderlintowers, gull-
enswirled.

Visits of drowned joiners to
these
plunging words:

Came, if there
came a man,
came a man to the world today, with
the patriarchs'
light-beard: he could,
if he spoke of this
time, he
could
only babble and babble,
ever- ever-
moremore.

("Pallaksch. Pallaksch.")
(*Selected Poems*, 159)

Celan's poem explores a particular personal memory of a place, and the title binds this place with time: January. Yet this month does not stand simply for the singularity of a date—it conjures up multiple dates. Already from "The Meridian" we recall the month's connection to both a literary and a historical trauma: Lenz's madness (*Wahnsinn*) and the date of the Wannsee conference. The time of madness in the poem is supported by the image of Hölderlin's tower: the place associated with the poet's mental

breakdown. Although he may weave throughout his poem images, lines, and themes from Hölderlin's poetry, Celan takes the poet and his poems through a series of estrangements and disfigurements.

Celan cites Hölderlin four times in the course of the poem using quotation marks, dashes, and parentheses. He begins by using one of the paradigmatic lines from Hölderlin's hymn "Der Rhein" and ends with a word taken from the poet's years of illness. We move from the familiar into a place of exile and madness. Celan's quotation marks, or "rabbit ears" (*Gesammelte Werke*, 3:202), compel the reader to be attentive, and through the trope of paronomasia we hear an echo from Hölderlin's "Brot und Wein": "What are poets for in a destitute time?" ("Wozu Dichter in dürftiger Zeit?") in Celan's "er *dürfte*, / spräch er von dieser / *Zeit*." But while Hölderlin's destitute time was preceded by the flight of the gods and the loss of the Greek world, Celan's destitute time is historically grounded in the aftermath of the Holocaust. The poem questions not the time to come, like Hölderlin's "der kommende Gott" from "Bread and Wine," but reflects on what the mad poet could say "Heute": 1961 in Germany. Finally, although not directly quoted in the poem, through an act of *Toposforschung* I situate "Tübingen, Jänner" within a poetic landscape evocative of Hölderlin's "Mnemosyne": the poet finds himself in a foreign land, a place of exile, and contemplates the possibility of remembering an event through poetry. In the closing stanza of "Mnemosyne" Hölderlin presents the death of memory, the destruction of a city, and the loss of mourning by the river Scamandros as he reflects on the deaths of Achilles, Patroklos, and Ajax. Thus, through such an association with "Mnemosyne," Celan's poem also invokes Hölderlin's central question regarding the relation between poetic language and mourning.

While Hölderlin had turned to the Greeks, to Pindar and Sophocles, Celan is not interested in mythopoetic loss in the aftermath of this catastrophe. Instead, he reflects on how language can mediate the historical loss of home and family. Conjuring up a specter, he turns to Hölderlin to reflect on the present moment in history and asks of him a word. Although he begins by addressing Hölderlin from the time of his hymns and elegies, the final word he receives from the poet comes from the period of his madness. In addition, Hölderlin becomes an amalgam in the poem of two exiled figures: the blind Oedipus and the stammering Moses. In this brilliant condensation of imagery Celan brings together the tensions central to post-Holocaust art. While the reader runs the risk of being trapped within an interpretive void in the poem's caesuras, the poet is consumed with the anxiety of falling into a stammer, of failing to convey the horror of the catastrophe. Celan's "lallen und lallen" is Dante's own anxiety in hell: "I cannot write it: this is a terror that cannot be told" (Canto 34, 23–

24). Even though "Tübingen, Jänner" does not refer directly to the Holocaust, a central problem indicative of Celan's poetics is present: the poet reflects on the breakdown of language. I will first look briefly at how the poet's aphasia anxiety manifests itself in Tübingen and then move to how he transfers this anxiety to the reader of the poem.

With its depictions of a river, madness, exile, failed speech, and memory, "Tübingen, Jänner" recalls topographically the opening and closing stanzas of Hölderlin's "Mnemosyne." Celan too has moved into a foreign land, forced into a historical exile, not a poetic one. In this "*dürftige Zeit*" the poet stands on a bridge overlooking not the Scamandros nor the Rhine, but the Neckar. He does not look directly at the mad poet, but only sees his place of refuge refracted by and multiplied upon the water's surface (*Hölderlintürme*) and watches the sinking of his own words (*diesen tauchenden Worten*) into the river's depths. Although he encounters only obliquely the poet's madness in relation to the river's surface, this potential mirroring devolves into both a drowning and a fragmentation of the Other's words. In this space of exile Celan questions his vocation as a poet living in a destitute time. The poem cannot hold itself together as the line from "Der Rhein" breaks apart and Celan writes, "Ein Rätsel ist ein Rein-/ entsprungenes."

Evoking the poet's near loss of speech in foreign lands in "Mnemosyne," Celan's poem ultimately falls into a stutter. With the image of the "Lichtbart der Patriarchen," Celan inserts Moses at the time of his glowing descent from Sinai after meeting with the Divine for forty days.[1] By comparing Hölderlin to Moses, Celan in effect takes the poet through a process of *Verjuden* and transforms him into the exiled and uncanny Other. One is reminded of Tzvetaeva's words that all poets are Jews cited by Celan at the beginning of "And with the Book from Tarussa." But the image of Moses brings us not simply to the question of the limits of representation linked to the Second Commandment; Moses is also known for his inability to communicate. As he tells the Divine, "I have never been a man of ready speech, I am slow and hesitant of speech" (Exodus 4.12). Celan's poem, in its movement toward a stammer (*lallen und lallen*), devolves into the very babble it fears. In addition to beholding these wounds of language in the architecture of a tower linked to madness (Hölderlin's tower), which resonates as well with the figure of the Tower of Babel, the reader is also confronted with the very breakdown of language that eventually overtakes the poem's development.

Celan's words begin to mirror not a particular scene, but they depict instead the possible collapse of communication through an atonal stutter-

1 In the depiction of his descent from Mt. Sinai in Renaissance art, Moses, one of the patriarchs of Judaism, is portrayed as having a beard of light after his meeting with God.

ing. With its blinding, drowning, loss of articulation, the poem ends by acting out the aphasiac fear embedded in Hölderlin's lines at the beginning of "Mnemosyne." The repeated words and phrases move closer together throughout the stanza: first separated by a line, then by a word (*lallen und lallen*), then by a comma (*immer-, immer-*) until they are attached (*zuzu*). Linguistic meaning has been replaced by the mere repetition of sound. Finally, the poem ends with a repeated word taken from Hölderlin's years of madness: "Pallaksch. Pallaksch," a word the poet had used to mean both yes and no (*Die Niemandsrose*, 36). The tragedy behind "Tübingen, Jänner" is expressed in the discursive nihilism that emanates through the proliferation of atonal symbols in the final stanza up until the poem's closing line; the prophet comes, stutters, and departs misunderstood. While the "tauchenden Worten" in the poem might seem to suggest a type of baptism, there is no emergence out of the water as the poem succumbs to images of drowning, babble, and madness.

If "Tübingen, Jänner" bears a thematic resemblance to Hölderlin's "Mnemosyne" and the *"dürftige Zeit"* that permeates Celan's poem suggests a time of absence, what then is the function of mourning in the poem?[2] Unlike Hölderlin's "Brot und Wein," where the "coming god" can alleviate this loss of the gods that fled, Celan's poem does not so much specify what is lost—*Jänner* carries with it the historical implications of all that happened—but is concerned with the limits facing the artist who attempts to convey this catastrophe. Yet in this time of irrecuperable loss that infuses Celan's poem, something is indeed found. While the beginning of "Mnemosyne" presents the near loss of linguistic signification in foreign lands and its ending ponders both the death of memory and the failure of mourning, "Tübingen, Jänner" ends not with the loss of words, but rather with the poet recovering a word from the tower. Like "Die Schleuse," which ends with the recuperation of the word *"Jiskor,"* Celan's Tübingen poem also closes with a foreign word that potentially estranges the reader. Joined to Lucile's suicidal call "Long live the King" and Lenz's mad desire to walk on his head, Hölderlin's "Pallaksch" functions as the poem's Breathturn. Approaching the space of the tower, Celan does not stop using language in this place of exile, but pauses in order to let the Other speak. What could Hölderlin say about historical catastrophe? This specter can only stammer.

2 Silke-Maria Weineck heeds Celan's call for *Aufmerksamkeit* and hears in the "ksch" of "Pallaksch" the word "Kaddisch," the Jewish prayer for the dead, which Celan uses a few poems earlier in "Die Schleuse" (Weineck, 267).

The opening image of a blinding, "Zur Blindheit über- / redete Augen," points to the figure of Oedipus, whose loss of vision was triggered, according to Hölderlin, by interpreting the oracle too infinitely.[3] But over-interpretation is no longer directed toward an ancient oracle or the origins of the Logos, nor does the blinding refer simply to Oedipus or to Hölderlin's delving into the question of origins. What ultimately undergoes a blinding is the very process by which the reader interprets the poetic voids of the text. As I have shown at the end of my analysis of "Die Schleuse" in chapter three, the potential threat to the reader stems from not knowing when to pause in the hermeneutic process of trying to decipher the meaning concealed at the poem's core. Guiding his reader into the poem's "very most narrows," which is configured by a double inscription of the parentheses and quotation marks, Celan leaves the reader with the foreign word. To insert Hölderlin's "Pallaksch" at the end of "Tübingen, Jänner" does not necessarily close off interpretation; instead, this interpretive limit functions to compel its receiver to depart from the disorienting space of the void and to translate Hölderlin's alienating word into a thoughtful remembrance of a traumatic date. In choosing this word from Hölderlin's exile in the tower, Celan fulfills his own call for an encounter with the Other by turning toward the afflicted and dispossessed poet, traveling into a foreign land, and recovering his word. In turn, his poem sets up a potential encounter between the reader and the Other, not the estranged poet in his tower, but the effaced Other for whom his mad word tries to speak. It is exactly such confrontational forms of art that intend to estrange the spectator by doing violence to his/her senses that the author Martin Walser critiqued in his Frankfurt Book Award speech in 1998.

Martin Walser in Frankfurt

In his concluding chapter of *Das zerbrochene Haus* Horst Krüger discusses "the ghost of Auschwitz" and tells of his reasons for going to the Auschwitz trial in Frankfurt in 1964: "I am going to the Auschwitz trial, because I want to see it. I believe that seeing demystifies every ghost. Auschwitz is like a ghost. The word has become a strange metaphor: the metaphor of evil for our time" [Ich fahre zum Auschwitz-Prozess, weil ich das sehen will. Ich meine, Sehen entzaubert jeden Spuk. Auschwitz ist wie ein Spuk. Das Wort ist zu einer seltsamen Metapher geworden: Metapher des Bösen

3 "Oedipus interprets the saying of the oracle too infinitely" ("Remarks on 'Oedipus,'" 102; "Oedipus den Orakelspruch zu unendlich deutet," in Hölderlin's "Anmerkungen zum Ödipus," *Sämtliche Werke*, 5:196).

in unserer Zeit] (113). For Krüger the visualization of the ghost signifies the moment when that which had been repressed or forgotten could rise to the surface and become memory. This return of the ghost, however, is not simply the return of evil as Krüger may suggest. The proper name "Auschwitz" conjures up as well the millions of nameless dead who were deprived of tombs. We are not merely "seeing" evil in this name that denotes a site of annihilation; we are also provoked into recalling those images that are stored within our mnemic archive, of everything that was incinerated in Auschwitz's fires.

While Krüger turned to the horror of the Auschwitz trial in Frankfurt in order to see or hear the remains of this haunting past, Martin Walser offered an alternative way of looking at what was left after Auschwitz. In his acceptance speech for the Frankfurt Book Award in 1998, Walser described how he looked away (*Wegschauen*) when the terror of Auschwitz came before him (*Erfahrungen beim Verfassen einer Sonntagsrede*, 18). His words and the ensuing reactions to his speech can be seen as the culmination of these memory debates in Germany at the end of the twentieth century. In opposition to Celan's "Meridian Speech" in 1960, the intention of Walser's Frankfurt speech was to liberate Germany from the traumatic history of the death camps. According to him, the memory of the Nazi genocide had become a part of ritualized public conscience that resulted in what he called a "banality of good" (20). Walser argued that German intellectuals and authors were using public spaces to both commemorate and confront their audiences with the horrors of the past in order to underscore their own sense of moral superiority. Furthermore, he used the occasion of the speech to critique the construction of the Holocaust Memorial in Berlin, which he compared to a "football field-sized nightmare" [*Fussballfeldgrossen Alptraum*] (20).

Walser described the repeated showing of the extermination sites on television as both a *"Moralkeule"* [moral bludgeon] and as a *"Drohroutine"* [threatening routine]. The very choice of words depicts how the spectator, in particular the German spectator, is assaulted by the images of the death camps. Informing his audience that he had a *"Zufluchtswinkel"* [refuge] from the images of "den schlimmsten Filmsequenzen aus KZ" [the most terrible film sequences from the camps] that appeared upon his television screen, he uses the term *"Wegschauen"* [looking away] to convey his act of fleeing in relation to these visual shocks. But from what exactly does he turn and flee? Walser does not try to escape from what he calls the "Grauenhaftigkeit von Auschwitz"; instead, he says that something else is presented in these images: "unsere geschichtliche Last," "die unvergängliche Schande," "Dauerpräsentation unserer Schande," "Präsentation unserer Schande," and the "Vorhaltung unserer Schande." It is the word *"Schande"*

(shame or disgrace), used by him six times in one paragraph, which becomes the focal point of his evaluation of how the Holocaust is recalled in contemporary German society.

In the forms Holocaust memory takes—such as the *"Erinnerungsdienst"* of German intellectuals (a reference to Habermas and Grass), the images constantly shown on television, and the construction of the memorial in Berlin—Walser sees it as a historical burden (*Last*) that refuses to fade from memory. While he acknowledges the poles of *"Opfer"* and *"Täter"* [victims and perpetrators] and unreservedly places himself among the accused (*Beschuldigten*), Walser ultimately goes on to depict himself and the Germans as victims of the Holocaust *"Erinnerungsdienst,"* a "memory army" that "attacks" Germany with discussions, images, and monuments of shame:

> Von den schlimmsten Filmsequenzen aus Konzentrationslagern habe ich bestimmt schon zwanzigmal weggeschaut … Wenn mir aber jeden Tag in den Medien diese Vergangenheit vorgehalten wird, merke ich, dass sich in mir etwas gegen diese Dauerpräsentation unserer Schande wehrt. Anstatt dankbar zu sein für die unaufhörliche Präsentation unserer Schande, fang ich an wegzuschauen (18).

Consider Walser's words in relation to his critique of the Holocaust Memorial in Berlin. This "football field-sized nightmare" is just one aspect of the "moral bludgeon" that keeps him awake at night. Through such an analogy, the site that is to remember the victims of National Socialism becomes the victimizer that bludgeons the German spectator now transformed into victim, and disturbs his/her sleep. Despite aligning himself at first with the perpetrators, Walser now describes himself as a victim whose internal defense mechanism (*in mir*) protects him (*wehrt*) against the *Moralkeule* of Auschwitz, which now threatens him (*Drohroutine*) with its incessant presentation. It is as if Walser erects a protective barrier (*Reizschutz*) through his act of *Wegschauen*, which protects him against the barrage of images that repeatedly (*zwanzigmal*) assault his vision. Yet this apparent act of constructing a barrier against shock does not seem to produce a remembrance of the victims of the Holocaust; rather, in his attempt to turn away from his shame before these scenes of genocide, Walser also exhibits a flight from memory.

Earlier in his speech, Walser had used the term *Wegschauen* in relation to how he turned away from the disturbing images of contemporary violence shown on his television screen. He described how he would shut himself off from these unbearable scenes in the world whose removal he could not control, "Ich habe lernen müssen wegzuschauen" [I had to learn to look away] and his look (*Blick*) would flee from the screen. But

this turning away does not necessarily guarantee reflection on these im-
ages of horror and Walser adds, "Auch in Wegdenken bin ich geübt ...
Ich käme ohne Wegschauen und Wegdenken nicht durch den Tag und
schon gar nicht durch die Nacht" [I am also skilled in thinking away ... I
could not get through the day without looking away and thinking away,
and certainly not through the night] (10–11). Whether before the filmic
images from the camps or their abstraction through the memorial, Wal-
ser's reaction is the same: visceral or somatic unease leads to a desire to
flee. Despite the fact that the cultural viewing context of 1945 is very dif-
ferent from that of Germany at the end of twentieth century, through his
own descriptions Walser seems to occupy a position similar to that of the
citizens of Weimar who were forced by Allied troops to stand before the
dead bodies in Buchenwald. He ignores any ethical demands that the in-
tensification of images and memorialization at the end of the twentieth
century might pose for the spectator. Instead, he maintains that what is
put on display is not the plight of the victims but the impact that the sight
of these crimes has on the spectator—namely, what is put on display is
"our shame," that is, Germany's shame.

In *On Escape*, Levinas defines shame as that which "arises each time
we are unable to make others forget our nudity. It is related to everything
we would like to hide and that we cannot bury or cover up" (64).
Wegschauen refers to Walser's own escape from what will not remain hid-
den, and this escape is most evident throughout the course of his speech.
Shame or disgrace does not lead toward any ethical comportment to the
dead, to the Other's face, but stops at the spectator himself. I will not
venture to guess what the spectator's turning away signified in 1945. I will,
however, examine the significance of Walser's act of *Wegschauen* not before
his television screen, but in the development of his speech in Frankfurt.
What I find problematic about his *Wegschauen* is where his flight takes him.
Immediately after using this public space as a forum to criticize Ger-
many's decision to construct the Holocaust Memorial in Berlin's center,
describing it as a *Schandmal* and *Alptraum*, Walser moves from history to
speculative philosophy as exhibited in his use of textual fragments from
Heidegger and Hegel.

Walser shifts in his speech from his critique of the memorial to an un-
critical use of the philosopher who demanded thinking (*nachdenken*) yet
failed to respond to the Nazi genocide. In doing so, he replaces a histori-
cal crisis of memory that he links to shame with an ontological predica-
ment by citing Heidegger, "Being guilty belongs to Dasein itself" [*Das
Schuldigsein gehört zum Dasein selbst*] (21). Without explicating Heidegger's
statement, Walser quickly jumps to Hegel, as if Hegel's words will eluci-
date Heidegger's notion of guilt: "The conscience, this deepest inward

loneliness with itself, where everything external and restricted has disappeared, this accessible pulling back into oneself ..." [*Das Gewissen, diese tiefste innerliche Einsamkeit mit sich, wo alles Äusserliche und alle Beschränktheit verschwunden ist, diese durchgängige Zurückgezogenheit in sich selbst* ...] (22). After citing these two fragments of thought, Walser concludes that, "Everyone is alone with his own conscience." The turn to Heidegger and Hegel reenforces the solipsistic movement at the heart of Walser's speech, who had stressed that his goal in Frankfurt was to speak in front of others, not to others ("Über das Selbstgespräch," 141).

In his attempt to clarify his rejection of the memorial by turning to Heidegger's and Hegel's reflections on conscience, Walser replaces his use of *Schande* with Heidegger's phrase *Schuld* ("guilt" or "debt"), and through this juxtaposition he tries to form a correspondence between the two terms. But Walser's use of *Schande*, like Heidegger's own application of *Schuld*, is devoid of any ethical associations. *Schande* refers to an affective response that is associated with how one sees himself or herself perceived by others. The sensation does not necessarily indicate any acknowledgment of an ethical failure or responsibility. In his debate with Walser over his speech in Frankfurt, Ignatz Bubis, the Chairman of the Central Council of Jews in Germany, underscored Walser's use of *Schande* and argued that nowhere in his speech did Walser use the term *Verbrechen*—a word that connotes the sense of a moral transgression—to refer to the Nazi crimes.[4] Likewise, by turning to Heidegger's concept of *Schuld*, Walser sustains this movement away from any notion of ethical responsibility. Although *Schuld* is a term that one might at first associate with an awareness of right and wrong, Heidegger's use of the word in the section where he develops his concept of "the voice of conscience" (*Gewissen*) in *Being and Time* is devoid of such ethical links. Neither term suggests some internal mechanism within the subject that helps establish a moral position. By turning to Heidegger, Walser applies an ontological model to probe the historical implications of the memorial. Walser might appear to draw on the ethical dimensions associated with such words as "guilt" and "conscience" in order to assess the memorial on what seem to be moral grounds. However, his misleading use of Heidegger eventually sets up his move away from the ethical import behind the shifting strategies of how to remember the Holocaust at distinct moments in history.

4 Bubis described Walser's speech as an attempt to extinguish the memory [*Erinnerung auslöschen*] of the Nazi crimes against the Jews (see Schirrmacher, 108). For an excellent reading of the Bubis-Walser debate, see Kai Evers's article "Monological versus Dialogical Remembrance," in which he examines how Walser's "poetics of soliloquy" reveals his attempt to liberate Germany from the traumatic history of the death camps.

In Heidegger's discussion of the "voice of conscience" from *Being and Time*, the voice discloses to *Dasein* its own *Schuld*. This voice is neither ethical nor psychological; rather, it has ontological significance. Heidegger writes, "The calling back in which conscience calls forth gives *Dasein* to understand that *Dasein* itself—as the null ground of its null project, standing in the possibility of its being—must bring itself back to itself from its lostness in the they, and this means *that it is guilty*" (*Being and Time*, 286–87). The voice of conscience indeed speaks of *Dasein*'s *Schuld*, but Heidegger does not use this term simply to imply a sense of guilt. In addition, the voice discloses to *Dasein* that it owes a debt (*Schuld*). Immersed among others in the world of things, the voice enjoins *Dasein* to return to the uncanniness of Being. The call of conscience "comes from the soundlessness of uncanniness and calls *Dasein* thus summoned back to the stillness of itself" (296). Heidegger's account of *Gewissen* and *Schuld* has nothing to do with the individual being in breach of a law. The voice that calls forth functions as an ontological imperative that orders *Dasein* to bring itself back (*zurückholen soll*) from its lostness in the they (*das man*) and fulfill its debt to the uncanny. While one might at first detect something structured like an ethics in this voice of conscience, the debt owed is not to the Other but to oneself as a being. Conscience does not demonstrate solicitude for Others, nor does *Schuld* become a marker that indicates one's responsibility to the Other; "In the call of conscience, however, this anonymous being is brought back to its own existence as owing to itself a self" (288). The ontological category of *Schuld* refers primarily to *Dasein*'s relation to itself.

If Walser had given more thought on a historical level to the implications of *Schuld* and conscience in relation to Berlin's Holocaust Memorial, he would have seen that the structure of the memorial actually conforms to Heidegger's figure of the voice of conscience that orders one to turn to the uncanny. Heidegger claims that being guilty or owing a debt implies one's readiness to feel anxiety that is constituted by the call to return to the uncanny (297). By opening up a sense of debt that summonses the spectator to enter its narrow spaces in order to recall those who were deprived of homes and graves, the Berlin memorial replaces the ontological catastrophe of Being with the ethical catastrophe one encounters before configurations of the Holocaust. While Heidegger describes how *Dasein* must face the threat of its negation by returning to the "null ground of its null project," the memorial functions as such a null ground; it not only signifies the sites where the Other was incinerated by the catastrophic flames of history, its design also consumes those who step across its multiple thresholds of stone. I will return later in this conclusion to the memorial's relation to the Holocaustal uncanny.

Walser, like Heidegger, turns away from these terrifying scenes when confronted with the anxiety invoked by the memory of the death camps. He does describe how he trembles in relation to Auschwitz, but this tremor results from an act of boldness ("Weil ich jetzt wieder vor Kühnheit zittere") when he tells his audience that Auschwitz has become a moral bludgeon and espouses the merits of both looking away and not thinking about the Nazi genocide (20). Furthermore, Walser's *Zufluchtswinkel* within his speech might at first seem like an attempt to transform the historical import behind the memorial into a debate on the ethics of representing the Holocaust. Asserting that public acts of conscience risk becoming symbolic or mere ritualized performances, he concludes through Heidegger and Hegel that conscience is outside the bounds of what can be represented within a public space. Although it appears as if Walser is shifting the question of Holocaust memory into a debate on the *Bilderverbot* (prohibition against images), he never explicitly rejects the placing into stone of the historical trauma of genocide or the memory of the exterminated; rather, he maintains that it is the affective tonality associated with the event, "Unsere Schande," which should not be displayed. Citing Hegel, Walser claims that *Gewissen*, or conscience, needs to remain interior.

What Walser conceals behind his ostensible turn to aesthetics, ontology, and speculative philosophy is history itself. Leading neither to an act of recalling the dead nor to the scene of historical trauma, self-reflexivity enables Walser to escape from the shame that history's unbearable images provoke in him. In his discussion of the Holocaust Memorial, Walser remarks that posterity (*Nachwelt*) can read later on (*Nachlesen*), "Was Leute anrichteten, die sich für das Gewissen von anderen verantwortlich fühlten ... Die Monumentalisierung der Schande" (20). Any sense of historical responsibility for the victims of the extermination is excluded from Walser's formulation. Shame is not a step on the way to contrition or remembrance, but stops at the self. What is couched in terms of an ethical conflict as seen in such words as *Moralkeule*, *Gewissen*, and *Schuld* moves to reflections on aesthetics, ontology, and idealism. Walser departs from the twentieth century's historical catastrophe to thoughts on the beautiful and what he identifies as his favorite period, 1790–1800. It is the era of German Idealism, when questions concerning beauty, dreams, the imagination, and inwardness flourished. In his flight from memory, which is simultaneously a flight from thinking, Walser repudiates the moral import behind remembering and representing the Holocaust at the end of the twentieth century.

Even in his discussion of his own personal memories and experiences during the period of National Socialism, Walser claimed that these experiences could not be adequately communicated to the generations that followed the Second World War. Ten years before his speech in Frankfurt, he described this impasse of memory in the following manner:

> I have the feeling that I do not know how to handle my memory [*Erinnerung*] like others do. For example, it is not possible for me to teach my memories with the help of acquired knowledge in the period between then and now. The images (*Bilder*) of each lesson are inaccessible. Everything that I have experienced in the meantime has not altered these images ... Acquired knowledge about the murdering dictator is one thing, my memory (*Erinnerung*) is another ... most of the representations of the past are therefore information about the present. (*Über Deutschland reden*, 76–78)

Walser is constructing here what he explicitly names in an interview around the time of his Frankfurt speech: the poles of *Erinnerung* and *Gedächtnis* (see Augstein). In the preceding passage, his delineation of acquired knowledge (*Wissen*) and information (*Auskünfte*) is consistent with what he names *Gedächtnis*. Describing his positing of such a temporal gulf between these two distinct generations as a "Verstehensgrenze" (boundary of understanding), Aleida Assmann claims that Walser wishes to underscore the radical alterity of his memories by maintaining they cannot be communicated to the generations that followed the period of National Socialism. According to Assmann, Walser is trying to convey the impossibility of translating [*keine Übersetzungsmöglichkeit*] his memories [*Erinnerungen*] under the era of National Socialism into a *Gruppengedächtnis* in Germany. Because the political uniqueness of these two periods would present a limit to what the *Nachgeborene* could understand, Walser himself would not risk translating his recollections of the Nazi regime across this temporal border.[5] While the authenticity of the past is preserved in *Erinnerung*, *Gedächtnis* on the other hand tends to falsify or distort the past; the conveyance of memory risks being contaminated by the ideological perspectives of the observer in the present. Thus, Walser decides to keep his *Bilder*, the interior images from the past that are preserved within the vault of *Erinnerung*, concealed within himself. To cross this border between *Erinnerung* and *Gedächtnis*, Walser feared, would only lead to the falsification of his memories. In opposition to Derrida's analysis of these poles of memory in relation to acts of mourning that were examined in the previous chapter, Walser privileges *Erinnerung* over *Gedächtnis*.

5 See Assmann's *Geschichtsvergessenheit/Geschichtsbesessenheit* (36–41), where she examines the problems of Walser's construction of memory. As she insists, "Die expliziten subjektiven Erinnerungen sind eingebunden in ein implizites Generationsgedächtnis" (38).

Similarly, by describing the construction of the memorial as an empty ritual, Walser maintains his rejection of *"Gruppengedächtnis"* within public spaces in order to uphold his defense of private forms of memory (*Erinnerung*). With regard to this polemic of memory, Walser seems to shift from a concern with aesthetics—how can the past be effectively represented?—to a question of epistemology: how can those born after the catastrophe step across the *Verstehensgrenze* of the memorial and gain access to the traumatic past? This boundary echoes Levinas's own reflections on whether or not those born after the Holocaust should be exposed to the same vertigo at the edge of the "gaping pit" of the camps. In response to Levinas's questions, "Should we insist on bringing into this vertigo a portion of humanity whose memory is not sick from it own memories ... Will they be able to understand that feeling of chaos and emptiness?" (*Proper Names*, 120), Walser's answer would be a resounding "no." Despite his reference to Heidegger on *Schuld* and conscience, Walser's goal is the avoidance of discomfort, anxiety, and the uncanny, and as he asserted in his conversation with Bubis, "I want my peace of soul (*Seelenfrieden*) ... and how I obtain it, that is inside myself, that is my conscience" (Schirrmacher, 449). The images and discussions regarding Auschwitz along with its memorialization in the center of Berlin subvert this peace of soul. By staying within the crypt of *Erinnerung*, Walser achieves his "peace" by refusing to translate his memories of the Nazi past into the present.

Although Assmann's figure of a *Verstehensgrenze* from her analysis of Walser refers to a temporal threshold that defies a possible transference of memory into the present, the translation of a spatial threshold is key to the Holocaust Memorial in Berlin and to each text I have examined in relation to the Holocaustal uncanny. It is this very threshold that the artist who engages with the Holocaust must write, paint, or build, while simultaneously acknowledging the impossibility of an actual crossing. Like Celan approaching the boundary of the poet in Tübingen, where he becomes a witness to the Other's suffering and returns with his estranged word, Kiefer and Libeskind go into the *topos* of Celan's poetry and translate his abstractions into visual forms of representation. In the space of the void, whether linguistic or architectural, we have reached not the limits of writing, painting, or building, but rather the interpretive and perceptual limits of reading, seeing, and going into the Holocaust's non-site.

The memorial, which I mentioned briefly in the previous chapter, selected by the Bundestag—with the assistance of an advisory committee headed by the American scholar on Holocaust museums and memorials James Young—was Peter Eisenman's model *The Pathos of Negativity*. Eisenman's memorial, comprising 2,711 pillars of concrete and located near Berlin's center, the Reichstag, the Tiergarten, embassies, and the Bran-

denburg Gate, can be read as fulfilling the task of Young's description of a "counter-memorial": it provokes and estranges the visitor, whereby the task of memory is transferred from the memorial's stones to the visitor who becomes the vehicle on which memory is contingent (*Texture*, 30). Eisenman's cenotaphic space of concrete pillars beckons the visitor to enter and walk through its narrow, labyrinthine, unsteady terrain. Yet the memorial site retains this sense of the Holocaust's impenetrability. Similar to how James Ingo Freed described the intended encounter between the Holocaust Museum and Memorial in Washington, D.C. and its visitors as, "Intestinal, visceral. It must take you in its grip," the Holocaust Memorial in Berlin wishes to destabilize the visitor's control through its massive terrain of concrete pillars (Freed, 59). In this prosthetic memory site there are no gestures of knowing what happened; the effects of shock, discomfort, or vertigo are the constitutive elements of the memorial.

But while a counter-memorial disappears, in Eisenman's memorial it is the visitor who is swallowed by the labyrinth of stones. Eisenman's installation, reminiscent of a graveyard filled with blank stones, can be seen as a reflection of the Jewish cemetery of Weissensee in Berlin—the largest Jewish Cemetery in Europe, overflowing with rows of unengraved headstones that point to those who died in exile or perished in the camps. By stepping into the memorial, the visitor enters the space of the Holocaustal uncanny. Leading the spectator into a field of tombs, the architect attempts to undermine the visitor's ability to orient herself among the pillars. The uneasiness or sense of dislocation elicited in the memorial space is the moment where historical comprehension falters. Eisenman creates a space where the shifting heights of the *stele*, blocked perspective, wave-like form, and uneven ground provide no illusion of becoming a witness or of sustaining any empathic understanding of the Holocaust. Derrida says of *le re-venant*, "Ghosts always pass quickly, with the infinite speed of a furtive apparition, in an instant without duration ... the ghost, *le re-venant*, the survivor, appears only by means of figure or fiction, but its appearance is not nothing, nor is it mere semblance" (*Memoires*, 64). As one walks through this memorial space, one is confronted by the flitting movement of other visitors disappearing and re-appearing between the pillars. The visitor becomes a part of the memorial, where the quick glance of her movement performs the act of haunting within this space. We ourselves become the reminders of this history as we are consumed and materialize again before the other's gaze.

Berlin's memorial functions as an architectural instantiation of a *Verstehensgrenze*, where the visitor is lured into crossing the threshold without being able to actually do so. Instead, the visceral effects associated with

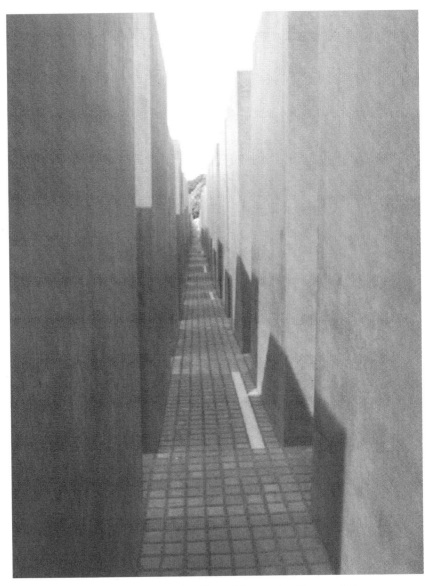

The Memorial to the Murdered Jews of Europe. Peter Eisenman, Berlin.
Courtesy of Leah Hochman

this space replace any illusion of knowing what happened.⁶ The encounter with the memorial's thresholds of stone is meant to provoke a shudder that both gestures to the limitations of remembering and comprehending the null ground of traumatic history and draws attention to the ethical catastrophe brought about by the policies of the Third Reich. In this act of translation characterized by one's stepping into the memorial site, the visitor is reminded of an absence conveyed through the pillars of stone. The missing inscriptions signify the *Schuld* infused in this landscape and prompt the visitor to recognize her continued responsibility to recall all that was effaced; the missing names are the debt that forces us to acknowledge that our act of crossing into this space is incomplete. The debt assigned to these stones re-affirms that something is inaccessible to the individual who enters the space of the memorial with the intention of becoming an historical witness. A part of history remains irrecuperable not simply for the poet, artist, or architect who attempts to translate the traumatic past into the present, but also for the reader-spectator who engages with prosthetic sites of memory. The debt that is passed on from the text to its recipient becomes constitutive of a perpetual haunting that reminds the reader/spectator of her ceaseless obligation to the past.

Although in his Frankfurt speech Walser quoted Hegel on how the individual's conscience is interiorized as he pulls back into himself, Walser seems to have bypassed Hegel's turn to the goddess of memory, Mnemosyne, in his reflections on the cultural and philosophical necessity of recollection; the philosopher exalts the task of the artist during times of historical crisis. Contrary to Walser's rejection of public forms of *Gedächtnis*, for Hegel it was the artist who was required to exteriorize the spirit of a people. In a fragment called "Über Mythologie, Volksgeist und Kunst" Hegel discusses the process in which the artists of a society convert interiorized memory into outward appearances, whereby *Geist* (spirit) is per-

6 One such pit that has actually been dug up is the site of Belzec's mass graves. The Belzec Memorial consists of a narrow path that both descends into and cuts through the landscape in which a half-million Jews were exterminated. The designers call this the "interstice," which is "like a crack in the earth." This cut "reveals the dimensions of the crime" and the site "evokes the terror of one of the greatest graves in the world." The interstice allows visitors to enter *into* this grave through a narrow trench. The exposure to the very viscera of the exterminated, their bones and ash, is itself symptomatic of what I would call an ethical catastrophe in relation to Holocaust memory: there is a total bankruptcy of the ability to imagine. The description of the memorial's concept tells how the "symbolic mass gravesites" contain "authentic mass gravesites within its border." In its very construction, the memorial seems to promise the visitor an unmediated or "authentic" experience with trauma: an immediacy that is impossible. Despite its attempts to be a memorial, Belzec's pathway signifies the foreclosure of the imagination. In turn, the integral concept of proximity and a movement toward the Other are undermined as the visitor is placed there, in the void in place of the Other. For images and history of the site, see <http//www.death camps.org/belzec.memorial.html>.

ceived in the communal space of a people. Without the visual and aural forms of representation through the arts, *Geist* remains concealed and cannot rise to the consciousness of a people.

> Mnemosyne, or the absolute Muse, art, assumes the aspect of presenting the externally perceivable, seeable, and hearable forms of spirit (*die Gestalten des Geistes*). This Muse is generally expressed consciousness of a people (*Bewusstsein des Volkes*). The work of art of mythology propagates itself in living tradition. As peoples grow in the liberation of their consciousness, so the mythological work of art continuously grows and clarifies and matures. This work of art is a general possession, the work of everyone. Each generation hands it down embellished to the one that follows; each works further toward the liberation of absolute consciousness (*Befreiung ihres Bewusstseins*) ... He (the artist) is like someone who finds himself among workers who are building a stone arch, the scaffolding of which is invisibly present as an idea. Each puts on a stone. The artist does the same. It happens to him by chance to be the last; in that he places the last stone, the arch carries itself. By placing the last stone, the artist sees that the whole is one arch; he declares this to be so and thereupon is taken to be the inventor ... So is the work of art the work of all. There is always one who brings it to its final completion by being the last to work on it and he is the darling of Mnemosyne. [7]

In Hegel's passage, memory, through the support of the artwork, strives to posit the "form of spirit" so that spirit can be perceived either visually or audibly. The historical consciousness of a people finds its articulation through the artworks of the muse of memory, Mnemosyne. In order for *Geist* to become apprehended, memory must be made external. Each generation of a people works toward the liberation of absolute consciousness [*Befreiung des absoluten Bewusstseins*], whereby memory becomes a communal act. This outward form of memory (*Gedächtnis*) can only unfold after a period of interiorization (*Erinnerung*).[8]

But in a post-Holocaust and post-traumatic age we need to rethink the meaning of Hegel's *Geist*, *Bewusstsein*, and the role of the artist and art. In the years following the Second World War the *Geist* that sat within the German "Volk" was radically altered. The word *Geist* no longer refers to Hegel's notion of spirit, but signals the traumatic residue of a ghost lodged in the German nation.[9] While in Hegel's fragment on Mnemosyne,

7 From Rosenkranz, 180–81; cited in Verene, 36–37.

8 See for instance the works of de Man and Derrida on the distinction between *Erinnerung* and *Gedächtnis* in relation to representation (*Vorstellung*) as it unfolds in Hegel's *Encyclopedia*. While *Erinnerung* refers to the inward preservation of experience, *Gedächtnis* is linked to concepts of writing and inscription. De Man writes, "In order to remember, one is forced to write down what one is likely to forget" ("Sign and Symbol," 772; Derrida, *Memoires for Paul de Man*). For a more detailed discussion of *Erinnerung* and *Gedächtnis* in relation to Derrida and the process of mourning, see chapter 6 of the current study.

9 We are very close here to the conclusion of Hegel's *Phenomenology of Spirit*, where he discusses how *Erinnerung* comprises images (*Bilder*), or a "Galerie von Bildern" that are ultimately

liberation of absolute consciousness seems to imply the completion of the arch, each artist that I examined here demonstrates the impossible act of putting down the last stone, as seen in their continued dialogue with and translation of Celan's poetics. By tracing the development of how artists have translated Celan, I have sought to point to some of the stones in this arch leading from the Holocaust to the present.

Furthermore, I have been trying to examine how the thing, whether it refers to an architectural space, a cinematic image, or a painting, is not a mirror to Celan's poems, nor is it a mimetic attempt to get inside the Holocaust. Rather, each text positions the spectator before the traces of Celan and the Holocaust. While one might at first recall Levinas's thoughts on the face-to-face encounter with the Other, the face of the Holocaust Other is withheld in Celan's Tübingen, Resnais's desolate landscapes, Kiefer's *Sulamith*, Libeskind's voids, and among Eisenman's stone pillars. Instead, these faces are refigured by the inscription of words sinking in a river, close-ups of marks on the gas chamber ceiling, a name or a lock of hair inscribed in leaden books, or architectural blind spots that challenge the spectators' position in a museum or memorial site. In the caesuras of Celan, Resnais, Kiefer, Libeskind, and Eisenman, the spectator runs up against not mythopoetic ruptures like in Hölderlin and Heidegger, but the ruins of catastrophic history.

At the end of his discussion with Bubis in the *FAZ*, Walser declared, "We are in search of a language of memory (*Erinnerung*) that is not yet available." One might hear in this statement either Dante's lament over the failure of his poetic voice to convey his memory of the inferno, or Hölderlin's "Mnemosyne," with its own depictions of both the inability to communicate and the death of memory. But unlike Dante and Hölderlin, who connect these breakdowns to an anxiety over how to properly mourn mythic loss, Walser's anxiety arises not from any inadequacy that might stem from the act of mourning, but rather Walser trembles when he propounds to his audience the benefits of diverting one's eyes and thoughts from the traumatic ruins of the Holocaust. Ironically enough, Walser uses the space of *Gruppengedächtnis*, the setting of an award ceremony, to promote a withdrawal from public acts and installations that call upon those present to recognize the debt of memory left in the aftermath of the Nazi genocide.

transformed (*aufgehoben*) as spirit becomes history. At this moment of transformation into history, recollection (*Erinnerung*) preserves the image (*Bild*) within itself. The place where Hegel's *Phenomenology* ends, where the *Bild* appears, occurs at what he calls "the Calvary (Golgotha) of absolute spirit": history is actualized, becomes represented or placed before us (*vorgestellt*) at the site of the skull, in the images from religion and art.

Walser's claim that a new language needs to be found to remember the past disregards the dynamic and evolving conversation that has taken place over the last six decades between Celan and those artists who have attempted to translate his poetics. Celan provided a name for this new language of memory and it is a word from which Walser most certainly would have turned away. In place of such words as Mnemosyne, *Andenken*, *Gedächtnis*, and *Erinnerung*, Celan recovered in "Die Schleuse" a lost word that enabled him to supplant these former modes of memory with *Jiskor*: a foreign word that acknowledges the very limits of what can be translated from the traumatic past into memory. *Jiskor* signifies a debt that always remains left over and can never be settled. Although Celan's use of a foreign word concedes the very *Verstehensgrenze* that Walser seems to support in his discussions concerning the limits of translating *Erinnerung* into *Gedächtnis*, Walser is actually in search of a new language for memory that would be devoid of any traits associated with the anxiety of a debt or of a perpetual haunting; instead, he seeks a language that will contribute to his "peace of soul."

In *Otherwise than Being*, Levinas writes, "The most lucid humanity of our time … has in its clarity no other shadow, no other disquietude or insomnia than what comes from the destitution of the others. Its insomnia is but the absolute impossibility to slip away and distract oneself" (93). Walser's speech in Frankfurt and his discussions regarding memory that ensued from his act of "looking away" reveal attempts to slip away from one's responsibility to the Other, in particular, the effaced Other. His support of looking and thinking away the Holocaust Memorial—a site that he calls a nightmare—discloses an ethical failure. In his description of the memorial, Walser forms a correspondence with Levinas's depiction of the ethical moment; the site produces a shudder that "jostles the presence of mind" (*Otherwise than Being*, 88) and contributes to an absolute insomnia that breaks one's "serenity of consciousness" (87). But it is this very shudder, a shudder that reminds the subject of his/her ceaseless obligation to the past, from which Walser tries to flee.

In one of the last encounters between Celan and Heidegger in March 1970, a month before drowning himself in the Seine, Celan reproached Heidegger for his supposed lack of attentiveness during one of his poetry readings in Freiburg. Heidegger said to a friend, "Celan is sick—hopeless."[10] In opposition to Heidegger's failure to hear Celan's imploring call to respond with a word of thought about all that had happened, each artist I examine here turns to Celan in order to face the vanishing point of the Holocaust. Dante had Vergil to guide, translate, and interpret for him

10 "Celan ist krank—heillos" (quoted in G. Baumann, 80).

the sights and words that were beyond his grasp in the Inferno. Hölderlin faced the Greeks to reflect on the flight of the gods, and Celan turned to the mad Hölderlin in his tower to question the role of the poet during destitute times. In their respective approaches to the horrors of the Nazi genocide, Resnais and Cayrol, Bachmann, Kiefer, and Libeskind turn to Celan as their point of reference to orient themselves within the traumatized landscape of the Holocaust. With its spatial and temporal breakdowns, the traumatic event is itself an epistemic rupture that retains its status as a lost experience. These disruptions of space and time are configured within the structures of the artwork. In turn, the textual break signals the moment when the reader/spectator is both compelled to translate the gap of a poem or the blank space of a memorial and to acknowledge the very boundaries of re-imagining the catastrophic scenes contained in these voids.

In facing Celan, each text not only functions as a mode of translation of Celan's poetics, but the artwork also sets up a potential encounter for the reader/spectator with scenes of traumatic shock that cannot be mastered, scenes that try to solicit from the recipient impossible acts of reading or seeing semantic and visual ruptures. The imposition of perceptual violence by the artist upon the spectator takes her from the space of art into a scene of historical trauma. Through such acts of disfigurement, the artist attempts to estrange the spectator's gaze as a means to demonstrate the very impossibility of witnessing or testifying from inside the catastrophe. Once face-to-face with these structural voids, at the moment of the Holocaustal uncanny, the reader/spectator is confronted with the fear of losing her vision. With this disruption of perception, which indicates simultaneously the breakdown of witnessing, the uncanny moment rises to the surface; the reader/spectator, trapped within the structural void of the catastrophe, must either remain in the vortex of signification or become a translator herself and step back across the frame with a memory—although incomplete—of a historical erasure. In the voids of Resnais, Kiefer, and Libeskind, we are left with something analogous to (>>Pallaksch. Pallaksch.<<). It is a word that both implores translation while recoiling back into its crypt.

Bibliography

Abraham, Nicholas. *The Phantom of Hamlet* in *The Shell and the Kernel: Renewals of Psychoanalysis.* 191–205.

Abraham, Nicholas, and Maria Torok. "Notes on the Phantom: A Complement to Freud's Metapsychology." In *The Shell and the Kernel: Renewals of Psychoanalysis.* Ed. and trans. Nicholas T. Rand. Chicago, IL: University of Chicago Press, 1994. 171–76.

Adorno, Theodor. *Aesthetic Theory.* Trans. Robert Hullot-Kentnor. Minneapolis, MN: University of Minnesota Press, 1997.

———. *Minima Moralia.* Frankfurt a. M.: Suhrkamp, 1994.

———. *Negative Dialectics.* Trans. E. B. Ashton. London: Routledge, 1973.

———. *Notes on Literature,* Vol. 2. Trans. S. W. Nicholsen, New York: Columbia University Press, 1992.

———. "Trying to Understand Endgame." Trans. Michael T. Jones. *New German Critique* 26 (1982): 119–30.

———. "What does Coming to Terms with the Past Mean?" (1959) Trans. Timothy Bahti and Geoffrey Hartman. In *Bitburg in Moral and Political Perspective.* Ed. Geoffrey Hartman. Bloomington: Indiana University Press, 1986. 114–29.

———. *Wörter aus der Fremde.* In *Noten zur Literatur.* Ed Rolf Tiedemann. Frankfurt a. M.: Suhrkamp, 1989. 216–32.

Arendt, Hannah. *Eichmann in Jerusalem: A Report on the Banality of Evil.* London: Penguin, 1977.

Armes, Ray. *The Cinema of Alain Resnais.* London: Zwemmer/Barnes, 1968.

Assmann, Aleida. *Erinnerungsräume.* Munich: C. H. Beck, 1998.

Assmann, Aleida, and Ute Frevert, eds. *Geschichtsvergessenheit-Geschichtsbesessenheit: Vom Umgang mit deutschen Vergangenheiten nach 1945.* Stuttgart: Deutsche Verlags-Anstalt, 1999.

Augstein, Rudolf. "Erinnerung kann man nicht befehlen: Martin Walser und Rudolf Augstein über ihre deutsche Vergangenheit." *Spiegel* 45 (1998): 48–72.

Avisar, Ilan. *Screening the Holocaust: Cinema's Images of the Unimaginable.* Bloomington: Indiana University Press, 1988.

Bachmann, Ingeborg. *Malina.* Frankfurt a. M.: Suhrkamp, 1971.

———. *Malina: A Novel.* Trans. Philip Boehm. Afterword by Mark Anderson. New York: Holmes & Meier, 1999.

Baer, Ulrich. *Remnants of Song: Trauma and the Experience of Modernity in Charles Baudelaire and Paul Celan.* Stanford, CA: Stanford University Press, 2000.

Barnouw, Dagmar. *Germany 1945: Views of War and Violence.* Bloomington: Indiana University Press, 1996.

Baumann, Gerhart. *Erinnerungen an Paul Celan.* Frankfurt a. M.: Suhrkamp, 1986.

Bauman, Zygmunt. *Modernity and the Holocaust.* Ithaca, NY: Cornell University Press, 1989.

Beaucamp, Eduard. "Die Verbrannte Geschichte. Anselm Kiefer und die Deutschen Mythen." *Frankfurter Allgemeine Zeitung* 11 April 1984. (Cited in Sabine Schutz, *Anselm Kiefer*, 349–50)

Benholdt-Thompsen, Anke. "Auf der Such nach dem Erinnerungsort." *Celan-Jahrbuch* 2 (1988): 7–28.

Benjamin, Walter. "Die Aufgabe des Übersetzers." *Gesammelte Schriften* 4. Eds. Rolf Tiedemann and Hermann Schweppenhäuser. Frankfurt a. M.: Suhrkamp, 1972. 9–21.

———. "A Berlin Chronicle." *Reflections: Essays, Aphorisms, Autobiographical Writings*. Ed. Peter Demetz. Trans. Edmund Jephcott. New York: Schocken Books, 1986. 3–60.

———. *Illuminations*. Ed. with intro. by Hannah Arendt. Trans. H. Zohn. New York: Schocken, 1969.

———. "One-Way Street." In *Walter Benjamin: Selected Writings Volume 1: 1913–1923*. Eds. Marcus Bullock and Michael W. Jennings. Cambridge, MA: The Belknap Press of Harvard University Press, 1996. 444–88.

———. *The Origin of the German Tragic Drama*. Trans. J. Osborne. Intro. George Steiner. London: New Left Books, 1977.

———. "Die Wiederkehr des Flaneurs." *Gesammelte Schriften* 3. Frankfurt a. M.: Suhrkamp, 1972. 194–99.

Betsky, Aaron. "Libeskind Builds." *Architecture* 87.9 (Sep. 1998): 101–23.

Bier, Jean-Paul. "The Holocaust and West Germany: Strategies of Oblivion 1947–1979." *New German Critique* 19 (Winter 1980): 9–29.

Biro, Matthew. *Anselm Kiefer and the Philosophy of Martin Heidegger*. Cambridge, UK: Cambridge University Press, 1998.

———. "Representation and Event: Anselm Kiefer, Joseph Beuys, and the Memory of the Holocaust." *Yale Journal of Criticism* 16.1 (2003): 113–46.

Blanchot, Maurice. *Writing of the Disaster*. Trans. Ann Smock. Lincoln, UK: Lincoln University Press, 1986.

Bloom, Harold. *Agon: Towards a Theory of Revisionism*. Oxford: Oxford University Press, 1982.

———. Introduction. In Kiefer, *Merkaba*.

Bogumil, Sieghild. "Celans Hölderlinlektüre im Gegenlicht des schlichten Wortes." *Celan-Jahrbuch* 1 (1987): 81–125.

———. "Todtnauberg." *Celan-Jahrbuch* 2 (1988): 37–51.

Böschenstein, Bernhard. "Hölderlin und Celan." *Paul Celan: Materialien*. Eds. Werner Hamacher and Winfried Menninghaus. Frankfurt a. M.: Suhrkamp, 1988. 191–200.

———. "'Tübingen, Jänner.'" *Über Paul Celan*. Ed. Dietland Meinecke. Frankfurt a. M.: Suhrkamp, 1973. 101–12.

Böschenstein, Bernhard, and Sigrid Weigel, eds. *Ingeborg Bachmann und Paul Celan: Poetische Korrespondenzen*. Suhrkamp: Frankfurt a. M.: 1997.

Böttiger, Helmut. *Orte Paul Celans*. Vienna: Paul Zsolnay Verlag, 1996.

Brailovsky, Anne. "The Epic Tableau: *Verfremdungseffekte* in Anselm Kiefer's *Varus*." *New German Critique* 71 (Spring/Summer 1997): 115–38.

Briegleb, Klaus. *Missachtung und Tabu. Eine Streitschrift zur Frage: "Wie antisemitisch war die Gruppe 47?"* Berlin: Philo, 2003.

Bruns, Gerald L. "The Concept of Art and Poetry in Emmanuel Levinas's Writings." *The Cambridge Companion to Levinas.* Eds. Simon Critchley and Robert Bernsaconi. Cambridge, UK: Cambridge University Press, 2002. 206–33.

Buchloh, Benjamin. "A Note on Gerhard Richter's October 18, 1977." *October* (Spring 1989): 89–109.

Büchner, Georg. *Werke und Briefe.* Frankfurt a. M.: Insel Verlag, 1965.

Buck, Theo. *Bildersprache. Celan-Motive bei László Lakner und Anselm Kiefer.* Aachen: Rimbaud, 1993.

———. *Muttersprache, Mördersprache.* Aachen: Rimbaud, 1993.

Burckhardt, Jacqueline, and Joseph Beuys. *Ein Gespräch. Beuys, Kounellis, Kiefer, Cucchi.* Zurich: Parkett-Verlag, 1986.

Burger, Hermann. *Paul Celan. Auf der Suche nach der verlorenen Sprache.* Zurich: Artemis, 1974.

Caltoir, Barbara. "Die Neuen Extasen: Zur Malerei der 'Jungen Wilden.'" *Frankfurter Allgemeine Zeitung* 12 Nov. 1981.

Caputo, John. "Heidegger's Scandal: Thinking and the Essence of the Victim." *The Heidegger Case: On Philosophy and Politics.* Eds. Tom Rockmore and Joseph Margolis. Philadelphia, PA: Temple University Press, 1992.

Carroll, David. Introduction. In Lyotard, *Heidegger and "the jews,"* vii–xxix.

Caruth, Cathy. *Unclaimed Experience: Trauma, Narrative and History.* Baltimore, MD: Johns Hopkins University Press, 1996.

Celan, Paul. "Briefe an Alfred Margul-Sperber." *Neue Literatur* 26.7 (1975): 50–63.

———. *Collected Prose.* Trans. Rosemarie Waldrop. Manchester: Carcanet, 1986.

———. *Die Gedichte: Kommentierte Gesamtausgabe in einem Band.* Ed. and commentary by Barbara Wiedemann. Frankfurt a. M.: Suhrkamp, 2003.

———. *Die Gedichte aus dem Nachlass.* Frankfurt a. M.: Suhrkamp, 1997.

———. *Gesammelte Werke* 1–5. Eds. Beda Allemann and Stefan Reichert. Frankfurt a. M.: Suhrkamp, 1985.

———. *Gisèle Celan-Lestrange. Briefwechsel 1–2.* Frankfurt a. M.: Suhrkamp, 2001.

———. *Glottal Stop: 101 Poems by Paul Celan.* Trans. Nikolai Popov and Heather McHugh. Hanover, N.H.: Wesleyan University Press/University Press of New England, 2000.

———. *Der Meridian. Tübinger Ausgabe. Endfassung, Vorstufen, Materialien.* Ed. Jürgen Wertheimer. Frankfurt a. M.: Suhrkamp,1999.

———. *Die Niemandsrose. Tübinger Ausgabe. Vorstufen, Textgenese, Endfassung.* Ed. Jürgen Wertheimer. Frankfurt a. M.: Suhrkamp, 1996.

———. *Poems of Paul Celan.* Trans. Michael Hamburger. New York: Persea Books, 1980.

———. *Selected Poems and Prose of Paul Celan.* Trans. John Felstiner. New York: Norton, 2001.

———. *Sprachgitter. Vorstufen, Textgenese, Endfassung.* Tübinger Ausgabe. Ed. Jürgen Wertheimer. Frankfurt a. M.: Suhrkamp. 1996.

Celan, Paul, and Hanne and Hermann Lenz. *Briefwechsel: mit drei Briefen von Gisèle Celan-Lestrange.* Ed. Barbara Wiedemann. Frankfurt a. M.: Suhrkamp, 2001.

Celan, Paul, and Nelly Sachs. *Briefwechsel.* Frankfurt a. M.: Suhrkamp, 1993.

———. *Paul Celan, Nelly Sachs: Correspondences.* Trans. Christopher Clark. Ed. Barbara Wiedemann, with an introduction by John Felstiner. Riverdale-on-Hudson, 1995.

Chalfen, Israel. *Paul Celan: A Biography of His Youth*. Trans. Maximilian Bleyleben. Intro. by John Felstiner. New York: Persea Books, 1981.

Cohen, Josh. *Interrupting Auschwitz: Art, Religion, Philosophy*. New York: Continuum, 2003.

Colin, Amy. *Paul Celan: Holograms of Darkness*. Bloomington: Indiana University Press, 1991.

Constantine, David. *The Significance of Locality in the Poetry of Friedrich Hölderlin*. London: Modern Humanities Association, 1979.

Coury, David N. "'Auch ruhiges Land...': Remembrance and Testimony in Paul Celan's *Nuit et Brouillard* Translation." *Prooftexts* 22 (2002): 55–76.

Dante Alighieri. *The Inferno*. Trans. John Ciardi. Ontario: Penguin Books, 1982.

Danto, Arthur. "Anselm Kiefer." *The Nation* 248 (1 Jan. 1989): 26–28.

Dawidowicz, Lucy. *A Holocaust Reader*. West Orange, NJ: Behrman House, 1976.

de Man, Paul. "Autobiography as De-Facement." *The Rhetoric of Romanticism*. New York: Columbia University Press, 1984. 67–81.

————. "Sign and Symbol in Hegel's *Aesthetics*." *Critical Inquiry* 8 (Summer 1982): 761–75.

Dean, Carolyn J. *The Fragility of Empathy: After the Holocaust*. Ithaca, NY: Cornell University Press, 2004.

Derrida, Jacques. *Cinders*. Trans. Ned Lukacher. Lincoln: University of Nebraska Press, 1991.

————. *Memoires: For Paul de Man*. Trans. Cecile Lindsay, Jonathan Culler, and Eduardo Cadava. New York: Columbia University Press, 1986.

————. *Points...: Interviews, 1974–1994*. Ed. Elisabeth Weber. Trans. Peggy Kamuf et al. Stanford, CA: Stanford University Press, 1995.

————. "Shibboleth for Paul Celan." In Fioretos, *Word Traces*, 3–72.

————. "Des Tours de Babel." In *Difference in Translation*. Ed. Joseph F. Graham. Ithaca, NY: Cornell University Press, 1985. 165–207.

————. *The Work of Mourning*. Eds. Pascale-Anne Brault and Michael Naas. Chicago, IL: University of Chicago Press, 2001.

Diner, Dan. *Ist der Nationalsozialismus Geschichte? Zu Historisierung und Historikerstreit*. Frankfurt a. M.: Fischer, 1987.

Dolar, Mladen. "'I shall be with you on your Wedding-night': Lacan and the Uncanny." *October* 58 (Fall 1991): 5–23.

Dorner, Elke. *Daniel Libeskinds Jüdisches Museum Berlin*. Berlin: Gebr. Mann, 1999.

Douglas, Lawrence. "Film as Witness: Screening Nazi Concentration Camps before the Nuremberg Tribunal." *Yale Law Journal* Nov.1995: 449–81

Elden, Stuart. "Heidegger's Hölderlin and the Importance of Place." *The Journal of the British Society for Phenomenology* 30.3 (Oct. 1999): 258–74.

Elon, Amos. "A German Requiem." *The New York Review of Books* 15 Nov. 2001: 43–44.

Evers, Kai. "Monological versus Dialogical Remembrance: Gert Neumann's Novel *Anschlag* in the Context of the Walser-Bubis Controversy." *The Germanic Review* 80.1 (Winter 2005): 7–27.

Ezrahi, Sidra DeKoven. *By Words Alone: The Holocaust in Literature*. Chicago, IL: University of Chicago Press, 1980.

————. "'The Grave in the Air': Unbound Metaphors in Post-Holocaust Poetry." In Friedlander, *Probing the Limits*, 259–76.

Fackenheim, Emil. *To Mend the World: Foundations of Post-Holocaust Jewish Thought.* New York: Schocken Books, 1982.

Felman, Shoshana, and Dori Laub. *Testimony: Crises of Witnessing in Literature, Psychoanalysis, and History.* New York: Routledge, 1992.

Felstiner, John. "Translating Paul Celan's "Todesfuge": Rhythm and Repetition as Metaphor." In Friedlander, *Probing the Limits*, 240–58.

————. *Paul Celan: Poet, Survivor, Jew.* New Haven, CT: Yale University Press, 1995.

Fioretos, Aris, ed. *Word Traces: Readings of Paul Celan.* Baltimore, MD: Johns Hopkins University Press, 1994.

Fletcher, Angus. *Allegory: The Theory of a Symbolic Mode.* Ithaca, NY: Cornell University Press, 1964.

Foster, Kurt. *Extension to the Berlin Museum with Jewish Museum Department: Daniel Libeskind.* Berlin: Ernst and Son, 1992.

Fóti, Véronique. *Heidegger and the Poets: Poiesis, Sophie, Techne.* New Jersey: Humanities Press International, 1992.

Freed, James Ingo. "The United States Holocaust Memorial Museum." *assemblage* 9 (1989): 59–90.

Freud, Sigmund. *Beyond the Pleasure Principle.* Ed. and trans. James Strachey. New York: Norton, 1975.

————. *The Ego and the Id.* Trans. Joan Riviere. New York: Norton, 1960.

————. "Further Recommendations in the Technique of Psychoanalysis: Recollection, Repetition, and Working Through." *Therapy and Technique.* Ed. Philip Rieff. New York: Macmillan, 1963. 157–66.

————. *Inhibitions, Symptoms, and Anxiety.* Trans. James Strachey. New York: W. W. Norton, 1959.

————. "Medusa's Head." *Sexuality and the Psychology of Love.* Ed. Philip Rieff. New York: Macmillan, 1963. 213-13.

————. "Mourning and Melancholia." *General Psychological Theory.* Ed. Philip Rieff. Trans. Joan Riviere. New York: Macmillan Publishing Company, 1963. 164–79.

————. *Origins of Psychoanalysis: Letters to Wilhelm Fliess, Drafts and Notes, 1887–1902.* Ed. Marie Bonaparte, Anna Freud, and Ernst Kris. Trans. Eric Mosbacher and James Strachey. New York: Basic Books, 1954.

————. "Repression." *The Standard Edition of the Complete Psychological Works of Sigmund Freud in 24 Volumes.* Vol. 14. Trans. and ed. James Strachey London: Hogarth Press, 1953–66. 141–58.

————. "The Uncanny." (1919) *Studies in Parapsychology.* Ed. Philip Rieff. New York: Macmillan, 1963. 19–60.

Friedlander, Saul . *Memory, History, and the Extermination of the Jews of Europe.* Bloomington, IN: Indiana University Press, 1993.

————, ed. *Probing the Limits of Representation: Nazism and the "Final Solution."* Cambridge, MA: Harvard University Press, 1992.

Fynsk, Christopher. "The Realities at Stake in the Poem." In Fioretos, *Word Traces*, 159–84.

Gadamer, Hans-Georg. *Gadamer on Celan: "Who Am I and Who Are You?" and Other Essays.* Eds. Richard Heinemann and Bruce Krajewski. Albany: State University of New York Press, 1997.

————. *Wer bin ich und wer bist Du? Kommentar zu Celans "Atemkristall."* Frankfurt a. M.: Suhrkamp, 1973.

Garloff, Katja. *Words from Abroad: Trauma and Displacement in Postwar German Jewish Writers.* Detroit, MI: Wayne State University Press, 2005.

Gelhaus, Axel. *Fremde Nähe: Celan als Übersetzer.* Marbach: Deutsche Schillergesellschaft, 1997.

Golb, Joel. "Reading Celan: The Allegory of 'Hohles Lebensgehöft' and 'Engführung.'" In Fioretos, *Word Traces,* 185–218.

Haar, Michel. "The Obsession of the Other: Ethics as Traumatization." *Philosophy and Social Criticism* 23.6 (1997): 95–107.

Habermas, Jürgen. *The New Conservatism: Cultural Criticism and the Historians' Debate.* Ed. and trans. Shierry Nicholsen. Cambridge, MA: MIT Press, 1989.

————. "Work and Weltanschauung: The Heidegger Controversy from the German Perspective." *Critical Inquiry* 15.2 (Winter 1989): 431–56.

————. "Der Zeigefinger. Die Deutschen und ihr Denkmal." *Die Zeit* 14, 31 March 1999: 42–44.

Haidu, Peter. "The Dialectics of Unspeakability: Language, Silence, and the Narrative of Desubjectification." In Friedlander, *Probing the Limits of Representation,* 277–99.

Hamacher, Werner. "The Second of Inversion: Movements of a Figure through Celan's Poetry." In Fioretos, *Word Traces,* 219–66.

Hamacher, Werner, and Winfried Menninghaus, eds. *Paul Celan.* Frankfurt a. M.: Suhrkamp, 1988.

Hanstein, Mariana. "Anselm Kiefer: Aus dem Absturz heraus entsteht der Gesang." *Die Welt* 2 March 1992.

Haverkamp, Anselm. *Leaves of Mourning.* Trans. Vernon Chadwick. Albany: State University Press, 1996.

Hebard, Andrew. "Disruptive Histories: Toward a Radical Politics of Remembrance in Alain Resnais's *Night and Fog.*" *New German Critique* 71 (Spring/Summer 1997): 87–113.

Hecht, Axel, and Werner Krüger. "Venedig 1980: Aktuelle Kunst made in Germany." *Art,* 6 (1980): 40–53.

Hegel, G. W. F. *Elements of the Philosophy of Right.* Ed. Allen W. Wood. Trans. H. B. Nisbet. Cambridge, UK: Cambridge University Press, 1991.

————. *Phenomenology of Spirit.* Trans. A. V. Miller. Foreword by J. N. Findlay. Oxford, UK: Clarendon Press, 1977.

Heidegger, Martin. *Basic Problems of Phenomenology.* Trans. Albert Hofstadter. Bloomington: Indiana University Press, 1982.

————. *Being and Time.* Trans. John Macquarrie. New York: Harper & Row, 1962.

————. *Discourse on Thinking.* Trans. John Anderson. New York: Harper & Row, 1966.

————. *Einführung in die Metaphysik.* Tübingen: Max Niemeyer Verlag, 1976.

————. *Erläuterung zu Hölderlins Dichtung. Gesamtausgabe* 4. Frankfurt a. M.: Klostermann, 1976.

————. *Gelassenheit.* Pfullingen: Verlag Günther Neske, 1959.

————. *The History of the Concept of Time.* Trans. Theodore Kisiel. Bloomington: Indiana University Press, 1985.

————. *Hölderlins Hymne "Andenken" (Wintersemester 1941/42)*. *Gesamtausgabe* 52. Ed. Curd Ochwadt. Frankfurt a. M.: Klostermann, 1985

————. *Hölderlins Hymne "Der Ister." Gesamtausgabe* 53. Frankfurt a. M.: Klostermann, 1984.

————. *Hölderlin's Hymn "The Ister."* Trans. William McNeill and Julia Davis. Bloomington: Indiana University Press, 1992.

————. *An Introduction to Metaphysics.* Trans. Ralph Mannheim. New Haven, CT: Yale University Press, 1959.

————. *On the Way to Language.* Trans. Peter Hertz. New York: Harper & Row, 1971.

————. "Only a God Can Save Us Now." Trans. Maria P. Alter and John D. Caputo. In Wolin, *The Heidegger Controversy*, 91–116.

————. "Remembrance of the Poet." Trans. Douglas Scott. *Existence and Being.* Intro. by Werner Brock. Chicago, IL: Henry Regnery Company, 1949. 233–69.

————. "Die Sprache." *Unterwegs Zur Sprache. Gesamtausgabe* 12. Ed. Friedrich-Wilhelm von Hermann. Frankfurt a. M.: Klostermann, 1985. 9–30.

————. "The Thinker as Poet." *Poetry, Language, Thought.* Trans. Albert Hofstadter. New York: Harper & Row, 1971. 1–14.

————. *Was heisst Denken?* Tübingen: Max Niemeyer Verlag, 1961.

————. *What Is Called Thinking?* Trans. J. Glenn Gray. New York: Harper & Row, 1968.

————. "Das Wort." *Unterwegs Zur Sprache. Gesamtausgabe* 12. Ed. Friedrich-Wilhelm von Hermann. Frankfurt a. M.: Klostermann, 1985. 145–225.

Herf, Jeffrey. *Divided Memory: The Nazi Past in the Two Germanys.* Cambridge, MA: Harvard University Press, 1997.

————. "The 'Holocaust' Reception in West Germany: Right, Center, and Left." *New German Critique* 19 (Winter 1980): 30–52.

Hertz, Neil. *End of the Line: Essays on Psychoanalysis and the Sublime.* New York: Columbia University Press, 1985.

Hirsch, Marianne. "Surviving Images: Holocaust Photography and the Work of Postmemory." *Visual Culture and the Holocaust.* Ed. Barbara Zelizer. New Brunswick, RI: Rutgers University Press, 2001. 215–46.

Hoffmann, E. T. A. "Der Sandmann." (1817) *Fantasie und Nachtstücke.* Munich: Winkler Verlag, 1960.

Hölderlin, Friedrich. *Hymns and Fragments by Friedrich Hölderlin.* Trans. Richard Sieburth. Princeton, RI: Princeton University Press, 1984.

————. *Sämtliche Werke.* Grosse Stuttgarter Hölderlin-Ausgabe. Vol. 5. Ed. Friedrich Beissner. Stuttgart: Kohlhammer, 1946–57.

————. "Remarks on 'Oedipus.'" *Essays and Letters on Theory.* Trans. Thomas Pfau. Albany: State University of New York Press, 1988. 101–08.

————. *Werke und Briefe.* Vol. 1. Ed. Friedrich Beissner and Jochen Schmidt. Frankfurt a. M.: Insel Verlag, 1982.

Hughes, Robert. "Germany's Master in the Making." *Time Magazine* 21 Dec. 1987: 46.

Huppert, Hugo. "'Spirituell': Ein Gespräch mit Paul Celan." In Hamacher and Menninghaus, *Paul Celan*, 319–24.

Huyssen, Andreas. *Twilight Memories: Marking Time in a Culture of Amnesia.* New York: Routledge, 1995.

Insdorf, Annette. *Indelible Shadows: Film and the Holocaust.* 3rd Ed. Cambridge, UK: Cambridge University Press, 1989.

Ivanovic, Christine. *Das Gedicht im Geheimnis der Begegnung: Dichtung und Poetik Celans im Kontext seiner russischen Lektüren.* Tübingen: Niemeyer, 1996.

Jaehner, Inge. "'Wenn ich untergehe, lasst meine Bilder nicht sterben': Felix Nussbaum—Leben und Werk." *Vernissage: Die Zeitschrift zur Ausstellung* 16 (1997): 14–55.

Janz, Marlies. "Haltlosigkeiten. Paul Celan und Ingeborg Bachmann." *Das schnelle Altern der neuesten Literatur. Essays zu deutschsprachigen Texten zwischen 1968–1984.* Eds. Jochen Hoerisch and Hubert Winkels. Düsseldorf: Claassen, 1985. 31–39.

———. *Vom Engagement absoluter Poesie. Zur Lyrik und Ästhetik Paul Celans.* Frankfurt a. M.: Syndikat, 1976.

Jeismann, Michael. *Mahnmal Mitte: Eine Kontroverse.* Cologne: Dumont, 1999.

Joris, Pierre. "Celan/Heidegger: Translation at the Mountain of Death." <http://wings.buffalo.edu/epc/authors/joris/todtnauberg.html>.

Kaes, Anton. "Holocaust and the End of History: Postmodern Historiography in Cinema." In Friedlander, *Probing the Limits*, 206–22.

Kant, Immanuel. *Critique of Judgment.* Trans. Werner S. Pluhar. Indianapolis, IN: Hackett, 1987.

———. *Critique of Practical Reason,* Trans. Lewis White Beck. New York: Macmillan Publishing Company, 1993.

———. *Critique of Pure Reason.* Trans. Norman Kemp Smith. New York: St. Martin's Press, 1965.

———. *Kritik der Urteilskraft.* Stuttgart: Reclam, 1995.

Kiedaisch, Petra, ed. *Lyrik nach Auschwitz? Adorno und Die Dichter.* Stuttgart: Reclam, 1995.

Kiefer, Anselm. *Merkaba.* New York: Gagosian Gallery, 2002.

Kipphoff, Petra. "Das Bleierne Land." *Die Zeit* 28 July 1989.

———. "Die Lust an der Angst—der deutsche Holzweg." *Die Zeit* 6 June 1980.

Kleinman, Arthur and Joan. "The Appeal of Experience: The Dismay of Images: Cultural Appropriations of Suffering in Our Times." *Daedalus* 1 (Winter 1996): 1–23.

Kloch-Klenske, Eva. "Die vollkommene Vergeudung. Eine Leseart des Romans 'Malina' von Ingeborg Bachmann." *Die Sprache des Vaters im Körper der Mutter: literarischer Sinn und Schreibprozess.* Ed. Rolf Haubl. Giessen: Anabas, 1984. 115–31.

Könneker, Sabine. *"Sichtbares, Hörbares": Die Beziehung zwischen Sprachkunst und bildender Kunst am Beispiel Paul Celans.* Bielefeld: Aisthesis Verlag, 1995.

Krass, Stephan. "'Wir haben Vieles einander zugeschwiegen': Ein unveröffentlichter Brief von Paul Celan und Martin Heidegger." *Neue Zürcher Zeitung* 3/4 Jan. 1998 (1): 49.

Krauss, Rosalind. "The Cultural Logic of the Late Capitalist Museum." *October* 54 (Fall 1990): 3–17.

Kretschmer, Heike, and Michael Schardt, eds. *Über Ingeborg Bachmann. Rezensionen-Porträts-Würdigungen (1952–1992).* Paderborn: Igel Verlag, 1994.

Kristeva, Julia. *Strangers to Ourselves.* Trans. Leon S. Roudiez. New York: Columbia University Press, 1991.

Kroll, Jack. "An Epic Artist of Desolation." *Newsweek* 111.3, 18 Jan. 1988: 77.

Krüger, Horst. *Das zerbrochene Haus. Eine Jugend in Deutschland.* Frankfurt a. M.: Fischer, 1986

Kuspit, Donald. "The Night Mind." *Artforum* Sept. 1982: 63–67.

———. "The Spirit of Gray." <www.artnet.com/Magazine/features/kuspit/kuspit 12-19-02.asp>.

LaCapra, Dominick. *History and Memory after Auschwitz.* Ithaca, NY: Cornell University Press, 1998.

———. *Representing the Holocaust.* Ithaca, NY: Cornell University Press: 1994.

———. *Writing History, Writing Trauma.* Baltimore, MD: Johns Hopkins University Press, 2001.

Lacoue-Labarthe, Philippe. "Catastrophe." In Fioretos, *Word Traces,* 130–58.

———. *Poetry as Experience.* Trans. Andrea Tarnowski. Palo Alto, CA: Stanford University Press, 1996.

Landsberg, Alison. "America, the Holocaust, and the Mass Culture of Memory: Toward a Radical Politics of Memory." *New German Critique* 71 (Spring/Summer 1997): 63–86.

———. *Prosthetic Memory: The Transformation of American Remembrance in the Age of Mass Culture.* New York: Columbia University Press, 2004.

Lang, Berel. *Act and Idea in the Nazi Genocide.* Chicago, IL: University of Chicago Press, 1990.

———. *Heidegger's Silence.* Ithaca, NY: Cornell University Press, 1996.

Leach, Neil. *Architecture and Revolution: Contemporary Perspectives on Central and Eastern Europe.* London: Routledge, 1999.

Lennox, Sara. "In the Cemetery of the Murdered Daughters: Ingeborg Bachmann's *Malina.*" *Studies in Twentieth Century Literature* 5.1 (1980): 75–105.

Lenz, Benjamin. *Alain Resnais.* Reihe Film, 38. Munich: Carl Hanser Verlag, 1990.

Levinas, Emmanuel. *Dieu, la mort et le temps.* Paris: Grasset, 1993.

———. *Difficile Liberté, essais sur le judaïsme.* Paris: Albin Michel, 1976.

———. *Difficult Freedom: Essays on Judaism.* Trans. Seán Hand. Baltimore, MD: Johns Hopkins University Press, 1990.

———. *Existence and Existents.* Trans. Alphonso Lingis. The Hague: Martinus Nijhoff, 1978.

———. "Language and Proximity." *Collected Philosophical Papers.* Trans. Alphonos Lingis. The Hague: Martinus Nijhoff, 1987. 109–26.

———. *Nine Talmudic Readings.* Trans. Annette Aronowicz. Bloomington: Indiana University Press, 1990.

———. *On Escape.* Trans. Bettina Bergo. Stanford: Stanford University Press, 2003.

———. *Otherwise Than Being or Beyond Essence.* Trans. Alphonso Lingis. The Hague: Martinus Nijhoff, 1981.

———. "Philosophie et transcendence." *Encyclopédie philosophique.* Paris: P.u.f., 1959.

———. *Proper Names.* Trans. Michael B. Smith. Stanford, CA: Stanford University Press, 1996.

———. *Time and the Other.* Trans. Richard Cohen. Pittsburgh, PA: Duquesne University Press, 1987.

———. "The Trace of the Other." Trans. A Lingis. In *Deconstruction in Context.* Ed. Mark Taylor. Chicago, IL: University of Chicago Press, 1986. 345–59.

Leys, Ruth. *Trauma, a Genealogy.* Chicago, IL: University of Chicago Press, 2000.

Libeskind, Daniel. "Between Method, Idea, and Desire." *Domus* 731 (Oct. 1991): 17–28.

———. *Chamber Works.* Graz: Architectural Association, 1983.

―――. "Deconstructing the Call to Order." *Building Design* 2 Sept. 1994.

―――. *Extension to the Berlin Museum with Jewish Museum Department.* Berlin: Ernst and Son, 1992.

―――. *Jewish Museum Berlin: Architect Daniel Libeskind.* Berlin: G and B Arts International, 1999.

―――. *Radix-Matrix: Daniel Libeskind Architekturen und Schriften.* Ed. Alois Martin Mueller. Munich: Prestel, 1994.

―――. *The Space of Encounter.* Afterword by Anthony Vidler. New York: Universe Publishing, 2000.

―――. "Traces of the Unborn." *Architecture and Revolution: Contemporary Perspectives on Central and Eastern Europe.* Ed. Neil Leach. New York: Routledge, 1999. 127–38.

―――. "Trauma." *Image and Remembrance: Representation and the Holocaust.* Eds. Shelley Hornstein and Florence Jacobowitz. Bloomington: Indiana University Press, 2003. 43–58.

Lyon, James K. Introduction. *Studies in Twentieth Century Literature* 8.1. Manhattan: Kansas State University, 1983. 1–7.

―――. *Paul Celan and Martin Heidegger: An Unresolved Conversation, 1951–1970.* Baltimore, MD: Johns Hopkins University Press, 2006.

Lyotard, Jean-François. *The Differend.* Trans. Georges Van Den Abbeele. Minneapolis: University of Minnesota Press, 1988.

―――. *Heidegger and "the jews."* Trans. A. Michael and M. Roberts. Foreword by David Carroll. Minneapolis: University of Minnesota Press, 1990

―――. *Lessons on the Analytic of the Sublime.* Trans. Elizabeth Rottenberg. Stanford, CA: Stanford University Press, 1994.

Makkreel, Rudolph. *Imagination and Interpretation in Kant: The Hermeneutic Import of the Critique of Judgment.* Chicago, IL: University of Chicago Press, 1990.

Manning, Robert John Sheffler. "The Cries of Others and Heidegger's Ear: Remarks on the Agriculture Remark." In Milchman and Rosenberg, *Martin Heidegger,* 19–38.

Masschelein, Anneleen. "Double Reading/Reading Double: Psychoanalytic Poetics at Work." *The Return of the Uncanny.* Special issue of *Paradoxa: Studies in World Literary Genres* 3.3/4 (1997): 395–406.

McGuire, Penny. "Past Masters." *The Architectural Review* 4 (1999): 48–53.

Meltzer, Françoise. *Salomé and the Dance of Writing: Portraits of Mimesis in Writing.* Chicago, IL: University of Chicago Press, 1959.

Michael, Robert. "Night and Fog." *Cineastic* 13.4 (1984): 37.

Milchman, Alan, and Alan Rosenberg, eds. *Martin Heidegger and the Holocaust.* New Jersey: Humanities Press International, 1996.

Mitscherlich, Alexander and Margarete. *The Inability to Mourn: Principles of Collective Behavior.* Trans. Beverley R. Placzek. New York: Grove Press, 1975.

Moeller, Susan. *Compassion Fatigue.* New York: Routledge, 1999.

Nägele, Rainer. "Paul Celan: Configurations of Freud." *Reading after Freud: Essays on Hölderlin, Habermas, Nietzsche, Brecht, Celan, and Freud.* New York: Columbia University Press, 1987. 135–68.

Neumann, Gerhard. "Die 'absolute' Metapher. Eine Abgrenzungsversuch am Beispiel Stephane Mallarmés und Paul Celans." *Poetica* 3.1/2 (1970): 188–225.

Olschner, Leonard. *Der feste Buchstab: Erläuterungen zu Paul Celans Gedichtübertragungen.* Göttingen: Vandenhoeck & Ruprecht , 1985.

——. "Poetic Mutations of Silence: At the Nexus of Paul Celan and Osip Mandelstam." In Fioretos, *Word Traces,* 369–85.

Ozick, Cynthia. "A Liberal's Auschwitz." In *The Pushcart Press: Best of Small Presses.* Ed. Bill Henderson. New York: Pushcart Press, 1976. 153.

Pingaud, Bernard. Interview with Alain Resnais. *L'Arc* 31 (1967).

Pöggeler, Otto. *Spur des Worts: zur Lyrik Paul Celans.* Freiburg i. Br.: K. Alber, 1986.

——. "Todtnauberg." In Milchman and Rosenberg, *Martin Heidegger,* 102–12.

Power, Samantha. *"A Problem from Hell": America in the Age of Genocide.* New York: Basic Books, 2002.

Quilligan, Maureen. *The Language of Allegory: Defining the Genre.* Ithaca, NY: Cornell University Press, 1979.

Rapaport, Herman. "Of the Eye and the Law." *Unruly Examples: On the Rhetoric of Exemplarity.* Ed. Alexander Gelley. Palo Alto, CA: Stanford University Press, 1995. 303–23.

Reddy, William. *The Navigation of Feelings: A Framework for the History of Emotions.* Cambridge, UK: Cambridge University Press, 2001.

Reemtsma, Jan Philpp. "Die einzige Loesung." *Die Zeit* 17 June 1999: 33–34.

Resnais, Alain, dir. *Gauguin.* French. B/w. 14 min. 1950.

——. *Guernica.* French. B/w. 13 min. 1950.

——. *Hiroshima mon amour.* French/Japanese/English. B/w. 90 min. 1959.

——. *Nuit et brouillard. (Night and Fog).* French. B/w. 32 min. 1955.

——. *Les Statues meurent aussi.* French. B/w. 30 min. 1953.

——. *Van Gogh.* French. B/w. 20 min. 1948.

Rosenkranz, Karl. *Hegels Leben. Supplement zu Hegels Werken.* Berlin: Duncker & Humblot, 1844.

Rosenthal, Mark. *Anselm Kiefer.* Munich: Prestel-Verlag, 1988.

Royle, Nicholas. *The Uncanny.* New York: Routledge, 2003.

Saltzman, Lisa. *Art After Auschwitz.* Cambridge, UK: Cambridge University Press, 1999.

Santner, Eric. "History Beyond the Pleasure Principle: Some Thoughts on the Representation of Trauma." In Friedlander, *Probing the Limits,* 143–54.

——. *Stranded Objects: Mourning, Memory, and Film in Postwar Germany.* Ithaca, NY: Cornell University Press, 1990.

Schirrmacher, Frank, ed. *Die Walser-Bubis-Debatte.* Frankfurt a. M.: Suhrkamp, 1999.

Schmidt, Dennis. "Black Milk and Blue: Celan and Heidegger on Pain and Language." In Fioretos, *Word Traces,* 110–29.

Schneider, Michael. "Fathers and Sons, Retrospectively: The Damaged Relationship between Two Generations." *New German Critique* 31 (Winter 1984): 3–51.

Schütz, Sabine. *Anselm Kiefer, Geschichte als Material: Arbeiten 1969–1983.* Cologne: DuMont, 1999.

Seidensticker, Peter, and Wolfgang Butzlaff. "Zwei Bemühungen um ein Gedicht: Paul Celan: 'Todesfuge.'" *Der Deutschunterricht* 12.3 (1960): 34–51.

Seng, Joachim. *Auf den Kreis-Wegen der Dichtung: zyklische Komposition bei Paul Celan am Beispiel der Gedichtbände bis "Sprachgitter."* Heidelberg: Universitätsverlag C. Winter, 1998.

Sereny, Gitta. *Albert Speer: His Battle with Truth.* New York: Vintage, 1996.

Sheehan, Thomas. "Heidegger and the Nazis." *The New York Review of Books* 16 June 1988: 41–43.

Siegel, Jeanne. *Art Talk. The Early 80s.* New York: De Capo, 1988.

Silbermann, Edith. "Paul Celan und die Bukowina: Von der Wirkung der Herkunft." *Pannonia* 14.1 (1986): 8–12.

Sontag, Susan. *Regarding the Pain of Others.* New York: Farrar, Straus and Giroux, 2003.

Sophocles *Antigone.* In *The Theban Plays.* Trans. E. F. Watling. New York: Penguin, 1974. 126–62.

Spies, Werner. "Überdosis an Teutschem. Die Kunstbiennale Venedig ist eröffnet." *Frankfurter Allgemeine Zeitung* 28 January 1980.

Szondi, Peter. *Celan Studien.* Frankfurt a. M.: Suhrkamp, 1972.

———. *Celan Studies.* Ed. Jean Bollack. Trans. Susan Bernofsky, with Harvey Mendelsohn. Palo Alto, CA: Stanford University Press, 2003.

———. "Reading 'Engführung.'" *Celan Studies.* Trans. Susan Bernofsky, with Harvey Mendelsohn. Foreword by Jean Bollack. Palo Alto, CA: Stanford University Press, 2003. 27–82.

Tsvetaeva, Marina. *Poem of the End: Selected Narrative and Lyrical Poetry: With Facing Russian Text.* Transl. Nina Kossman, with Andrew Newcomb. Introduction by Laura Weeks. Ann Arbor, MI: Ardis, 1998.

van der Knaap, Ewout. *Uncovering the Holocaust: The International Reception of Night and Fog.* London: Wallflower Press, 2006.

Vaughan, William. "Heidegger *silentio.*" In Milchman and Rosenberg, *Martin Heidegger,* 70–101.

Verene, Donald Phillip. *Hegel's Recollection: A Study of Images in the Phenomenology of Spirit.* Albany: State University of New York Press, 1985.

Vergil. *The Aeneid.* Trans. Robert Fitzgerald. New York: Vintage, 1990.

Vidal-Naquet, Pierre. *Assassins of Memory.* New York: Columbia University Press, 1992.

Vidler, Anthony. *The Architectural Uncanny: Essays in the Modern Unhomely.* Cambridge, MA; MIT Press, 1992.

———. *Warped Space: Art, Architecture and Anxiety in Modern Culture.* Cambridge, MA: MIT Press, 2001.

Von Moltke, Johannes. "Architecture between the Lines: Daniel Libeskind's Design for the Berlin Jewish Museum." *Found Object* 5 (Spring 1995): 78–101.

Wagner, Anne. "Resisting the Erasure of History." In Leach, *Architecture and Revolution,* 130–38.

Walser, Martin. *Friedenspreis des Deutschen Buchhandels 1998: Erfahrungen beim Verfassen einer Sonntagsrede.* Mit der Lauditio von Frank Schirrmacher. Frankfurt a. M.: Suhrkamp, 1998.

———. "Über das Selbstgespräch: Ein flagranter Versuch." *Ich vertraue. Querfeldein.* Frankfurt a. M.: Suhrkamp, 2000. 125–50.

———. *Über Deutschland reden.* Frankfurt a. M.: Suhrkamp, 1989.

Weber, Samuel. *The Legend of Freud.* Stanford, CA: Stanford University Press, 2000.

Weigel, Sigrid. "Ein Umzug im Kopf." In Kretschmer and Schardt, *Über Ingeborg Bachmann,* 248–50.

Weineck, Silke-Maria. "Logos and Pallaksch: the Survival of Poetry in Celan's 'Tübingen, Jänner.'" *Orbis Litterarum* 54.4 (1999): 262–75.

Weissman, Gary. *Fantasies of Witnessing: Postwar Efforts to Experience the Holocaust.* Ithaca, NY: Cornell University Press, 2004.

Werner, Uta. *Textgräber: Paul Celans geologische Lyrik.* Munich: Wilhelm Fink Verlag, 1998.

West, Thomas. "Interview at Diesel Strasse." *Art International,* Spring 1988:75–83.

Willemeit, Thomas. "Musik und Architectur bei Daniel Libeskind." *Architese* 28.5 (Sept./Oct. 1998): 18–24.

Witte, Bernd. "Zu einer Theorie der hermetischen Lyrik. Am Beispiel Paul Celan." *Poetica* 13.1/2 (1981): 133–48.

Wolin, Richard, ed. *The Heidegger Controversy: A Critical Reader.* Cambridge, MA: The MIT Press, 1993.

Young, James. *At Memory's Edge: After-images of the Holocaust in Contemporary Art and Architecture.* New Haven, CT: Yale University Press, 2000.

———. "Gegen Sprachlosigkeit hilft kein Kreischen und Lachen." *Mahnmal Mitte: Eine Kontroverse.* Ed. Michael Jeismann. Cologne: Dumont, 1999. 218–27

———. *The Texture of Memory.* New Haven, CT: Yale University Press, 1993.

Zelizer, Barbie. *Remembering to Forget: Holocaust Memory Through the Camera's Eye.* Chicago, IL: University of Chicago Press, 1998.

Index of Names

Printed in Great Britain
by Amazon